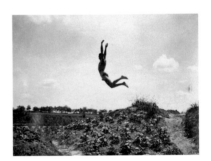

I am an amateur and I intend to stay that way for the rest of my life. I reject all forms of professional cleverness or virtuosity.... As soon as I have found the image that interests me, I leave it to the lens to record it faithfully. Look at reporters, amateurs—both of whose sole aim is to gather a memory or a document; that is pure photography. KERTÉSZ, 1930

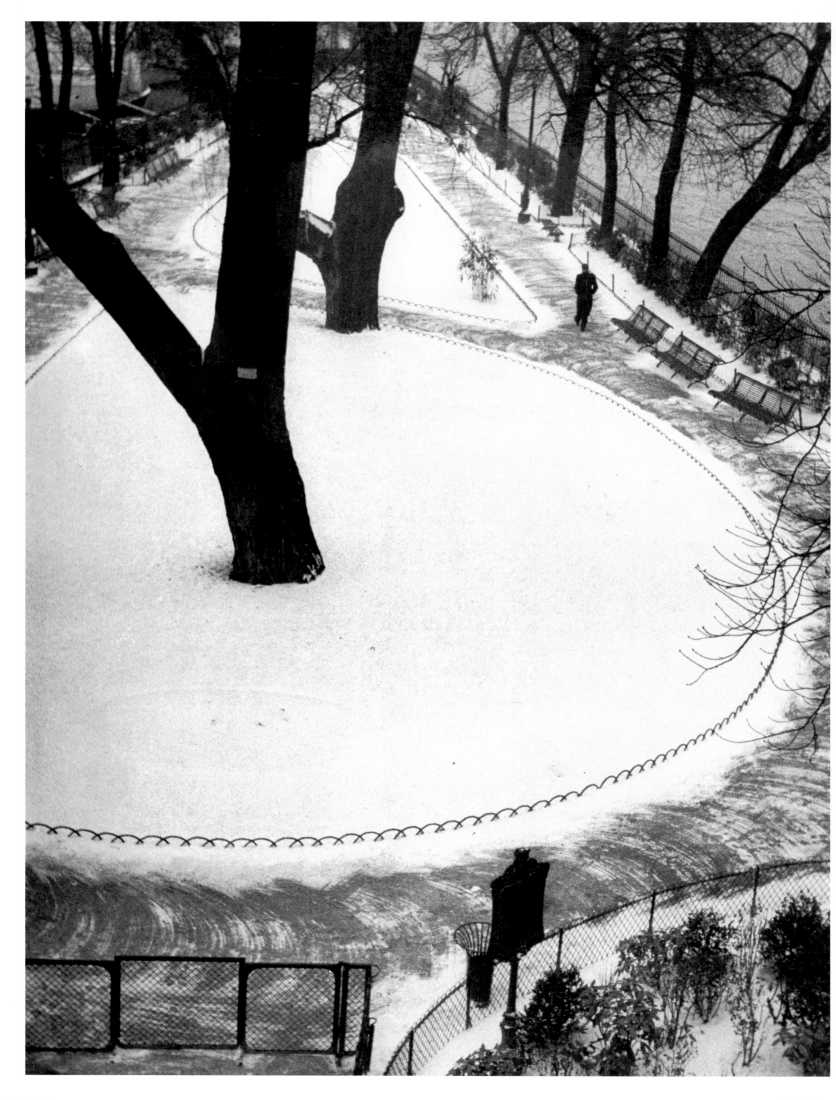

André Kertész

Sarah Greenough · Robert Gurbo · Sarah Kennel

National Gallery of Art · Princeton University Press

The exhibition has been organized by the
National Gallery of Art, Washington.

Exhibition Dates:

National Gallery of Art
6 February – 15 May 2005

Los Angeles County Museum of Art
12 June – 5 September 2005

André Kertész photographs reproduced
courtesy of the Estate of André Kertész
and the Jeu de Paume / French Ministry
for Culture and Communication

Produced by the Publishing Office,
National Gallery of Art
www.nga.gov

Editor in Chief, Judy Metro
Edited by Julie Warnement
Designed by Margaret Bauer

Typeset in Adobe Minion and FF Eureka
Sans by Graphic Composition, Inc., Atlanta,
Georgia. Printed on PhoeniXmotion
Xantur by Dr. Cantz'sche Druckerei, Germany

Separations by Robert J. Hennessey

Hardcover edition published in 2005 by the
National Gallery of Art, Washington, in
association with Princeton University Press

Princeton University Press
41 William Street
Princeton, New Jersey 08540

In the United Kingdom:
Princeton University Press
3 Market Place
Woodstock, Oxfordshire OX20 1SY

pup.princeton.edu

Library of Congress Control Number
2004115085

ISBN 0-691-12114-1 (cloth)
ISBN 0-89468-312-8 (paper)

10 9 8 7 6 5 4 3 2 1

Contents

Director's Foreword · In the final years of his life, André Kertész had the good fortune to see his photographs highly acclaimed, and widely exhibited and reproduced. With his modest demeanor, he took great delight in telling his many admirers that his deceptively simple photographs, like those of an amateur, sprung solely from his desire to express feelings about the world around him. But all who saw them also recognized that his perceptive insight, coupled with his finely tuned sense of form and composition, enabled him to infuse his photographs with a haunting poetry and quiet authority few other photographers of his time—or any other—could rival.

In the years since his death, Kertész's work has not been forgotten, but there has not been a major retrospective exhibition that presents vintage photographs surveying his entire career from its inception in Hungary in 1912 to his last works made in New York in the 1980s, nor has there been a scholarly reexamination of his art and life. Instead, the stories that Kertész himself told at the end of his life about his history have, on the whole, been accepted without question. Our aim is to present a more accurate and balanced picture by carefully studying Kertész's photographs and the large archive of diaries, correspondence, and memorabilia he himself preserved. This research reveals not only a far more complex and at times contradictory man, but also a more significant artist. It demonstrates that he was, from the very beginning of his career, deeply involved with other artists of his time; it shows how he consciously embraced the style of amateur photography; and it reveals how he is emblematic of a generation of twentieth-century artists whose migrations, whether chosen or forced, enabled them to rethink the nature and aims of their art as they sought to reconcile their inherited sensibilities with new cultures.

To The André and Elizabeth Kertész Foundation, we extend our deepest thanks, especially to its president, Alexander Hollander, treasurer, Jose Fernandez, and curator, Robert Gurbo, for their assistance with this exhibition, their many donations to the Gallery of Kertész's photographs, and their generous support of this publication. We also thank The Estate of André Kertész and the French Ministry for Culture and Communication for sharing copies of the artist's extensive archive and for granting permission to reproduce his photographs in this publication.

At the National Gallery, the exhibition has been made possible by generous donations from the Trellis Fund and The Ryna and Melvin Cohen Family Foundation. Their support has allowed us to embark on a new program of exhibitions of photographs.

The exhibition has been selected and organized by Sarah Greenough, curator and head of the department of photographs at the National Gallery, who also authored the catalogue with Robert Gurbo and Sarah Kennel, assistant curator at the Gallery. Their extensive research has enabled them to shed new light on Kertész's life and the development of his art.

We are also indebted to our many lenders, both public and private. Without their enthusiastic support and their willingness to share their treasured examples of Kertész's art, this exhibition would not have been possible.

Earl A. Powell III

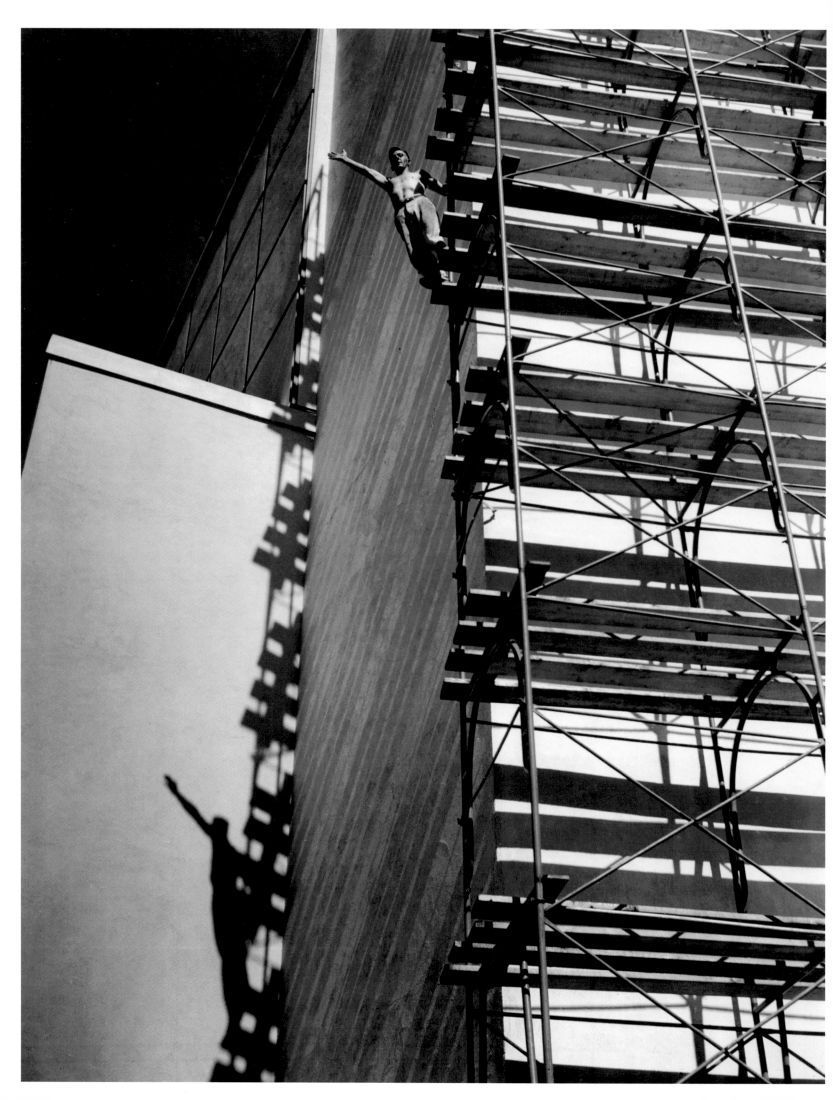

This exhibition
is made possible through
the generous support
of the Trellis Fund and
The Ryna and Melvin Cohen
Family Foundation

Additional support for the
catalogue was provided by
The André and Elizabeth
Kertész Foundation, New York

The Art Institute of Chicago

Soizic Audouard

The Buhl Collection

Eric Ceputis and David W. Williams

The Cleveland Museum of Art

Karen Daiter

The Detroit Institute of Arts

Emily Anne Dixon-Ryan

Edwynn Houk Gallery, New York

Fraenkel Gallery, San Francisco

Gilman Paper Company Collection

Mary Reese and Donald Ross Green

Hallmark Photographic Collection, Kansas City

Wendy Handler

Susan Harder

The J. Paul Getty Museum, Los Angeles

Sir Elton John

Joy of Giving Something, Inc., New York

Betsy Karel

The Estate of André Kertész

The Metropolitan Museum of Art, New York

The Museum of Fine Arts, Houston

The Museum of Modern Art, New York

National Gallery of Art, Washington

New Orleans Museum of Art

Pace/MacGill Gallery, New York

Prentice and Paul Sack Photographic Trust
of the San Francisco Museum of Art

Dorothy Press

Nicholas Pritzker

Private Collections

Stephen Daiter Gallery

Margaret W. Weston

Introduction · For more than forty years André Kertész (1894–1985, born Kertész Andor) has been widely hailed as one of the most important photographers of the twentieth century. He made some of the most deceptively simple yet compelling photographs ever created—from his first works taken in his native Hungary just shortly before World War I to his last studies from New York in the early 1980s. Working intuitively and seldom interacting with his subjects, he sought to capture the poetry of modern urban life, with its quiet, often overlooked incidents and odd, occasionally comic, or even bizarre juxtapositions. Combining an amateur's love for the personal and immediate with a modernist's sense of form and composition, he created a purely photographic idiom that celebrated a direct observation of everyday life. Yet, in his best, most haunting photographs, he sought not the decisive moment when an external action completed an intriguing formal arrangement, but the instant when the world was infused with personal meaning. Working more from his heart, he explained, "you don't see" the things you photograph, "you *feel*" them.[1]

In the 1960s and 1970s, when Kertész began to receive a significant amount of critical attention, he regularly told the story of his life. Asserting that he was born to be a photographer, he recalled his keen desire, even as a young child, to make photographs, and his passionate embrace of the medium when he finally purchased his first camera in 1912. He spoke in great detail of his innate belief that the medium's true strength lay not in the imitation of painting but in its capacity to reveal the commonplace, and he reminisced on his years as a soldier during the war and his unusual wish to record not the heroics, the carnage, or the chaos of battle, but his comrades during their moments of leisure. He remembered his subsequent boredom after the war with his job at the stock exchange, and his intense, ever-growing desire to move to Paris to pursue his chosen path as a photojournalist. He recalled his years in Paris from 1925 to 1936 in only the most glowing terms: he spoke warmly about his immediate embrace by the artistic community, both fellow Hungarian émigrés as well as painters, sculptors, poets, and writers of many other nationalities; and he more modestly described his distinguished career as the leading photojournalist of the time, whose many exhibitions and publications were eagerly anticipated and widely praised. He also excitedly remarked on his 1928 discovery of the Leica camera, with its fluid, graceful integration of eye, hand, and mind, and its ability to give order and meaning to the rapidly changing world. And with bitter undisguised contempt, he frequently and vociferously lamented his decision to move to the United States in 1936: from his disastrous relationship with the Keystone Press Agency, which had lured him to this country with false promises, to his cool reception by the Museum of Modern Art in New York and his indignation at their preposterous request that he crop a print, removing a model's pubic hair, to make it acceptable for exhibition. Mourning his subsequent decline into oblivion in the 1940s and 1950s, he decried the American publishing industry, especially the editors at *Life* who had criticized his work, stating that his "pictures talked too much," and he repeatedly condemned the American predilection for technique over content, precision over passion. A fiercely competitive yet deeply insecure man of great ambition, Kertész was easily wounded and, even at the height of his acclaim, made no attempt to hide the pain of these experiences.[2]

In retelling his story, whole years were collapsed into a few brief comments, while major events, influential relationships, and critical actions were minimized, even overlooked. Kertész's limited English further circumscribed his recitation, for though he lived in the United States for more than forty years, he never fully mastered the language. Even when speaking in his native Hungarian, he often felt hampered by his inability to adequately express himself. Then, too, his audience in the 1960s and 1970s was predominantly young and frequently American, unfamiliar with the kinds of experiences—both personal and political—that had shaped Kertész's life and career. From his decisions to emigrate, not once but twice, abandoning family, home, culture, and language for strange environments and an uncertain future, to his experiences during both world wars, Kertész had followed a peripatetic path that was foreign to most of his admirers in the 1960s and 1970s. Perhaps his apprehension of being misunderstood accounts for the relative simplicity of Kertész's accounts of these years.

Yet newly examined archival material—diaries, date books, and correspondence— reveals that as his stories were reduced and simplified, they lost not only their flavor and complexity, but also much of their truth.[3] Kertész was hardly the first artist to fabricate a personal narrative that differs substantially from the facts. Certainly the construction of a persona is an integral part of being an artist. In addition, the creation of identity— of adaptation and re-creation of self—is part of the difficult saga of all immigrants who leave behind their past lives, relationships, and even their stories and attempt to forge a new life, even a new history, in a foreign land. But with his curious blend of great certainty in his accomplishments and deep pessimism that the world would ever acknowledge his importance, coupled with his intense need for recognition and verification, Kertész created fabrications that go well beyond those of most other immigrants. Throughout his career he was keenly attuned to the power of images, both visual and verbal. While he was living in Paris in the 1920s and early 1930s, he began to explore a variety of ways of presenting himself. As he came to recognize that the seeming naiveté of his photographs could be a profound source of power in his art, he also realized that these presumably simple, unpremeditated records demanded an equally untutored personal history. And so this sophisticated photographer, perhaps playing on the provincialism of his Parisian audience, diminished his earlier associations with other artists in Hungary and purported to be nothing more than a gifted amateur. Later in the 1940s, 1950s, and early 1960s, when his own career ground to a halt and he saw photographers whom he had influenced, even trained, such as Brassaï, Robert Capa, and Henri Cartier-Bresson, or those who worked in a similar manner, such as Jacques Henri Lartigue, gain far greater prominence and acclaim, he once again modified his personal and artistic narrative. In his new history, he not only clarified his development, eliminating life's usual detours and giving it a greater sense of inevitability, but also emphasized his instinctive skills and minimized his failings or missteps. At the same time he also recropped and reprinted several earlier photographs, especially those from his years in Hungary, in order to assert that he was an innate modernist long before his arrival in Paris.

If Kertész had been a photographer like his compatriot László Moholy-Nagy, who preferred objective, formal studies and often constructed images purely out of light, these inaccuracies, this self-mythologizing and calculated self-effacement, would matter less, for they would not significantly affect our interpretation of his artistic achievement. But they do matter precisely because Kertész emphatically proclaimed that his photographs were a visual diary of his life.[4] When asked how his photographs influenced his life, he invariably reversed the question and asserted that it was his life that had influenced his photographs.[5] "The subject" of his art, he often insisted, "is me!"[6] Almost as soon as he began to photograph he seems to have recognized, perhaps intuitively, that he could use his camera to question, explore, and ultimately understand his relationship to the people and things around him. And, if not immediately then certainly at some point early in his career, he came to recognize that these intimate, highly autobiographical investigations could provide the foundation for an intensely personal and poetic art that could give form to those thoughts and feelings he was otherwise unable to articulate. Thus, because he wove the very fabric of his life into his art, the facts of his life, as well as his evolving interpretation of it, are critically important.

The essays that follow—on his years in Hungary, 1894–1925; Paris, 1925–1936; and New York, 1936–1961 and 1962–1985—seek to reevaluate Kertész's art through a close study of his photographs and the archival material he himself saved, as well as an examination of his relationship to the social, cultural, and artistic communities within which he worked. Their aim is not to point out the inaccuracies in Kertész's own, more simplified story, but to convey more fully the richness of both his life and his accomplishment and to demonstrate how the tension between the facts of his life and his perception of it is often at the root of his most compelling photographs.

Sarah Greenough and Robert Gurbo

A Hungarian Diary, 1894–1925 Sarah Greenough

I would like to go back there during the summer, but with a camera.
What great pictures could I take. All filled with poetry.[1] KERTÉSZ, 1912

In October 1925, a deeply discouraged thirty-one-year-old Kertész Andor left his home in Budapest to start a new life in Paris. In the thirteen years since he had graduated from high school he had tried many jobs, from bank clerk to beekeeper, but none had sustained his interest, let alone captivated his imagination. Since 1912 he had been intrigued with photography, but primarily as a pastime, not a profession. He had already made several works that would be widely celebrated in his later years, including *Sleeping Boy,* 1912, and *Blind Musician, Abony,* 1921 (plates 2, 12). But not yet fully understanding their strength and originality, he lacked confidence in their merit. Plagued by self-doubt, often paralyzed by indecision, and ruled by his heart, he was, in his own words, "a nobody."[2] For most of his young life, only his love for various women, which at times bordered on all-consuming infatuation, had impelled him to take decisive action. But, even with his girlfriends, he was often frustrated by feelings of inadequacy and by his inability to find the right words to express himself. Since 1919 he had been besotted with a dark-haired art student eight years his junior, Erzsébet Salamon, but in 1924 she insisted he leave Budapest. Asserting that she was the stronger, more focused, and ambitious of the two, Salamon "imperiously" demanded, as the devastated Kertész noted in his diary, that he go away, establish a career for himself, and only then contact her again.[3] After several months of vacillating, Kertész resolved to do just that and left Budapest.

Despite this apparent lack of success, Kertész in later years repeatedly insisted that the seeds for all he became were sown in Hungary.[4] To a great extent, this assertion is true. Budapest's rich intellectual, literary, artistic, and musical life at the turn of the century—from its acclaimed educational system and lively press with its early and sustained exploration of photojournalism to its active community of painters, sculptors, and photographers, both amateurs and professionals—nurtured the young Kertész, providing him

with a strong community as well as influences and examples that proved critical to his development. Although somewhat younger than the celebrated "generation of 1900" of Hungarian artists, writers, musicians, scientists, and philosophers, Kertész reaped the same benefits from a cosmopolitan culture that had enjoyed more than thirty years of peace, prosperity, and unprecedented growth.[5] At the turn of the century, Budapest was not only Europe's fastest growing city but also one of its most dynamic.[6] With the biggest port on the Danube, Europe's largest stock exchange (constructed in 1895) and the first electric subway line (opened in 1896), as well as municipal water, and extensive gaslight, Budapest in 1900 was brimming with self-confidence. "Big with the future," as a journalist noted at the time, the city was full of possibilities for the young Kertész.[7]

Yet Hungary nourished Kertész in other less obvious ways as well. With its high respect for all kinds of intellectual investigations, Hungarian society applauded the achievements of not only the established intelligentsia but also the gifted amateur, and thus held open the promise of accomplishment for those who pursued different paths.[8] Because the legal age of majority was not reached until twenty-four, Hungary also gave the shy, sensitive, and hesitant young Kertész time to mature, without forcing him to conform to prevailing expectations or a proscribed agenda. In addition, he, like his compatriots, imbibed Budapest's simultaneous celebration of its modern, urban life and Hungary's rural past. Merging old and new, this modern culture did not categorically reject the past, but melded polished sophistication with an intense love for life's simple, traditional pleasures.[9] Finally, sitting at the crossroads between East and West, Hungary was—and is—both a part of Europe, yet also separated from it, isolated by a language that shares no common roots with that of any of its neighbors.[10] Within Hungary itself, Kertész found his outsider status further intensified by being Jewish, especially in the early 1920s when anti-Semitism increased markedly.[11] And he was even more isolated, particularly in his youth, by his persistent inability to articulate his thoughts. This duality—the sense of embracing the most advanced ideas of the time while cherishing older values, of being a part of a culture and yet somehow, often inexplicably, being separated from it—is fundamental to Kertész's experience in Hungary and lies at the core of his best photographs, not only during his early years, but throughout his life.

I lack the words, even though I have it inside me. KERTÉSZ, 1912

In later years Kertész repeatedly insisted that he was "born" to be a photographer.[12] In truth, his path was far richer and much less direct. He was born on 2 July 1894, during the hot, sultry Hungarian summer when the pungent smell of the rich surrounding country-side pervaded the city of Budapest. His parents, Lipót and Ernesztin, lived in an apartment building on Bulyovszky Street in Pest, but soon moved to a middle- and lower-middle-class area, just off Teleki Square, also in Pest.[13] East of the elegant Andrássy Avenue, with its wide boulevards and prosperous apartments, and west of the Inner City, with its grand hotels, celebrated coffeehouses, restaurants, and shopping promenades, the Józsefváros (Joseph district) where they lived was one of the most crowded areas of the city. Even though Budapest, and especially the newer area of Pest, was experiencing a building boom—595 new apartment buildings were constructed the year after Andor was born—traces of the older city could still be found, with smaller, one-story structures often

occupied by tradesmen—cobblers or coachmen.[14] Less regularized and renovated than the rest of Budapest, these older streets often had parks with open-air markets, making them more reminiscent of rural Hungarian towns than a thriving metropolis.

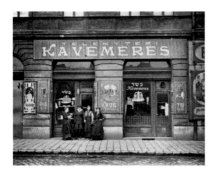

1.
André Kertész, *Coffee Shop*, 1912–1925, gelatin silver print, Kertész Foundation

Not much is known about the family's history. They had lived in Hungary at least since 1848.[15] An earlier relative had changed the name from Kohn to Kertész, which means "gardener" in Hungarian.[16] Befitting their bucolic-sounding name, Kertész's parents, like so many others in this thriving city at the turn of the century, were born in the country. His father was a bookseller.[17] His mother ran a nearby coffee shop, and may have had German or Austrian ancestors, as she frequently mixed German with Hungarian in her barely legible letters (figure 1).[18] Also, like most residents of this cosmopolitan city, the rest of the family spoke and wrote in Hungarian. They were often amused by Ernesztin's fractured speech, seeing it as charming but antiquated. Both parents, though, were proud of their Hungarian heritage and gave all three of their sons traditional names: Andor, who was called Bandi by his family and friends; Imre, born in 1889; and Jenő, born in 1897.[19] (Curiously, Andor and Jenő, who were very close, had speech problems—Andor lisped slightly in childhood and Jenő stammered throughout his life—which may have contributed to the frustration both felt in expressing themselves verbally.) Although the family was Jewish and identified with their faith, keeping its customs and holidays, they were also ecumenical, celebrating many Christian holidays as well, including Christmas. In February 1909 Lipót died, and the fourteen-year-old Andor, perhaps concerned about the family's financial plight, quit school in March and worked as an apprentice for two months.[20] Ernesztin's brother, Lipót Hoffman, a wealthy grain merchant, quickly assumed the role of guardian to both his sister and nephews, and he remained a strong presence in their lives until his death in 1925. Although not intellectuals, the family was well educated. Very loving and intensely involved in each other's lives, they communicated frequently, occasionally disagreed but quickly made up, and poked gentle fun at each other's foibles yet were always supportive.

While Kertész was clearly disturbed by his father's death, it may also have been a convenient excuse for him to leave school, for academics bored him intensely. Although intelligent and perceptive, he rarely studied, even when tests were imminent. Easily stung and especially sensitive of his failings, he railed when he, predictably, failed his courses, blaming not himself, but the system: "This is my reward for defending my honor," he fumed in his diary. "They kill every desire one has to study."[21] As a child he loved to visit his parents' relatives in the country, especially those in Ráckeve and Szigetbecse in the Csepel area, south of Budapest.[22] There, he, his brothers, and many cousins fished, swam in a branch of the Danube, and played with the animals. As a teenager he enjoyed sports, especially track events such as running and jumping. He also read the popular novels of the day, including *The Memories of Fanni,* and saw the fashionable plays, such as Sándor Bródy's *The Orphan Girls,* or the comedy *The Young Lass* by Pierre Weber and Henri de Gorsse.[23] He also began to keep extensive diaries at age fifteen, in which he noted not only his activities and aspirations, but also his frustrations. Yet lacking a clear understanding of his goals and seemingly bereft of any dreams for his future, Kertész was largely propelled by chance or, more frequently, love. From the time he was eleven in 1905 through his twenty-first birthday in 1915, he was passionately in love with Jolán Balog, a girl whose family lived across the street. Riding an often wrenching emotional roller coaster, he swung

wildly from intense adoration to deep insecurity about his worthiness to jealousy at her perceived infidelities. As he copiously detailed in his diaries, Kertész obsessively watched Balog from his window for hours at a time, days and months on end.[24] His vigil went well beyond simple curiosity, surveillance, or even voyeurism—his actions were so extreme it was as if he believed that by seeing her, even from a distance and through the filter of his window, he could come to know and more fully understand both her and their relationship.

Increasingly, though, Kertész struggled to find other ways to express his feelings for Balog. Between 1910 and 1912 he wrote turgid poems and he practiced his recorder.[25] He wanted to "play so that everyone would be enchanted by it," he confided in his diary. "Beautifully, slowly—with feeling, so that the listeners would cry over it." He continued, "I would play most beautifully for her. I would put my whole soul into it, so that she would cry either of joy or of sadness."[26] In 1912, perhaps to sharpen his expressive skills or to use culture as a way to mitigate his personal insufficiencies, he began to attend more plays and visit museums, where he bought reproductions of paintings, including Sándor Bihari's *Honeymoon* (figure 2).[27] But recognizing that he looked "for the poetic in everything," he felt that he lacked objective criteria to evaluate paintings.[28] "I judge them too much according

2.
Sándor Bihari, *Honeymoon*, 1905, oil, Hungarian National Gallery, Budapest

to my own personality," he lamented, not yet understanding that what he perceived as a weakness would later become the strongest asset of his art.[29] Yet, to his "greatest joy," he gradually discovered that he was "somewhat able to judge objects of art … although only in broad outlines. I cannot penetrate deeply yet. I lack the words," he sadly but correctly concluded, "even though I have it inside me."[30]

That summer, just a few days before his final high school examinations, Kertész's mother bought Jenő and him a camera. He had first expressed an interest in photography in February 1912, seeing it as a way to convey the poetry of the world around him.[31] But at least for the first few years Jenő was as fascinated with the camera as he was, and together the two sorted out the complexities of the process, especially developing and printing the small, 4.5 by 6 centimeter glass plates. In fact, they worked so closely that he often referred to the photographs that Jenő had taken as his own.[32] One of Jenő's first successful photographs of the Balog sisters made Kertész "so happy, there are no words for it."[33] Noting that their print "came out splendidly," he described it as a "tiny picture, but sharp. I can stare at it endlessly, and I am very happy."[34]

High school degree in hand, Kertész searched for a job in the summer of 1912, with help from his extended family. He regarded working with the same profound dread that he had approached school, and he was no more successful with it than with his studies. Eventually, the Giro Bank—a transfer or clearing bank—hired him. Although he readily admitted he did not have "a drop of ambition," he limped along at this job through 1914.[35] With his intense wish to record his life, he continued to keep a written diary, but he also began to make more photographs. Largely through trial and error, he and Jenő perfected their technique, learning how to make small carefully masked contact prints on printing-out-paper. Taking greater pride in his accomplishments and, no doubt, wishing to distinguish his work from Jenő's, he also signed some of his prints in 1913. Like any amateur, he recorded

both people and places with personal meaning: the young man asleep in a coffee shop; the park where he and Balog frequently—secretly—met, continuing their torrid affair; or women parading on the street with their fancy hats (plate 2; figure 3). "Slowly, slowly" he "became crazy for photography," he remembered many years later, and, like other avid amateurs, he began to push himself to do more, exploring new subjects and technical challenges.[36] For example, using his brothers as models, he posed Imre as a brooding romantic or had Jenő stand still for several minutes in a dark street at night (figure 4; plate 3). Showing how deeply he had "absorbed" the art of others, he also made a photograph of an amorous couple, surely inspired by Bihari's *Honeymoon* and possibly also by the celebrated author Endre Ady's story "The Kiss" (figure 5).[37]

On weakened legs I walked around the town the whole day.
I took photographs. KERTÉSZ, 1915

Throughout the summer and early fall of 1914 Kertész's diary is strangely silent. Preoccupied with personal matters, he made no mention of the assassination by Serb nationals on 28 June 1914 of Archduke Franz Ferdinand, heir to the Austro-Hungarian throne and nephew to the popular emperor, Franz Josef, and no notation of Austria-Hungary's declaration of war on Serbia a month later on 28 July. Like so many others during that summer of 1914, Kertész had no realization that an attempt by nationalistic forces in the Austro-Hungarian monarchy to deal with a long-simmering regional conflict in the Balkans would catapult the world in a matter of weeks into the Great War. The war's legacy in Hungary—the death and suffering inflicted between 1914 and 1918; the loss of two-thirds of the kingdom in the Treaty of Trianon; the lingering racial hatred and rising anti-Semitism; and the sense that modernity itself was somehow the cause of these problems—would slowly and painfully choke Budapest's dynamic culture in the 1920s.[38] But the war also had significant and unexpected consequences for Kertész as well, helping him begin to understand how he could not only forge a career as a photographer but also use the medium as a tool for personal expression, even self-examination.

Kertész's first mention of any of these events occurred on 25 October 1914, when he noted in his diary that he, along with more than three million of his countrymen, had been mobilized a few weeks earlier (figure 6). Initially, he approached his military service with the same adolescent world-weariness with which he had treated his job. Noting that he "wanted to escape from life and this is a splendid opportunity," he hoped "to be annihilated" in the war.[39] If his diary is to be believed, his days, at first, were uneventful: he made friends, went out to drink in the evenings, and played his recorder to the delight of his comrades and commanders. But as the war that both sides thought would "be over by Christmas" dragged on through the winter of 1915, Kertész began to shed his adolescent demeanor and showed the strain of his surroundings. Hospitalized with typhoid for more than two months in early 1915, he was briefly transferred to a unit in Esztergom, near Budapest, before being sent by train in July to the Eastern Front, near Gologóry in Galicia (now Holohory in the Ukraine), an area of intense fighting throughout the war. With great sensitivity and empathy he wrote of "the crying, the last words of farewell," as families sent their husbands, sons, and brothers off to the front, of "the visible utter desperations," and of the "heartbreaking scenes." He described one "poor woman [who] was running

3

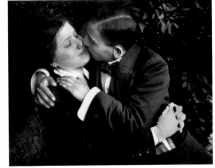

5

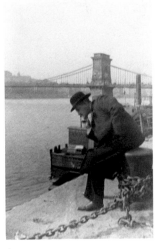

4

3.
André Kertész, *Women on Street*, 1913, gelatin silver print, Kertész Foundation

4.
André Kertész, *Imre Kertész*, 1913, gelatin silver print, Kertész Foundation

5.
André Kertész, *The Kiss*, 1915, gelatin silver print, Kertész Foundation

6.
André Kertész, *Self-Portrait*, *Görz*, 1914, gelatin silver print, Kertész Foundation

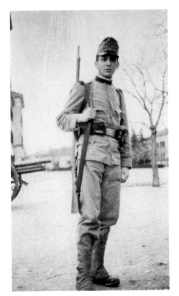

6

after the train, reaching up with her arms and when she saw it was hopeless, she stopped and dropped her head in utter desolation."[40] As Kertész's troop neared the front they saw burned, destroyed towns and villages, freshly dug graves, and trains filled with wounded and dying soldiers; once there, they encountered more than 1,500 starving, destitute Orthodox Jews who had been captured by the Russians, robbed, beaten, and forced to work as slaves.[41]

Although Kertész began the war with the innocence of both his age and time, he endured it, like so many others of his generation, with no small degree of ironic detachment. Shortly after his arrival at the front, he matter-of-factly noted how he stood in the dugout one morning, and "without any foreboding, a stupid bullet flew by directly next to me. It was the first bullet intended for me."[42] With fierce fighting all around him, he was not so fortunate the next time: after writing two postcards to be sent to his family and Balog should he be killed, Kertész was wounded in the arm and hand sometime late in August or early September 1915.[43] He was first evacuated to a hospital in Eperjes in Hungary (now Prešov, Slovakia), where his worried family and friends tried to contact him; their efforts were further complicated because his entire company, along with thousands of other troops, had been taken prisoner by the Russians after his departure.[44] He subsequently was sent to the Ferencz József Hospital in Budapest, where he had an operation and spent a year recovering, receiving "electric and massage treatment" to restore movement to both his arm and hand.[45] In the fall of 1916 he returned to active duty and was stationed in Esztergom.[46] Deemed unfit for battle, he spent the rest of the war escorting soldiers to military units throughout central and eastern Europe.[47]

Like many other soldiers in the Austro-Hungarian army, Kertész packed a camera into his knapsack. Most of the troops, no doubt, simply wanted to record the people and places they encountered; but others hoped, with good reason, to see their photographs published in Hungary's burgeoning illustrated press. Since the turn of the century, many of Budapest's more than twenty daily newspapers, as well as the numerous weekly and monthly periodicals, had included halftone reproductions of photographs. Most, like the popular *Vasárnapi Újság* (Sunday Newspaper), used one or two photographs, made by professionals, merely to illustrate an article, providing a portrait of a politician, for example, or the interior of a famous building. But, a new standard was set in March 1913 with the release of the first issue of *Érdekes Újság* (Interesting Newspaper), later extravagantly praised by Stefan Lorant, the acclaimed editor of the *Münchner Illustrierte Presse,* as "the first modern pictorial magazine."[48] This lively weekly magazine, as its title suggested, sought not just the news, but interesting tidbits. Thus, it included pieces by leading authors—such as Endre Ady or Ferenc Molnár, for example—as well as articles on current events, sports, theater, and vignettes on Hungarian life, all profusely illustrated with photographs: the first issue, for example, included an article titled "This Is Pest," with "typical images" that depicted "the nature of the city."[49] Unlike the usually stiff records in such publications as *Vasárnapi Újság,* many of the photographs in *Érdekes Újság* were casual and unposed images, closer to those of an amateur, not a professional photographer. Soon *Érdekes Újság* gave credit to the photographers whose work was reproduced, and soon, too, it used photographs alone, with minimal captions, to tell its stories.

Érdekes Újság continued its innovative use of photography during the war. Six months after the fighting began, it announced a competition for soldiers to submit photographs on both the bravery of the troops and their "rare moments of rest on the front."[50] With more than 1,500 entries vying for prizes totaling 3,000 koronas, the competition was a resounding success, enthusiastically received by a public that was eager to know how their loved ones were faring and prized the soldiers' own photographs as indicative of what they had experienced, even how they felt. Four more competitions were held from 1915 though early 1917, and in 1915 and 1916 *Érdekes Újság* published ten albums with twelve reproductions each of selected photographs (figure 7).[51] The lushly printed rotogravures revealed the diverse representation of the war that the competition had engendered: from grizzly depictions of the carnage and destruction to heroic renditions of fallen warriors, as well as studies of peasants in traditional costumes. Most of the photographs, though, were of soldiers at rest— fishing, writing home, flirting with women, and washing, shaving, or eating—showing, as the editors noted, "our soldier's invincible spirit" and "the good aspects of war."[52] Other publications, not to be outdone, quickly followed suit. Some, such as *Vasárnapi Újság*, used works by official photographers assigned to the army, like Rudolf Balogh, or by established professionals; others, such as *Borsszem Jankó* (Johnny Peppercorn), blatantly copied *Érdekes Újság*, creating a competition for humorous drawings and photographs by "hobbyists" so that the "funny memories" of the war would not go unrecorded.[53] Although jingoistic in tone, the competitions were both a clever marketing ploy and a boon to amateur photographers. Their photographs, which had been taken purely for personal reasons, were suddenly thrust onto the national stage, assuming a historical importance vastly beyond their original intention.

Kertész was keenly aware of these developments. In November 1914 Jenő sent him an Ica Bébé camera with twelve glass plate holders, each 4.5 by 6 centimeters. Extolling its versatility, Jenő assured him that it was "just the machine for you."[54] In March 1915, the day after Kertész was released from the hospital in Görz (now Gorizia, Italy), where he had been treated for typhoid, he walked "on weakened legs…around the town," making photographs.[55] He continued to photograph after his transfer to the front later that summer. Demonstrating a sophisticated understanding of the different publications, Kertész sent his exposed film home to Jenő for development and included detailed instructions on where the prints should be submitted.[56] "If you send the enlargements," to a newspaper or periodical, he instructed, "do not use my real name, use some pseudonym. For example, send the humorous pictures under the name 'Impostor' and those with serious subjects briefly under my initials. Also, try to sell the simpler shots at the trashier papers."[57] Jenő submitted at least one photograph (probably a self-portrait of Kertész, seated by a creek near the front lines, removing lice from his clothing) to the 1915–1916 *Borsszem Jankó* competition, where it won the ninth prize (see chronology, *Self-Portrait, Picking Lice*, 1915).[58] He sent two more—*The Fairy Tale* and *Village Council*—to the fourth *Érdekes Újság* competition, which had solicited "Hungarian subjects," and they were among the few prize-winning photographs reproduced in the March 1917 issue (plate 9).[59]

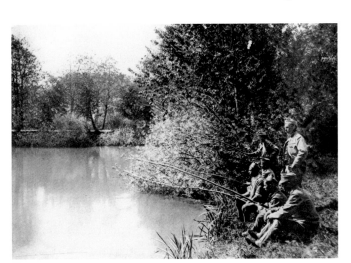

7.
Fülle Lajos, *Halaszo katonák (Fishing Soldiers)*, in *Érdekes Újság — Háborus Albuma (Interesting Newspaper — Wartime Album)*, vol. 4, National Library of Hungary, Budapest

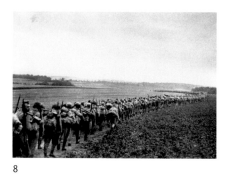

8

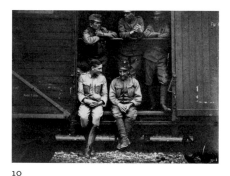

10

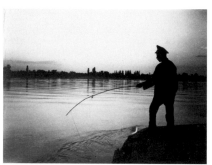

9

These acknowledgments were, no doubt, rewarding for the young Kertész, but he gained far more from his photographs made during the war than a fleeting sense of notoriety. By necessity, he mastered skills that he would continue to use for the rest of his life. Because he had a limited number of plate holders for his camera and had to carry all of his equipment, he learned how to conserve his exposures and patiently wait until composition, expression, and mood succinctly summarized an incident. Because he was a soldier with little authority, he had to be inconspicuous when he photographed for fear his commanders would take notice. And so, much as he had once watched Balog's window for hours at a time, he now discovered how to linger in the background, quietly observing the evolving scene. Even when he inserted himself into a rapidly changing situation or a highly charged event, as in *A Red Hussar Leaving*, he learned to not draw attention to himself; to become almost invisible so that he did not destroy the veracity of the moment; to look over the shoulders of people around him to convey a sense of immediacy; and to organize pictorial space quickly, almost intuitively (plate 7). In the process, he found that he could not only illuminate an event, but also make it appear genuine and palpable.

He also discovered new subjects. He could not record battle scenes, the most heroic, dramatic, and obvious subject matter at hand, because he was a soldier whose job was to fight, not a professional photographer assigned to the army. But neither was he interested in presenting the chaos and destruction of the war's aftermath.[60] Instead, perhaps encouraged by the *Érdekes Újság* war competitions or perhaps simply as a result of his own interest in revealing the poetry of the world, even in war, he sought the undramatic and unheroic moments of the soldiers' daily lives: their long marches and train rides; their moments of fellowship, reflection, and boredom; and their games and diversions (plates 4, 6, 8; figures 8, 9). Much as the editors at *Érdekes Újság* before the war had sought the interesting incidents that alluded to Hungary's larger culture, so too did Kertész come to realize

that by looking in the periphery of the nominal subject, he could find seemingly minor details—what he, perhaps in homage to *Érdekes Újság,* would later call "the little things" or "little happenings"—that spoke not of the facts of an event, but of its texture and tone, and conveyed his experience of a particular time and place.[61] And much as the editors at *Érdekes Újság* during the war prized the immediacy and veracity of the soldiers' own records, so too did Kertész begin to realize that his intensely personal photographs could resonate with a larger audience.

Using a crude self-timer and a tripod that he carried on top of his pack, Kertész also made many self-portraits during the war (plate 5; figure 10).[62] Like any amateur, he may have been initially inspired to make self-portraits to reassure his family and friends that he was well. But as he became ever more intrigued with revealing his experiences, he recognized that self-portraiture was an obvious way of constructing a visual diary—a metaphor he would frequently use later in his life to describe all of his work.[63] (And, the more convinced he became of photography's ability to function as his visual diary, the more he neglected his written accounts.[64]) In addition, the ironic distancing that helped him maintain his sanity during the war is also often present in his self-portraits. He frequently posed himself with an amusing, sardonic tone, in many different settings—in his uniform in the field, delousing himself by the front, or seated with peasants—and the resulting photographs became a way of distancing himself from his surroundings and of presenting himself as both a director and actor in his own personal play. As in *Albania* (plate 8), he often looked not at the camera but at his subjects, directing the viewer's gaze and becoming himself more of an observer than a participant.[65] In this way, self-portraiture gave him something that his written diaries did not: it allowed him to see himself in a way that his more effusive and unmediated diaries never had, giving him a way to reconcile his public and private selves. But the duality of his work—his combination of a diaristic approach with its celebration of immediacy and veracity and the distanced nature of many of his self-portraits—creates a curious tension within his art, making it at once casual but contrived, naive but studied. Thus, while Kertész began the war as a novice photographer, he emerged four years later with a keener appreciation of the public's appreciation of the medium, a more articulated approach, and a far more nuanced understanding of the medium's power and potential.

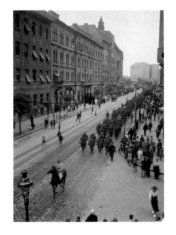

11.
André Kertész, *Budapest,* 1919, gelatin silver print, National Gallery of Art

My Brother as Icarus KERTÉSZ, 1919

Demobilized, most likely late in 1918, Kertész returned to Budapest, where he found and occasionally recorded a city in turmoil. He photographed the political demonstrations during the liberal Count Mihály Károlyi's rule in late 1918 and early 1919, which followed the collapse of the Austro-Hungarian monarchy; the Communist parades and May Day celebrations during the brief but brutal reign of the Bolshevik Béla Kún in the spring and summer of 1919; and the far more somber arrival of the Romanian troops later that August (plates 24, 25; figure 11). Despite the fevered pitch of the time, he once again shied away from the obvious events and frequently separated himself from the demonstrations, often looking across a street or down from a high vantage point. Even when he was in the midst of a dense crowd seething with revolutionary zeal, he often focused not on the faces and reactions of those closest to him, but on distant figures who had also separated themselves

from the masses. Although he was initially supportive of many of the reforms of both Károlyi and Kún—"I was leftist, like every normal human being, absolutely leftist," he later explained—he, unlike so many avant-garde artists of the time, was "not the activist type."[66] Uncomfortable with ideological rhetoric or political agendas, he recognized that the crowd's reaction was all too often programmatic, even rote, and not suffused with the personal, individual emotion that he sought.[67] Moreover, he came to understand that while he could document these events, he could not interpret them: "politics don't happen in my everyday life," he later noted, "it was outside of me."[68]

Instead, like so many others in the wake of the carnage of World War I, Kertész became fascinated with recording scenes of active, physically fit young people exuberantly enjoying life. He had begun to explore this subject during the war when he made photographs of himself and other soldiers swimming in the pools in Esztergom as they recovered from their wounds. Even though the seemingly decapitated young man in the *Underwater Swimmer,* 1917, eerily and ironically mimicked the battlefield injuries that many had witnessed, this photograph was but one of many studies Kertész made at this time of soldiers energetically celebrating their newfound health (plate 16; for uncropped print, see chronology, 1917). Beginning in the summer of 1919 he often used Jenő as his model or set up his camera on his tripod and used his self-timer so that he could record their physical contests and their races through the countryside (figure 12). Fascinated with flight, mythology, and the legend of Icarus, he asked Jenő to leap into the air and pretend he was flying, or to dance a scherzo as if he were a faun (plates 17, 18, 20).[69] Because Jenő was such a willing model, because he looked like a more handsome version of Kertész himself, and because Kertész captured such intimate moments of pure, unmediated emotion, these studies of Jenő almost become self-portraits, as if his brother were his own radiant alter ego (plate 19). Demonstrating that he, too, saw this connection, Kertész made a carefully symmetrical study of himself and Jenő: they seem to be looking not so much at each other as staring into a mirror (plate 30).

These subjects and themes—family and friends, as well as speed, flight, movement, and physical activity—and this style—spontaneous, loose, and unpremeditated—were all part of the amateur's vocabulary at the turn of the century. But Kertész's celebration of an

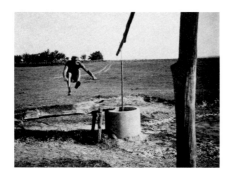

12.
André Kertész, *Self-Portrait,*
1919–1923, gelatin silver print,
Kertész Foundation

13.
Károly Patkó, *Harvesters' Rest,*
1925, oil, Private collection, Courtesy
of Hungarian National Gallery

14.
André Kertész, *My Artist Friends*
(left to right: József Kraszna-Kultsár,
poet; Emil Kelemen; Kató Vulkovics,
painter; two unknown men; Vilmos
Aba-Novák; unknown woman; Béla
Fonagy, art dealer), 1923, gelatin silver
print, Kertész Foundation

idealized youth was also one that resonated with many Hungarian artists of time. During Kún's rule in the spring and summer of 1919, the heroic, often striding, Cézannesque male nude was a common subject in many of the posters created by avant-garde artists in support of the Communist regime. But the subject had even greater appeal to artists of Kertész's generation who had come to maturity during the war and then began to establish their careers immediately after the spring 1919 revolution, under the subsequent reactionary rule of Miklós Horthy. Taking advantage of the vacuum created when many of the most advanced artists immigrated to Vienna and Berlin after the revolution, painters such as István Szőnyi and his followers Vilmos Aba-Novák and Károly Patkó burst into the public arena in the early 1920s with several highly successful exhibitions that proposed a new vision for Hungarian art.[70] As the country sought to redefine itself in light of its defeated and diminished status, they and others came to believe that a "new method and a new style" must be found, as the minister of culture announced in 1922, so that "a new Hungarian ideal, a new Hungarian type of man" could be realized, "who speaks and spouts less, but works and creates more."[71] Replacing the revolutionary experimentation of the war years with realism and neoclassicism, these artists, like their counterparts in Paris, sought to find the roots of a new Hungary in its rural past.[72] Szőnyi, Aba-Novák, and others looked to earlier artist colonies from the turn of the century—especially Nagybánya and Szolnok—for examples on how to create a Hungarian art nurtured "by the soil of our native land with renewed contact with the Hungarian people."[73] Seeking to extract an order out of the war's chaos, they embraced the heroic nude set in an arcadian or, more particularly, a Hungarian landscape as representative of a new idealized man (figure 13). Striving to establish a new synthesis of permanence and order, they looked not just to Hungary's folk and peasant traditions, but also to Renaissance and classical models and to biblical and mythological subjects for an idyllic vision of the unity of man and nature.

Kertész was an intimate member of the circle of artists who espoused these ideas. Although he had no association with such avant-garde artists as Lajos Kassák, he was, as he himself said, "close friends" with both Szőnyi and Aba-Novák, whom he met probably during or just shortly after the war.[74] He also knew several other followers of Szőnyi, including Patkó, Emil Kelemen, and Imre Nagy, as well as such painters as Rezső Czierlich, Imre Czumpf, Pál Pátzay, Emil Novotny, and Gyula Zilzer; his new girlfriend, Erzsébet Salamon, was an art student who studied drawing with Álmos Jaschnik (plate 23; figure 14).[75] He frequently photographed them in their studios and they spent weekends working closely together in the countryside where they shared many subjects. The duality between cultivating

15.
André Kertész, *Unknown Artist and Jenő Kertész*, 1922, gelatin silver print, Kertész Foundation

16.
André Kertész, *Jenő Kertész*, 1922, gelatin silver print, Kertész Foundation

17.
André Kertész, *Jenő Kertész*, 1919 – 1925, gelatin silver print, Kertész Foundation

18.
Károly Patkó, *Bathers at Rest*, 1925, etching, Private collection

19.
André Kertész, *Jenő Kertész*, 1919 – 1925, gelatin silver print, Kertész Foundation

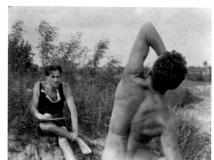
15

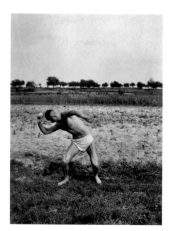
16

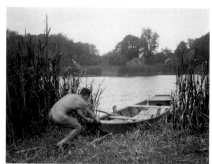
17

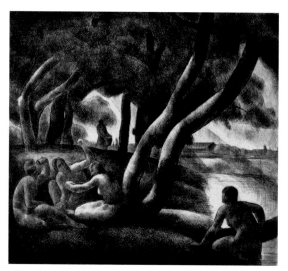
18

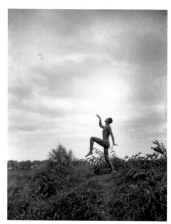
19

a sense of immediacy and a distanced observation, which had emerged in his work during the war, continued to be present in the 1920s, for he made casual, unposed studies of his friends, as well as carefully arranged compositions. While they painted and sketched the obliging Jenő, he recorded both them and his brother (plate 22; figures 15, 16). Under their influence, Kertész not only explored mythological subjects, but also made many studies of bathers and carefully posed photographs of Jenő that emphasized his lean muscular physique and clearly recall Greek, Roman, and occasionally even Egyptian sources (plate 21; figures 17, 18, 19).

As they sought to find the roots of a new Hungarian identity not in the modern city but the rural village, these artists made frequent depictions of peasant life. Kertész, too, had made many photographs of villagers during the war, and no doubt encouraged by Szőnyi, Aba-Novák, and others, he continued to explore this theme of the ennobled peasant in such studies as *Blind Musician, Abony*, 1921 (plate 12). Seeking to celebrate a dying way of life and assert a cultural identity, these artists created images that focused on traditional culture roles. In Kertész's photographs of women feeding animals, children playing in fields, or families listening to music, the intrusion of modernity on older ways of life was notably absent.

In their search for a new Hungarian man, Szőnyi and his circle also made many portraits of each other and of other notable Hungarians, as well as self-portraits of themselves at work or with models, families, and friends. In their self-portraits they occasionally engaged the viewer with questioning glances, but more often averted their gaze, looking off to the side or downward, as if in lonely introspection (figure 20). This aspect of their work was so important that an entire exhibition devoted to their self-portraits was mounted in Budapest in 1923.[76] Again, likely with their encouragement, Kertész made numerous self-portraits throughout the 1920s of himself alone or with his brothers, family, and friends. Often, too, he looked not at the camera but at those around him, as if examining his relationship as brother, son, friend, or lover (plates 29, 30; figure 21). Still deeply uncertain about his future, he made so many self-portraits in the early 1920s—

20.
István Szőnyi, *My Wife and I*, 1924, oil, Janus Pannonius Museum, Pécs

21.
André Kertész, *Self-Portrait with Erzsébet Salamon*, 1919–1925, gelatin silver print, Kertész Foundation

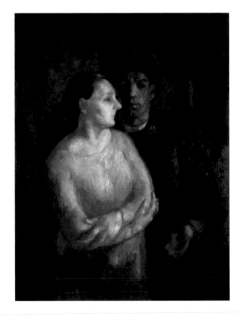

22.
André Kertész, *Self-Portrait as a Woman*, 1921, gelatin silver print, National Gallery of Art

more than eighty are extant—that they almost seem to have been a way for him to try on different personas and see which suited him best: artist, athlete, bureaucrat, farmer, even woman (plate 28; figure 22). In this way, the camera became for Kertész not just a method to construct a visual diary of his life, but a tool for self-scrutiny, even self-awareness.

But Kertész gained more from these painters than simply camaraderie or challenging subjects. As they sought to construct a new, more rational order, Szőnyi and his followers were deeply influenced by Cézanne and endeavored to strip down their compositions to the most basic formal building blocks. Aba-Novák in particular modeled his bold forms by faceting them, layering the planes one on top of another to build his compositions. Thus, they imparted to Kertész an understanding of Cézanne's approach, an appreciation of the importance of formal structure, and a recognition that he could create a composition simply by opposing geometric forms. In addition, like many artists after the war, Szőnyi and his followers were passionately interested in the graphic arts, seeing them as an effective and economical way of circulating their work.[77] (Kertész owned several of their prints.[78]) Aba-Novák's enthusiasm extended even further. This bold draftsman placed great importance on the power of drawing, believing that painters must not only use the pure colors of the impressionists but also build their compositions "up from black and white."[79] He even went so far as to assert, "within a short space of time black and white will be the general requirement."[80] Since the beginning of his career, Kertész had been innately attuned to the importance of geometric design, as can be seen in his 1912 *Sleeping Boy* (plate 2). But under Szőnyi's and Aba-Novák's guidance, his photographs, such as *Wine Cellars, Budafok*, 1919, or *Feeding Ducks, Tisza Szalka*, 1924, reveal a rigorous formal structure and a graphic intensity that was unknown in his previous work (plates 31, 10).

Szőnyi aided Kertész in quieter but no less critical ways. By the middle of the 1920s, as Szőnyi grew increasingly disillusioned with the prospect of creating a new Hungary through art, his work grew more introverted, contemplative, and lyrical. He increasingly focused on solitary or isolated figures, who seem to be searching for a self-awareness, and on private, intimate human events—a funeral or a mother holding a child, for example. Abandoning his wish to create an image of an idealized life, he sought simply to express a poetic, intensely personal experience. Thus, with Szőnyi's example, Kertész became keenly aware that the habits he had once lamented—his tendencies to seek the poetic and to express only his subjective response to the world—were not faults but assets to be carefully cultivated. That Szőnyi, one of the most celebrated artists of his time, shared his aspiration to create a personal, lyrical vision was surely profoundly encouraging for Kertész.

This was the circle, then, that sustained and nurtured Kertész in the early 1920s; that inspired his art, often prodding him to tackle new subjects and to push his ideas ever deeper; and that gave him at least a measure of self-confidence. But Kertész was also involved with both amateur and professional photographers at this time. As elsewhere in Europe, photography, especially by amateurs, blossomed in Hungary after the war, encouraged by the illustrated press and the relative cheapness and ease of photographic materials. Responding to the same nationalism that inspired Szőnyi and his followers, professional photographers such as Rudolf Balogh, István Kerny, and Angelo (Pál Funk), as well as numerous amateurs, embraced the tenets of pictorialism and popularized what came to be known as the "Hungarian style."[81] Making soft-focus, bromoil or gum bichromate prints, they presented a highly romantic vision of Hungarian life and sought, as Balogh wrote, "the true subject of Hungarian photography in the Hungarian village, the Hungarian landscape" (figure 23).[82] Banding together to form associations, these photographers actively promoted their vision of Hungarian photography in their clubs' journals and annual exhibitions.[83]

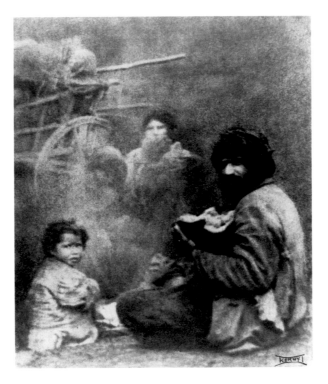

23.
István Kerny, *Cingaros*, 1915, bromoil print, Hungarian Museum of Photography

24.
André Kertész, *Esztergom*, 1918, gelatin silver print, Collection, Ann and Harry Malcolmson

25.
André Kertész, *Angelo*, 1924, gelatin silver print, Kertész Foundation

Kertész was at least marginally involved with these activities. He was a member of the National Association of Hungarian Amateur Photographers, a group of primarily pictorial photographers, and in September 1922 he submitted three photographs to their annual exhibition that were praised by the jury as the work of someone advancing "uniquely interesting ideas."[84] In the spring of 1924 he submitted three more photographs, one of a square in Budapest and two titled *Spring* and *Spring Impression,* which the national association also exhibited.[85] Although he never made bromoil or gum bichromate prints, he, like other amateurs associated with this group, did occasionally make sepia-toned enlargements (figure 24). He also knew Angelo, one of the most popular pictorial photographers of the period. After studying with photographers in Munich, Berlin, London, and Paris, Angelo established a studio in Budapest in 1919 and was so successful that he opened others in Paris and Nice in the next few years.[86] In May 1924, needing assistance with his Budapest business, Angelo offered Kertész an apprenticeship.[87] Kertész accepted his proposal to learn how to become a professional photographer and the two occasionally worked together in the summer and fall of 1924, even taking a group from the national association to photograph in Budafok (figure 25). But tensions rose between them and Kertész never assumed a position in Angelo's studio.[88]

In addition, Kertész, like his contemporary the photographer Martin Munkacsi, continued to be intrigued with the photographs he saw reproduced in the popular press. After the war, numerous newspapers—such as *Pesti Napló* (Pest Diary), *Pesti Hirlap* (Pest Daily), and *Érdekes Újság*—as well as specialized periodicals—such as *Szinházi Élet* (Theater Life)—were published in Budapest and extensively illustrated with photographs. Although these publications included many photographs of celebrities or news events, they also frequently reproduced pictures of average people engaged in simple, everyday events.

Encouraged by his brother Jenő, who believed that "reportage is the only kind of modern photography," Kertész had limited success in this arena as well.[89] In June 1925, his photograph *Evening in the Taban* was reproduced on the cover of *Érdekes Újság* and earlier that year Angelo apparently asked him to make a series of photographs of the daily life of a street in Budapest. Kertész was deeply disturbed, however, when these photographs were published in *Szinházi Élet* with Angelo's name, not his.[90]

By the early 1920s, therefore, Kertész's art had grown ever more visually sophisticated, graphically strong, and conceptually nuanced. While he had explored the worlds of contemporary amateur and professional photography, he had not embraced them. Instead, he had begun to carve a new path for himself, one far more closely aligned with painters and other artists, and he had sought, albeit tentatively, to have his work published in the popular press. But at the same time, his personal life crumbled. Although his family dearly needed him to provide a steady income to compensate, in part, for rising inflation, he bounced from one job to another. After the war he returned to the Giro Bank, but in 1921 he was denied two positions, in rapid succession, because he was Jewish.[91] Hoping to find work out in the countryside, he tried beekeeping. When that led nowhere, he worked for his uncle and then in a stock exchange.[92] Although he hungered for privacy, he still lived at home, where he often vehemently argued with his older brother, Imre. Although he lusted to spend more time with his girlfriend Salamon and was as emotionally dependent on her as he had been on Balog, he was unable to make a commitment to her. And although he was exactly the same age as Szőnyi, Aba-Novák, and Angelo—all born in 1894— their careers were thriving, while his hardly existed. In short, he "suffered terribly," as he lamented in the summer of 1924, for he continued to be ruled by his emotions and to "think with my heart."[93]

Thus, when Salamon demanded he leave Budapest to establish a career for himself, he had little to lose and everything to gain. Encouraged by Aba-Novák, Szőnyi, and other artist-friends, and perhaps bolstered by his recent exhibitions, Angelo's offer of employment, and the publication of his photograph on the cover of *Érdekes Újság,* he determined to go to Paris to pursue his photography. His choice of Paris was somewhat unusual: at the time most Hungarians who emigrated went to Vienna or Berlin, and Kertész, who had never been adept with languages in school, spoke no French at all. (His German, though, was also very poor.) Thinking with his heart, he may have selected Paris because Ady had spent so much time there earlier in the century; more practically, he and his family may have hoped he could gain employment at Angelo's Paris studio and his friend Zilzer had already settled there.[94]

Rejected by his lover but with the full support of his family, Kertész left Budapest in October 1925, "very shaken."[95] But if success is at least in part a result of innate skills coupled with blind leaps of faith and fortunate timing, then Kertész headed to Paris far better prepared than he realized.

I wish I could play the recorder better. I'd like to play so that everyone would be enchanted by it. Beautifully, slowly—with feeling, so that the listeners would cry over it. I wish I could. I would play most beautifully for her, I would put my whole soul into it, so that she would cry either of joy or sadness. I would conquer her family with my playing, all the relatives, I would be a beloved boy, and they would not regard me as such a good-for-nothing. I can't help that I have this kind of temperament. I really can't. KERTÉSZ, 1909

1 *Camera in Landscape, 1918–1925*

2 *Sleeping Boy, 1912*

3 *Bocskay-tér, Budapest, 1914*

4 *Soldier with Cello, 1914 – 1918*

5 *Self-Portrait, 1915*

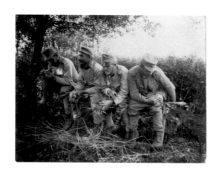

6 *Latrine, Gologóry, Poland, 1915–1916*

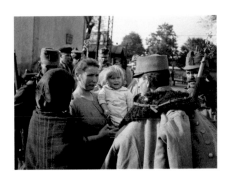

7 *A Red Hussar Leaving, 1919*

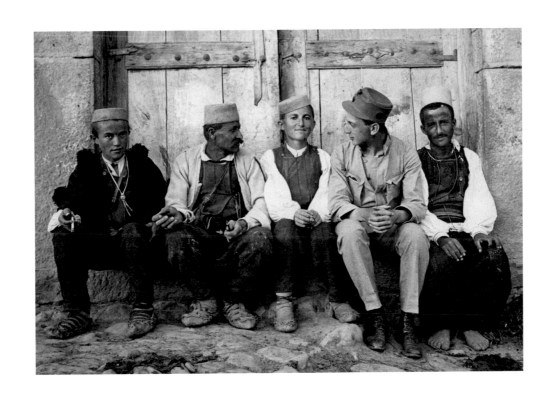

8 *Albania, 1918*

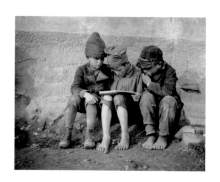

9 *The Fairy Tale, 1914–1917*

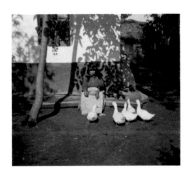

10 *Feeding Ducks, Tisza Szalka, 1924*

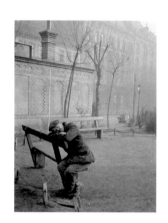

11 *Népliget, Budapest, 1918*

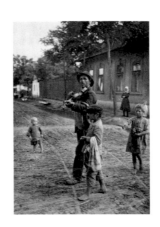

12 *Blind Musician, Abony, 1921*

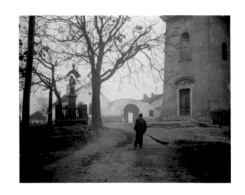

13 *Esztergom, 1917*

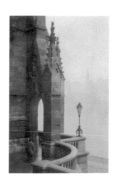

14 *Parliament Building, Budapest, 1919–1925*

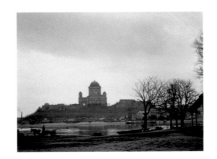

15 *Esztergom Cathedral, 1917*

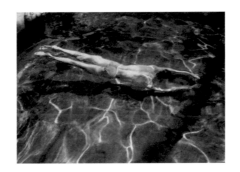

16 *Underwater Swimmer, Esztergom, 1917*

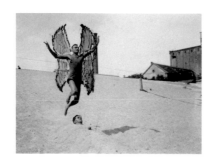

17 Jenő Kertész, 1923

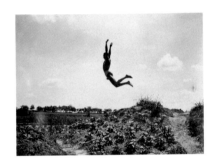

18 *Jenő Kertész as Icarus, 1919–1920*

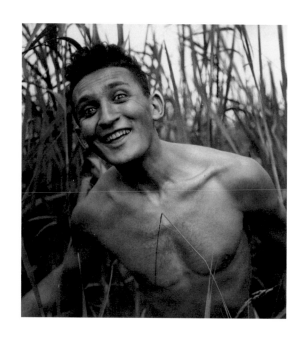

19 *Jenő Kertész, 1919–1924*

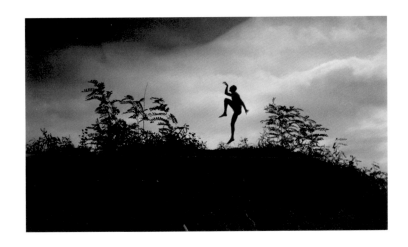

20 *The Dancing Faun, 1919*

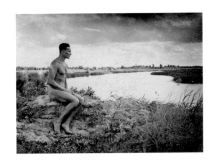

21 Jenő Kertész, 1920

22 *Erzsébet Salamon, Imre Czumpf, Andor Kertész, and Rezső Czierlich, 1924*

23 *Vilmos Aba-Novák and Káto Vulkovics, 1923–1924*

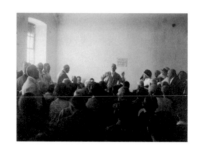

24 *Meeting, Budapest, 1919*

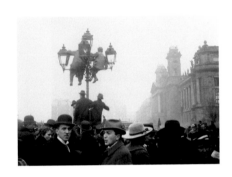

25 *Budapest, 1919*

26 *Street Scene, Budapest,* 1919

27 Jenő Kertész, 1920

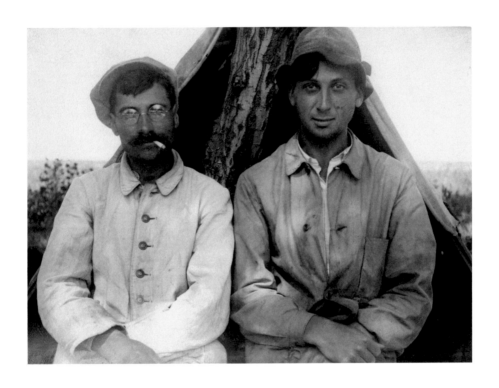

28 *Self-Portrait with Ede Papszt, 1921*

29 *Self-Portrait with Erzsébet Salamon, 1920*

30 *Self-Portrait with Jenő Kertész, 1923*

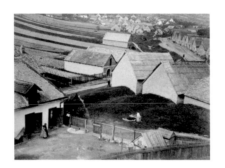

31 *Wine Cellars, Budafok, 1924*

To Become a Virgin Again, 1925–1936 Sarah Greenough

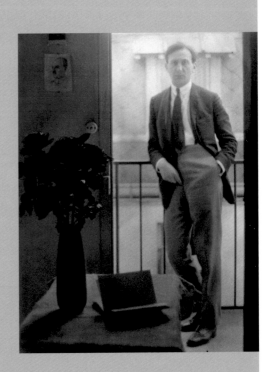

I am an amateur and I intend to stay that way for the rest of my life. KERTÉSZ, 1930

In October 1925 when the thirty-one-year-old Hungarian Kertész Andor arrived in Paris, he had a temporary visa lasting only a few months, limited understanding of his skills, and modest hopes.[1] He wanted to determine if he could support himself through his photography, perhaps working in a studio or possibly even for a periodical.[2] What he discovered, instead, was something entirely beyond his expectation. In 1925 Berlin, Vienna, and London all had vibrant artistic communities, but Paris was the cultural center of the Western world, a mecca for the most innovative artists, writers, musicians, and architects from around the globe. Such celebrated figures as Pablo Picasso and Gertrude Stein, such rebels as André Breton and Jean Cocteau, and such young upstarts as Man Ray, as well as countless unknowns jostled for attention and voraciously consumed all that was new and experimental. They congregated on the Left Bank, especially in the cafés—the Café du Dôme and Les Deux Magots were among the favorites. There, in a babble of languages, they held court, making new friends and exchanging the latest ideas and information—abstraction, constructivism, neoplasticism, purism, and surrealism were as intently debated as the latest gossip. They readily welcomed newcomers, especially fellow émigrés, into their supportive communities, acting as friends, guides, critics, promoters, and even surrogate families.

Once again, Kertész was not only part of a community but also slightly separated from it. Never fluent in French, he found that during the years he was in Paris his closest friends were fellow Hungarians, including the painters Lajos Tihanyi, Gyula Zilzer, and István Beőthy, the sculptor József Csáky, as well as the painter-journalist Gyula Halász, who later took the name Brassaï when he started to photograph. Kertész met and photographed such luminaries as Marc Chagall, Colette, Sergei Eisenstein, Tristan Tzara, and many others. But, too hesitant and deferential, he was not close to them, even though their art often greatly influenced his own. Yet he enjoyed a special status both because he was one of the

few photographers among a coterie of painters, sculptors, architects, poets, and writers, and because photography itself was gaining such attention in the popular press. At a time when artists sought to shatter the boundaries of their work—when painters made films and architectural models, sculptors constructed their work out of the refuse of society, and poets enlisted visual artists in their movements—and when all flourished on the infusion they received from such nontraditional forms of expression as African, tribal, and folk art, photography in general and Kertész's photographs in particular elicited significant interest and acclaim. As these artists came to appreciate more fully the power of photography both to construct a new idiom for a new world and to reclaim past traditions, often as a result of their relationship with Kertész, they helped in substantial ways to further his career, mold his vision, and clarify his understanding of photography. Thus his very outsider status—a photographer among a bevy of painters, sculptors, poets, and writers—was no longer a drawback but an extraordinary asset.

Not only was Kertész's medium perfectly suited to the demands and temperament of the time, so too was his imagery. As painters and sculptors in France and elsewhere in Europe struggled to come to grips with the war, they looked both backward and forward, nostalgically remembering the presumed purity and simplicity of the prewar period even while embracing the Machine Age.[3] As Kertész's poetic celebrations of traditional Parisian life and culture—its cafés, fairs, and parks; its streets, clochards, and the Seine—became ever more informed with an astute understanding of modernism's formal vocabulary and conceptual aspirations, he succinctly and elegantly encapsulated both the old and new that the age so strongly desired.

Kertész was also fortunate to arrive in Paris at the moment when the European illustrated press dearly needed photographs to fill its pages. Although German publications, including the *Berliner Illustrirte Zeitung, Die Dame, Die Woche, Der Querschnitt,* and *UHU,* dominated the market in the middle of the decade, by the end of the 1920s and early 1930s such French periodicals as *Vu, Voilà,* and *Regards* grew to have wide audiences. As competition for readers became more intense, graphic design became bolder and the photographs—not the words—told the stories. Seeking highly individualistic and innovative photographs, these periodicals clamored to publish Kertész's work, often giving him nearly full rein in determining which stories to illustrate, which subjects to photograph, and how to do it. Equally interested in his experimental photographs as well as those made specifically for publication, these periodicals provided him not only with a lucrative income throughout most of his time in Paris, but also with access to intriguing people and places. Here again, his limited language skills and his inability to articulate his thoughts were not weaknesses but strengths, as he was called on to respond to new situations visually and intuitively, not verbally or analytically. Taking full advantage of this propitious environment, Kertész made some of his most celebrated photographs of the period while on assignment for these periodicals.

This Parisian community nourished and validated Kertész in a way he had never known before. Inspired and influenced by the artists of Montparnasse and Montmartre and the publishers of Paris, as well as Berlin and Munich, he thrived in this fertile mix of the aesthetic and the commercial, high and low, old and new. Coupling his voracious visual appetite with his marked lack of interest in theoretical issues, he had no difficulty in

sampling almost all the current artistic movements, appropriating bits of each into his work and using them as a springboard for his own innovative discoveries. Combining an outsider's sense of wonder with an insider's sophistication, he rapidly absorbed the lessons of Parisian avant-garde painters and sculptors. As he grew more conscious of his objectives and more confident of his approach, his photographs became not only more resolved but also more knowing. While he never abandoned his amateur's faith that mundane life was capable of pictorial revelation or that photography had an inherent grasp of visual reality, he also came to recognize that the apparent naiveté and transparency of his work—his seemingly simple, unpremeditated, casual snapshots of everyday life—could be a profound source of power in his art. Cultivating the very notion of naiveté in his work, he began to explore the idea of what it meant to be an amateur photographer—stylistically, conceptually, pragmatically—even while he, paradoxically, increasingly derived most of his income from the publication of his photographs in periodicals. With this growing sophistication, he shed the more provincial Kertész Andor, embraced the cosmopolitan André Kertész, and found his profession, his voice, and a new vision for photography.

One's eyes became the eyes of a painter, because the sight itself approximated art.[4]

JANET FLANNER, "PARIS WAS YESTERDAY"

Kertész's first several months in Paris were hard and lonely. Stymied by the language and deeply in debt to his family, he searched for meaningful work, but without much success. After contacting the photographer Angelo, whom he had known in Budapest, as well as other acquaintances from Hungary in the hope of securing employment, he temporarily found a job in late October in a studio in the suburbs.[5] In January 1926 he became the Paris representative of Continental Photo, a Budapest-based agency, but he received few, if any, assignments.[6] He subsequently worked for three months in a studio in suburban Boulogne-sur-Seine, but lacking "the soul to make the same pictures that everyone had done before me," as he remarked a few years later, he was again unemployed by the summer.[7] As he thrashed about for gainful employment, he even considered a new profession and signed up for a course in cinematography.[8] Further demonstrating his initial difficulty in finding a foothold in Paris, he moved frequently: in the first six months he had more than seven mailing addresses.[9] Attempting to allay the concerns of his worried family and friends in Budapest, he sent them a photograph of himself (possibly figure 1). But they were not assuaged: he looked "in pretty bad shape," his brother Imre told him in early 1926, while later that summer his friend the photographer Max Winterstein noted he was "jobless again" and counseled, "You are not advancing, you don't earn enough and Paris is seemingly not the ground where you could establish your future."[10] Imre was more direct: "You have insurmountable language difficulties," he pointedly wrote, insisting, "your situation is even more serious.... Bandi, come home!"[11]

1.
André Kertész, *Self-Portrait,* 1925, gelatin silver print, Kertész Foundation

But Kertész did not return home. Instead, much as he had earlier attempted to understand his relationship to Jolán Balog by watching her through the window of his Budapest apartment, he strove to know and understand his feelings for Paris by scrutinizing the city through the lens of his camera. Later in his life he frequently recalled that he made his first photographs of Paris the morning after his arrival.[12] Opening the shutters of his hotel window, he focused his camera looking down on a woman in a building across the street,

who was also looking down on the passing spectacle (plate 56). Succinctly illustrating the ways in which he sought both people and things that mirrored his feelings, this photograph also reveals how he continued to separate himself from his surroundings, observing but not actively participating in the world immediately around him.[13]

Kertész found his emotions reflected in many other aspects of the city as well. Like so many other newcomers, he wandered alone for hours, during the day and night, in the rain and fog, and under the luminous gray light of the Parisian fall and winter sun. He discovered that the poetry of the city itself—its pallid facades and elegant bridges, its sinuous trees and the majestic Seine—perfectly suited his lonely temperament. In an exceptional series of photographs made between the fall of 1925 and the fall of 1926—his most accomplished work to date—Kertész revealed, as few other photographers before him had, the fundamental mystery of the French capital. He photographed the complex web of foliage, chairs, and shadows in the Luxembourg Gardens, describing it as a rich, intricate, but barely decipherable maze (plate 39).[14] He recorded draped crates stacked behind Notre Dame, endowing them with an enigmatic beauty far beyond their humble utilitarian function (plate 34). He depicted a modest street carnival in the fading evening light, evoking the loneliness of a solitary observer encountering the gaiety and fraternity of others (plate 37). And he photographed darkened city streets where shadows seem to bear no relationship to their surrounding objects, but instead assume a life of their own, as if controlled by an elusive presence just outside the camera's range (plate 36). Although infused with the immediacy and veracity of everyday life, these works are not the casual, boisterous, or obvious views of a tourist, but the quiet, deeply personal, and intensely observed investigations of a sophisticated practitioner. Even when he photographed the Eiffel Tower, the most obvious symbol of his new home, he presented it not as the embodiment of strength, modernity, or progress, but as a seemingly unattainable presence, hovering above the fog like a heavenly mirage (plate 33). Usually devoid of people, these are photographs where inanimate objects reverberate with animate life and where the true meaning or significance of things remains just beyond the viewer's grasp. In the few instances where Kertész included people they are separated from him, but at the same time mirror his activities. In his study of fishermen patiently standing on the banks of the Seine, with their long poles delicately posed over the river itself, for example, the men appear as intent as he was on silently plumbing the secrets of their surroundings; in his photograph made in Montmartre, a woman, like Kertész himself, is faced with the daunting challenge of navigating a cascade of delicate but steep and complexly patterned steps (plate 38). Passionate and poignant, these photographs speak of Kertész's loneliness, of his efforts to penetrate the character of the city, and of his separation from it. But they also reveal his rapt awe at the beauty around him and his fascination in its dense, layered, and ultimately unknowable complexity.

During his first few months in Paris, Kertész was not without support or companionship. While most of his family was concerned about his prospects, his brother Jenő—whom Kertész later described as his "most perfect collaborator"—had a different perspective.[15] Much as he had during the war and the early 1920s, Jenő continued to act as André's agent, sending him a Goerz 10 by 12.5 cm camera as a Christmas present in 1925 and submitting his photographs to Hungarian periodicals and amateur competitions; he even made prints from some of the negatives Kertész had left behind in Budapest.[16] Jenő also offered

2.
André Kertész, *Ballet Dancer, Paris*, 1927, gelatin silver print, National Gallery of Art, The Herbert and Nannette Rothschild Memorial Fund in memory of Judith Rothschild

3.
Lajos Tihanyi, *Self-Portrait, Interior*, 1922, oil, Hungarian National Gallery, Budapest

practical and perceptive advice, urging his brother to take portraits of fellow Hungarians to send home to their families, but to remember "reportage photography is the only kind of modern photography."[17] Jenő also critiqued his brother's photographs. Stressing the importance of cultivating his own style, Jenő in 1926 noted which of Kertész's photographs were "conceived in Angelo's spirit" and which was his "first independently visualized picture."[18] "The greatest surprise," he encouragingly wrote, were the portraits (figure 2): "Here…you have your own personality. It is not the camera any more that takes the picture, but the lens portrays it the way you want." Writing in amazement, Jenő continued to discuss one portrait, noting, "it is not sharp, but not annoyingly blurry, it is softly drawn, but the contrast is strong. Technically it is impeccable, and in its composition I do not recognize you. When we parted you were hesitant, lacked self-awareness, [had] little individuality, much imitation…. It seems you needed a year's torment for the daily bread to become independent and conscious."[19]

Kertész's leap to an independent and conscious art, however, was the result not of his torment for daily bread, but of his association with his new friends. The painter Gyula Zilzer, whom he had known in Budapest, had arrived in Paris in 1924 and quickly introduced Kertész to the Hungarian émigré community, including Tihanyi, Csáky, and Brassaï, as well as the painters Beőthy and Tivadar (later Theodore) Fried, the architect Ernő Goldfinger, the pianist Imre Weisshaus (later Paul Arma), and the writer György Bölöni. Just as Kertész had found direction in Budapest from the artists associated with Szőnyi and Aba-Novák, so in Paris he enjoyed not only the camaraderie of these émigré artists, but also their instruction and inspiration.[20] As Jenő had suggested, Kertész made many studies of his new friends in his first year there, photographing Zilzer, Csáky, and Arma, as well as several young émigré women, including the Hungarian sculptor Anne-Marie Merkel and the journalist Jean Jaffe (plates 44, 45). Perhaps also following Jenő's advice, he printed most of the photographs on inexpensive, gelatin-silver-coated postcards that could be easily mailed to friends and family back home. Almost all were proudly signed, "A. Kertész, Paris."

Of all the Hungarians émigrés living in Paris in the 1920s, Tihanyi was the most important to Kertész during his first few years in France. Although childhood meningitis had left Tihanyi deaf and rendered his speech barely intelligible, the charismatic painter had a wide circle of friends and a moderately successful career.[21] In Hungary he had been associated with the most advanced artists of the prewar period and during the war he was involved with the avant-garde publications *Ma* and *Nyugat*. After the collapse of the Hungarian Soviet Republic in 1919, he fled Budapest, going first to Vienna, then to Berlin, and finally settling in Paris in 1923. A little over a year after his arrival he exhibited at Jan Sliwinsky's gallery Au Sacre du Printemps in April 1925.[22] His work of the early 1920s, such as *Self-Portrait, Interior*, 1922, was indebted to both cubism and expressionism (figure 3). Utilizing a tilted perspective, he constructed his compositions out of flattened, geometric forms that splay out at their edges to create a dynamic, highly charged integration of objects and their surroundings. By the middle of the 1920s, his art had become increasingly abstract, as he, like so many others, wrestled with the implications of the cubists' break with single-point perspective and sought to construct a new order in the wake of the war. Under the growing influence of purism, neoplasticism and constructivism, he came to believe that painting must be an absolute entity unto itself, with no relationship to the

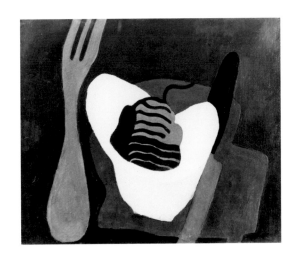

4.
Lajos Tihanyi, *Still Life with Pipe*, 1923, oil, Private collection

5.
Lajos Tihanyi, *Still Life with Knife and Fork*, 1928, oil, Hungarian National Gallery, Budapest

external world — an expression, as he wrote in 1928, exclusively "in itself and for itself [of] colors on a surface."[23] Advocating a truth to materials, he created ever more simplified compositions — such as *Still Life with Pipe*, 1923, and *Still Life with Knife and Fork*, 1928 — that used fewer geometric forms to investigate the inherent qualities of pigment on canvas (figures 4, 5).

6.
André Kertész, *Lajos Tihanyi*, 1926, gelatin silver print, Museum of Fine Arts, Houston, Museum purchase with funds provided by the National Endowment for the Arts matched by funds from Mrs. Joan H. Fleming

Later in his life, Kertész repeatedly insisted that while he had many artist-friends in Paris, their work did not influence his own; his style developed "very naturally," he firmly maintained, and "without knowledge."[24] His relationship with Tihanyi and other artists at this time, however, suggests otherwise.[25] Kertész made many portraits of Tihanyi during the first few years of their friendship, including his 1926 study that sensitively alludes to the painter's speech defect by presenting him with a broad, twisting band of smoke that languorously spills from his mouth in the same way that he slowly uttered his thick, garbled, booming words (figure 6).[26] Tihanyi secured jobs for Kertész, who photographed Tihanyi's paintings, no doubt as a service to his friend; he also unabashedly copied several of them in his own photographs, no doubt studying their lessons on form, composition, even light, as well as the models they provided for the new art and ideas around him.[27] Mimicking Tihanyi's *Self-Portrait, Interior*, which was shown at the painter's 1925 exhibition, Kertész made his own *Self-Portrait, Paris* (plate 43).[28] Presenting himself as an urbane figure, Kertész, like Tihanyi, posed himself in a confident stance in front of an open window and next to a table with a book and vase of flowers, symbols of his cultivation. With its tilted perspective, flattened picture plane, minimal geometric forms, and dynamic use of negative space, Tihanyi's *Still Life with Pipe*, also shown in the painter's 1925 exhibition, was surely the inspiration for Kertész's *Mondrian's Glasses and Pipe*, 1926; and the painter's *Still Life with Knife and Fork* may also have inspired the photographer to create his own radically simplified studies of cutlery, including *Fork*, 1928 (plates 51, 52).[29] But Tihanyi did more for Kertész than simply provide fodder for challenging pictorial lessons. His growing belief that "the author 'composes' with words, the sculptor with stone and metal, wood, the painter…with colors," propelled Kertész to consider the inherent characteristics of photography.[30] If pure painting was, as Tihanyi and others persuasively reasoned, about paint on canvas, what was photography about — light, form, time, point of view? And who was a "pure" photographer?

As Kertész wrestled with these questions, Zilzer's friend, the Belgian poet-critic Michel Seuphor introduced him to Piet Mondrian in 1926. At the time, Mondrian was writing an article on his philosophy of neoplasticism—the renunciation of all representational elements in painting for a concentration on a greatly reduced vocabulary of line, space, and color. In this essay, he argued that neoplasticism was not just a theory for painting but a model for creating an ideal harmony between man and his environment.[31] Because his studio represented the embodiment of his ideas, Mondrian asked Kertész to photograph it soon after they met, possibly for inclusion in the article. Although they spoke no common language (Kertész's French was still poor and his German was not much better), these two reserved men established a rapport. As Kertész returned several times throughout the year to photograph Mondrian, his friends, and the studio, he began to engage his own photographs in a sophisticated dialogue with Mondrian's art and ideas.[32] Perhaps one of his best-known works, made most likely in the summer of 1926, depicts Mondrian's vestibule (plate 50).[33] Standing inside Mondrian's studio but looking out into the adjacent hallway, Kertész photographed the intersection between the painter's carefully controlled interior environment and the often unruly exterior world. While the interior consists of precisely ordered horizontal and vertical rectangles of light and dark, a tulip whose offending green leaves the artist had painted white, and a coat and hat carefully hidden in the shadows, the exterior is replete with diagonal lines, perhaps an allusion to the recent split between Mondrian and his former colleague Theo van Doesburg over the latter's use of diagonal lines in his paintings.[34] This contrast may not have been coincidental, for the thesis of Mondrian's article was the disharmony between interior and exterior spaces and the need to create a more fluid and open integration of the home and its surroundings.[35]

Kertész also photographed the painter's studio, described by many as a "revelation" that simultaneously explained Mondrian's art and revealed it to be of "the highest spiritual artistry" (plate 49).[36] Disregarding the necessary but incongruous stove that sat almost in the middle of the space, as well as Mondrian's easel, the more obvious studio attribute, Kertész focused on a corner illuminated by a bank of windows. In homage to Mondrian and perhaps with Seuphor's instruction, he created his own neoplastic photograph, using towels, bed, shelves, partitions, windows, and shadows to fabricate an abstract composition of squares and rectangles, light and dark forms.[37] And just as Mondrian in his sketches carefully adjusted the relationships between colors and horizontal and vertical lines so that no single portion of the composition was more important than any other, so too did Kertész make several different prints from his negative, varying both the cropping and tonal values to create the perfect equilibrium (figure 7).

Kertész responded to Mondrian's paintings in other photographs made at this time. Surely inspired by Mondrian's diamond paintings, which preoccupied the painter in 1925 and 1926, Kertész created his own lozenge-shaped photograph in 1927.[38] Perhaps because of the cramped space of Mondrian's studio, or perhaps because Kertész knew that Mondrian himself had the highly unusual habit of making his paintings by looking down on sheets of paper or canvases placed flat on his work table (not hung vertically on an easel, as was commonly done), Kertész climbed onto a chair to make a photograph looking down on Mondrian and his friends (figure 8).[39] As he searched for innovative ways to depict other friends, he often repeated this practice in the coming months, pointing his camera downward from the tops of staircases or even from the top of a ladder.

7.
André Kertész, *Mondrian's Studio*, 1926, gelatin silver print, Kertész Foundation

8.
André Kertész, *Seuphor, Zilzer, Unidentified Man, and Mondrian* (left to right), 1926, gelatin silver print, New Orleans Museum of Art, Museum purchase, Women's Volunteer Committee Fund

9.
André Kertész, *Corner of Fernand Léger's Studio*, 1926, gelatin silver print, Kertész Foundation

As he became more at ease in his new home, Kertész also responded to avant-garde painters other than Tihanyi and Mondrian, frequently in a lighthearted manner. For example, when photographing in the studio of Fernand Léger, whom he most likely met through his friend Csáky, he recorded a corner of the room where a sculpture by the artist sat on a table surrounded by a thermometer, almanac, shoe tree, ashtray, wine bottle, and child's toy (figure 9). The photograph playfully alludes to the challenge Léger had posed in 1924 when he insisted that contemporary art must be able to withstand "comparison with a manufactured object."[40] Remembering both Szőnyi's and Aba-Novák's habit of depicting themselves with their art, Kertész often presented his new friends with their paintings or sculpture, frequently making life imitate art. When photographing the sculptor Ossip Zadkine, for example, Kertész posed him in his studio, playing an accordion and mimicking the sculpture directly above his head (figure 10). When photographing Beőthy's studio in 1926, Kertész not only assumed a high perch, but had the dancer Magda Förstner lie down on a couch, as if it were a pedestal, and mimic the dynamic, twisting pose of Beőthy's sculpture in the background (plate 47). In another work, to further suggest the energetic nature of Beőthy's art, Förstner gestured as if she were doing the Charleston (figure 11). The following year Beőthy responded with a generous interpretation of Kertész's work, making a drawing of a photographer who, like the Eiffel Tower itself, towers above the teeming city street, seeing with his camera what the people below him with bent heads and no eyes are unable to perceive (figure 12).

Taking his cues not from other avant-garde photographers of the time—Alexander Rodchenko or László Moholy-Nagy, for example—Kertész made many photographs shortly after his arrival in Paris that reflect the influence of these painters and sculptors—Tihanyi, Mondrian, Léger, Csáky, Beőthy. Mondrian's formal concerns, for example, as well as the delicate patterning of some earlier compositions, such as *Pier and Ocean 5*, which hung in his studio in 1926, are readily apparent in Kertész's *Stairs, Montmartre* and *Chairs, Luxembourg Gardens*.[41] The bold linearity and the elongated, often overlapping forms of

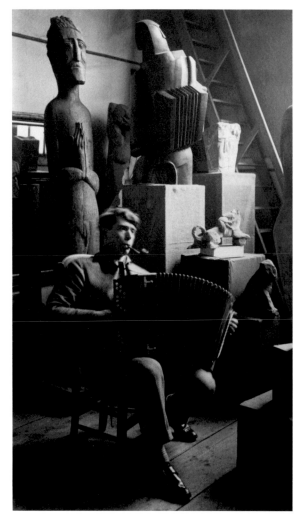

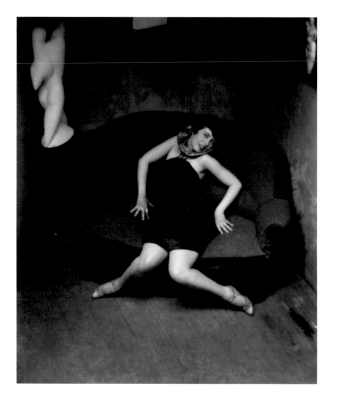

10.
André Kertész, *Atelier of Ossip
Zadkine*, 1926, gelatin silver print,
The J. Paul Getty Museum,
Los Angeles

11.
André Kertész, *Satiric Dancer*, 1926,
gelatin silver print, Patrimoine
Photographique, Paris

12.
István Beőthy, *Paris*, 1927, etching,
Private collection

13.
József Csáky, *Deux Figures*, 1920,
stone, Kroller-Muller Museum

Csáky's relief sculptures (figure 13) are also evident in Kertész's highly abstract compositions, such as *Quartet* and *Cello Study* (plates 53, 54). Yet, liberated by the work of these artists, Kertész embarked on even more radical experimentation in his photographs in 1926 and 1927. More attuned to the startling compositions that could be created by using nontraditional points of view, he not only looked down on his subjects from high vantage points, but also looked up at those who towered above him.[42] Fascinated with the way Léger and other artists used parts of the body to signify the whole, he radically cropped a photograph to show only the hands and violins of a string quartet (plate 53). As Kertész voraciously consumed the art and ideas of the painters and sculptors around him and quickly moved from one subject to the next—from portraits to still lifes to figure studies—his work became more innovative and confident, as well as more playful and exuberant. In his first year and a half in Paris, he made an astounding leap from a talented but unknown and uncertain provincial photographer to one of the most accomplished artists of his time. He did not remain unknown for long.

In our home for the blind, Kertész is a brother seer. PAUL DERMÉE, 1927

André Kertész is "the sensation of Montparnasse," the Budapest daily newspaper *Magyar Hirlap* proudly noted in October 1926. Explaining that he was "not a painter [but] a photographer," the paper assured its readers that "what he does is art." "We will certainly hear of him more often," the paper continued, for the "original vision" of his "extraordinary" photographs was widely praised by Parisian artists, "known for their demanding taste."[43] This prediction soon proved to be true, for Sliwinsky offered Kertész an exhibition at his gallery Au Sacre du Printemps. Opening on 12 March 1927, the exhibition paired Kertész's photographs with paintings by the Hungarian constructivist Ida Thal.[44] Echoing this coupling, Kertész's exhibition announcement included a poem dedicated to him by the

surrealist poet Paul Dermée, Seuphor's friend, while Thal's announcement included one by Seuphor.[45] Titled "Frère voyant" (Brother Seer), Dermée's poem praised Kertész as a "discoverer and inventor…whose retinas, with each blink, become virgin again." Dermée continued:

No rearranging, no posing, no gimmicks, nor fakery.
Your technique is as honest, as incorruptible, as your vision.
In our home for the blind,
Kertész is a brother seer.[46]

Neither the placement of works in the exhibition itself, nor the pairing of Kertész and Thal was accidental (figure 14). All Kertész's portraits were grouped on one wall, while all of his studies of Paris hung in a line on another, above which were placed several still lifes.[47] Thal's abstract paintings were interspersed along both walls. By uniting these two artists, Sliwinsky made clear Kertész's relationship to the constructivist movement, but he also succinctly illustrated the cross-fertilization between the arts that fascinated so many at the time. The opening event, organized by Dermée and Seuphor, was an international celebration of "oeuvres d'esprit nouveau" (Works of the New Spirit), as the announcement proclaimed, with music played by Sliwinsky and readings in four languages of prose and poetry by the German Johann Wolfgang von Goethe, the French François Rabelais, the Hungarian poet Attila József, and the Swiss surrealist Tristan Tzara. The opening was a manifestation of the ideas expressed by Dermée, Seuphor, and Enrico Prampolini in their short-lived periodical *Documents internationaux de l'esprit nouveau*, which sought to illustrate the wide diversity of contemporary art. The sole issue, released in 1927, included writings by Hans Arp, F. T. Marinetti, and Tzara, and reproductions of paintings by Léger, houses by Walter Gropius, chairs by Marcel Breuer, and photographs by Kertész and Moholy-Nagy.[48]

14.
André Kertész, *Jan Sliwinsky, Herwarth Walden, and Friends at Au Sacre du Printemps*, 1927, gelatin silver print, The J. Paul Getty Museum, Los Angeles

The exhibition was "a revelation," the *Chantecler* critic wrote: "curious and smitten," Kertész "opens his eyes to the creation of the world."[49] The critic in the *Chicago Tribune* was more restrained, but no less complimentary: "The work of Kertész is gratifyingly honest and free from trickery"; his "subject matter…is as free from complexities as his technique…for he has an artist's instinct for the exact placing of objects." The reviewer continued, "What makes ordinary objects and scenes take on a fresh value in the photographs of Kertész is his habit of placing the accent in an unexpected place or of taking his picture from a new angle…. [His] portraits are as unaffected as a snapshot. His sitters, seemingly unposed, are presented as casually and unemphatically as though they were seated at a café table."[50] Like the *Chantecler,* almost every publication noted the revelatory, even surreal quality of his photographs and often linked them to those by Man Ray. Describing him as a poet, the critic in the *Comoedia* noted that he revealed a "new world where fantasy is the younger sister of reality."[51] And later that summer in an article entitled "The New Photography," the *Tageschronik der Kunst* asserted that he showed "the mysticism of the real."[52]

In the 1960s and 1970s when he was asked about his years in Paris, Kertész repeatedly and emphatically insisted, "I am not a surrealist. I am absolutely a realist."[53] Of course, to a great extent he was correct. He was not mentioned in André Breton's *Surrealist Manifesto,* published with great notoriety in 1924, the year before he arrived in Paris, nor were his photographs reproduced in *La Révolution surréaliste,* 1924–1929, nor was he friends with the movement's leading proponents: the poets Breton, Louis Aragon, and Paul Éluard, the painter Max Ernst, the sculptor Hans Arp, or even the painter-photographer Man Ray. But Kertész's later reluctance to associate himself with surrealism may be rooted less in fact than in his slanted perception in the 1960s and 1970s that the movement was "too artificial," as he said at the time, and primarily encouraged fabricated photographs, like Man Ray's; he may even have feared that the taint of surrealism would undermine the understanding of his art as essentially humanist in nature.[54] For Kertész was unquestionably aware of the movement, perhaps even as early as the fall of 1925, when he wrote Jenő that one of his photographs had been described as "surrealistic."[55] Beginning in 1928 his work was frequently published in several magazines associated with surrealism, including *Bifur, Variétés,* and *Le Minotaure.* Some of his acquaintances, including Tzara, were directly associated with Breton's movement and even more indirectly imbibed its spirit.[56] Although Dermée was never an official member of the surrealist group, he coined his own variant and sought the "transportation of reality to a higher level." His 1927 poem to Kertész, with its description of him as a "seer" whose "retinas…become virgin again," was heavily indebted to surrealist imagery and vocabulary.[57] And although Brassaï, like Kertész, later in life disassociated himself from surrealism and refused Breton's invitation to join the group when it was reconstituted in 1929, he, too, admitted, "I was friends with them anyway…. They liked my photographs. They found a kind of surrealism in my pictures."[58]

While Kertész's aversion to polemics and theoretical issues, his modest demeanor, and his distrust of flamboyant displays precluded a close association with the surrealist poets and painters, he, like so many others of the time, could not avoid its influence.[59] As the surrealists sought to reveal the creative powers of the subconscious, they became fascinated with dreams, sexual ecstasy, madness, and stream of consciousness—all of which they believed lessened the inhibitions of reason and allowed the mind to roam deeper into the realm of the imagination. They also became captivated with new techniques—including

collage, frottage, games of chance, puns, and automatism—that they thought allowed them to wrench objects from their accustomed contexts and to construct images of startling, even shocking illumination. And they embraced photography, especially in the first few years of the movement in the late 1920s. Linking the camera to automatic writing, Breton described it as a "blind instrument," a machine that produces objective records but does not interpret, that allows the intervention of chance and suspends the confining restraints of a critical mind.[60] Suggesting that human vision itself was an act of the imagination, Salvador Dalí asserted in 1927 that an anonymous photographic document was a "pure creation of the mind."[61] And in 1928 Breton used Jacques-André Boiffard's seemingly neutral studies of Parisian streets to illustrate his novel *Nadja* and show how the world was but a veil of signs waiting to be deciphered.[62]

The surrealists' desire to reveal not just the visual richness of the ordinary photograph, but its mystery, ambiguity, and fecundity—especially its ability to be impregnated with multiple meanings and stories—was profoundly important to Kertész at this time. So too was their appropriation of Eugène Atget's photographs, which were published in *La Révolution surréaliste* and *Le Minotaure*, along with anonymous amateur snapshots, movie stills, and even police photographs. Hailing Atget as a pure naif—the Douanier Rousseau of photography—the surrealists marveled at his ability to record the banal with such directness and transparency that it became unexpected, even haunting.[63] Atget created "a dream and a surprise," the surrealist poet Robert Desnos wrote in 1928, awed, like so many others, by the photographer's ability to infuse his own personality into seemingly objective records: Atget's "viewpoint of the world," he wrote, "determined by an apparently mechanical medium, is also the vision of his soul."[64]

Kertész saw all this attention, and he observed the swift transformation of Atget immediately after his death in 1927 from a craftsman who made "simple documents" for use by artists and artisans to the progenitor of a documentary style.[65] He also witnessed the almost simultaneous coupling of their names. A 1928 *Cahiers d'Art* article (which Kertész saved for the rest of his life) asserted, "the first person to have given capital importance to documentary photography was E. Atget"; and he predicted that a forthcoming book on Atget's work would demonstrate in a "preemptory way…the unsuspected significance of documentary photography [which] already includes such recognized names as the Hungarian André Kertész."[66]

The surrealists' fascination with all types of photographs generated a significant body of critical literature in the late 1920s and early 1930s, written by those closely associated with the movement as well as by others who were indirectly inspired by its innovative ideas. One of the most important new critics of photography—and certainly the one of greatest importance to Kertész—was his friend, the poet and novelist Pierre Mac Orlan.[67] As Mac Orlan expanded this evolving concept of documentary photography, he celebrated many different kinds of photographs, from amateur snapshots to scientific documents, but he recognized that a new generation had emerged in Paris, including Kertész, the American Berenice Abbott, and the Polish Germaine Krull. These photographers, he asserted, were able to profoundly stimulate the imagination by capturing the bizarre and unexpected juxtapositions that so frequently occurred when modern technological life collided with the remains of older traditional cultures.[68] Labeling them as "photographic reporters"

and "photographer-poets," he lauded them as "lyrical, meticulous witnesses," even "*révélateurs*" (revealers, or even informers).[69] While he knew that these photo-reporters might "search for six hours to find the unique second when life, in some way, is 'caught in the act,'" their intuitive and immediate art, he asserted, was essentially one of "instinct."[70] Noting that their work "is literary without knowing it, because it is no more than a document of contemporary life captured at the right moment by an author capable of grasping it," he understood that much of the power of their work lay in their ability to capture pregnant pauses that were waiting to be completed in the mind of the viewer.[71] Stressing the importance of time as a critical element in the revelatory truth of these photographer-poets (and revealing his own preoccupations as the author of several mystery novels), he wrote, "the greatest field of photography for the literary interpretation of life consists, to my mind, in its latent power to create, as it were, death for a single second. Any thing or person is, at will, made to die for a moment of time so immeasurably small that the return to life is effected without consciousness of the great adventure."[72]

Mac Orlan's layered understanding of documentary photography resonated deeply with Kertész, as did his celebration of its mystery and poetry; his acknowledgment of its psychological intensity and disquietude; his recognition of its literary aspirations and ambiguity; and especially his deep faith that it was a far more significant expression of modern life than the fussy, pseudopainterly photographs that dominated the annual salons throughout Europe. Never before had a critic so forcefully defended the importance of the kind of photograph that Kertész had made for more than a dozen years or so clearly articulated the ideas that fascinated him. Just as he had earlier appropriated bits of the art of Tihanyi, Mondrian, and others, so now he adopted aspects of Mac Orlan's theories as his own. Recognizing the potency of amateur photographs—not the painterly images that had dominated the Hungarian amateur movement of his youth, but raw and untutored snapshots—Kertész reinvented his past when speaking to a Hungarian interviewer in 1929.[73] Omitting his close association with Szőnyi, Aba-Novák, and others, he suggested that he, like Atget, had simple roots, a lack of artistic training, and made "laughably inane amateurish pictures" before he came to Paris.[74] In 1930 he went even further, "I am…an amateur," he declared, "and I intend to stay that way for the rest of my life. I reject all forms of professional cleverness or virtuosity."[75] Echoing Mac Orlan, he explained, "I assign to photography the role of establishing the proper character of things, the soul that they emit; the art of the photographer as I conceive it is an incessant discovery that demands patience and time."[76] Linking himself to the literary art Mac Orlan had proposed and answering Tihanyi's implicit question about the nature of pure photography, Kertész continued, "Look at reporters, amateurs—both of whose sole aim is to gather a memory or a document; that is pure photography."[77] Firmly separating this "pure photography" from the other arts, he told a critic from *L'Art Vivant,* "photography is one thing, painting is one thing, but they are not the same things."[78] Forceful declarations of his allegiance to this new style of documentary photography, these statements were his most important aesthetic pronouncements to date, and he would continue to espouse them for the rest of his life. After his arrival in Paris, whenever Kertész was asked to describe his work, he insisted that he was a "photo-reporter" and that the photographs he made were "reportage" or "photo-reportage."[79] Even when asked in English if he meant photojournalism, he responded "reportage" or "literary journalism," for Kertész, unlike the photojournalist, did not seek to depict and elucidate the critical events and people of his time, nor did he, like his subsequent friend Robert Capa, want to describe heroic actions or defend moral positions.[80]

15.
André Kertész, *Legs, Paris*, 1925,
gelatin silver print, The J. Paul Getty
Museum, Los Angeles

16.
André Kertész, *Shadows*, 1931, gelatin
silver print, Kertész Foundation

Armed with these ideas, Kertész began to significantly change his work in 1927 and 1928. More integrated into Parisian life, he no longer separated himself so markedly from his surroundings but instead confronted people and things more directly and immediately. Less lonely, he no longer looked so intently for the poetic but rather sought the pointed. As Mac Orlan suggested, he now attempted, like a reporter, to make notes of the fantastic, whimsical moments of everyday life; to delineate the sharp juxtapositions or absurd elements that added a frisson, a shock of recognition, to his compositions, firmly rooting them in their time and place. Thus, when an editor requested "mysterious things" and "surrealist" works in 1927, he posed wooden figurines as if they were alive. He also depicted a mannequin's severed and upended legs (figure 15) as if illustrating Breton's dream of "a man…cut in half by the window," which had inspired the formation of surrealism.[81] In 1928 for an article on the ballet dancer Ida Rubinstein, he photographed only the arms and legs of the corps during a rehearsal.[82] In 1929, no doubt responding to Atget's photographs, he recorded mannequins in a shop window, their backs turned to the camera, their heads covered in scarves. When this photograph was published in *Bifur* in 1929, it was paired with another by Kertész of a street corner at night, one wall covered with movie posters.[83] Together, the composite image was so intriguing the surrealist poet Louis Aragon commented on it many years later.[84] Revealing the juxtapositions that Mac Orlan celebrated, as well as a fascination with the puns and word games that intrigued the surrealists, Kertész often contrasted people and posters: in 1926 and 1927 he noted the striking disparities between an enormous sign extolling *sécurité* and the harsh reality of a homeless person and between a dark, heavily clothed, and stooped form of another clochard and the light, lithe, modern figures in an advertisement directly above him (plates 40, 41). In 1929 he once again photographed the Eiffel Tower, but this time he looked down from its observation platform, capturing only a portion of the tower and showing instead its weblike shadows and, as the title announced in its first publication, "the ants"—the people—who scurried below (plate 64).[85] That same year, playing with inversion and the curious disjunction of modern urban space, he photographed the pont des Arts as seen through the transparent face of a clock, the hour hand seemingly poised to decapitate a statue that rests directly below it (plate 63). While time threatens to crush the past in this photograph, even time itself is suspect, for the clock face is reversed and the numbers count down not to the end of time, but to its beginning. In 1931, just as the surrealists had found unusual objects and, by isolating them from their normal contexts, invested them with new significance, Kertész discovered that by photographing a group of pedestrians while looking straight down on them, he could endow their shadows with more animation than their actual bodies, thus wrenching the normal into the abnormal (figure 16). In 1933 he photographed puppets, posed as if they had just engaged in a sexual act.[86] And in 1934, perhaps in homage to the detective stories of Mac Orlan, he returned to the stairs of Montmartre on a dark and deserted night and photographed them illuminated only by street lamps, with an ominous pool of liquid gleaming on the sidewalk to the right and an open car door in the background (figure 17). Concise and descriptive, but evocative and bizarre, these photographs demonstrate, as Mac Orlan had suggested, that Kertész had learned not only what subjects would address the spirit of his time, but how to depict them, like a poet or novelist, without ever destroying their fundamental mystery, ambiguity, or complexity.

Kertész also began simultaneously to pay far more attention to the importance of time in his photographs and to embrace, even celebrate chance. "Have confidence," he boldly stated in 1930, "in the inventions and transformations of chance."[87] After more than fifteen years of making photographs, he knew that by capturing the fortuitous accidents of chance, his art would be continually refreshed and he would, as Dermée had written, "with each blink, become virgin again." He saw that chance enabled him to capture such a bizarre photograph as *Meudon* (plate 58). An image that seems more like one ripped from a dream than a record of reality, *Meudon* shows a train on a stone viaduct that towers above a street lined with nineteenth-century facades, in the middle of which stands a man holding a package and staring intently, even menacingly, at the viewer.[88] And chance gave him *Montparnasse*, 1928, whose equally incongruous elements—a man harnessed to a cart that appears to be driven by a white statue—make it seem more like the product of a hallucination than an illustration of everyday life (plate 61).

If chance gave Kertész these fantastic scenes, the Leica camera that he bought in 1928 enabled him to capture them. With a fast shutter and 35 mm roll film that could be quickly advanced—unlike the individual sheets or glass plates he had previously used—the small, lightweight Leica liberated Kertész to respond more immediately to the rapid, fluid pace of urban life. Because he brought the Leica to his eye to look through its viewfinder —instead of holding it at his waist as he had done with other cameras—his photographs also more closely recorded what he saw. As he seamlessly merged the camera's eye with his mind's eye, he carried his new Leica "with me wherever I went," he later recalled.[89] Not surprisingly, he also began to make many more photographs on the street. Once again, as in his earlier pictures made in Hungary and Paris, he focused not on the crowds, but on the individual. Whereas earlier he had often depicted people from some distance, he discovered that with his small, discreet Leica, he could get much closer without drawing attention to himself or destroying the character of the scene. And whereas earlier he had concentrated on bigger gestures and pose to convey emotion, he discovered he could record more subtle expressions—the exhaustion and loneliness of a man seated at a café table or the hesitancy of a woman in a tram. And, though his first photographs made in Paris were often timeless and still, he realized that by matching the speed and nimbleness of the Leica with his new-found desire to "catch life in the act," he could place increasing emphasis on capturing a fortuitous moment of time. He sought, as he later said, that "moment when something changes into something else," when the obvious and mundane was transformed into the mysterious, enigmatic, or provocative.[90]

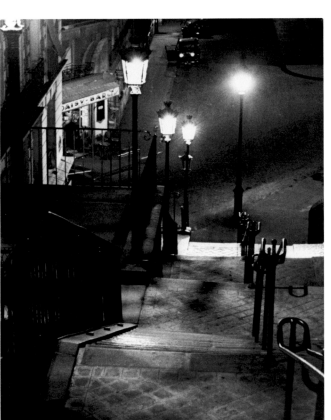

17.
André Kertész, *The Daisy Bar, Montmartre*, 1934, gelatin silver print, Steven Daiter Gallery

But even though Kertész purported to be a naive, untrained amateur, even though his photographs were understood at the time to be as "casual as a snapshot," and even though the very ease of the Leica, coupled with its small viewfinder, encouraged others to make loose compositions of random subjects, his working methods remained deliberate and calculated. With his modest background and the many years he had spent making photographs during the war, he had a deeply ingrained habit of conserving his film, and he

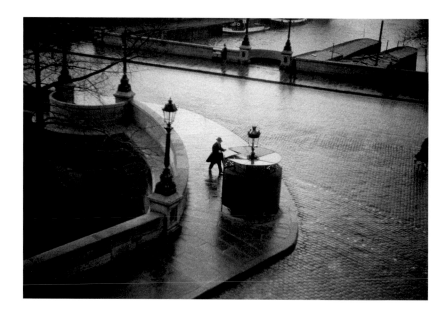

18.
André Kertész, Contact sheet for
Le Pont-Neuf, 1931, gelatin silver print,
Patrimoine Photographique, Paris

19.
André Kertész, *Le Pont-Neuf*, 1931,
gelatin silver print, Patrimoine
Photographique, Paris

continued to make very few exposures with his Leica (figures 18, 19). Instead, once he found a subject that intrigued him, he patiently waited, even stalked it, until composition and expression were correct. To make *Meudon,* for example, he photographed the street on at least two different occasions: once recording it empty, then returning a second time to capture it with a train on the viaduct before he finally made his third exposure with people walking in the street as a train, smoke streaming from its engine, streaks across the viaduct (figure 20).[91] Kertész may even, in part, have previsualized the photograph before going to Meudon, for others before him had created very similar studies (figure 21). And he further perfected this "transformation of chance" by carefully cropping the final print, eliminating much of the foreground to increase the sense that the man was striding out of the picture frame to confront the viewer. Flirting with naiveté, he insisted that his images were, just like any amateur's snapshots, spontaneous, transparent records of his response to the world. "I looked, I saw, I did," he repeatedly asserted, but, as he later admitted, most required him to be "ready for the picture before it happens."[92] Even though he delighted in the "inventions of chance," he knew from the intense and perceptive study he had made of Parisian art in the last few years that providence favored those who were well prepared.

To translate the precipitous rhythm of everyday life. LUCIEN VOGEL, 1928

Kertész's first few years in Paris had provided him with a profound artistic and personal education, but he hungered to perform on a larger stage. In the late 1920s he found himself positioned to take advantage of the growing interest in photography throughout Europe. Exhibitions provided one opportunity to establish his name and reputation.

20.
André Kertész, Contact sheet for
Meudon, 1928, gelatin silver print,
Patrimoine Photographique,
Paris

21.
Lionel Feininger, *The Viaduct*,
Meudon, 1911, etching,
Worcester Art Museum, Gift of
Mr. and Mrs. Karl Lowenstein

Although pictorial photographs with their sentimental subjects and painterly style dominated most exhibitions in France as elsewhere in Europe in the 1910s and 1920s, a new kind of photography debuted in Paris in the 1928 *Premier Salon Indépendant de la Photographie (First Exhibition of Independent Photography)*. Known as the *Salon de l'Escalier* because the photographs were hung in a staircase of the Comédie des Champs-Élysées, the works were selected by the editor Lucien Vogel, the filmmaker René Clair, and the critics Florent Fels and Georges Charensol. They specifically excluded all photographs that took "their inspiration from painting, engraving, and drawing," as Fels wrote.[93] Instead, they included "exact, clean, precise" works by Kertész, Abbott, Krull, and Man Ray, portrait photographer Laure Albin-Guillot, fashion photographer George Hoyningen-Huene, and a separate historical section devoted to work by Atget and Nadar.[94] Kertész exhibited more photographs than any other living photographer—fifteen examples, including portraits, studies of Paris, and such recently completed still lifes as *Fork* and *Mondrian's Glasses and Pipe*.[95] They were also among the most well received (plates 51, 52). His *Fork* was "moving in its purity," Pierre Bost wrote in *La Revue Hébdomadaire,* while the *Paris-Midi* reviewer asserted that his *Glasses and Pipe* was the best work in the exhibition.[96]

In 1928 other shows followed in rapid succession in Amsterdam, Rotterdam, and Brussels. In 1929 his work was shown in a touring exhibition that opened at the Museum Folkwang, Essen, and traveled to Berlin, London, Frankfurt, Vienna, Amsterdam, and elsewhere; in each venue, it was extensively reviewed in the press.[97] That same year Kertész was also included in the large and important *International Ausstellung von Film und Foto* (*International Exhibition of Film and Photography*) in Stuttgart, organized by the Deutscher Werkbund. The exhibition, which sought to demonstrate the profound impact of all kinds of photography on modern life, presented works by celebrated photographers from around the world—including the Russian painter-photographer Alexander Rodchenko, the German Albert Renger-Patzsch, the Czech Karel Teige, and the American painter-photographer Charles Sheeler—as well as anonymous scientific photographs, X-rays, and press and advertising images. As the show traveled throughout Europe—and even to Japan—it, too, generated great interest in photography in general and Kertész's work in particular: after the September 1929 presentation of *Film und Foto* in Vienna, the director of the Graphische Lehr-und Versuchsanstalt asked Kertész to donate one print to the museum's collection, and later that year he sold three photographs to the Museum König-Albert in Zwickau.[98]

But exhibitions, on the whole, provided Kertész with "moral" victories, as he wrote to his family, not financial rewards.[99] Even though he had thoroughly imbibed the precepts of modernism and professed to be a pure photographer, and even though Tihanyi, Mondrian, and others had instilled in him the purists' insistence on a truth to materials, he, like many other photographers of the time, saw no need to separate art from commerce or to remain aloof from mass culture. Perhaps because the exhibitions of the late 1920s erased formerly rigid divisions and seamlessly mixed work by all kinds of photographers (professionals, amateurs, and scientists); possibly, too, because a photographer like Kertész had little hope of supporting himself through sales to museums or individuals; and surely because of the profound influence of the Hungarian popular press on his early art and aspirations, Kertész actively sought to have his works reproduced in the popular press at this time. As the illustrated press blossomed in France in the late 1920s and early 1930s, he gained a significant reputation, influence, and commercial success.

In late 1927 or early 1928 Kertész met Vogel, an editor who had formerly worked as an art director at *Vogue* and was then preparing his own publication, *Vu*.[100] Inspired by the German press, Vogel intended the big, splashy, weekly *Vu* to celebrate the energy and vitality of modern French life and to publish serialized novels, often mysteries, that he hoped would encourage a devoted readership. "Overflowing with photographs," and "conceived in a new spirit and realized with new methods," as Vogel wrote in the first issue in March 1928, *Vu*, he hoped, would "translate the precipitous rhythm of everyday life," and be "a magazine that teaches and documents all the manifestations of contemporary life: political events, scientific discoveries, cataclysms, explorations, sports events, theater, cinema, art, fashion."[101] From his training at the École des Beaux-Arts and his years working on *Art et Décoration* and *Gazette du bon ton*, Vogel knew the importance of good printing and a strong graphic design: Irène Lidova was the art director for the early issues and Alexander Liberman designed later ones. Carefully selecting their photographs to create jarring or ironic contrasts and felicitous or amusing similarities, they created dynamic layouts with collagelike compositions of overlapping, cropped, and even silhouetted images, and succinctly demonstrated that photographs, far more than words, successfully conveyed the ideas and spirit of the magazine.

Kertész's photographs first appeared in the 18 April 1928 issue of *Vu*, and he soon became one of the magazine's leading photographers, along with Krull, Man Ray, and Eli Lotar. Deeply inspired by Vogel's support, Kertész remembered their relationship in later years in the most favorable terms. He recalled his initial concerns that his poor French would hinder his abilities to effectively complete assignments, but Vogel assured him, "you express yourself with your photographs, and that's enough!"[102] Vogel's enthusiasm for Kertész's photographs was patently obvious: by the end of *Vu*'s first year of publication, they had been included in fourteen issues; in 1930 they were included in twenty-three out of twenty-six issues.

22.
André Kertész, "Le Triomphe de la Femme," *Vu* 104 (1930), 203, Library of Congress, Washington

For the next several years Vogel sent Kertész all over France to photograph such diverse subjects as cats and the culinary arts, monkeys and mayors, as well as archers, fire engines, the Eiffel Tower, and wineries. As *Vu*'s reputation grew, thanks in large part to its bold use of innovative photographs, Kertész began to illustrate stories by such celebrated authors as Colette and Philippe Soupault; through assignments from Vogel, he also met such distinguished figures as Marie Laurencin.[103] Making no distinction between his commercial and avant-garde work, Vogel was as interested in Kertész's more experimental photographs—vertiginous views looking down from the top of a fireman's ladder or details of the lips, ears, and eyes of Miss France—as he was in the photographer's more traditional studies (figure 22).[104] He also appreciated Kertész's often oblique or quirky perspective on stories—for example, for an article on how signs had altered travelers' appreciation of the countryside, he photographed a billboard from its side, as if it were a new kind of tree growing in the landscape.[105] And he published many of Kertész's photo-reportage stories, such as his studies of people who vacation in Paris.[106]

Although *Vu,* more than any other publication, secured Kertész's reputation in the late 1920s and early 1930s, he created a wide network of other publications that used his work: he himself established contacts with such publications as *Bifur, Jazz, Les Grands Journaux Ibéro-Américains,* and *Les Nouvelles littéraires;* through acquaintances, he sold occasional stories to *Die Dame;* and through his friendship with the Hungarian-born editor of the influential *Münchner Illustrierte Presse,* Stefan Lorant, he secured commissions to make many photographs for that publication as well.[107] Beginning in 1930 and continuing for the next several years, he also worked extensively for *Art et Médecine,* a lavish periodical designed for doctor's waiting rooms and published by Dr. Fernand Debat. *Art et Médecine,* like *Vu,* sent him throughout France: he photographed, for example, in Lyon and Brittany; he even traveled to Corsica. Despite the variety of publications he worked for, Kertész's photographs remained remarkably consistent. He submitted vignettes on life in Paris or in the countryside and studies of notable people and places, often infused with a sense of the mystery, poetry, even the sweetness and humor of life. But he never photographed breaking news and even when he recorded a topical event—such as the opening of the *Colonial Exposition*—he concentrated not on the thing itself, but on small details or quiet incidents in the background, even the architecture, to allude to the larger idea.[108] Too insistent and emphatic, the news event demanded a literalness and a brashness that were as foreign to his art as they were to his character.

In later years Kertész often referred to Paris as his "best girlfriend" (*bonne copine*) and he recalled his time there as a freelance photographer as one of the most productive and enjoyable experiences of his life.[109] While his work was widely published, his relationships with editors and publishers—even with Vogel—were far more complex than his later recollections indicated. Dynamic, assertive, with "the refined lifestyle of the 'Old French,'" as Krull remembered, Vogel had a clear vision of his objectives and strong proprietary claims over the work of his photographers.[110] In December 1928 Vogel announced his intentions to sell photographs that *Vu* had commissioned by Kertész, Krull, and Lotar to other European and American journals.[111] When these "three independent photographers of the avant-garde," as they described themselves, failed to convince Vogel to allow them to retain the German rights for their works, Kertész sold the sensational photographs that *Vu* had commissioned him to make of monks inside a Trappist monastery—purportedly the first ever made—to the *Berliner Illustrirte Zeitung.*[112] When the *Zeitung* printed the photographs in January 1929 before *Vu* published them, Vogel was incensed.[113] Many other people were also outraged: according to Vogel's agent, the abbot in charge was called to Rome to face disciplinary charges for allowing a Jewish photographer to record the monastery and develop his film in the monk's lavatory.[114] Although Vogel reproduced fewer of Kertész's photographs in 1929, no doubt as a consequence of this incident, the two repaired their relationship. But, easily wounded and at times suspicious, perhaps in part because of his imperfect command of the language, Kertész was not so forgiving with other publishers: the influential critic and editor of *Voilà,* Fels wrote Kertész in 1934 of his "regret you did not understand how it would be to your advantage to collaborate with us" and become their "premier reporter"; and his editors at *Les Nouvelles littéraires* expressed exasperation at his unprofessional silence.[115]

Just as Kertész's relationship with Vogel and other editors was more conflicted than he later suggested, so, too, was his life in Paris in the 1930s far more tenuous and troubled

than he remembered. As the American depression spread to Europe and the social and political climate slowly but inexorably changed—speeding the ascendance of nationalism, racism, fascism, and totalitarianism—the popular periodicals that weathered the economic collapse became increasingly politicized. *Vu* grew ever more strident in its tone and political in its content. Instead of celebrating the evocative nature of Kertész's photographs as they had in the 1920s, *Vu*'s editors increasingly sensationalized them; in 1936 Liberman pasted a photograph of a German bomber onto his photograph of the Eiffel Tower at night.[116] Struggling to make commercially viable photographs, Kertész made studies of religious icons, haute couture, and fashionable women: he even photographed elegant country houses, creating views similar to the airless ones he would make in the 1950s for *House and Garden*.[117] He also worked briefly, without much conviction, for *Regards*, a Communist publication. Even though the situation became increasingly tense and unsettled, politics, as he later asserted, remained "outside of me."[118]

He continued to submit work to periodicals, but increasingly, instead of making new photographs, he recycled old ones.[119] Especially after Hitler clamped down on the German press in 1933, sending enlightened publishers and editors like Lorant into exile, Kertész's work was reproduced far less often: whereas in 1929 his photographs were printed in more than forty articles, in 1936 they were included in less than ten. As he searched for new markets for his work, he responded belatedly to the growing interest in photographic books. Between 1933 and 1937 he produced several, including *Enfants,* 1933, with a text by Jaboune (Jean Nohain); *Az Igazi Ady,* 1934, by György Bölöni with photographs by Kertész; *Nos amies les bêtes,* 1936, with text by Jaboune; and *Les Cathédrales du vin,* 1937, with text by Pierre Hamp. Most of the photographs for these productions were made in the months—sometimes even in the weeks or days—immediately prior to publication.[120]

His series of photographs of nudes reflected in a fun-house distorting mirror, which he first titled *Grotesques,* was another one of these projects, completed in a handful of sessions in the spring of 1933 (plates 69, 70, 71).[121] Since the war, Kertész had been fascinated with optical distortions caused by water, mirrors, globes, and lamps, and he had made many photographs of soldiers swimming, friends reflected in lamps, and even himself and one of his editors at *Vu,* Carlo Rim, seen in a fun-house mirror (plate 68). More recently, a number of his colleagues—Brassaï, Krull, Albin-Guillot—had published nude studies, some of which—especially Brassaï's—were so extensively manipulated that they looked more like drawings or etchings than photographs. These preoccupations and influences came together when the publisher Querelle asked Kertész to contribute nude photographs to his saucy magazine *Le Sourire.* Using three mirrors, two models—one older, one younger—a borrowed studio, and his 9 by 12 cm camera fitted with a precursor of the zoom lens that enabled him to focus on details without changing position, Kertész created almost two hundred photographs that he later described as "great amusement, absolute fun."[122] As the mirrors twisted and distended, contracted and elongated, and occasionally even dismembered and multiplied the women's bodies, Kertész transformed them into supple, rubbery forms that recall not so much Brassaï's nudes as those of Pablo Picasso, Henri Matisse, Henry Moore, and Constantin Brancusi. Yet, while there is a playful sense of discovery to these photographs, and while many are, as Kertész later wrote, "sculpturesque," many are also, as he continued, "sometimes horrible and cadaverous," more ominous than seductive, more grotesque than alluring.[123]

As was noted at the time, these photographs are also a "far cry" from Kertész's earlier work.[124] He had made nudes only once before, in Hungary right after the war, and although he had occasionally worked in a studio, he found its predictability uninspiring. He discovered, though, that the distorting mirror added the same element of chance that invigorated his work on the street, for "with every movement of the model," as he recalled many years later, "there was some interesting transformation, some fantastic design."[125] But for a photographer who proclaimed to be a naive amateur, who only three years earlier had categorically rejected "all forms of professional cleverness or virtuosity," and later adamantly insisted that his photographs were never premeditated or staged, *The Grotesques* or *Distortions*, as he came to call them in the late 1930s, are a paradoxical group of images.[126] After he moved to the United States in 1936, Kertész discovered, ironically, that for a brief time these works, his most artificial and painterly studies to date, were far more widely celebrated than any of his other photographs.[127] And he, too, came to value them highly—so much so, that he returned to the subject almost fifty years later.

In many ways, *The Grotesques* are analogous to the many photographs he made of amputees on the streets of Paris: both are unsettling, strangely threatening, with an ominous conflation of sexuality and death.[128] Since his arrival in Paris he had been deeply touched—especially as a wounded veteran who had spent many months in hospitals— by the number of amputees and others mutilated by the war that he encountered on the streets, and he made several photographs of them and their prosthetic devices. As a sensitive observer of street life, he also saw that society tried hard not to look at these painfully deformed reminders of the war's cost. And, as an astute witness of the relations between the sexes, he also recognized that the very presence of these mutilated war veterans called into question traditional notions of masculinity and femininity. He poignantly addressed this confrontation between the new modern woman and the mutilated veteran in the *Muguet Seller,* in which a woman, dressed plainly and severely in a hat and coat and toting a briefcase, brusquely strides by a legless man who plaintively offers her a bouquet of lilies of the valley (plate 60). Contrasting her restrained manner and evident self-sufficiency with his dependency and emotional vulnerability, Kertész showed that the amputee, like many of the women depicted in *The Grotesques,* had been robbed of allure and sexuality.

Paris Vu par André Kertész, 1934, the most important of all of his projects in the early 1930s, presents an equally unsettling view of Paris in the 1930s. In the previous few years, Kertész had seen many of his colleagues publish books of their photographs, several of which focused on Paris, a subject dear to him. Between 1928 and 1937 Krull, whom Kertész later dismissed as the type of photographer who was always "shooting, shooting, shooting," published more than a dozen books, including *100 x Paris,* 1929.[129] In 1930 Mac Orlan released *Atget, photographe de Paris;* the next year the enigmatic Moï Ver issued his highly experimental *Paris;* and in 1933 Brassaï, whom Kertész taught to photograph only a few years earlier, published his widely acclaimed *Paris de Nuit,* with an introduction by the well-known author Paul Morand.[130]

Intensely competitive, Kertész deliberately responded to Krull's *100 x Paris* and Brassaï's *Paris de Nuit* in *Paris Vu par André Kertész,* with a text by Mac Orlan.[131] As he had done so often in the past, he evaluated and appropriated aspects of the design, structure, and

intention of these precedents to fabricate one of the most innovative photographic publications of the decade. As the title makes clear, the book presents Paris as Kertész saw it—not as a synopsis of the city or an examination of one aspect of it, but rather as an expression of his personal response. Further, by agreeing with his publisher not to produce another book on Paris for two years, he also demonstrated that it was his definitive statement on his adopted home.[132]

The frontispiece and facing title page of *Paris Vu par André Kertész* immediately set it apart from its predecessors. Unlike both Krull's and Brassaï's publications, which include photographs made in only a few years, Kertész's book opens by pairing one of his earliest studies of fishermen by the Seine from 1925 with one of his most recent views of pedestrians crossing a street from 1933, thus proving his long-standing claim to the subject (figure 23). Further, unlike the didactic *100 x Paris,* which conforms to earlier topographical studies

and presents a tourist's overview of famous monuments and buildings, and unlike the sensational *Paris de Nuit,* which explores the seductive Parisian nightlife, *Paris Vu par André Kertész* announces in its opening page spread that it focuses on not the obvious symbols of Paris, but on anonymous people, common urban spaces, and the ways in which the two influenced each other. The design of the three books is also different. Whereas in Krull's book each photograph is carefully centered on a page and bears little connection to the ones around it, Kertész expanded on Brassaï's example and that of popular journals of the time by pairing photographs that echo and

23.
André Kertész, Plates from *Paris Vu par André Kertész,* National Gallery of Art Library

enrich one another. In Brassaï's book, however, the similarities and contrasts between images are emphatic; in *Paris Vu par André Kertész,* they are subtle, quiet, but intimately linked in mood and form. Kertész further modified Brassaï's model by creating an asymmetrical layout—for example, placing one photograph in the lower left and one on the facing page in the upper right—so that the viewer, like the peripatetic photographer himself, would be propelled from one scene to another.

The sequence of photographs in *Paris Vu par André Kertész* is also different from its predecessors. Although Krull's book begins with an overview of the Seine and ends with the Eiffel Tower at night, its structure is loose and random—a series of postcards strung together that leads the viewer from one monument to the next. Brassaï's *Paris de Nuit* follows one reveler's adventures, beginning near famous monuments in the early evening and concluding as carts deliver the morning milk. *Paris Vu par André Kertész* employs none of these conventions: its sequence is not chronological, temporal, or topographical, but thematic and emotional. Following the title page are fifteen photographs of the Seine and its immediate surroundings. For many years, Kertész had been fascinated with the resonance of rivers within urban environments, seeing the collision between natural and man-made forms as a way to contrast feelings of freedom, tranquility, and individuality with restraint, rigidity, and conformity. The first fifteen photographs depict the various

24. – 26.
André Kertész, Plates from *Paris Vu*
par André Kertész, National Gallery of
Art Library

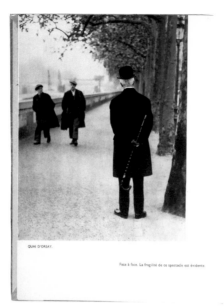
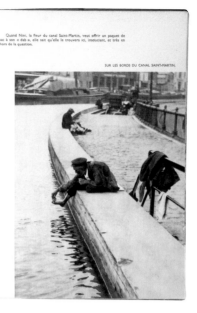

24

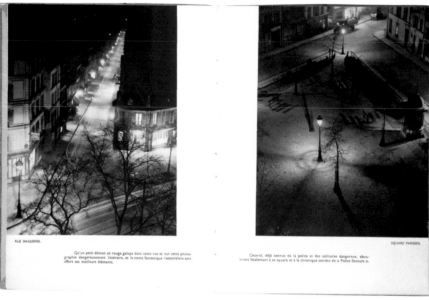

25

26

people—clochards, fishermen, laborers, amputees, even older gentlemen; a painter, a laundress, and a lamplighter—who inhabited the banks of the Seine and made this public space a personal one. Kertész reveals how they used it for sleeping, reading, recreation, even, occasionally, for work or for such intensely intimate acts as bathing or darning clothes. Most important, he showed how they used it as a place for contemplation. Few of these inhabitants are gainfully employed, many have suffered the scorn or revulsion of their fellow Parisians, and almost all live on the margins of society; even the most traditional of all, the older, obviously bourgeois gentleman with his bowler hat and cane, is removed from his social circle and confronted by two laborers (figure 24).[133] Those who do work perform soon-to-be outmoded jobs, like the lamplighter, or menial, backbreaking labor, like the laundress.

Following the opening sequence devoted to the Seine are four night views of empty city streets and squares. In one, Kertész stood outside a lighted café and looked in on the gaiety and fraternity of others; in two others, he looked down from windows onto the parks below, again separating himself and the reader from the scenes (figure 25). Like Kertész, readers may witness, even enjoy these scenes, but from afar; they cannot revel in the immediate, physical presence or experience the resonance of the spaces. Next are five studies of people: flea-market vendors, a one-legged war veteran, and three clochards, two of whom are asleep, no doubt inebriated, with their empty bottles close to their sides. Kertész's next two groups of photographs relieve this somber note—four depict empty but animated chairs that seem to dance across the parks and gardens, and three record street fairs or carnivals. These places were among the few areas in the city itself where Kertész had seen evidence of the inhabitant's vitality and individuality.

Echoing the opening sequence is a concluding series of fifteen photographs—all of urban architecture. But unlike the quays, bridges, and paths by the Seine, these urban spaces are oppressive, inhospitable, and forbidding. Kertész looked across rooftops or up at buildings, but he eliminated all foreground space within which readers—even the photographer—could situate themselves. He looked down from the Eiffel Tower or from windows onto dwarfed people enmeshed in an architectural web of shadows or confined in narrow courtyards. He presented people who tried to express their individuality within these spaces—a wandering violinist and child or a man reading on a roof—but they are trapped in their surroundings with no clear way of entering or exiting their spaces (figure 26). Far from the dazzling, exuberant studies of the 1920s, these scenes from the 1930s are expressions of an increasingly confined, even claustrophobic photographer.

The book ends with *On the Boulevards*, one of the photographs taken just before the volume's release in 1934 (plate 62). A bleak picture of alienation within the urban environment, it presents a man and a woman set within the narrow confines of a city sidewalk. The man strides behind the woman as she sits on a bench. Backs turned, they do not notice each other, even though, as Mac Orlan tells the reader in his caption, "she searched her whole life for the great true love who was behind her." The curious, disjointed coupling of the figures and their lack of emotional interaction are both echoed and contrasted in the posters behind them. Yet the animated gaiety of this fractured collage makes the comparison all the more bizarre, as if Kertész is suggesting that within this new metropolis the only emotion is flat, two-dimensional, and stilted. In one poster,

a man sits at a café table, pouring a glass of Dubonnet; his back, too, is turned to a woman in another poster below. Wearing a top hat and tuxedo, she is the androgynous star of the review *George et Georges*. The reader can only wonder if she, with her confused sexuality, has, like her counterpart seated on the bench, just missed the love of her life as well.

Sad and somber, the Paris that Kertész saw in 1934 was no longer a city of mystery, beauty, fraternity, and culture, as it had been in the 1920s, nor was it one of sensuality, as it was for Brassaï, nor even one of grand cultural history, as it was for Atget and Krull. Instead, populated by outsiders, it was a place of unease and melancholy at best, and loneliness, isolation, alienation, and deformity at worst. Critics of the time recognized the disturbing quality of *Paris Vu par André Kertész*. The novelist Eugène Dabit, also Kertész's friend, described the book's photographs in a review as "either cruel, or charged with a troubled poetry and a fierce melancholy."[134] Another acquaintance of the photographer noted, "despite the crisis, Paris is not peopled only by tramps and unemployed workers," and he suggested Kertész should have titled it "'Misery in Paris.'"[135]

Kertész's personal life changed dramatically in the 1930s. Early in 1927, he moved to 5, rue de Vanves, where Rozsi (Josephine) Klein, a fellow Hungarian immigrant and an accomplished violinist, also lived. They were married in October 1928 and Kertész taught her how to photograph.[136] In homage to him she assumed the name Rogi André when she began to publish her work in the early 1930s. But the marriage was difficult; they separated in 1931 and divorced in 1932.[137] Thereafter, Kertész never again mentioned her or their marriage. In 1933 he married Erzsébet Salamon, his girlfriend from Hungary.[138] Yet the oddly fractured nature of the portrait he made of them in 1933 suggests their marriage, too, had its difficult moments: Erzsébet, entirely absorbed in herself, is strangely separated from Kertész, while he fusses over her, attempting to create a sense of intimacy (plate 73). He also drifted apart from many of his artist-friends: in 1929 and 1930 Tihanyi traveled to America for several months; in 1932 Zilzer moved there, and Fried followed soon thereafter. Perhaps in part because of Erzsébet, he no longer socialized with Mac Orlan nor, if his photographs are any indication, did he attend the raucous artist-parties that he had frequented in the 1920s. He lost not only the camaraderie of these artists and critics, but also their inspiration and direction, and in the mid-1930s his photographs also began to lose some of their rigor, innovative edge, and vision.

By 1935 Kertész admitted that while he continued to garner professional praise, he and Erzsébet were just "scraping along.... Morally I succeed but we better not talk about the material rewards."[139] Thus, in the spring of 1936 when he received an offer from the Keystone Press Agency to move to New York to establish a fashion studio, the prospect of steady employment must have been tempting.[140] While his earlier attempts to work in studios in both Budapest and Paris were not successful, he had occasionally worked for *Vogue* in Paris.[141] His family was overjoyed that he and Erzsébet would escape Europe. His brother Imre, who remained in Hungary, had a much more accurate understanding of the desperate nature of the times, especially for Jews, and he noted that friends in Budapest "fall on their knees before the name of Keyston [*sic*]."[142] Imre enthusiastically suggested his brother could do a book of "New York, Chicago, etc, *vu par André Kertész,* or even better, have Keystone sponsor a trip for preparing 'USA vu par André Kertész'.... Thus on Keystone's expenses, who might want to exploit you, you could gather for yourself

material of incredible artistic and commercial value."[143] Expressing the dreams of many immigrants, he added, "To ponder what kind of commercial opportunities that might represent, one can turn to the novels of Upton Sinclair—Oil!"[144] Surely knowing the success of Hungarian filmmakers in Hollywood, he told his brother to send Charlie Chaplin a copy of *Paris Vu par André Kertész,* assuring Kertész he would find "an enlarged material, at once monumental and bottomless, in its own crass American coarseness. An unheard of subject field that no creative artist has yet crafted in pictures."[145]

Although Kertész remained uncertain of Keystone's proposal through early July 1936, by August he had accepted it, raised $200 for "advance expenses," and received immigration visas for permanent residence for himself and Erzsébet.[146] An ecstatic Erney Prince of Keystone urged him to study fashion photography, "leaf through the American *Vogue* and *Harper's Bazaar,*" and look at Hoyningen-Huene and Horst P. Horst, for their "style is what is needed here."[147] Noting that he would earn a salary of approximately $4,000 a year—a comfortable wage for the time—he added that Kertész should "study and study, and once again study the English language as much as you can, so that when you arrive you can babble a little."[148]

Thus, with some reservations, but knowing full well what kind of work was expected of him, André and Erzsébet Kertész left Paris for New York in October 1936. Although their departure almost certainly saved their lives, they did not foresee how much they, especially André, would nostalgically look back on his years in Paris. By any measure he had accomplished a great deal in the eleven years he spent there: not only had he established himself as one of the leading photographers of his generation, but he had also developed a nuanced understanding of the nature and strength of his art. But nostalgia often clouds the truth. In the years to come as he held fast to his myth of naiveté, he not only minimized the influences on his art of some of the most advanced Parisian art of the time, but also undercut the sophisticated dialogue he had initiated with these artists. And as he subsequently painted all of his time in Paris in the same palette, depicting the 1930s in the same glowing manner as the 1920s, he robbed his own history of its veracity and richness, and denied much of the complexity and meaning of his later work. Thereafter, this tension between the reality of his present life and the myth of his earlier one would pepper his conversations, permeate his psyche, and power his art.

Have confidence in the inventions and transformations of chance.

KERTÉSZ, 1930

33 *Eiffel Tower, 1925*

34 *Behind Notre Dame, 1925–1926*

35 *Théâtre Odéon at Night, 1925 – 1926*

36 *Behind the Hôtel de Ville, 1925*

37 *Fête Foraine, 1926*

38 *Stairs, Montmartre, 1926*

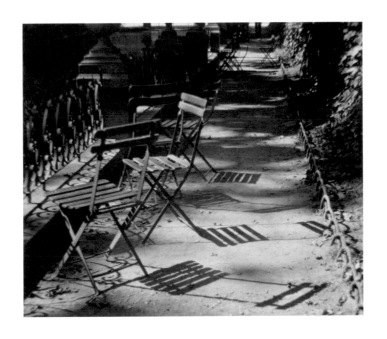

39 *Chairs, Luxembourg Gardens, 1926*

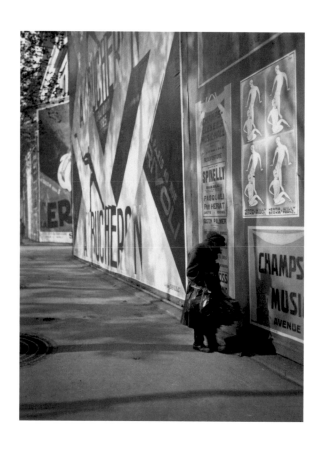

40 *Wall of Posters, 1926–1927*

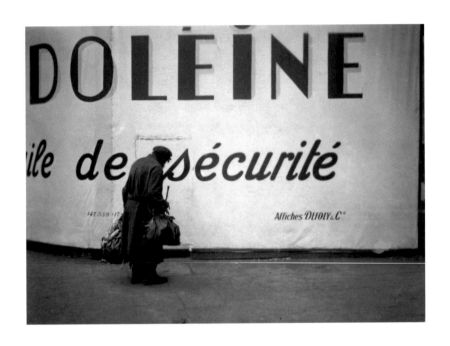

41 *Sécurité, Grand Boulevard, 1926–1927*

42 *Portrait of a Young Yugoslav Bibliophile, 1926–1927*

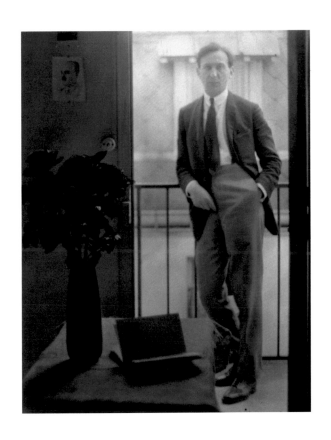

43 *Self-Portrait, Paris, 1926–1927*

44 *Mlle Jaffe, 1926*

45 *Portrait of Mme R., 1926*

46 *Magda Förstner, 1926*

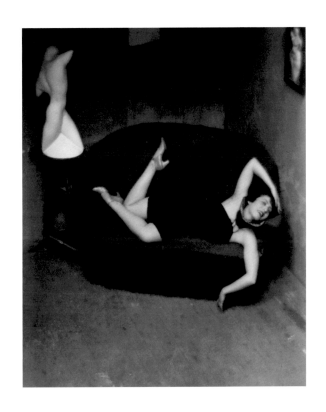

47 *Satiric Dancer, 1926*

48 *Géza Blattner, 1925*

49 *Mondrian's Studio, 1926*

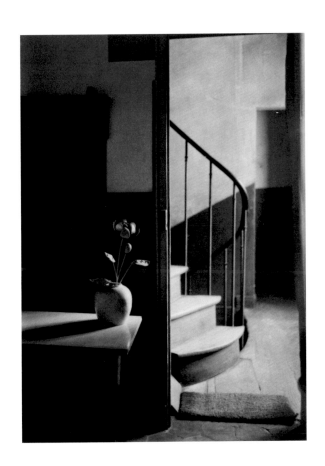

50 *Chez Mondrian, 1926*

51 *Mondrian's Glasses and Pipe, 1926*

52 Fork, 1928

53 *Quartet, 1926*

54 *Cello Study, 1926*

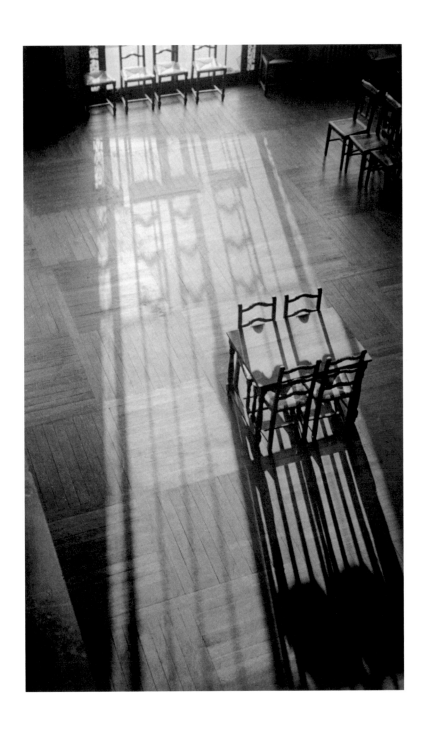

55 *Chairs in the American Library, 1928*

56 *Rue Vavin, 1925*

57 *Siesta,* 1927

58 *Meudon, 1928*

59 *Quai d'Orsay, 1926*

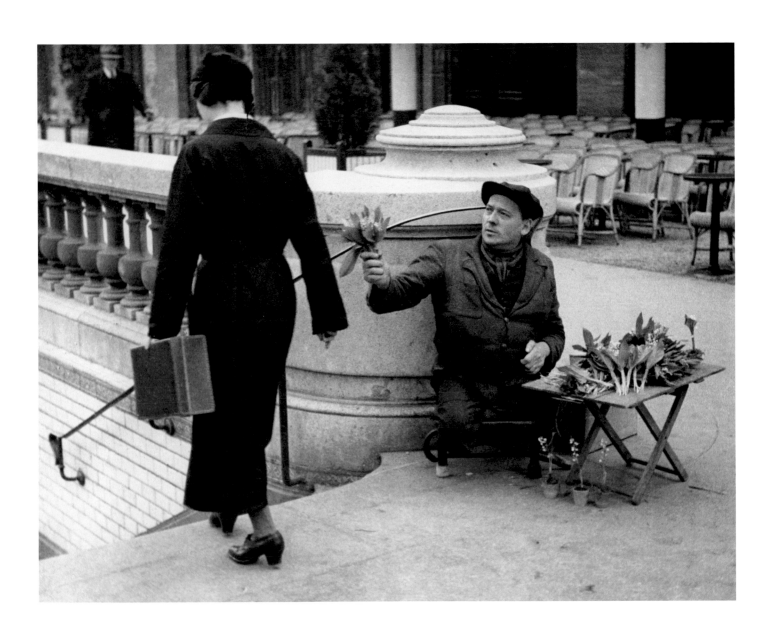

60 *Muguet Seller,* 1928 or 1930

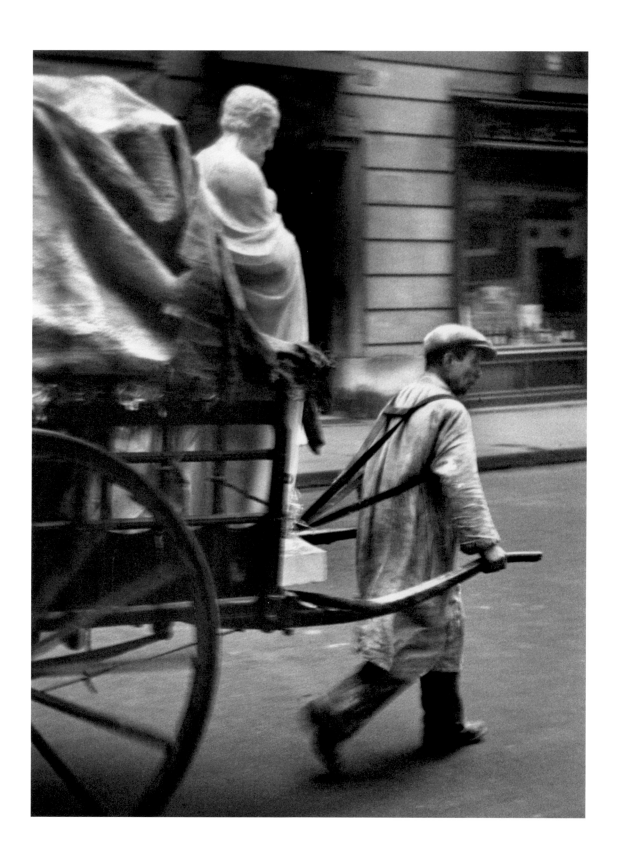

61 *Montparnasse, 1928*

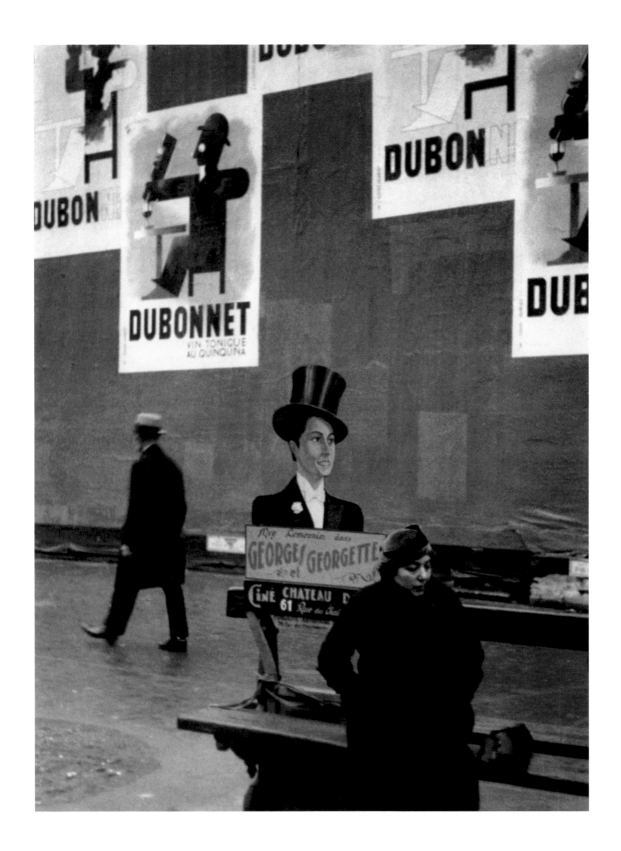

62 *On the Boulevards, 1934*

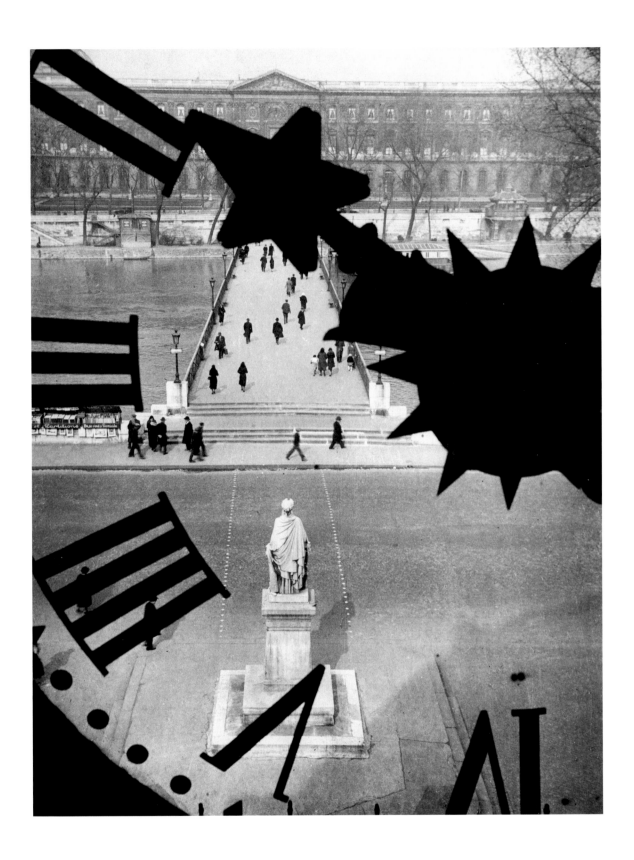

63 Clock of the Académie Française, 1929

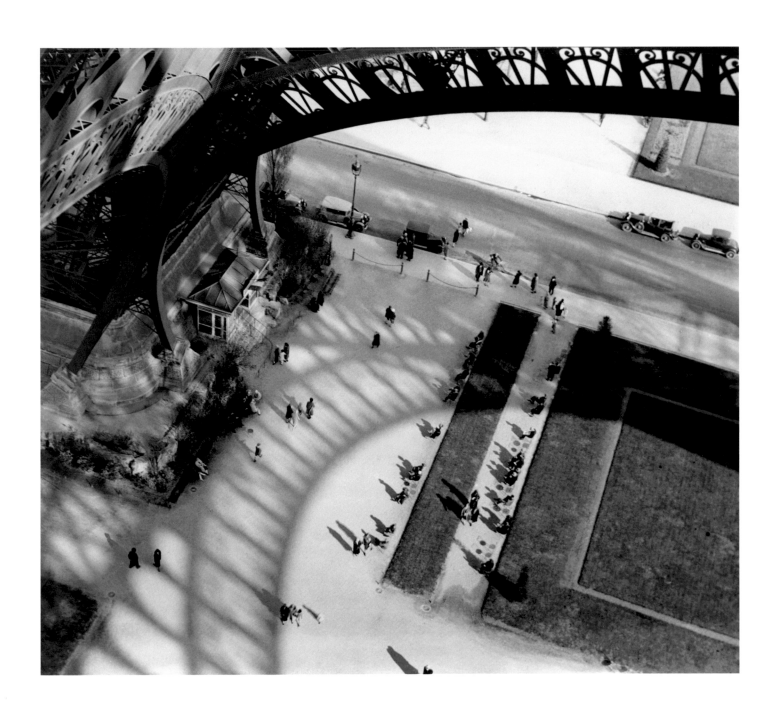

64 *Under the Eiffel Tower,* 1929

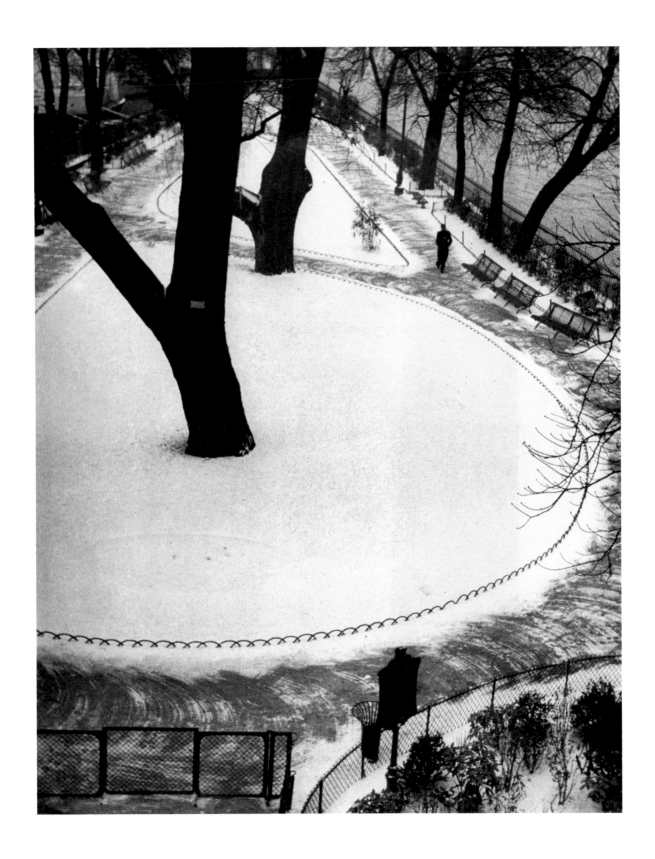

65 *The Vert-Galant under the Snow, 1935*

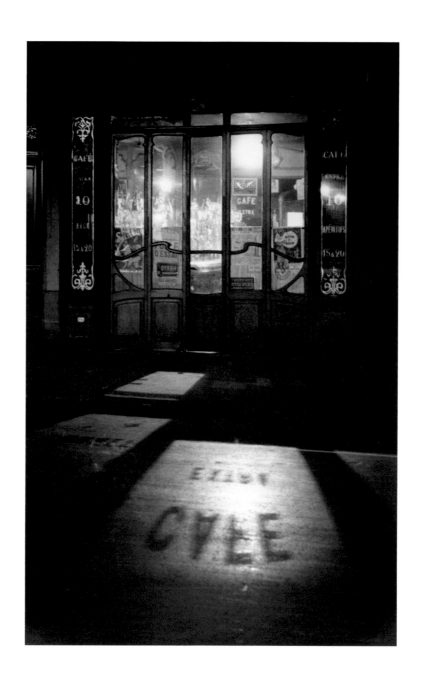

66 *Café Extra, 1927–1932*

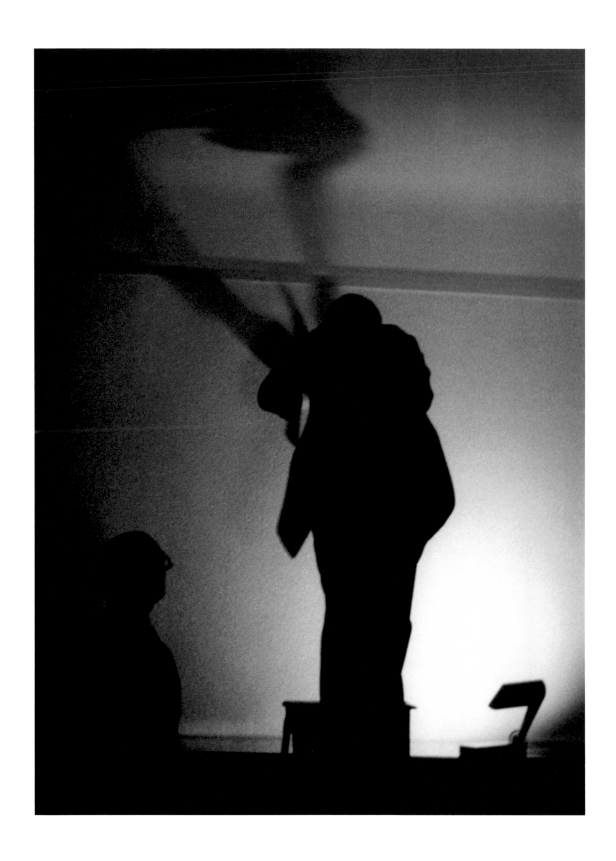

67 *Hanging Pictures, 1928*

68 *Distortion — Self-Portrait with Carlo Rim, 1930*

69 *Distortion #40, 1933*

70 *Distortion #150, 1933*

71 *Distortion #167, 1933*

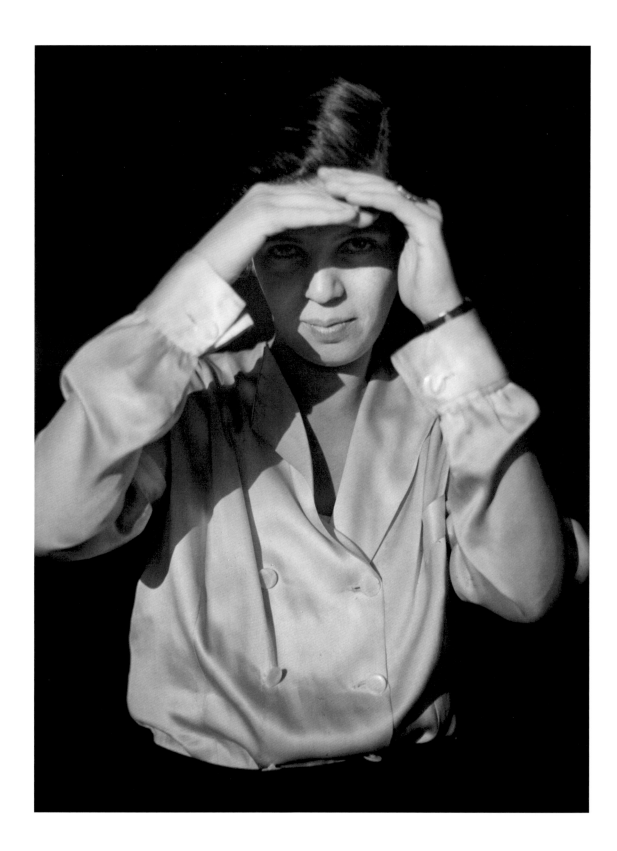

72 *Elizabeth, 1931–1936*

73 *Elizabeth and I, 1933*

74 *Self-Portrait*, 1927

The Circle of Confusion, 1936–1961 Robert Gurbo

I'm dead! You're seeing a dead man.[1] KERTÉSZ, C. 1956

In late August 1936, after weeks of indecision, André Kertész agreed to work as a fashion photographer for Erney Prince at Keystone Press Agency in New York. He told family and colleagues that he hoped New York would provide him with a steady income and new photographic terrain, both of which had recently eluded him in Paris.[2] But rising anti-Semitism and a shift in photojournalism away from his more lyric, often oblique style to one more politically engaged and strident had also made his life there increasingly diffi-cult. Although he had deep reservations about immigrating to America—he feared his trip would "come to nothing"—he also had dreams of grandeur.[3] Spurred by his brother Imre, Kertész considered publishing new books, similar to *Paris Vu par André Kertész*—perhaps a *New York, Chicago,* or even *America Vu par André Kertész.*[4] He even entertained the possibility of branching out into cinematography, envisioning his visual sensibilities incorporated into Charlie Chaplin's films.[5] Elizabeth also had ambitious plans, hoping to parlay her experience working for Helena Rubinstein in Paris into a business of her own in New York.[6] After purchasing new equipment for the New York studio and wiring $200 to Prince to secure permanent visas, André and Elizabeth Kertész sailed to New York on the SS *Washington,* leaving behind the city that had been his home for the last eleven years.[7]

Kertész's dreams were well founded, for in many respects he appeared, once again, to have arrived at the right place at the right time. Although photographically illustrated maga-zines had been published in America for many years, they were radically transformed in the mid-1930s. Inspired by their innovative European counterparts—and often using the same editors and art directors—they increasingly incorporated bold designs and used photographs to convey their ideas. More than any other American city, New York, the home of *Life, Fortune, Harper's Bazaar,* and *Vogue,* among many others, was the hub of this thriving industry. In addition, in the mid-to-late 1930s, as a growing number of painters, sculptors, architects, writers, critics, and dealers fled the fascist regimes in Europe

and immigrated to America, New York became a dynamic center for art. Although this transformation was at first largely by default, the city evolved in the years immediately around World War II from a cultural sidelight into the mecca that Paris had been in the 1920s. Such artists as André Breton, Marc Chagall, Fernand Léger, and Piet Mondrian—whom Kertész had photographed in Paris—as well as the Hungarian painters Theodore Fried and Gyula Zilzer, sculptor Ossip Zadkine, and photographers Robert Capa and Martin Munkacsi all found shelter in New York, and many gained profound inspiration from their new home.

But Kertész's reservations soon proved justified, for his arrival in the United States marked the beginning of a personal and professional quagmire that engulfed him for the next twenty-five years. His association with Keystone was a failure: he quickly found that Prince was not prepared to provide any meaningful work beyond studio fashion photography, which suited neither his temperament nor his style. His contract was prematurely terminated, amid legal disputes, in the summer of 1937. By this time, even if André and Elizabeth had wanted to return to Paris, they could not.[8] They were desperately short of money and, as Europe edged closer to war, only the most foolhardy person, especially one from a Jewish family, would contemplate such a move. Since there was no turning back, they applied for naturalization in the fall of 1937.[9]

Kertész, however, swiftly became disillusioned with almost every aspect of his life in America, particularly in New York. To be sure, he had some success in the 1930s and 1940s, especially considering the dire nature of the time. His photographs were reproduced; he developed a cordial association with curators at the Museum of Modern Art (MOMA), where his photographs were included in group exhibitions; he had one-person retrospective exhibitions in 1937 and in 1946; he had a few champions in the photographic press; and his 1945 book *Day of Paris* was lavishly and widely praised. But, with his considerable reputation as a leading figure in European photography and as an introspective individual who was easily offended and keenly felt the difference between what was and what might have been, he had expected and wanted much more. His greatest humiliation was that *Life*—a magazine that celebrated photographs similar to his own—rejected his work not once but three times in ten years. Equally dispiriting, for years he was not given a position of prominence at any major American periodical (as Margaret Bourke-White had at *Fortune* or Alfred Eisenstadt at *Life* and Munkacsi at *Harper's Bazaar*), nor did he have a steady source of income until the late 1940s. And whereas he floundered for many years, unable to find a means of employment that utilized his distinct vision, other recent immigrants, like Eisenstadt and Munkacsi, easily transferred the styles they had established in Europe to their work in the United States. Perhaps as a result of these disappointments, in 1947 Kertész accepted a contract from Condé Nast to become a staff photographer for *House and Garden*. Hampered by his poor English and lacking a natural ability to promote himself or his work, especially within a corporate culture, he languished there for fifteen years. He made technically proficient but lifeless architectural studies of celebrities' homes that required little use of his abilities to infuse his photographs with wit and insight.

Kertész also found it difficult in New York to reestablish a sense of community. In Budapest and Paris he had cultivated a group of painters, sculptors, writers, editors, publishers, and, to a lesser extent, photographers, as well as family members, who fueled his creative

spirit, giving him direction and inspiration. Because of New York's size and diversity, because of its mercantile character and fast pace, and because it lacked the tradition of café life, the city's artistic community was far more scattered, less cohesive or communal than the ones Kertész had known in Europe. For a reticent artist like Kertész, these obstacles proved enormous and for the next quarter of a century he was deeply lonely, both personally and professionally. Far removed from the influential relationships he had cultivated in Paris, his interactions in New York with writers, editors, art directors, and publishers were, with few exceptions, adversarial. His associations with painters and sculptors, so critical to his development in the past, were minimal and apparently not meaningful. Separated by the war and unable to communicate for many years with his brothers in Hungary and Argentina and old friends in Budapest and Paris, he relied instead on his wife and for the first time in his life aligned himself with photographers, particularly a group called the Circle of Confusion. The name, derived from an aberration caused by light refracted from a lens, denoted the members' passionate embrace of the 35 mm camera.[10] But the group's title also aptly represents the missteps Kertész took and the misunderstandings he endured from 1936 to 1961 as he tried unsuccessfully to construct a new career for himself in America.

In the 1970s and 1980s, when he was hailed as a significant figure in twentieth-century photography, Kertész referred to this period in his life as his "lost years" and mourned his diminished productivity.[11] Despite his lament, he continued to photograph, but his lack of professional success and his personal isolation had a powerful effect on his psyche and significantly altered his art. To a great extent, he explored the same themes and motifs in New York that he had pursued in Paris—especially self-portraiture and the bizarre and unexpected juxtapositions that so frequently occurred in modern urban life—but his photographs of these subjects gained a new edge and harshness. In addition, for the first time in his career he began to support himself by making highly artificial, staged, controlled, and impersonal studies that were diametrically opposed not only to almost all of his earlier work, but also to the kind of photography he had loved and championed for almost twenty-five years. As he sought to come to grips with the ever-widening gap between his professional and personal work, he also struggled to reconcile his inherited sensibilities with the new culture before him. Like so many other immigrant artists of his generation, he found that as he was forced to construct a new artistic persona, he began to use his art to search for an understanding of his place in this new world. For this intensely introspective artist, that search resulted in unexpectedly rewarding and important photographs.

If America has anything to give the poets and artists and musicians of France who have been driven here by the Nazi terror, it is not the secret and magical freedom to discover the current of their own lives, but the opportunity to find in the current of American life a force and a direction they can recognize as theirs without sacrificing their character as Frenchmen or their integrity as artists.[12]

ARCHIBALD MACLEISH

When André and Elizabeth Kertész arrived in New York in the fall of 1936, they moved into the Beaux-Arts Apartments at 307 East 44th Street, just a block away from "Studio Prince" and the Keystone Press Agency. Within a few days of his arrival, Kertész was at work, making fashion photographs for Best and Company and the designer Jay Thorpe.[13] Although

Prince had told Kertész that he would work in a studio and urged him to study contemporary fashion photography before he arrived in the United States, the artist found himself bewildered and lost in this environment.[14] The few fashion photographs he had made in France were casual, outdoor views, far removed from the stylized and highly popular work of George Hoyningen-Huene, Cecil Beaton, or Horst P. Horst, whose photographs filled American publications. He had not enjoyed working in a studio earlier in his career in Budapest or Paris and now he found it even more challenging. He had allowed chance to help him create his compositions for so long that he had great difficulty fabricating lively scenes or coaxing his models' expressions (figure 1). Indeed, most of the extant photographs from his work for Keystone are competent but ordinary fashion photographs, as well as uninspired commercial portraits, dramatically different from the intimate studies of friends he had made when he first arrived in Paris.[15]

Frustrated by Prince's unwillingness to supply him with material that took him out of the studio and anxious that he was not building a reputation in America, Kertész began to look elsewhere for other jobs. Early in 1937 he accepted a commission from Alexey Brodovitch, a Russian-born art director who was now working for *Harper's Bazaar,* to photograph the activities that took place at Saks Fifth Avenue, the department store, after closing time.[16] Published in the April 1937 issue of *Harper's Bazaar,* the affectionate photo-essay included thirteen photographs and revealed a private world, a bustling subculture of human endeavor unknown to most New Yorkers.[17] The assignment not only suited Kertész's style, it also displayed his ability to create a succinct body of work illustrating a single subject and to find unexpected and amusing anecdotes—such as an empty glove stand that seems to reach out and pinch the backside of a mannequin or carpenters stooped over a rack of women's coats, as if examining their price tags (figure 2). Although

Harper's Bazaar was known more for its bold, splashy design than for its use of documentary photographs, it was, with Brodovitch's seemingly insatiable quest for all that was new, one of the most innovative American publications of its time. Thus, it was an important place for Kertész to publish so many photographs so soon after his arrival.

His employers at Keystone, however, did not celebrate this publication, for Kertész had an exclusive contract with them. They sued him in the summer of 1937; he countersued, claiming Keystone had withheld commissions.[18] Although the actions were settled two years later, they hung over him for many more, as he was forced to subsist on freelance work for the next eleven years.[19] The entire experience undercut his self-confidence as well, for Keystone had been his reason for immigrating to the United States.[20] Moreover, as he scrambled to support himself and Elizabeth in 1937 and 1938, he was shocked to discover that his past achievements seemed of little importance to his new American audience. Instead, like so many other immigrants, he was forced to start over and construct a new persona. In keeping with the desperate nature of his circumstances, the new André Kertész that he began to project was not just a photographer who made insightful reportage stories or evocative portraits, but a multifaceted generalist: "everything," he said a few years later, "is my specialty."[21] In his first few years in the United States, he demonstrated his varied skills by photographing children for *Harper's Bazaar,* building on the reputation of his book *Enfants;* he recorded models for *Vogue,* both in the studio, in front of plain backdrops, and on the street, supposedly shopping for wines or tea; he photographed high society for *Town and Country* at horse shows or in restaurants; and he recycled numerous studies of Paris for *Coronet.*[22] As he bounced from one assignment to the next, he worked in a variety of styles—from high fashion to more casual studies of models and from portraiture to individual commercial and advertising photography (figure 3). Seeking to find an approach that appealed to the American audience, he also studied the work of other fashion and commercial photographers. He paid particular attention to those who had made successful careers publishing their photographs in magazines, such as Munkacsi, and made several photographs of dancers that emulated his dynamic, energetic style (figure 4). But the jobs were few, the pay minimal, the work hard, and the photographs not his best.

With no regular employment, Kertész had a great deal of time for his own work. One of his earliest studies made in New York was a self-portrait taken at the Beaux-Arts Apartments (plate 75). As in his self-portrait made in Paris soon after his arrival, he positioned himself in front of an open window, but the differences between the two photographs are striking (plate 43). [23] In *Self-Portrait, Paris,* he presented himself as an elegant young man, situated comfortably within an intimate, personal environment, and exuding a sense of familiarity and belonging. The later study, however, is far more ambivalent. Precariously poised between self-confidence and vulnerability, he depicted himself as visually carnivorous but unsure of his position within this new environment. Perched like a hawk and firmly grasping a large format camera, he showed himself as a strong, focused figure, sleeves rolled up and seemingly eager to tackle the world outside his window. But the window, instead of providing a means of entry into the city, seems to isolate him from it, allowing him to examine but not participate in the life outside. And the world beyond the window is entirely different, both physically and psychologically, from the one he recorded in Paris. Composed of monolithic, impenetrable structures with no distinguish-

3.
André Kertész, *Dead End*, early 1940s,
gelatin silver print, Kertész Foundation

4.
André Kertész, *Marian Winslow and
Foster Fitz-Simons*, 1941, gelatin silver
print, Kertész Foundation

ing characteristics, it is inhuman and inhospitable, not inviting or mysterious, as he had found Paris to be in the 1920s. Further, by excluding all of his and Elizabeth's apartment, he depicted himself as oddly confined—even trapped—within a tight, anonymous space that provided him shelter but no comfort.

Disquieting and often disjointed, Kertész's photographs from the late 1930s and early 1940s are pervaded by a sense of duality and a curious mixture of awe and disgust, exuberance and uncertainty, cautious optimism and anxiety. To fill his empty time, he roamed the streets of New York looking for physical details and psychological nuances that would help him to ascertain both the character of his new home and his place in it. As he had done in Budapest and Paris, he was drawn to public places that he could infuse with personal meaning. Like so many others who came to New York in the early twentieth century, Kertész was both amazed and overwhelmed by the scale of the city's skyscrapers, and he frequently photographed them in his first few years in America. Most often, though, he used them to address not the city's strength or modernity, but his own alienation and loneliness. In *Lost Cloud* (plate 78), 1937, he photographed a small, lone cloud that butts up against the Empire State Building, as if its path were blocked by this imposing structure. Equating himself to the cloud, Kertész later recalled that he was "very touched" when he saw it because it "didn't know which way to go."[24] In *Skywriting*, 1937–1940, Kertész again matched sky to skyscraper, presenting the delirious and upside down letters from a wayward skywriter next to the monolithic slab of Rockefeller Center (plate 79). But the pilot was as lost and confused as Kertész, for if done correctly, skywriting is never seen upside down by people standing on the ground. Both playful and despondent, the photograph presents a world in which everything seems to have gone awry, for the efforts of the pilot are as futile and ephemeral as Kertész's own.

In his first few years in New York, Kertész was drawn to other subjects that revealed both the city's dazzling architectural wonders and its inhospitable nature. In *Poughkeepsie, New York,* 1937, he used all the formal lessons he had learned in Hungary and Paris to record the complex web of the modern mechanized city (plate 76). He contrasted the jagged staircase descending to the platform with the gleaming lines of the track and an expanse of white roof in order to create a boldly dynamic photograph of modern urban life. But in *Poughkeepsie, New York* none of the people interact with each other; they look down at the platform, off to the side, or past one another. And, except for one man in white who, hands on hips, impatiently waits for the train, this place is one where the architecture seems more energetic and engaged than its inhabitants. In *Arm and Ventilator* (plate 81), 1937, Kertész, as he had in Paris, again explored the bizarre and unexpected sights that so frequently occurred in the modern city, but in New York the results were far more brutal, ominous, and devoid of the humor that had lightened his earlier work. He showed a person reaching his arm through the blade of a fan, presumably to repair it, one eye peering through the slotted darkness. At first glance, the arm appears to be part of the machine, a reluctant—and unsettling—extension of it. Like the mannequin's legs he had photographed in Paris, the arm, too, seems dismembered, but in the later work the potential for violence is much stronger and very real.

Aggressive, impersonal, and confusing, the new world that Kertész discovered in New York in the late 1930s and early 1940s was one that had been turned upside down, where

man-made objects posed insurmountable hurdles, where people were isolated from each other and did not communicate, and where violence was immanent. Even in his more exuberant photographs from this time, Kertész presented the city as not only a place filled with dazzling sights, but also one where danger lurks. In *Communications Building, New York World's Fair,* 1939, he captured a workman boldly balancing on the outside edge of a scaffold (plate 77). But with only one hand tentatively grasping a pole, he seems to disregard how easily he could plummet to the ground below. Like the workman and his shadow, Kertész's city was also a place where people's lives were bifurcated and disconnected.

Many other photographers, including Berenice Abbott, Walker Evans, and Alfred Stieglitz, recorded New York at this time. Kertész knew Abbott in Paris and surely saw her 1939 book *Changing New York;* although he never met Evans, he saw that artist's 1938 exhibition at MOMA; and he met Stieglitz and had several opportunities to see the older photographer's studies of the city.[25] Many parallels exist between Kertész's work and theirs. Like Abbott, Kertész was intrigued by the visual geometry of the city's buildings and streets, by the clash between old and new, and by its vertiginous vistas. Like Evans, he was fascinated with the commonplace, seemingly incidental details of everyday life, and with the city's signs and humble shops. Like Stieglitz, he delighted in demonstrating his ability to impose a visual order and logic on the city's cluttered cacophony of streets and buildings. However, whereas Abbott was concerned with a documentary exactitude and Evans with cool, dispassionate observation, Kertész's approach was, perhaps, closest to that of Stieglitz, for like the older photographer, he always saw the city as emblematic of his feelings. But Abbott, Evans, and Stieglitz all approached New York as insiders, fundamentally at ease on its streets, among its people, and within its culture. Kertész, however, viewed New York as an outsider, as someone never fully at home. In Paris he had embraced the theme of the romantic outsider, but in New York this theme was slowly transformed into one of bitterness, loneliness, and isolation.

It was a great day for American photography when André Kertész landed on our shores—a greater day than many editors, critics and museum curators realize as yet. Not having a flair for self-advertising, he is being "discovered" but slowly.[26] JOHN ADAM KNIGHT, 1942

Like many immigrants, especially those uncertain about their decision to leave their home, Kertész spent his first few years in New York looking both backward and forward, attempting to put down roots in his new environment even while he worried about those left behind. Letters from his brother Imre and sister-in-law Gréti reassured him of "how right it was for the two of you to leave Europe. Paris, in fact the whole of France has undergone tremendous convulsions and anxieties in this past year and a half."[27] But, at the same time they made him acutely aware of how difficult life had become for all Jewish people under the ever-growing repression of the Nazis: "Human existences are reduced to zero on this contemptible, vile continent, smeared with the thin veneer of culture," Imre bitterly wrote in September 1938. The situation had grown markedly worse in recent months, he noted, when "an isolated new subspecies was created, the 'non-Aryans,' [who are] treated with cold pogroms. I don't know what tomorrow will bring and I don't know if there will be a tomorrow here at all."[28]

Adding to the emotional torment of the late 1930s and 1940s, Kertész's career swung from a few moments of great accomplishment to long periods of neglect and deep disappointment. Heeding Imre's fervent pleas, he made several valiant attempts in the late 1930s to establish himself within the photographic community and to promote his photographs. Shortly after his arrival in New York, he accepted an invitation from Manuel Komroff, a writer he had known in Paris, to become a member of the Circle of Confusion.[29] A loosely knit organization dedicated to miniature cameras and 35 mm photography, the group was founded in the early 1930s by Komroff, Willard Morgan, and others, and during its forty-year history came to include scientists, engineers, executives of camera companies, as well as such photographers as Eisenstadt, Peter Stackpole, and Nat Resnick, and the critic Jacob Deschin.[30] The Circle of Confusion members enthusiastically celebrated the advantages of the 35 mm camera, especially its speed and portability, and its ability to give order to the rapidly changing world. But they also embraced its limitations, believing that its slightly blurry images and lack of focus helped to enhance emotional content of their photographs. While Komroff later said that their meetings consisted mainly of whiskey and dinner—occasionally attended by such celebrated figures as photographers Ansel Adams and Weegee, and curators Beaumont Newhall and Edward Steichen—their conversations often focused on such technical issues as new equipment or recent developments in film emulsions.[31] Kertész, who became a "devoted member," may not have gleaned important aesthetic revelations from this group, as he had from the painters and sculptors he had known in Budapest and Paris, but members of the Circle of Confusion occasionally helped him to secure much-needed jobs.[32] And although their impact on the larger photography community was minimal at the time, their support was significant for Kertész, especially in the 1940s when the sharp-focus, highly detailed view camera studies of Edward Weston, Adams, and other photographers associated with the California group f.64 were widely celebrated in exhibitions and in the photographic press. Many years later their friendships also proved critical to the renaissance of Kertész's career.

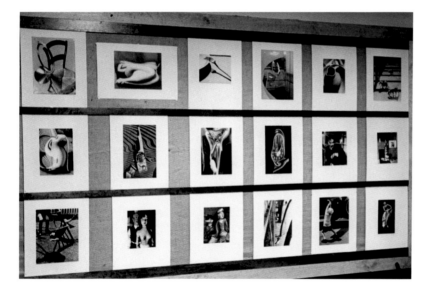

5.
Installation view, PM Galleries, 1937,
Kertész Foundation

In December 1937, just a little over a year after his arrival in New York, Kertész showed sixty photographs at the PM Galleries in New York, a small exhibition space designed to bring the work of photographers, designers, and illustrators to the attention of the leaders of the publishing world (figure 5).[33] Eager to use the show as a springboard for more commissions and to demonstrate his versatility, he carefully selected works to appeal to this commercial audience. He presented portraits of celebrated figures, like Alexander Calder, and studies of children. He showed examples of his reportage work and fashion photographs, as the checklist noted, made "For *Harper's Bazaar*" and "For Paris *Vogue*."[34] But, recognizing the commercial nature of American society, he also exhibited photographs specifically intended for advertising purposes—including "Still Life for Advertising"—for the first time in his career.[35] He also displayed several *Distortions,* here titled *Grotesques,* for the first time since his arrival because he believed they elicited a "strong emotional response," as he wrote a few years later, and "naturally have a place in modern advertising." His *Grotesques* included both nudes made

in Paris, as well as photographs made in New York of a clock that seemed to have melted, a greatly elongated vase, and "*Grotesque* for Cigarette Advertising."[36]

Although the exhibition in general elicited little attention and appears not to have generated significant commissions, the *Grotesques* provoked great interest—so much so that when they were the subject of an extensive review in 1939 in *Minicam*, a periodical for amateurs, the critic felt compelled to note that Kertész's other photographs were "a far cry from the style in which André Kertész is a recognized master—distortion."[37] Following Alfred Barr's highly influential and popular 1936–1937 exhibition *Fantastic Art, Dada, Surrealism* at MOMA, the press immediately saw the connection between these photographs and surrealism, hailing Kertész as the one who had "introduced Surrealism into photography long before that word had ever been coined by the inner cultural circles of Paris, New York, and London."[38] Although Stieglitz, perhaps recognizing that these photographs could be perceived as gimmicks, cautioned him, as Kertész wrote in 1944, that if he displayed his *Grotesques* or *Distortions* once, "everyone will do it, and then forget it," he did not take the older photographer's advice. Instead, he exhibited and reproduced them many times in the late 1930s and early 1940s.[39] Insisting that he "invented the technique" of making photographs with a distorting mirror, he even tried to sue others who made similar works.[40] Stieglitz, unfortunately, was correct, and as the American fascination with surrealism grew, numerous other photographers began to use mirrors, collage, combination printing, and other techniques to make surreal photographs. They soon saturated the market, and editors and publishers grew weary of them.[41] Although Kertész adamantly maintained, as he wrote in 1941, that distorted photographs were "one of the highest forms of photography" and repeatedly sought to exhibit and reproduce them, by the late 1940s they were ignored and forgotten.[42]

Between 1937 and 1942, as Kertész sought to get his work more widely known, he also submitted his photographs, including *Distortions* and other pieces made for advertising, to several exhibitions in museums and commercial galleries, as well as to photographic salons.[43] His closest association, though, was with MOMA. In 1936 when he was in Paris doing research for the museum's landmark exhibition *Photography 1839–1937*, Beaumont Newhall tried to contact Kertész, but he had already left for New York.[44] When the two finally met a few months later, they developed a cordial relationship. When Newhall, fearing adverse public reaction, asked him to crop one of the Paris *Distortions* to eliminate the model's pubic hair, Kertész complied. Although in later years he repeatedly stated that he was incensed and had found the request a harsh welcome to America, at the time he appears to have been delighted by the inclusion of five of his photographs—*Road Mender, The Vert-Galant under the Snow* (plate 65), *Fashion Plate,* and two *Distortions*—in the 1937 exhibition.[45] He congratulated Newhall on the success of the show; sent him a dedicated copy of *Paris Vu par André Kertész;* allowed his photographs to be included in a smaller version of the exhibition that traveled around the country in 1937 and 1938; and even offered to help Newhall translate a manuscript into French.[46] As further evidence of his support, he also donated a photograph to MOMA in February 1941, his first work to enter an American institution.[47] Later that year he, along with numerous other photographers from around the country, responded to the museum's challenge to "look at these United States" and determine "what gives our lives meaning?…What are our resources and our potential strength?"[48] Works by more than sixty photographers, including Imogen

Cunningham, Wright Morris, Eliot Porter, Charles Sheeler, Aaron Siskind, Frederick Sommer, and Minor White, were presented in the subsequent exhibition *Image of Freedom,* selected by Barr, Newhall, Adams, and others. Two of Kertész's photographs were included—*Peace, Vermont,* a landscape, and *Armonk, New York,* a study of a simple schoolhouse that seems to rise out of a severed tree trunk and expressed, Kertész wrote, a "pure American atmosphere" (plate 85).[49] Both were also acquired by the museum.[50]

In 1939, perhaps recognizing that his poor marketing skills and limited English may have curtailed his exposure, Kertész hired a representative, Wick Miller, to prospect for jobs.[51] Through Miller's efforts he received assignments, for example, to photograph a department store in Hudson, New York; he also spent over two weeks in Cleveland photographing the Cleveland Play House, worked for the Long Island Duck Association, and took a series of pictures on mushroom cultivation (figure 6).[52] He put much effort into these assignments, traveling great distances with heavy equipment to take photographs for often demanding commercial clients, but the financial rewards were limited and the work, often stiff and contrived, gave him little popular exposure.

Also in 1939, probably through Miller's efforts, Kertész appears to have received a commission from *Life* to photograph the New York and New Jersey harbors.[53] The American counterpart to *Vu,* the French periodical that had nurtured his art and secured his reputation, *Life* seemed a natural home for his photographs. As it announced in its first issue—which was released on 23 November 1936, just weeks after his arrival—the magazine sought "to see life; to see the world…to watch the faces of the poor and the gestures of the proud…to see and take pleasure in seeing; to see and be amazed; to see and be instructed"; in short, it sought precisely the things Kertész had photographed for more than twenty years.[54] Using photographs on a single theme, arranged to tell a story, explicate an idea, or convey a mood, *Life* was enormously popular in the late 1930s and early 1940s and the pinnacle of achievement for a photographer like Kertész. Not surprisingly, he put a great deal of effort into his photographs of the harbor, taking full advantage of *Life*'s prestige and, no doubt, a healthy expense account. Striving to record the subject from every possible point of view, he flew in a dirigible over the city, photographing the glistening waterways, the bold geometric pattern of the New Jersey piers and rail lines, and the Empire State Building as it stood "Sentry" over the metropolis.[55] He climbed many stories above the docks to make a photograph looking down on a harbor master shouting instructions to giant ocean liners below; he went into offices to depict the bureaucrats who controlled the harbors; and he went out on a tugboat to record the lives of the operators; he even included a copy of *Life* next to their bunks (figures 7, 8). Mimicking the bold, aggressive style of the magazine, especially Bourke-White's photographs that had graced its first issue, Kertész's photographs of the harbor are emphatic and assertive, distinctly different from the nuanced and often witty works he made for publication in Europe. Late in August 1939 he submitted over two hundred photographs to *Life*—far more than he would normally make for a story—but none were ever published there.[56] On 3 September 1939 England and France declared war on Germany, and although America did not enter World War II for over a year, the country's long-standing friendship with England precluded such a prominent magazine as *Life* from showing "air shots of the docking of the Queen Mary and the Normandy," as Kertész wryly noted in 1941, for these "were records of activities that no longer existed."[57]

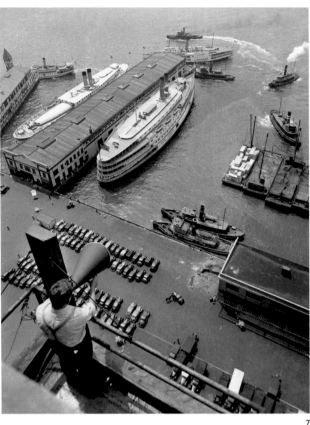

7

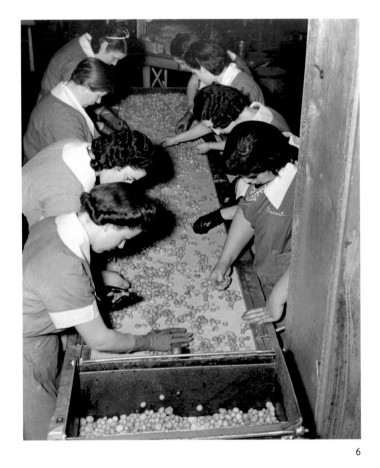

6

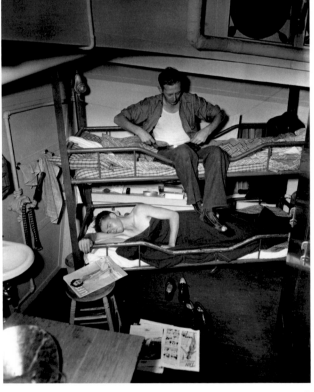

8

6.
André Kertész, *Sorting Mushrooms*,
1941, gelatin silver print, Kertész
Foundation

7.
André Kertész, *New York Harbor*,
1939, gelatin silver print, Kertész
Foundation

8.
André Kertész, *The Tugboat*, 1939,
gelatin silver print, Kertész
Foundation

Although *Life* did much to familiarize the American public with the power of photography, many photographers who worked for the magazine felt their images were treated as commodities, not hard-won, carefully considered studies that required years of experience to create.[58] Moreover, they often found that their meaning was subverted both by the captions and sequencing of the photographs within the story—as *Life*'s influential executive editor Wilson Hicks noted, it was not the "picture for the picture's sake" that mattered, "but the picture for the idea's sake."[59] Years later Kertész remembered that Hicks told him that his photographs "talked too much"—that is, that they were not malleable enough to suit *Life*'s needs.[60] Acerbic, "icy-eyed and unbending," Hicks had a reputation of provoking his photographers to demand more of themselves, and of pitting one against another, as if each was the other's "deadliest foe."[61] Surely knowing Kertész's considerable reputation, Hicks may have hoped his comment would prod him to work even harder; instead, it insulted and offended Kertész. He was also amazed to learn from Hicks that *Life* had twenty editors to interpret photographs.[62] Far more bureaucratic and corporate than any publication Kertész had previously encountered in Europe, *Life* was also more impersonal. Like so many others, Kertész soon discovered that six people, most of whom he never met, stood between him and the publication of his photographs: researcher, department editor, negative editor, picture editor, designer, and managing editor.[63] His pride hurt and with no personal relationship with any members of its staff, Kertész lacked the guidance and inspiration he had received from European editors such as Lucien Vogel. But he did not give up. In 1942 he submitted eleven photographs from his sensational 1928 study on the Trappist monks, a series that had elicited widespread comment when it was first published in both the *Berliner Illustrirte Zeitung* and *Vu*.[64] But *Life* declined his offer because they "did not fit into our schedule."[65] He tried one more time in 1949 and sent *Life* some of his witty studies of chimneys, but the photographs were returned unused.[66]

Other disappointments soon followed, and often Kertész's exaggerated reactions only exacerbated his plight. In November 1940 *Coronet*, a Chicago magazine that had published more than twenty-five of Kertész's photographs in recent years, devoted an entire section in its fourth anniversary issue to an "Anniversary Dividend of 32 Memorable Photographs."[67] Only one Kertész photograph was included in the selection, far fewer than his previous contribution merited, while a number of works by other Hungarians, such as Ernő Vardas, were published. Kertész responded by refusing to submit additional photographs to the magazine.[68] Earlier, when *Look* had published seven of his photographs with Prince's name in 1938, he had also stopped submitting work to them.[69] A few years later in November 1944 he was again stymied when M. F. Agha, a friend and colleague from Paris who had become an art editor at *Harper's Bazaar,* excluded him from a special issue of the magazine devoted to the history of photography, even though contemporaries like Abbott, Bourke-White, Evans, Munkacsi, László Moholy-Nagy, and Albert Renger-Patzsch were all included, as were photographers whom Kertész had taught or influenced, such as Brassaï and Henri Cartier-Bresson.[70] And in 1945 *Minicam* returned more than a hundred photographs they had commissioned, telling Kertész they simply "don't understand them."[71] A sensitive but intensely competitive man who was easily slighted, Kertész keenly felt the pain of these slights. Many other photographers shared his tribulations, but his acerbic posturing only worsened his relations with editors and publishers and deepened his financial difficulties.[72] It also had a devastating effect on his art, as he had previously relied on assignments to gain access to new and different places and to challenge him as

an artist. Whereas in Paris, especially in the 1920s, his art and professional work had merged as one, in New York they remained disconnected, and both suffered.

Stress brought on medical problems that intensified his professional misfortune. On hearing from mutual friends that André and Elizabeth had been "starving for months" and "deteriorating to the extremes," his worried family anxiously wrote, proposing remedies for André's numerous health problems: nausea, vomiting, anemia, and difficulties with balance (later diagnosed as Meunier's disease), even emaciation.[73] In the 1970s Kertész portrayed the late 1930s and early 1940s as one of the bleakest times in his life, remembering how he became dizzy and collapsed on the sidewalk when he and Elizabeth were

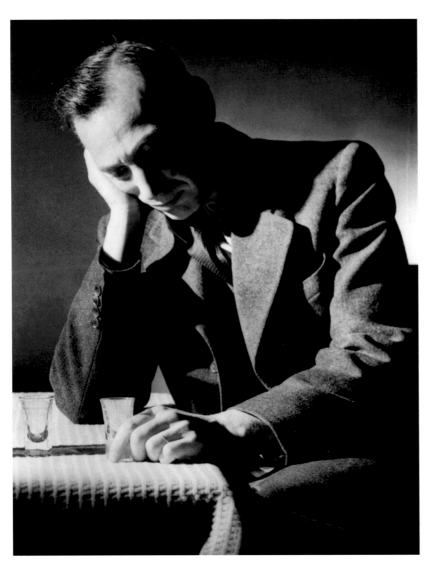

9.
André Kertész, *Self-Portrait*, 1940,
gelatin silver print, Kertész Foundation

locked out of their apartment because they were late with their rent.[74] He also recalled that a doctor told him that he could no longer work in the darkroom because its red light caused him to have dizzy spells and attacks of vertigo.[75] Forced to engage professional printers for the rest of his life, he struggled to obtain the delicate results that he desired. He also said that he was fingerprinted as an enemy alien after America entered the war in December 1941 and told not to photograph on the streets—"they thought I was a spy," he scornfully noted in the 1970s.[76] Few of these recollections can be documented. (In 1942 he did receive a license for "the use of photographic equipment," yet was quickly told that, as a Hungarian national, he did not need it; and in 1944, when materials were rationed, he had difficulty obtaining more than a few rolls of film per month.[77]) But they nevertheless help to explain his own later autobiographical interpretation of *Melancholic Tulip*— it was, he said, like him, youthful and fresh, but sadly wilted before its time—and the melodramatic nature of his self-portrait with a shot glass (plate 80, figure 9).[78] He made few photographs purely for himself and not for clients, but those that he did—such as *Homing Ship*, 1944, or *Lion and Shadow*, 1949—express his nostalgia, loneliness, and a sense of being trapped and unable to express himself (plates 83, 82). He had a few champions in the press: in the early 1940s John Adam Knight, another recent immigrant, mentioned Kertész a few times in his column in the *New York Post* and in 1944 Maria Giovanna Eisner wrote an article on him when he received his citizenship papers.[79] While undoubtedly important to Kertész, these brief comments generated little interest and few commissions. He published little during the war, particularly in 1942 and 1943: the few photographs that were reproduced were mainly older, recycled images, while the new ones were uninspired fashion studies.[80] His financial situation became so precarious that he even resorted to making copy photographs of works of art.[81]

Perhaps out of desperation, he returned to the idea of publishing a book of photographs—one devoted not to New York or Chicago, as he had originally intended, but to Paris, a subject he knew better and had explored more thoroughly than almost any other photographer currently living in the United States. Although he first conceived of *Day of Paris* in 1942, the book was not released until 1945.[82] Designed by Brodovitch, with captions by George Davis and sequencing by them and Kertész, *Day of Paris* is a lyric poem intended to capture the "day of a wanderer [who] follows no guide book, is willing to lose himself, to become patiently and tenderly nobody."[83] Like *Paris Vu par André Kertész, Day of Paris* avoids the famous monuments and the obvious vistas. Instead, its 147 photographs are arranged in a literal and narrative sequence charting the wanderer's path in the "Morning," "Afternoon," and "Evening." Less flamboyant and more quiet than many of Brodovitch's other publications from the time, the book is similar in layout to other photographic books published before the war, such as Brassaï's *Paris de Nuit,* 1933, or Bill Brandt's *The English at Home,* 1936, and *London at Night,* 1938.[84] Frequently two photographs are paired on a page spread; occasionally one photograph is placed opposite a blank page or extends over two pages (figures 10, 11). The result is a syncopated rhythm that mimics the way a person might travel through a city, quickly surveying many sights and sporadically pausing to contemplate others. When two photographs are placed opposite each other, they often repeat similar subjects, forms, and compositions, and thus create witty visual puns and poignant pauses (figure 12). Enhancing this visual dialogue, Davis' text frequently links the photographs, noting parallels between them and even at times suggesting that the people in one image were conversing with those in the adjacent photographs (figure 13). Thus, the reader seems almost to be eavesdropping on conversations; they not only see Paris, but also hear its many voices.[85] In arranging the images, Kertész built on the lessons he had learned in *Paris Vu* and his work on Robert Capa's 1938 book *Death in the Making:* the sequence itself from one page spread to the next often echoes similar forms or motifs in order to link disparate subjects. For example, the upraised arms of women protesters on one page are reiterated on the next by the raised hand of a lonely man seated at a table smoking a cigarette, and contrasted on the adjacent page with those of a blind and crippled man who grasps a walking stick (figures 14, 15).[86]

A collaborative effort between designer, writer, and photographer, *Day of Paris* sought to address the life of everyday Parisians, to show the small details that combined to give the city its character, and, as Davis wrote, to reveal the city's "most precious secrets: a woman's hand at a window, the eyes of a carrousel horse, the violence of a deserted street."[87] But in this way, it was far less personal than *Paris Vu par André Kertész*—it strove to be not a record of how Kertész had seen or experienced Paris, but a more general expression of the fundamental nature or spirit of the city. And, therefore, it also spoke to a much wider audience than his earlier publication ever had. Released in the waning days of the war, the book benefited from the enormous nostalgia that had built up not only for Paris, but also for a past and presumably more pure and simple way of life that many feared had been forever erased by the Holocaust. Immensely popular, *Day of Paris* was reviewed in almost every major newspaper across the United States: from the *St. Louis Post Dispatch*— "This is Paris, and you will either weep in memory of her or look forward to knowing her again"—to the *New York Post*—"truly magnificent pictures of the heart, the humanity, the tinsel and the truth of Paris"—to the *Nashville Banner*—this is "a Paris beloved by millions."[88] Noting that it was a "balm to throbbing nerves," the *Saturday Review of Literature* asserted that it gave readers "a renewed conviction that, whatever improvements are made

Many in Paris have never left their quartier to see the Seine. There are others who are prisoners of the river. It is not the bridges that hold them; not the gay little excursion boats, nor the slow brutish barges. They hardly notice the to-and-fro of the day. They are listening to the quiet the quiet of one who has known all man's violence, anguish, renunciation.

50 *51*

10

To those who have found in Paris a true friend and consoler, and who lose themselves in the city to win back certainties for the soul, there is a meaning no others may know in the words of Montaigne: "I love hir so tenderlye that hir spots, hir blemishes and hir warts are dear to me." And they learn, too, in their wanderings, an infinite compassion for the lonely and the lost.

130

11

10. – 12.
André Kertész, Plates from *Day of Paris*, 1945, National Gallery of Art Library

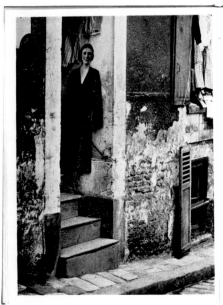

La mode.

35

12

13. – 15.
André Kertész, Plates from *Day
of Paris*, 1945, National Gallery of
Art Library

13

14

15

in the post-war world, much of the past can be retained with profit," while *Popular Photography* used it as an occasion to sing praises for the medium itself, writing "what war destroys, photography has already perpetuated."[89]

But Paris, not Kertész, was the focus of most of the reviews. Despite the fact that almost every commentator acknowledged the beauty of Kertész's photographs, his contribution was oddly minimized, as if he were little more than the fortunate mediator and Paris essentially revealed itself. He reaped little professional benefit from the book's great success. Thirty-seven photographs from *Day of Paris* were presented in a one-person exhibition at the Art Institute of Chicago in the summer of 1946, but only one brief review appeared in the local press.[90] Deeply disappointed, Kertész later recalled that he hoped the show would bring him "a real break"; when it did not, "I felt like I was buried alive."[91] Besides reproductions from *Day of Paris*, less than ten of his photographs were published in 1945 and almost all were dry architectural studies, significantly different from the evocative and often amusing images that had garnered so much acclaim in *Day of Paris.* The following year produced a similarly slim group of published photographs; he also suffered the ignominy of seeing a few of his competent but uninspired architectural photographs published in an issue of *Harper's Bazaar* that included numerous photographs of a masked ball by Brassaï, as well as ten studies of the Brooklyn Bridge by Cartier-Bresson.[92]

In January 1947, after eleven years of struggling to establish a career, Kertész signed an exclusive one-year contract to work for Condé Nast and its publication *House and Garden.* Alexander Liberman, the magazine's art director (and a former colleague from *Vu*), had arranged for him to receive a minimum of $10,000 a year—a princely sum for a man who had been scraping by on far less—if he agreed "to do no photography for use in editorial pages of any other periodicals or newspapers except when specifically approved in advance by The Condé Nast Publications Inc." The contract also specified that Condé Nast would own "all reproduction rights in, and the right to take out and own the copyright on, all photographs taken by you and furnished to us."[93] Although he later claimed that he had initially refused the contract and only accepted after Liberman offered to let him to do reportage stories in addition to the architectural studies required of him, no such reportorial photographs by Kertész were ever published in *House and Garden.*[94]

For the next fourteen years as he repeatedly renewed his contract, he photographed the homes of the country's richest individuals and most famous celebrities. He received compliments from such appreciative customers as Winthrop Rockefeller, Peggy Guggenheim, and Cole Porter, and had access to their homes. But he garnered little aesthetic stimulation or sense of accomplishment.[95] To some extent, the job matched the photographer Kertész had become. In the last few years when he had worked as a fashion photographer or made studies for corporate bulletins and industrial companies, he had learned to apply the same close attention to the details of a scene that he had previously given to a rapidly changing street scene. And, whereas once he had fortuitously alighted on a single element in a street tableau that gave order and meaning to the scene, now he discovered he could insert an open book, adjust a chair, or wait until the light streamed through an open doorway in order to inject a human element, no matter how faint, into his compositions (figure 16). But the work was hard, especially for an aging man who was not in good health. He traveled all over the country: in 1949 alone his itinerary included

16.
André Kertész, *Interior*, gelatin silver
print, Kertész Foundation

Dallas, Fort Worth, Houston, and San Antonio, Texas; Chicago, Lake Forest, and Lake Bluff, Illinois; Pittsburgh, Pennsylvania; Boston and Marblehead, Massachusetts; Washington, D.C.; and Warrenton, Virginia, as well as numerous trips throughout Connecticut, New Jersey and New York.[96] After years of drought, he became so busy his relationships with friends and family suffered: as he wrote to Jenő in 1957, "the way we live here, by the time we grab a pen, we are too exhausted."[97]

But, if the work was hard and uninspiring, why did he continue to renew his contract year after year? In part, he may have done so simply because he had few other sources of employment and feared the poverty—and suffering—he had endured during the war. In part, too, after so many years of neglect, he may have been genuinely flattered to be a staff photographer for a magazine who garnered kind words from some of the country's most prominent individuals. But he may also have been motivated by Elizabeth's success. In the late 1930s she had established a business with Frank Tamas, a Hungarian émigré who had been a chemist in Paris at Helena Rubinstein and established his own cosmetics firm, Cosmia Laboratories, before moving to New York. Their New York–based Cosmia Laboratories sold fragrances in America. It struggled during the war, but as the American economy rebounded in the late 1940s and 1950s, their business grew. Thus it was Elizabeth, an astute businesswoman fluent in several languages, who allowed them to afford the luxuries they had for so long gone without. Even though neither of them liked New York, her business was probably one of the reasons why they never moved back to Europe after the war.

In 1952, with their combined incomes, they were able to rent an apartment in a new building at 2 Fifth Avenue in New York. Years later Kertész recounted the story of discovering the building while it was under construction, of going from floor to floor, window to win-

dow, to find the perfect vantage point.[98] One of the few tall buildings in lower Manhattan at the time, it offered magnificent views of the city below, and the twelfth-floor apartment that they leased overlooked Washington Square Park and all lower Manhattan. Their new life was now situated around Greenwich Village, which with its narrow streets, low buildings, and fluid mix of residential and commercial structures was more reminiscent of Paris than was any other part of the city. When they first moved into the new building, the elevator operator and a number of the building's maintenance crew were Hungarian; therefore Kertész could began each day by greeting people in his native tongue. Noting that they "did not want the everyday life of America" in their apartment, he and Elizabeth organized their home with the same close attention to detail that he applied to his photographs and she to her business.[99]

The apartment at 2 Fifth Avenue helped to ground Kertész, and it was there that his artistic regeneration began. For the first time since he had arrived in New York, he found a sense of home and a newfound sense of self-confidence. It also offered him a new pictorial vantage point from which to observe and photograph the city below, as well as the equanimity with which to address it. In both the bright light of summer and muted gray of

17.
André Kertész, *Washington Square*, 1959, gelatin silver print, Kertész Foundation

winter, he looked down onto the rich, ever-changing life below, photographing Washington Square Park, nearby rooftop gardens, and the city streets, delighting—for the first time in years—in the complex interplay of people, things, and nature. Sometimes cool and removed, sometimes playful, and frequently eloquently poignant, he often captured the lone individual, isolated within the urban vista (plate 91), much as he had done in many of his most memorable photographs from Paris (plate 65). Using an assortment of different focal length lenses, he honed in on artists, musicians, and nude sunbathers on adjacent rooftops; on neighbors tending their window boxes; and on the park below (figure 17). Although voyeuristic, these photographs are also reverent statements about the private moments of contemplation that all urban dwellers seek. And, despite the distance, they are surprisingly intimate, as Kertész was once again capturing the quite moments of everyday life.

Kertész also began organizing and rearranging still lifes on bookshelves, glass cabinets and window ledges. Composed out of the figurines and statues he and Elizabeth had collected, each small vignette represented different ideas and feelings. With its high vantage point with windows facing south and west, the apartment was bathed in constantly shifting sunlight, at times producing sharp and angular shadows, and at other moments filling the rooms with a soft glow. He found that photographing the still lifes became as much a discovery as his street photography. He approached it the same way, patiently observing and waiting as the sun sculpted the arrangements, and grabbing his camera when they had been transformed into a found still life (figures 18, 19).

18.
André Kertész, *Still Life*, gelatin silver print, Kertész Foundation

19.
André Kertész, *Still Life*, gelatin silver print, National Gallery of Art

But looking down from his lofty perspective and working within his hermetic environment, he grew more isolated from the world below. All around him, the artistic community was changing profoundly as painters, sculptors, architects, and photographers, liberated from the travel constraints imposed during the war, now flocked to New York. A new, younger generation of photographers, including Robert Frank and Roy DeCarava, for example, and somewhat later Diane Arbus, Lee Friedlander, and Garry Winogrand, began to establish themselves in the city. Like Kertész in his youth, they were fascinated with the fluid, rough complexity of the urban vista; like him, too, they often used 35 mm cameras and available light, freely sacrificing focus for expression. But while many of these younger photographers knew Kertész's name, they had only a vague recollection of his art and little sense they were working in a direction he had pioneered, for there were few opportunities to see his photographs in the 1950s.[100] Although MOMA, with Edward Steichen heading the photography department, mounted numerous photographic exhibitions in the 1950s, Kertész's work was completely ignored. Unlike Cartier-Bresson, whose work was shown at the museum in 1947, or Brassaï, whose recent photographs of graffiti were shown in 1956, Kertész was not given a one-person show at the museum in the 1950s, nor was his work included in any group shows during this time. Most perplexing, his photographs were not shown in Steichen's enormous, highly popular 1955 exhibition *The Family of Man*, which with its focus on family, home, and community seemed to offer many opportunities to present his work. However, MOMA was not the only institution to ignore Kertész's work in the 1950s: from 1947 through 1959 he was not given a one-person exhibition at any American museum and his work was rarely included in group shows. [101] Although MOMA was the dominant force in the photography community in New York—indeed, at the time, in the country—other people and museums tried to offer alternative venues and some were slightly more favorably inclined to Kertész's work. His photographs were shown at the Metropolitan Museum of Art in 1960 in the exhibition *Photography in the Fine Arts II*, organized by the photographer Ivan Dmitri, who was associated with the Circle of Confusion, and selected by Newhall, now head of the George Eastman House, and A. Hyatt

Mayer, curator of prints and drawings at the museum, among others.[102] But such public recognition was rare. Except for his photographs made for Condé Nast and *House and Garden,* Kertész's work was rarely reproduced in other periodicals during this time.

In the 1950s, as his anger over his rejection grew, his health problems once again escalated, and he increasingly confided to friends that he "hated the United States."[103] As his professional and personal work split apart, his photographs also became more literally bifurcated. Throughout the 1950s and into the early 1960s, he repeatedly photographed people cut in half by their surroundings, partially obscured by trees, walls, and buildings, so that only a portion of their bodies was visible (plates 89, 95, 96). Sometimes the unforgiving architecture seems to consume its inhabitants—in *Disappearing Act,* a collage of different parts of one negative, Kertész cut a woman's body in half, pasting an empty staircase over her shoulders and head so that she appears to have turned, as he said, "into nothing" (plate 86).[104] Sometimes his subjects are rendered wholly inadequate by nothing more than the absurdity of life—in *Layfayette,* 1961, Kertész presented a torsoless couple that seems as powerless to act as the prone wooden statue before them (plate 89).

In September 1961 when he was hospitalized for five days, Kertész seized the opportunity to take stock of his life. His older brother Imre had died a few years earlier in 1957. He was now sixty-seven years old, exhausted and immensely bored with making the same kinds of photographs for *House and Garden* for more than a dozen years. His relationship with Liberman had deteriorated greatly. Unlike so many other photographers in the 1950s who flourished under Liberman's and Condé Nast's support—Irving Penn, for example— Kertész withered, for he and the urbane, immensely social Liberman failed to establish a close friendship or easy professional relationship. By the mid-1950s, as American magazines came to favor flamboyant designs and exuberant, exotic, or daring photographs, Liberman grew to regard Kertész's photographs as "too sentimental—an unforgiving failing."[105] By the early 1960s, he also found that even the photographs Kertész made for *House and Garden* were unsatisfactory, and he published them much less frequently. "In the end," as Kertész himself admitted, his relationship with Condé Nast and Liberman was "horrible."[106]

Despite his fears that he would not have enough vitality and time to resuscitate his art, Kertész quit working for *House and Garden* late in 1961, determined to embrace his roots as a photographer and become an amateur again. Later, Kertész bitterly looked back on these years, but adversity and isolation had sharpened his senses, increased his propensity to infuse himself into his pictures, and resulted in the creation of an eloquent expression of his struggle for identity in a lonely world. The personal deprivation he had endured also prepared him well for the next phase of his career, when he engineered a remarkable artistic rebirth and finally bridged the three periods of his life—Hungary, Paris, and New York—into one seamless whole.

It is not enough to fight, you have to reeducate your soul.

JENŐ KERTÉSZ TO ANDRÉ KERTÉSZ, 1943

75 *Self-Portrait in the Hotel Beaux-Arts,* 1936 or 1938

76 *Poughkeepsie, New York, 1937*

77 Communications Building, New York World's Fair, 1939

78 *Lost Cloud, 1937*

79 *Skywriting, 1937–1940*

80 *Melancholic Tulip, 1939*

81 *Arm and Ventilator*, 1937

82 *Lion and Shadow*, 1949

83 *Homing Ship*, 1944

84 *Ballet, 1938*

85 *Armonk, New York, 1941*

86 *Disappearing Act*, 1955

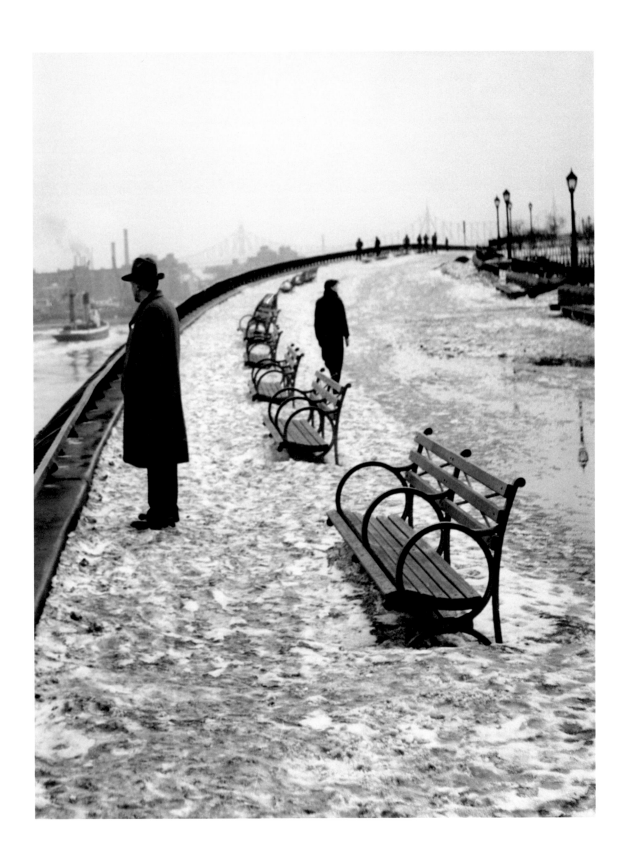

87 *River Walk of Carl Schurz Park, 1948*

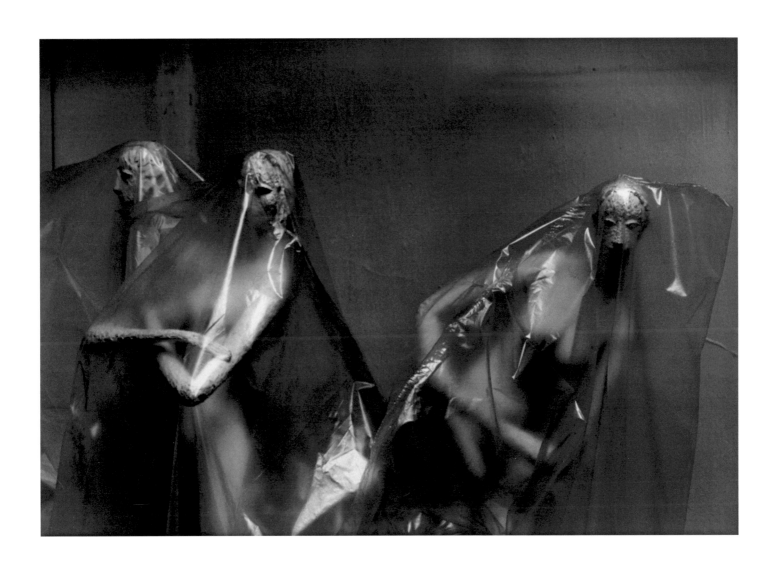

88 *Studio Corner of Miss Maxine Picard, 1956*

89 *Lafayette, Munson-Williams-Proctor Museum, 1961*

90 *MacDougal Alley, 1961*

91 *Washington Square, 1954*

92 *Billboard, 1959*

93 *Going for a Walk*, 1958

La Réunion, 1962–1985 Robert Gurbo

As I give up the slave work, I start again where I stopped before I stepped onto this sacred land. In the little time that I have left, I want to live according to my own taste, if possible. Or rather, to work according to my own style.[1] KERTÉSZ, NOVEMBER 1962

The year 1962 marked a period of profound change in André Kertész's professional and personal life. Frightened by his advancing age and frail health—he had been hospitalized in late 1961—and disappointed with his diminished role at *House and Garden,* Kertész quit his job in the fall of 1961.[2] Soon thereafter he resolved to use "the little time" he had left to "work according to my own style." Energized by his new freedom to work as he wished and by the recognition he received for several retrospective exhibitions in the early 1960s, he returned to his art with passionate conviction and dedication, exploring new subjects and investing old ones with newfound relevance and inspiration. But he also recognized that other factors were critical to his success and, with a zeal he had not demonstrated since leaving Paris, began the process of cultivating a circle of friends, collectors, dealers, curators, and photographers who could provide much-needed support, advice, inspiration, and opportunity. He also worked aggressively to produce exhibitions and publications of his photographs, and he gave extensive interviews to promote them. As he related the events of his life to a newly interested audience, he began to codify a personal history that not only minimized his missteps and shortcomings but also established him as a prescient modernist and pioneering photojournalist. For the first time in many years, Kertész's aspirations and activities matched those of his time: while he strove to rediscover and reassert his artistic achievements, vigorously and successfully consolidating his reputation as one of the century's most innovative and talented photographers, a younger generation of photographers, collectors, dealers, and curators sought both to know more about the history of the medium and to celebrate its modern masters.

Kertész's newfound professional and artistic vitality was bolstered in important ways by larger shifts in the photographic culture of the 1960s and especially the 1970s, when

interest in exhibitions of photographs and in photographic books exploded in the United States and produced a corresponding boom in the market for original prints.[3] A dramatic rise in both the economic and cultural value of photographs was spurred in part by a new appreciation of the photograph as an art object, by the institutionalization of a history of photography in universities and museums, and by a concomitant celebration of its early practitioners. Thus, while photographs were emerging as prized commodities in the marketplace, they were also increasingly understood as important documents in the history of the medium itself.

Capitalizing on the intensified interest in photography as well as on a growing nostalgia for imagery of Europe in more innocent times, Kertész found a receptive audience in the United States not only for his recent work but especially for the images he had created many years before in Hungary and in Paris. In this regard, Kertész was not alone; Brassaï, Jacques Henri Lartigue, Henri Cartier-Bresson, and other European photographers who came of age in the interwar years also saw their stars rise. But for Kertész, who—unlike his sometime colleague and competitor Brassaï—witnessed his artistic reputation all but vanish in the 1940s and 1950s, the recognition and accolades he finally received in the last two decades of his life were at once immensely gratifying and searingly bittersweet.

Today at the age of sixty-nine Kertész is once again available. Age does not matter. He can now free himself from that long period of alienation.[4] BRASSAÏ, 1963

On 13 January 1962, fifteen years to the day that he had signed his first contract with Condé Nast, the publisher of *House and Garden,* Kertész contacted his brother Jenő in Argentina.[5] Although they had kept in touch through sporadic letters, this conversation was the first time that they heard each other's voices in more than thirty years. Later that year he spent several weeks with Jenő and his family in Argentina. Embarking on a new phase of his life, Kertész clearly felt the need to reestablish contact with the man he had once acknowledged to be "his perfect collaborator" and whose support and advice had been critical to his artistic growth in Hungary.[6] And once again, Jenő provided Kertész with emotional sustenance, writing to him that the "pictures from New York in 1960 and 1961 are not only modern, but they would also play a significant role even at an avant-garde exhibition" and encouraging him to continue to independently pursue his art.[7]

Nevertheless, for Kertész, starting a new phase of his career at age sixty-eight entailed an arduous, self-searching process of evaluating work that spanned five decades. Making comprehensive lists of photographs taken in Paris, Hungary, and New York, one of which he titled, with quiet understatement, "Copy for Myself," Kertész reviewed all contact sheets and old prints, scouring for photographs whose merits he had neither the time nor opportunity to explore during the years he worked for *House and Garden.*[8] Perhaps in anticipation of exhibitions and publications, he had new prints made of many images from throughout his career. Printed uniformly, each new print could be judged on an equal footing with works he already recognized to be his classics. As Kertész reviewed his negatives and contact sheets and built his inventory, he also reviewed and grouped together photographs with similar themes. Throughout his career he had repeatedly photographed

carefree children, often at play; dramatically compressed buildings; solitary figures lost in the art of reading; and lonely figures amidst the urban landscape. Negatives depicting these and other subjects were printed, examined, categorized, grouped, regrouped, and boxed.[9] Although he worked intuitively, the act of photographing was for Kertész a process of fine-tuning his thoughts and ideas. Like any artist, once he had established his vocabulary, he was free to investigate in an unimpeded fashion the overarching questions that beckoned him to the camera. This process of reviewing and editing hundreds of photographs taken over a period of fifty years proved invaluable, for it helped him to heighten his instincts, revive latent ideas, clarify his photographic intentions and strengths, and, perhaps of greatest importance, reaffirm his confidence in his vision.

The process of organizing his artistic output of the past fifty years also aided Kertész in conceiving and shaping a retrospective exhibition of his work. Indeed, as he planned his reentry into the artistic community, Kertész accepted a long-standing offer from Nathan Resnick, a photographer and member of the Circle of Confusion, for a solo exhibition at Long Island University in the fall of 1962.[10] Although this was an important exhibition for him—his first solo show in more than fifteen years—the venue was a relatively safe choice. Located in Brooklyn, the exhibition space was modest, with thumbtacks used to attach works of art to walls that had been painted various colors from earlier shows.[11] In glass display cabinets, Kertész composed delicate still lifes with an array of small Hungarian contact prints and Parisian *carte postale* prints, interleaved over opened books, in order to create carefully arranged vignettes of his former lives. A small catalogue produced for the exhibition, which ran from 10 October through 9 November 1962, reveals that the show contained photographs made in his early years in Hungary as well as those made "only last month."[12]

At Long Island University, looking down from a building's window, he spied and captured a tableau that became one of his most celebrated photographs from the 1960s. *"Buy," Long Island University* (plate 100), 1962, shows a billboard depicting a perky young woman, with a frozen smile, and a six-pack of beer, coupled with the exhortation "Buy Bud." Much as he had done in Parisian images like *On the Boulevards* (plate 62), 1934, here he contrasted the upbeat and youthful rhetoric of the billboard to the disconsolate atmosphere of the street below, where a man, listless in the summer heat, leans on a stop sign for support. Highly critical of the commercialization of American society, Kertész in *"Buy," Long Island University,* created a powerful statement about the duplicitous nature of advertising and the darker side of American culture.[13] Although Kertész was never a political artist, his recent New York images, including those exhibited in the Long Island University show, revealed that he had become a keen observer who perceived the social realities of life in America.

Despite its relatively humble location, the exhibition garnered several positive reviews, including a laudatory *New York Times* article by Jacob Deschin, a fellow member of the Circle of Confusion.[14] Over the next several months, Kertész's name, so long absent, would begin to appear everywhere. An article in the January 1963 issue of *U.S. Camera* introduced him to a broad audience as a pioneering photojournalist and talented artist whose self-effacement had, in part, led to the years of relative obscurity.[15] Three months later, the Switzerland-based *Camera* published a portfolio of Kertész's photographs, prefaced by

Brassaï's article "My Friend André Kertész"; two months later, in conjunction with the *Camera* portfolio, Modernage Studio in New York mounted a small retrospective exhibition of Kertész's work.[16]

Romeo Martinez, the editor of *Camera,* was also instrumental in securing for Kertész a forty-two-work retrospective at the 1963 Venice Biennale, where, along with Morris Gordon and Arnold Newman, he was awarded a gold medal. With his confidence nurtured by the recent string of successes, Kertész, aided by Martinez and Jean Adhémar, curator of prints and drawings at the Bibliothèque Nationale, mounted an exhibition of his work in Paris, the city of his artistic flowering. Accompanied by a small catalogue with an introductory essay by Alix Gambier, the seventy-print exhibition at the Bibliothèque Nationale offered an expansive overview of a career that had spanned almost fifty years. In addition to prints from Hungary and Paris and copies of books and reportage from *Art et Médecine, L'Art Vivant,* and *Vu,* the exhibition featured twenty-two photographs taken in the past four years; of those, three had been taken in Paris only a few weeks before the opening. Such a display of talent did not go unnoticed. *Le Photographe, Les Nouvelles littéraires,* and *Le Monde* devoted lengthy articles to the exhibition and lavished praise on what one critic described as "the summation of a life dedicated to one art."[17]

This show and its positive reception bolstered Kertész's long-starved ego. In his extended absence from Paris, Brassaï and a much younger Henri Cartier-Bresson had eclipsed him. Although Kertész always claimed he had taught Brassaï how to photograph and had deeply influenced Cartier-Bresson, they were the artists widely recognized in Paris as the leading pioneers in twentieth-century photography; indeed Brassaï had held a retrospective exhibition at the Bibliothèque Nationale in May 1963, only six months before Kertész's exhibition at the same venue.[18] Kertész's Paris exhibition not only helped to reestablish his importance, but, of greater significance to him, it also revealed that he was the first to have explored the subjects and styles the two younger photographers had popularized.[19]

While in France, despite recurrent dizzy spells, Kertész energetically attempted to reinsert himself into Parisian life. During the two months he spent in Paris, he renewed friendships with old acquaintances and established new ones. He discussed book and exhibition proposals, including a book of New York photographs, and gave interviews. He also attempted to photograph Paris once again, in the hopes of publishing a modern sequel to *Paris Vu par André Kertész* and *Day of Paris.*[20] Applying the same professionalism to this project that he had to earlier photo-essays, he approached the act of photographing Paris as if it were an assignment, describing it in his date book as "work."[21] He took down the names of people he photographed, noted the specific dates of negatives made, and jotted down notes: "Beatniks at Notre Dame"; "Morning in Luxembourg"; "Young Girl with nun"; "Invalid feeding pigeons."[22] His long emotional and artistic separation from Paris had finally come to an end as, camera in hand, he immersed himself in the city he identified as his true home. He recorded in his date book that he photographed in a profound state of absorption: "worked [in] Montmartre and after that like in a trance."[23]

Although in Paris Kertész was drawn to the specific sites and qualities he had so lovingly photographed years before, he did not try to capture the city that he had left behind over twenty-five years ago, nor did he seek to show how it had changed. Instead, he wanted to

show the city "the way I see it today."[24] Thus although his image of a young man reading on the quai of the Seine (figure 1) recalls the poetry of marginality Kertész first explored in *Siesta* (plate 57), the image also registers how Kertész's eye, honed by years of photographing the distinctive urban environment of New York, witnessed the French capital in new ways. The earlier photograph explores the ragtag community of the dispossessed who forged a life along the riverbanks. The later image, tightly composed with large slabs of trees framing and encapsulating a seated figure who is oblivious to his surroundings, offers a poignant vision of a quiet moment of contemplation as haven from the bustling urban environment. It is an image of Paris as seen through the lens of a longtime—albeit unwilling—New Yorker.

Returning to the site of one of his most celebrated photographs, *Stairs, Montmartre* (plate 38), 1926, Kertész in *Montmartre* (figure 2), 1963, reveled in the play of light and shadows across the glistening, rain-soaked stairs, the crumbling beauty of the nineteenth-century buildings, and the lush tangle of ivy overtaking a brick wall. But whereas the 1926 photograph derives its strength and interest primarily from the mysterious beauty of shadows as they crisscross the expanse of stairs, in the 1963 photograph Kertész embraced the Parisian atmosphere of the rain-swept city to which he had so longingly dreamed of returning. Although he is closely attuned to the two lonely individuals who wearily mount the steep and seemingly endless stairs, it is an empathetic gesture of solidarity with his fellow Parisians on their daily journey.

Energized by his contact with the city of his artistic flowering and the reestablishment of ties to an artistic past that had been rent apart by years of frustration and neglect, Kertész resolved to take care of long unfinished business. When he left Paris in 1936, he had entrusted his negatives and papers to Jacqueline Paouillac, a journalist and friend, who had agreed to make his photographs accessible to European publishers while he was in America. The outbreak of World War II, the subsequent deportation of her husband, and her relocation to the south of France interfered with this plan. Although Kertész had visited her during his 1948 trip to France, for unexplained reasons he had not reclaimed the material at that time.[25] In 1963 he tried to contact her again, coincidentally at the same time that she, on reading of the success of his exhibition at the Bibliothèque Nationale, wrote him a letter in care of a Parisian newspaper.[26] When they met again in December, she recounted to him how the negatives and documents had, remarkably, narrowly escaped destruction a number of times during the war and were still in her care.[27] Early on she had stored them in Paris in her basement, under the stairs, along with an archive of her own writings. In the spring of 1940 she moved to the country and took the heavy, fragile glass plate negatives and other materials with her, incrementally and surreptitiously in order to avoid detection by the authorities. She was fearful that the Nazis would have considered Kertész's negatives "degenerate" and that their discovery could easily have resulted in her arrest.[28] Paouillac eventually became a farmer in La Réunion, a small village near Casteljaloux in Lot-et-Garonne, south of the Dordogne, where the crated negatives were hidden in a small, ditchlike space between two buildings that had been built for irrigation purposes.[29]

Inexplicably, the negatives were still underground when Kertész arrived on 4 December 1963 to reclaim them. Inspired, he took the opportunity to commemorate this high point in his personal history by creating a small documentary entitled "La Réunion."[30] He

1.
André Kertész, *Paris*, 1963, gelatin
silver print, Kertész Foundation

2.
André Kertész, *Montmartre*,
1963, gelatin silver print, Kertész
Foundation

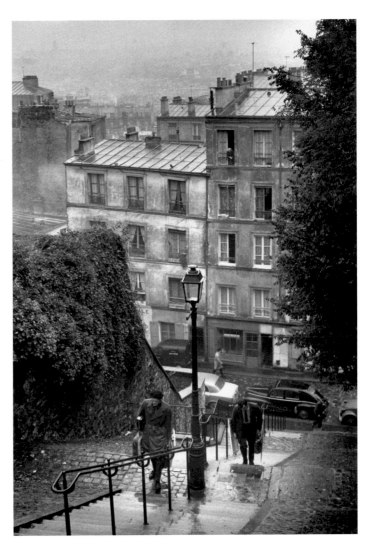

2

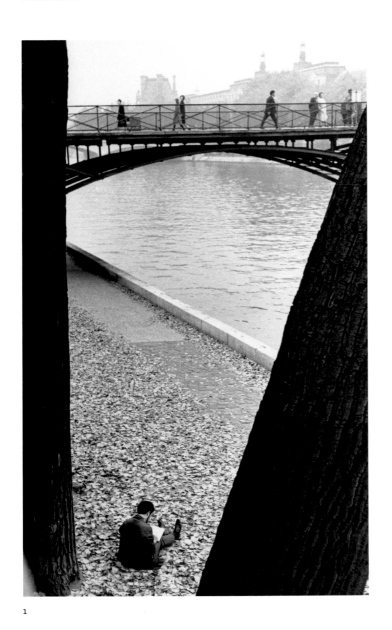

1

approached this intimate essay like a true photojournalist, letting the pictures tell the story. Setting his camera on a tripod and using his self-timer, he photographed himself standing next to a car, talking to Paouillac. He recorded the damage inflicted on her home during the war and showed the ditchlike space where the negatives and memorabilia had been stored. Next he photographed the removal of the chest from the dense overgrowth of its longtime home and then, the opened suitcase, with its neat rows of glass plate negatives, many but not all of which were broken (figure 3).

Shipping the materials to New York proved to be complicated; they did not arrive until July 1964. Finally reunited with his negatives, Kertész now had the opportunity to bridge the three major periods of his work—Hungary, Paris, and New York—and to merge the past with the present in order to fashion his future. He was now able to make enlargements of negatives made in Hungary and Paris, many for the first time. During this process, he also honed images by cropping them, making incremental adjustments in order to enhance the emotional emphasis and strengthen the geometric design. With some, he created entirely new works. To remake *Swimmer*, 1919 (figure 4), for example, he severely cropped and inverted the original photograph (figure 5). Noting he had limited finances and little access to an enlarger while living in Hungary, he claimed this presentation was how he had originally envisioned the image.[31]

Ever curious and innovative, Kertész even found virtue in a glass plate negative that had cracked from the harsh conditions of wartime storage. The original photograph of an ordinary Parisian cityscape had been created to test a new lens.[32] When printed, however, the cracks created the effect of a bullet hole in a window (plate 94). Whereas another

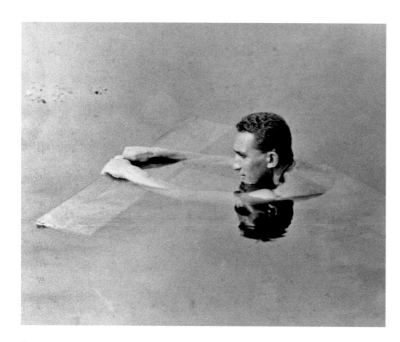

4.
André Kertész, *Swimmer*, 1919, gelatin silver print, Kertész Foundation

5.
André Kertész, *Swimmer*, 1919, gelatin silver print, 1960s, Kertész Foundation

photographer might have discarded the compromised negative, he embraced it, allowing this fractured and seemingly negligible glass plate to blossom into an entirely new work, rich with meaning and melancholy. The broken window, which actually never existed, convincingly dominates the photograph and further separates both Kertész and the viewer from the past, while the unchanged city, like his memory, recedes into the background. As his past is viewed through the veil of the broken window, Kertész seems to suggest with this shattered image that the Paris of his youth had become a dream forever separated from the reality of his present life.

Let me say only that it is great what you have accomplished and what is happening to you now. There is no more that…one can achieve in a life.[33] ELIZABETH KERTÉSZ, 1963

6.
André Kertész, *Elizabeth Kertész and Frank Tamas,* 1962, gelatin silver print, Kertész Foundation

The bittersweet nature of Kertész's hard-won triumph in Paris was underscored by both health and personal problems, particularly by tensions with Elizabeth. While the couple's relationship had always been complicated, it became more complex in the late 1950s and early 1960s. Elizabeth was forced to devote more time to running her business after her close friend and business partner Frank Tamas (figure 6) suffered serious medical problems, including severe vision loss.[34] Citing Tamas' needs, for he, too, absorbed much of her time and energy, she declined to join Kertész in his joyful reunion with Jenő and his family in Argentina in June 1962. Even more painful was the fact that, although she traveled with him to Paris in the fall of 1963, she returned early to the United States and did not attend his opening at the Bibliothèque Nationale.[35]

Her absence did not, however, mean that she was uninvolved in Kertész's career. On the contrary, she often incited him to action designed to secure success and recognition. For example, in letters she sent to him in Paris, she tried to instill in him some of her hard-won business acumen. Recognizing that Kertész was not adept at promoting himself, she admonished him to "learn from me."[36] She criticized his poor handling of the American publicity for the Parisian exhibition, telling him, "I'm convinced that if you had sent invitations to many places here in the U.S. you would have had reviews."[37] She sent him names and addresses of people, such as Deschin, and publications, such as *Vogue,* to whom he should send press releases, and she informed members of the Circle of Confusion of his success. She even suggested to Kertész other venues throughout Europe for the exhibition.[38] Alone in New York, Elizabeth found that her brief but convivial time in Paris had sparked a deep nostalgia and thrown into sharp relief how difficult their lives in New York had been. Just as she had issued an ultimatum to Kertész in 1924 to leave Budapest and establish a life for himself, now she instructed, "Go and see everyone—try to make a new career in Paris and then we will go over and live there…. I only see now how ugly it is [in New York] and how much I dislike it."[39]

The complex and changing nature of their relationship is alluded to in the reinterpretations that Kertész made of a portrait of himself and Elizabeth (plate 73). Soon after he made the exposure in 1933, he clearly saw it as enticing raw material, for he made several prints at that time, cropping the negative in different ways in each one (figures 7, 8). However, the earliest surviving print of the most famous and most severe crop—in which he revealed only half of Elizabeth's face and only his hand on her shoulder—dates to

7.
André Kertész, *Elizabeth and I*,
1933, gelatin silver print, 1960s,
Kertész Foundation

8.
André Kertész, *Elizabeth and I*,
1933, gelatin silver print, 1960s,
Kertész Foundation

9.
André Kertész, *Elizabeth and I*,
1933, gelatin silver print, 1964,
Kertész Foundation

7

8

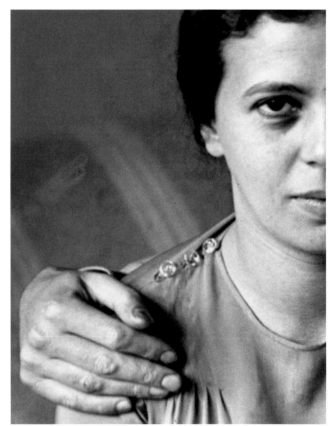

9

10.
André Kertész, *Hazy Day*, 1920,
gelatin silver print, 1960s, Kertész
Foundation

11.
André Kertész, *John Szarkowski*,
1963, gelatin silver print, Kertész
Foundation

1964 (figure 9).[40] Kertész explained that for him this cropped version "bears the connotation of the Hungarian word for a wife, 'feleség.' This would correspond with the English words 'better half.'"[41] Searching for understanding of his relationship to Elizabeth, he continued to reinterpret this negative and fashion fresh incarnations even after her death in 1977 (see figure 16).

The many reinterpretations of older negatives Kertész made during the 1960s function in multiple ways: as a reflection of the artist's searching desire to understand his personal history, as a sign of his intense curiosity concerning the possibilities of photographic form, and as witness to his prescient modernism. Older images reworked to conform to contemporary trends in photography, his reinterpreted prints served to demonstrate his innate avant-gardism. For instance, his decision to crop and invert *Swimmer*, 1919 (see figures 4, 5), transformed the original image of Jenő grasping a plank of wood into an audaciously experimental work that reverses the expected relation between an object and its reflection. In other works, such as the enlarged and cropped version of *Hazy Day*, 1920 (figure 10), the grainy structure and the inclusion of only light hues of gray become an integral part of the work's new interpretation and also serve to mask its roots in pictorial photography.[42] Always published with the original date—that is, the date the negative was made—these prints were meant to fortify Kertész's claims of his incipient modernism and to demonstrate his innate sensitivity toward the possibilities of photographic form.

In this regard, he was aided and abetted by a figure who would soon become one of the most powerful critics and tastemakers in American photography, John Szarkowski (figure 11). Appointed as curator of photography at MOMA in 1962, Szarkowski immediately began dismantling the legacy left by Edward Steichen, who had reigned as curator since 1947. Populist, broadly inclusive, and occasionally bombastic, the exhibitions mounted by Steichen at MOMA, including *The Road to Victory* (1942), for which he was guest curator,

and *The Family of Man* (1955), championed the universal, humanistic potential of photography as both social document and rhetorical device. In contrast to Steichen's sociological and popular approach to photography, Szarkowksi understood photographic history as the product of a dynamic interchange between the exploration of the aesthetics of the photographic medium and the exploitation of its technological possibilities. This concept shaped one of the earliest exhibitions Szarkowski mounted at MOMA, *The Photographer's Eye*. It opened in May 1964 and included several works by Kertész—nine according to a draft of the checklist at MOMA, though only six were included in the catalogue. It was also the first time he had been shown at MOMA since *The Image of Freedom* exhibition, which opened in 1941. *The Photographer's Eye,* juxtaposing the work of established figures like Henri Cartier-Bresson and Edward Weston with the work of anonymous nineteenth- and early twentieth-century photographers, presented photography as a vernacular art in which the "fine art tradition" and the "functional" tradition were "intimately interdependent aspects of a single history."[43]

The amateur photographer played a central role in Szarkowski's evolving theoretical and curatorial investigation of photographic form. Of Jacques Henri Lartigue, the "child wonder" whose first solo exhibition in the United States was presented at MOMA in July 1963, Szarkowski wrote that the amateur photograph was not "the product of a conscious concern with formal values" but rather served as a powerful expression of the characteristics that were basic to the medium itself.[44] And in *Five Unrelated Photographers,* which was held at almost the same time as the Lartigue exhibition, Szarkowski championed the "snapshot" aesthetic of Garry Winogrand, later describing it as a powerful expression of "stripped, essential camera vision."[45] By no means did Szarkowski esteem all amateur or untrained photographers; to the contrary, only those practitioners whose work revealed a coherent, "photographic" mode of seeing were worthy of interest.[46]

As a self-styled amateur whose images nevertheless revealed an inherent formal sophistication, Kertész dovetailed neatly with Szarkowski's understanding of photographic achievement. In November 1964, Szarkowski mounted a retrospective exhibition of Kertész's photographs that included approximately seventy works uniformly printed from negatives supplied by Kertész. Although the exhibition featured some of his most audaciously modern images, including *Mondrian's Studio,* 1926, and a cropped print of *Underwater Swimmer, Esztergom,* 1917 (plates 49, 16), it also included one of his earliest works, *Sleeping Boy* (plate 2), 1912, as well as recent New York photographs.[47]

The catalogue to the exhibition comprised fifty-five reproductions and a concise essay by Szarkowski that presented Kertész as a naturally gifted photographer who had possessed from the start "an intuitive understanding of the realism of the camera—of its ability to imprison the telling detail, the convincing texture, the climactic moment."[48] Importantly, the essay also offered an explanation for Kertész's eclipse in the United States that not only justified the photographer's disillusionment with his experiences in America but also secured his reputation as an authentic artist, incapable of being swayed by the commercial demands of the magazine world. While some photographers would have molded their talents to suit the new conditions of production that he faced upon arrival in the United States, Kertész, Szarkowksi wrote, "is a different kind of man," one whose "very versatility, the variety of experience that has charmed him, his unquestioning acceptance of life,

have produced an art which is centrifugal, unpredictable and romantic."[49] These qualities had little appeal in the commercial world of American magazine photography but were, for Szarkowski, valuable aspects of much modern photography. Szarkowski's closing assessment of Kertész's pictures cast them not only as fresh enough to seem "the work of a greatly gifted beginner discovering for the first time the beauty of photography," but also as betraying the "economy and ease" that is the hallmark of a master. Such a judgment was immensely gratifying to Kertész's ego, for it reinforced the artistic reputation that Kertész had acquired in Paris, gradually lost after his move to New York, and was slowly, but with increasing boldness, constructing anew in the 1960s.

Amateur period? I regard myself as an amateur today, and I hope that's what I will stay until the end of my life. Because I'm forever a beginner who discovers the world again and again.[50] KERTÉSZ, 1963

While Kertész directly benefited from Szarkowski's interests in the vernacular and amateur traditions in photography, his work also began to find broad favor with an American audience increasingly fascinated with European photography of the period preceding World War II. In their seemingly unmediated images of Parisian life, with its flea markets and street fairs, its rivers and quais, and its dance halls and dandies, Kertész, Brassaï, Cartier-Bresson, and Lartigue offered to American audiences in the 1960s what Szarkowski identified as "the persuasive charm of a vanished world."[51] From Kertész's exuberant children watching the *guignol* (a Punch and Judy style puppet show) to Brassaï's "seamy, picturesque, and completely unpretentious" images of Parisian nightlife, the quixotic and often humorous images of a seemingly lost way of life appealed to viewers living in an era marked by fears of Communism and nuclear holocaust, civil unrest and racial tensions, and proliferating urban blight, as well as by the often disorienting transformations in traditional modes of communication.[52] Even Kertész's images of people reading—an increasingly quaint activity in a televised world—evoked affectionate nostalgia.[53]

Joined with this interest in the subject matter of Belle Epoque and prewar France was a growing fascination with the spontaneous aesthetic of 1920s and 1930s photography that was made possible by the development of highly portable, handheld cameras like the Leica. The seemingly intuitive and uncontrived imagery of Kertész, Lartigue, Cartier-Bresson, and others was not only appealing in its rhetoric of immediacy and authenticity but could also be understood as the historical precursor to the casual snapshot aesthetic favored by contemporary photographers like Robert Frank, Winogrand, and Diane Arbus.[54] Even a lack of technical finesse became, in the right hands, a virtue. Of MOMA's 1968 exhibition of Brassaï's photographs from the 1930s, which one critic described as looking "as though the photographer had slept in them," the willingness to accept technical imperfections was understood as the fair price for candidness and spontaneity.[55] For Kertész, who had always denigrated as artificial and lifeless the technical perfection represented by the work of the f.64 group, which was highly influential on American photography in the 1940s, the growing critical and popular appreciation for the casual and the lyric aspects of small camera photography was surely gratifying.[56]

Perhaps in recognition of this growing fascination with the spontaneous and candid aspects of amateur and documentary photography, Kertész attempted to affirm his primacy in both. At the same time, he insisted that he did not *merely* document, but rather interpreted what he felt through the act of photography.[57] In a 1964 *Popular Photography* article entitled "André Kertész: Rebirth of an 'Eternal Amateur,'" Kertész told Jacob Deschin that he strove "to give meaning to everything about me with my camera, to make photographs as by reflection in a mirror, unmanipulated and direct as in life…in short, to photograph only what I see, with both personal and technical integrity." In the same article, Kertész related how he first became aware of photography's possibilities while leafing through the illustrated pages of old magazines in the attic of his home. Like the child prodigy Lartigue, who had received exceptional attention following his 1963 show at MOMA, Kertész began to present himself as an intuitive, natural photographer, a "born amateur" who had developed a kind of photographic imagination long before he ever held a camera. Kertész may have directly appropriated Lartigue's story of using his mind's eye, or his "eye-trap" as he referred to it, at age six to pretend to take photographs before he owned a camera, or Lartigue's recollections may have jarred Kertész's own childhood memories; in any case, Kertész recognized that this anecdote enabled him to suggest that his style had sprung fully developed with no outside influences; from then on, it became an established part of Kertész's self-construction.[58]

The enhanced attention both to the role of the amateur and to 1920s and 1930s photography that had prompted Kertész to assert his artistic originality and precedence also encouraged him to shape his biography accordingly. Competitive and acutely sensitive of his artistic legacy, Kertész began retelling the stories of his life, refining them almost into sound bites, and at times conflating two events into one in order to illustrate a point. Omitting failures, he redirected blame and rearranged facts in the creation of a more flattering and marketable curriculum vitae. Overlooking his rich interactions with artists in Hungary and the strong influence of the Hungarian illustrated press on his early work, he, like Lartigue, emphasized that he was a self-taught amateur whose passion alone fueled his creativity. As his story evolved throughout the 1960s and early 1970s, he further minimized or entirely omitted the influence that Tihanyi and other Hungarian painters had had on his art in Paris in the 1920s and, no doubt because of Mondrian's fame, overemphasized his closeness to the Dutch modernist. He also made no mention of his precarious professional standing, his financial troubles, or his increasing sense of isolation and loneliness in Paris in the 1930s. His brief marriage to Rozsi Klein was entirely erased from his public accounts, as were his failed plans to become a fashion photographer in America. Instead, he steadfastly insisted that he had been tricked into coming to the United States by Keystone; that he had had no idea they wanted him to work in a studio; and that he and Elizabeth had only intended to stay for a "one year sabbatical," even though Elizabeth's plans to open a business certainly indicate that they planned to stay permanently. Still overwhelmed by a sense of loss and failure, Kertész clearly felt the need to justify the "forgotten" years he had spent at Condé Nast.[59]

Similarly, Kertész's complicated relationship with Brassaï became codified into a history of betrayal (figure 12). Although the exchange of warm letters and visits suggests the two shared a friendly, if not intimate, relationship up to the early 1970s, a rupture occurred

soon thereafter that not only ended the friendship, but appeared to rescript its history as well. When asked about Brassaï, Kertész maintained that he taught Brassaï how to photograph; introduced him to night photography, for which Brassaï subsequently became famous; and lent him the necessary equipment, including his first camera. Kertész even went so far as to claim that Brassaï's photographs were imitations of his own: "I gave him a crash course on night photography: what to do, how to do it, and how long the exposures had to be. Later, he started to copy my style in night photography and that, more or less, was the type of work he did for the rest of his life."[60] And, according to Romeo Martinez, Kertész had been offered the book *Paris de Nuit* first, and had refused because the conditions did not suit him.[61]

Brassaï, however, offered another account of their relationship. Although in his flattering 1963 article "My Friend André Kertész," he acknowledged that he was introduced to photography by Kertész, Brassaï later downplayed Kertész's role, claiming that while the latter offered him "some advice," Brassaï never borrowed his camera; moreover, he maintained that his night photographs were entirely the product of his own natural inclinations toward the nocturnal and the demimonde.[62] Acutely conscious of the perceived similarity between their work and of Brassaï's successful career in the 1940s and 1950s, a period when Kertész felt as if he had been "buried alive," Kertész surely must have been stung by Brassaï's refusal to acknowledge the importance of his role.[63] Yet according to Brassaï, it was he who first convinced Romeo Martinez to publish a profile on Kertész in the April 1963 issue of *Camera,* an event that Brassaï described as a "turning point in Kertész's life and career, as he himself has proved by the numerous letters of thanks he wrote to me."[64] Brassaï claimed that Kertész, "succumbing to an odd jealousy," even refused to attend the opening of his show *Secret Paris* in 1976.[65]

While the exact nature of their early working relationship will never be known, Kertész as he grew older tenaciously clung to a version of events that cast himself as a victim. Of course, Kertész was hardly the first photographer to bend the facts to suit his story. Indeed, for a medium so rooted in depicting reality, photography has a rich history of biographical adjustment and fabrication. As with other artists like Man Ray and Arshile Gorky, name changes were common; mythology and historical fact were often interchangeable. Kertész knew that the Hungarian photographer Martin Munkacsi had changed his name—he was born either Mermelstein or Marmorstein—and he may also have been aware that Munkacsi told and retold his story in so many different ways that even his daughter did not know truth from fiction.[66] While living in Paris, Kertész had also seen how Andrei Friedmann had had the genius to reinvent himself as the agent of the fictitious Robert Capa, a supposedly gifted photographer who was too busy to meet with clients. Even when Capa was discovered to be Friedmann, he kept the name because he had succeeded in creating a market for himself.[67] In addition, Kertész learned from Capa's example that retooling his autobiography would help to foster his career in an increasingly competitive and growing art market. As the years passed, Kertész stuck to his re-created histories, for the modified and enhanced stories had evolved into a comforting and necessary new "truth." They were how he himself began to remember his life and how he wanted his life to be remembered by others.

12.
André Kertész, *Brassaï*, 1963, gelatin silver print, Kertész Foundation

It is true that Kertész retreats to give way to his object, but not into anonymity.
His presence can be intensively felt in all his pictures.[68] ANNA FÁROVÁ, 1966

By the mid-1960s Kertész was no longer, as he once lamented to Brassaï, "a dead man."[69] Propelled by the successes of his exhibitions in Venice, Paris, and New York, Kertész began actively planning several publications, including a book of New York photographs, which inspired a significant increase in both the volume and intensity of his photography. In *MacDougal Alley,* a 1961 view of New York on a snowy evening, he recorded the city softly illuminated by the lights of apartments (plate 90). Whereas once he had depicted New York as filled with impersonal monolithic structures, in this image he saw it as an intimate small town, closer in spirit to the Budapest of his youth or the Paris of his adulthood. With a newfound agility, in *Washington Square,* 1968, he captured a disparate group of people— a couple walking, children playing, a man exuberantly jumping—intertwined by a delicate but complex web of branches (plate 105). In other more complicated images, he continued to explore a sense of isolation and dislocation within the urban environment. *The White Horse,* 1962, depicts two separate worlds: a small city garden graced with an ornamental white carousel horse, and the street outside, where a partially obscured woman (only her legs are visible through the branches of a tree) is pulled along by her dog, whose nose is to the ground (plate 96). The gaiety and lightness of the horse contrast sharply with the threatening, wolflike mien of the dog, a creature transmogrified by the late afternoon shadows. The emphatic line of the fence, it seems, will forever protect the secret beauty hidden within. Other photographs reveal Kertész's keen eye for poetic detail. For example, in *MacDougal Alley* (plate 101), 1962, a small puddle photographed next to a dense pattern of rooftops and chimneys becomes a glistening river. Created with assurance and conviction, these mature and complex photographs reveal that Kertész's timing, precision, and vision were back in full force. By the time these and other New York photographs were published in *Of New York* (1976), Kertész—who had long considered himself an outsider in New York—was lauded as one of its most sensitive interpreters. As one critic put it in 1979, "New York has learned to see itself from where Kertész now stands.... His wryness, his romanticism, his visual cadences…have long since fused into a way of looking at New York, a vision of this city which has begun to shape the work of other of its celebrators."[70]

Kertész's next step was finding venues for the sale and publication of his growing corpus of imagery. In this endeavor he was aided by Cornell Capa (Kornel Friedmann), the younger brother of the late Robert Capa, who introduced him in 1966 to a darkroom technician, Igor Bakht, who became Kertész's primary printer for the rest of the photographer's life.[71] As Kertész oversaw the production of each print, Bakht grew extremely sensitive to his style, and they established a strong professional relationship. No longer did Kertész have to search from lab to lab to find a technician who understood his pictorial language and responded to his needs, for he had finally found a printer who did "exactly what I would do."[72]

Capa supported Kertész in other ways as well. In 1964 he offered Kertész a coveted invitation to join the ranks of Magnum Photos, Inc. as an honorary member. More important, in 1967 he included Kertész in the first exhibition organized by the International Fund for Concerned Photography, an organization founded by Capa and dedicated to the commemoration and perpetuation of the work and traditions of his deceased brother and

three other photographers, each of whom had also died in pursuit of professional duty and devotion to a cause.[73] Capa described the group's first exhibition, *The Concerned Photographer* at the Riverside Museum in New York, as "six one man shows which stressed the importance of the individual" and demonstrated each photographer's "personal contribution to history and art."[74] The exhibitors were Werner Bishof, Robert Capa, Leonard Freed, David Seymour (Chim), Dan Weiner, and André Kertész. The show, which traveled to Tokyo, Paris, London, and many other cities, was an overwhelming success. Garnering rave reviews and attracting more than thirty-seven thousand visitors, *The Concerned Photographer* introduced Kertész to a worldwide audience. Kertész attended the opening in Tokyo and was enchanted to discover that he had a personal following in Japan.[75] "The occasion was a personal triumph for Kertész," Capa recalled. "The public stood in line for his signature on catalogs."[76]

The accompanying publication emphasized the individual vision of each photographer by devoting separate sections to each artist with carefully sequenced reproductions of the work. It was widely celebrated and praised as the first time photojournalists were given prominence and serious historical consideration in a publication in the United States. But despite the acclaim of *The Concerned Photographer,* major cost overruns resulted in financial deficits. Capa later recalled: "Making what was then a brave decision, we determined to sell original prints to cover our deficit. Kertész alone (whose famous *Chez Mondrian* was the most expensive print offered) brought in half of the deficit, and saved the day."[77]

In the 1960s, however, commercial sales of photographic prints were still limited. Determined to sustain his professional renaissance, Kertész had since 1961 focused his energies on the one arena in which he had always found success: books. His first project, *André Kertész,* was a small-format publication with finely reproduced images from throughout his entire career. Featuring a short introduction by Anna Fárová, the book was published in 1966 by Paragraphic Books, a division of Grossman Publishers. This project was the beginning of a productive relationship with Richard Grossman, who with Bryan Holmes of Studio Books (a division of Viking Press) had published the handsome volume *Diary of a Century* by Lartigue.[78]

At the end of 1971 Grossman released *On Reading,* a small-format book with a series of Kertész's intimate photographs of people reading. Depicting people of all walks of life in a multitude of settings from 1912 through 1970, the book attracted a wide audience, well beyond those interested only in photography. Kertész himself derived great satisfaction from this inexpensive and accessible volume, and it was widely praised in the press.[79]

In the early 1970s, Grossman Publishers was absorbed by Viking Press, where Kertész worked closely with Nicolas Ducrot, the assistant director of Studio Books of Viking Press. The son of Jean A. Ducrot, a Parisian photojournalist Kertész had known in the 1920s and 1930s, Nicolas Ducrot was passionate about Kertész's photographs and eager to establish his own credentials as a designer and editor.[80] Over the next several years, he and Kertész developed an intimate professional and personal relationship. While Ducrot worked closely with Kertész on the production of his books, Kertész was deeply dependent on Ducrot's support and judgment, echoing the relationship that Kertész had developed with publishers and editors like Lucien Vogel. Their first collaboration resulted in *André Kertész: Sixty*

Years of Photography, 1912–1972, which was released at about the same time that a retrospective exhibition of Kertész's photographs opened at the Hallmark Gallery in New York. While Ducrot aided Kertész in the selection of the images, including many previously unpublished works, Kertész maintained strict control over the quality of the finished proofs, making sure that they accurately reflected the subtle tonal range of his originals.[81] With high quality reproductions printed by the renowned Braun of France, the publication received enthusiastic reviews and the French edition (published by Editions du Chêne) won the coveted Prix Nadar. In an interview given at the time, Ducrot referred to the publication, as "his" book, one that represented both his and Kertész's "most cherished professional achievement—in a way, their life's work."[82] Brendan Gill, a colleague of Ducrot's, wrote one of the many positive reviews in the *New Yorker:* "Among the greatest of living photographers, Kertész is perhaps first among his peers for the intellectual power that informs his work. Each of his pictures is dominated by a strong idea, which he has taken care to purge of the least taint of melodrama."[83] One journalist, noting that Kertész's work was never published in *Life,* remarked on the ironic twist of fate that this book was released within a few weeks of the magazine's demise.[84]

The timing was more than coincidental. In the early 1970s, as television began to supersede still photography as the dominant medium of visual communication in the world of journalism, the cultural and economic influence of the great picture magazines began to decline. *Life* was not the only victim of this transformation; *Look* folded in 1971, and before it, *Collier's, Coronet, American Weekly,* and the *Saturday Evening Post* had shut their doors.[85] While the heyday of the great picture magazines was over, photography had by no means lost its appeal to American audiences. Released from the commercial and stylistic constraints of journalism, the photograph itself was increasingly viewed as an object that possessed artistic and intellectual value apart from its role in witnessing history. The new value placed on the photograph as a work of art formed part of a larger interest in photography in American culture, most clearly demonstrated in the increasing number of exhibitions devoted to photography and the development of academic and commercial institutions for the study and diffusion of photographs.[86] While museums across the country began to develop or expand collections of photography, commercial galleries devoted specifically to the medium began to sprout up in major U.S. cities, including Witkin Gallery in New York, which opened its doors in 1969 and carried some of Kertész's work in 1970, as well as the Siembab Gallery in Boston, Tom Halsted outside of Detroit, Helen Johnston at Focus Gallery in San Francisco, and David Mancini's Photopia in Philadelphia.[87] In 1971 George Rinhart began dealing privately, Castelli Graphics in New York started to represent several leading photographers, and LIGHT Gallery was founded by Tennyson and Fern Schad, with Harold Jones as its first director. Despite Witkin's early dominance in New York, LIGHT Gallery rapidly changed the contemporary photography market, as it was exclusively devoted to twentieth-century photography. It soon attracted many contemporary photographers, including Wynn Bullock, Harry Callahan, Emmet Gowin, Aaron Siskind, Frederick Sommer, Jerry Uelsmann, and Kertész, whose first exhibition there opened in September 1973. That same year, LIGHT produced two portfolios of Kertész's most popular photographs and sold individual prints of his work. According to former LIGHT director Charles Traub, Kertész's photographs became a major source of the "gallery's bread and butter." And LIGHT, in turn, "produced a steady stream of income for André through sales of individual prints…and from the sales of his portfolios."[88]

While the first portfolio included some of Kertész's most famous images from Hungary and Paris, including *Underwater Swimmer, Esztergom; Chez Mondrian;* and *Satiric Dancer* (plates 16, 50, 47), the second portfolio offered more recent work, including the startlingly bleak *Broken Bench* (plate 97), 1962, made on a trip to visit an acquaintance in a sanatorium, and the brooding *Martinique* (plate 106), 1972, made during a vacation that André and Elizabeth took in the Caribbean. This photograph, taken on New Year's Day 1972, shows the silhouette of a man, seen through a frosted glass partition, leaning on a railing and gazing out to the dark and seemingly impenetrable ocean. Composed of large rectilinear shapes—the glass partition, the horizon, and the railing—and subtle gradations of tone, this forlorn image communicates a sense of isolation and aloneness. Throughout his career, Kertész had often recorded isolated individuals, usually men, in the urban landscape; for example, he had depicted a lone street sweeper in *Esztergom* (plate 13), 1917. Whereas he had allowed the poetry of the place and the formal strength of his compositions to infuse such early photographs with a visual lyricism, in *Martinique* the harsh, tight geometry only further increased the despondent nature of the subject.

Kertész was so skillful at transforming the man into a symbol for himself that many viewers assume that *Martinique* is a literal self-portrait. Indeed, like the solitary figure in *Martinique,* Kertész brooded about his future: although he had begun to achieve considerable success, he was no longer youthful and he and Elizabeth were increasingly beset with health problems. Furthermore, as Kertész became more of a celebrity, his relationship with Elizabeth became more complex and fraught. Their complicated interaction is alluded to in his photograph *Mauna Kea* (plate 107), 1974, a study of Elizabeth seated at a table on a balcony. Kertész presented her as deeply involved with her writing: her arm and hand, raised to shield her eyes from the sun, also actively separate her from his gaze. Kertész symbolically underscored this distance as well as their connection by capturing their shadows intertwined on the wall.

Kertész brings a lover's eye to his encounters with the world.[89] HILTON KRAMER, 1974

By the mid-1970s, a succession of high quality books, exhibitions, and portfolios made Kertész a rising star in the photography world. Thanks to the growing network of independent galleries, he exhibited and sold prints around the world, as major museums, collectors, and investors acquired his photographs. Starting in the late 1970s, vintage prints became especially prized commodities in the market for photographs. Of these, Kertész's vintage prints were among the most sought after and often commanded steep prices. As his fame increased, he also received numerous invitations to exhibit, lecture, and publish. In 1975 Kertész was the guest of honor at the Rencontres Internationales de la Photographie in Arles, and in 1976 he was appointed Commander of the Order of Arts and Letters by the French government. That same year, the British Broadcasting Company (BBC) and the Canadian Broadcasting Corporation filmed interviews for documentaries on Kertész. He had also succeeded in earning enough money to become independently wealthy. The years of failure and compromise had finally come to an end. His extraordinary success more than met Elizabeth's 1963 challenge to "try to make a new career."

Yet 1976 would also prove to be a year of extreme trial, as major health problems began to dominate their lives. In March, Kertész was rushed to the hospital for a life-threatening thrombosis, diagnosed as phlebitis in his left leg. Although he was in and out of the hospital several times in 1976, he eventually recovered. Elizabeth, however, came down with what was originally thought to be a bad cold, but was eventually diagnosed as lung cancer.[90] She struggled with the disease for the next eighteen months while Kertész devoted himself to caring for her.

Most of his pictures from this period are imbued with both sadness and tenderness. In an affectionate 1977 photograph of the terrace of their apartment at 2 Fifth Avenue, New York, where they had spent many summer evenings, he depicted a favorite chair quietly reconfigured by a blanket of snow, its lush texture marking her absence (figure 13). In another work from 1977 he underscored his "new aloneness" by capturing a couple together on the snow-covered street below, where even the tire tracks insist on being paired (plate 104). In still another, birds in flight and shadows of trees on a nearby building are vividly presented in the fall light—dreamlike, as if the moment is frozen in time (figure 14). In *Flowers for Elizabeth*, 1976, a beautiful homage to his lifelong companion, an array of flowers consumes the foreground, while a smaller bouquet sits on a cardboard box in the background as a bright and gentle light blankets the room (plate 108). Kertész quietly inserted himself into this photograph by including his shirt, carefully hung over the chair, and his eyeglasses, placed on an open book displaying a reclining nude. The flowers were ones that he had sent to her in the hospital. His visceral memory of the events surrounding the moment would quickly surface whenever he viewed or discussed this photograph and he poignantly recalled that it was made while their apartment was being painted as a surprise for her return.[91] She never saw it.

Kertész even photographed Elizabeth in her hospital bed just shortly before she died on 21 October 1977. And, with the courage and fortitude of a dedicated reporter, he gracefully captured her image one last time beside an array of flowers as she lay in her casket. In their crypt next to her urn, he placed a photograph of the two of them, taken years earlier, sitting side by side in a Parisian café. Kertész gave voice to the pain of the greatest tragedy of his life in the only language in which he felt fluent.

Physically and mentally exhausted by Elizabeth's illness and death, Kertész was devastated and found it difficult to work. "Vertigo often overwhelmed him," critic (and friend) Ben Lifson wrote, "tremors in his hands forced him to rely on a tripod."[92] Nevertheless, a few months later in 1978 Kertész agreed to publish four more books with Ducrot that he planned to dedicate to Elizabeth. The books were to be thematic, similar in format to *On Reading* (1971) and *Washington Square* (1975), a book of photographs Kertész had taken of the park near his apartment. But Kertész was in no shape to manage a project of this magnitude and he left everything to a growingly desperate Ducrot, who was by then suffering from both serious personal and professional problems.[93] No longer a rising star in the publishing world, Ducrot had no money to produce the books, and as Nina Barnett (Ducrot's assistant at Viking Press from 1973 to 1978) remembers, "he cut every corner to fulfill the contract. [He] slashed the size, the paper quality, page quantity and printing quality, etc.... Aware that André would have disapproved of these decisions, he went to press without showing him the proofs."[94] In 1979 Ducrot delivered the four finished books

13.
André Kertész, *New York*, 1977,
gelatin silver print, Kertész
Foundation

14.
André Kertész, *Birds*, 1977, gelatin
silver print, Kertész Foundation

as promised: *Portraits, Americana, Birds,* and *Landscapes.* But they were poorly designed and printed, with the text in each book compressed to two pages and placed on the insides of the front and back covers; even the selection of photographs was questionable. On seeing the results, Kertész was visibly shaken. An important publishing opportunity had been squandered. There were no reviews. Kertész was particularly enraged that his dedication to Elizabeth had been merged with the copyright information on the colophon page. Feeling deeply betrayed, Kertész ended his relationship with Ducrot. Within a few months, Kertész discovered the books in the remainder sections of local book stores, ignominiously stacked in huge piles with thousands of other unwanted books and selling for one dollar each.

I have little purpose left in life now that she is gone.[95] KERTÉSZ, 1978

After a period of bereavement, Kertész turned to his camera to express his grief and loss and found the process cathartic. He began working on a series of still lifes, using small statues and mementos he and Elizabeth had accumulated throughout their years together. This series was actually a continuation of an earlier body of work that he had started in 1952 when they moved to their Fifth Avenue apartment. But these delicate compositions became a way for him to cope with Elizabeth's death, his own aging, and mortality. His inherent ability to compose a still life, perfected through years of precise architectural and interior studies at *House and Garden,* had evolved into a powerful form of self-expression.

Kertész often told of seeing in the window of a nearby store a glass bust that had reminded him of Elizabeth.[96] He recalled, "I was touched…the neck and shoulder…it was Elizabeth."[97] After three months of resisting his impulse to buy it, he succumbed and began

15.
André Kertész, *Still Life*, 1979,
Polaroid sx-70, Kertész Foundation

16.
André Kertész, *Untitled*, 1981,
Polaroid sx-70, Kertész Foundation

incorporating the bust into the still lifes. At first he photographed it with 35 mm black-and-white film, but he also began using a Polaroid sx-70 camera. He chose to use a Polaroid not because he was embracing color—indeed, he claimed he was partially color blind—but because of the instant results inherent in the process. For the first time since 1939, when attacks of vertigo prevented him from working in the darkroom, he was able to work autonomously. The instantaneity of the medium permitted Kertész a much deeper personal investigation, resulting in a voluminous and powerful body of work. Speaking of these photographs a few years later, he recalled:

I began shooting slowly, slowly, slowly but soon going crazy. I worked mornings and late afternoons. With morning light the sky was nice, and in the late afternoon, full of variation. I would come out in the morning and begin shooting, shooting, shooting; no time to eat. I discover the time has gone and no breakfast. The same in the afternoon.... I forget my medicine.[98]

Not dependent on a lab to develop and print these images, he was able to work quickly and respond immediately to the visual challenges posed by the new technique. At first, Kertész was frustrated with the unstable process, which would produce unpredictable results: "Nothing comes out the way you want. You take two pictures, and the blue is different each time, after one minute, after five minutes. You can't treat the film the way you want; it does exactly what it wants. If I open the lens a little more, everything is bad. And with this *ridicule* thing I tried expressing myself."[99] Yet by embracing its flaws, he finally mastered the Polaroid process. "You have to learn the limits of the medium," he claimed, "and then learn to work on the edges of those boundaries."[100] Similar in size, scale, and intimacy to the stunning *cartes postales* that he had created when he was first in Paris, the Polaroid prints—which Kertész referred to as "photo croquis," or photographic sketches—proved to be the perfect format for him at this time in his life.[101]

Kertész obsessively photographed the glass bust throughout the apartment, but was most successful with the evocative imagery created when he placed it on the windowsill, contrasting the graceful curves of the sculpture with the skyline that had grown before his eyes (plate 109). He continued to photograph it among the artifacts he and Elizabeth had collected and even purchased a second bust, photographing the two together in the

intense afternoon light (figure 15). He eventually began photographing other personal objects in his home with the Polaroid. He even took new photographs, using his old photographs as backdrops. For instance, in a 1981 photograph (figure 16), he made his final interpretation of the 1933 *Elizabeth and I* (plate 73). As he photographed with his Polaroid the radically cropped version of half of Elizabeth's face and his hand over her shoulder, he placed a crown of thorns over his hand, creating an emotionally fraught image torn between guilt and anger, love and loss. In other photographs he made new interpretations of earlier themes. In *Self-Portrait* (plate 115), 1984, he recorded his shadow much as he had done in his earlier self-portrait from 1927 (plate 43), but in the later work he showed evidence of his aging body: the youthful shadow that delicately depressed the cable release in 1927 had been replaced by a frail and bent shell.

Publicly he called the work "just a little play," but privately he searched for avenues of relief, both spiritual and temporal. He transformed the artifacts of his and Elizabeth's life together into symbols of joy, frustration, loss, bitterness, and mortality. He included religious objects from various faiths, exploring the symbols of Elizabeth's Catholicism, most notably the crucifix.[102] The process of creating these charged images helped him work through his grief and eventually led to a renewal. "Suddenly, I'm losing myself, losing my pain, losing hunger, and yes, losing sadness."[103] Elegiac and mournful, these photographs were published in the small, elegant book *From My Window* (1981). Kertész had finally and successfully created a proper homage to Elizabeth.

I am a lucky man, because I can do something with almost anything I see. Everything is interesting to me.[104] KERTÉSZ, 1979

While he felt keenly the loss of Elizabeth, Kertész in the years after her death experienced a dramatic flowering of professional success and recognition, in the process cultivating a convivial circle of friends and admirers. No longer sheltered by Elizabeth's protective and occasionally stifling embrace, he frequently entertained artists, curators, scholars, dealers, and reverent photographers who came to pay homage. He gave numerous interviews, and although he pretended to be annoyed by all the fanfare, he clearly enjoyed his time in the limelight and welcomed the recognition. After many years of loneliness, he was once again working in a supportive environment. However, he never fully recovered from or forgot his years of professional struggle and given the chance would repeat his well-worn sagas of what had happened to him in the United States.

From 1978 until his death, Kertész devoted most of his energies toward solidifying his status as an artist of international standing. He traveled to numerous openings and award ceremonies around the world—going as far afield as Japan for the opening of the 1985 retrospective *André Kertész: A Portrait at Ninety*. During this period, he also returned several times to Budapest and Paris and took new photographs of the cities he knew so well. Revisiting the famed gardens near the Louvre in 1980, the eighty-six-year-old photographer demonstrated in *The Tuileries Gardens* (plate 110) that he still retained his extraordinary ability to capture the "prodigious intensity" of childhood.[105] Responding quickly to a rapidly changing scene, Kertész captured in a single frame the striking, yet wholly uncontrived, conjunction between a young girl's carefree buoyancy and the truncated sliver of a departing man.

The final years of Kertész's life were filled with honors and awards, perhaps the greatest of which was receiving the decoration of the Legion of Honor from the French government. As a sign of his deeply felt connection to the country where he had first achieved significant artistic success, Kertész made plans to donate his archive to the French government, including a lifetime of notes and correspondence as well as his negatives and contact sheets. He also founded the André and Elizabeth Kertész Foundation in New York and dedicated it to supporting the arts and preserving his legacy. Ever cognizant of his artistic reputation, he once again began the tedious process of organizing his work, reviewing negatives and contact prints, and reprinting and redating images that had lost their vital information. This act of summarizing his career was undoubtedly fueled by the publication of numerous retrospective books in the 1980s, including *Hungarian Memories,* a book of his early photographs; *André Kertész: A Lifetime of Perception,* a catalogue that accompanied his retrospective at the Canadian Centre for Photography in Toronto; and *Kertész on Kertész,* a book of the artist's favorite photographs with text by him. Kertész's stature as an artist of central importance to the history of photography was solidified in 1985, when the Art Institute of Chicago and the Metropolitan Museum of Art mounted an exhibition of his work from 1925 to 1962: *André Kertész: Of Paris and New York.* The catalogue, including essays by Sandra Phillips, David Travis, and Weston Naef, was the first scholarly investigation of his work; it also revealed the beauty and brilliance of Kertész's photography to wide audiences.

That same year, he arranged to have an exhibition at the Museo Nacional de Bellas Artes, Buenos Aires, so that his brother Jenő could share in the fame that he now enjoyed. Since their first phone call in 1962 after years of sporadic communication, the brothers had reestablished a close relationship. His brother, however, suffered a massive stroke shortly before the exhibition opened. Kertész traveled to the exhibition, attending all the festivities associated with it, but spent the rest of his time sitting by his brother's side in the hospital.

Although Kertész himself had suffered health problems in the last few years, when he left for Argentina he had looked fit and youthful for a man of his age. When he returned, he was physically and mentally exhausted. He talked of how sad it was to watch his brother lie unconscious in the hospital and expressed discomfort that once again he would be outliving a younger loved one. He began to fail and was briefly hospitalized. Friends tried to convince him to hire a home-care attendant but he dismissed this idea, citing his need for independence. On 27 September 1985 Kertész announced, "I am all used up."[106] He died the next day.

For me, the camera was there to document, to show how I lived.... It is very much a tool, to express and describe my life, the same way poets or writers describe their life experiences. It was a way to project the things I found.[107] KERTÉSZ, 1978

Almost up to the day he died, Kertész continued to explore the world through his camera with the same playful curiosity and wonder he had demonstrated in his earliest images from Hungary. During his final trip to his beloved Paris in 1984, Kertész re-created the distortion experiment of 1933 for a film by Teri Wehn-Damisch, *André dans les Villes.* This time, instead of using fun-house mirrors, Kertész directed the camera toward distorted

reflections in a stretched, twisted piece of Mylar, a mirrorlike substance. While he once again created evocative images of the female body uncannily stretched, multiplied, and compressed, he also turned the camera on himself, just as he had occasionally done in the 1930s (figure 17). Doubling back to his artistic youth, the technique of optical distortion used to create this photograph also appeared to transform Kertész into a taller, leaner version of himself. When showing this print, he would say, "Look, I am a young man again." To a certain extent it was true, for both his posture and expression emanate the power and self-control that he had captured in his earlier photograph *Self-Portrait in the Hotel Beaux-Arts* (plate 75), 1936 or 1938. These distortions possess a dreamlike clarity that endows them with an almost visionary quality. Like the magnificent 1926 photograph *Chez Mondrian* (plate 50), 1926, Kertész's *Paris* (plate 112), 1984, an image of a hallucinatory, distorted door, is divided in half: on one side is an elegant paneled wall, on the other a twisted, wavering door. But whereas the subtle distinctions between interior and exterior, between light and shadow, and between the natural and human-made energize *Chez Mondrian,* in *Paris* the photographic meaning seems to reside in a meditation on reality and illusion, and on vision itself. Indeed, when he showed this photograph, Kertész would solemnly and knowingly raise his eyebrows, as if he sensed this mysterious and evocative image represented his exit from the world he had so faithfully photographed for almost three quarters of a century.

17.
André Kertész, *Self-Portrait,* 1984, gelatin silver print, Kertész Foundation

[I want] to give meaning to everything about me with my camera, to make photographs as by reflection in a mirror, unmanipulated and direct as in life. KERTÉSZ, 1964

94 *Broken Plate, Paris, 1929 / late 1960s*

95 Promenade, 1962

96 *The White Horse, 1962*

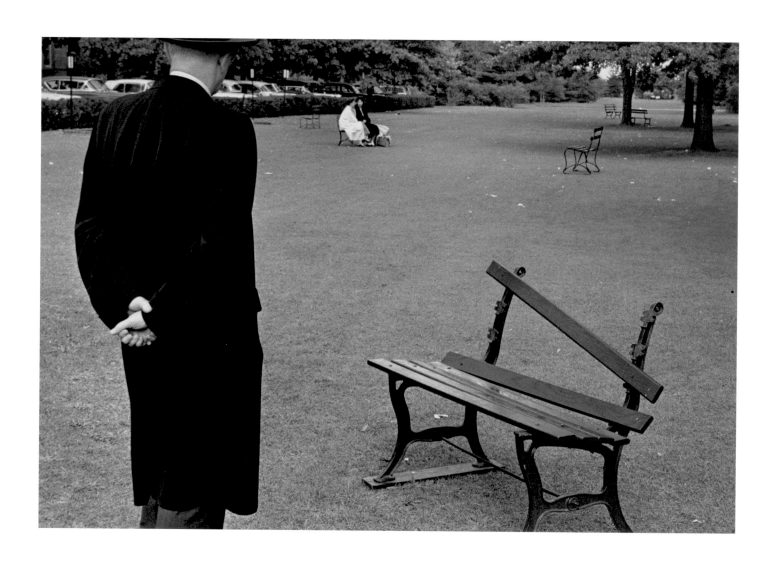

97 *The Broken Bench, 1962*

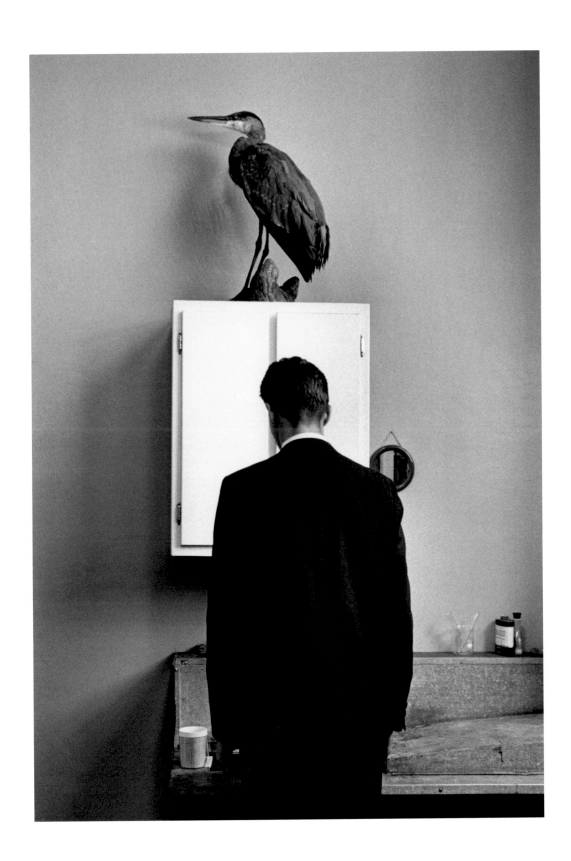

98 *The Heron, 1969*

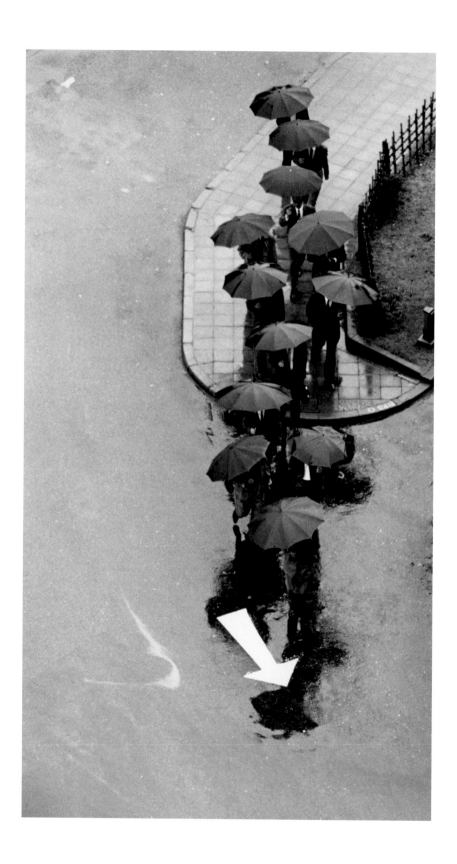

99 *Rainy Day, Tokyo, 1968*

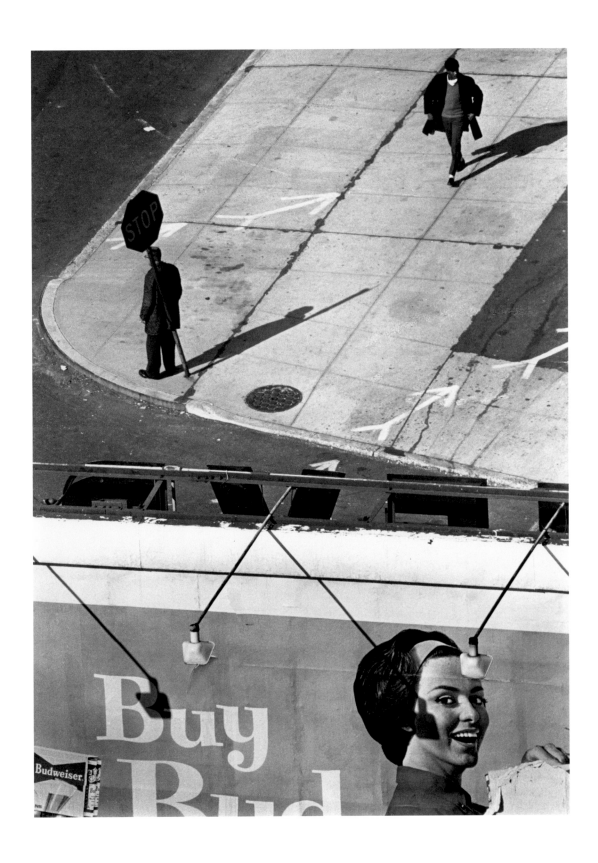

100 "Buy," Long Island University, 1962

101 *MacDougal Alley, 1962*

102 *Shadows and Buildings, 1966*

103 *Washington Square*, 1966

104 *MacDougal Alley, 1977*

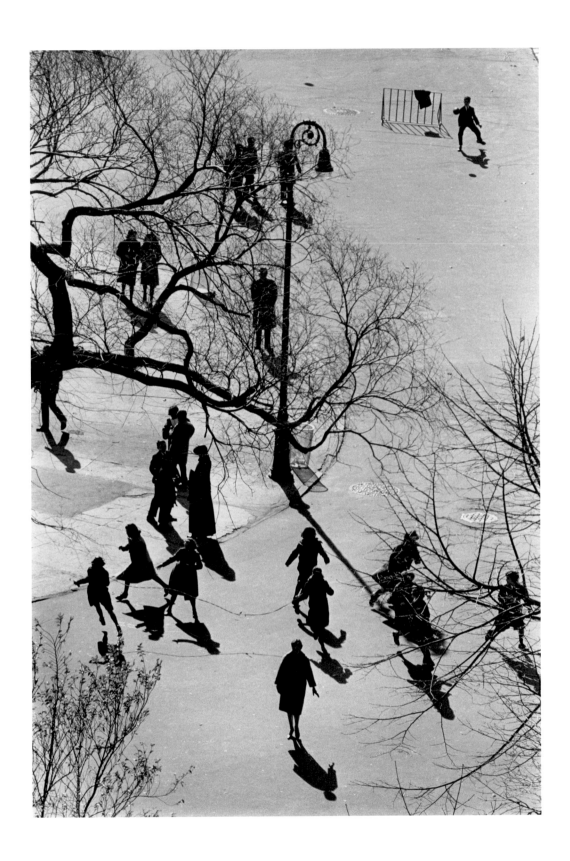

105 *Washington Square, 1968*

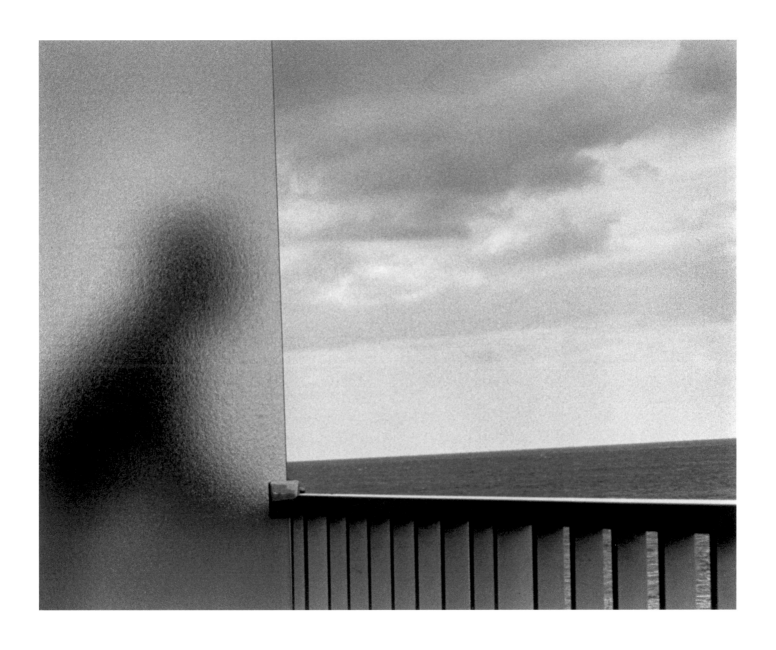

106 *Martinique, 1972*

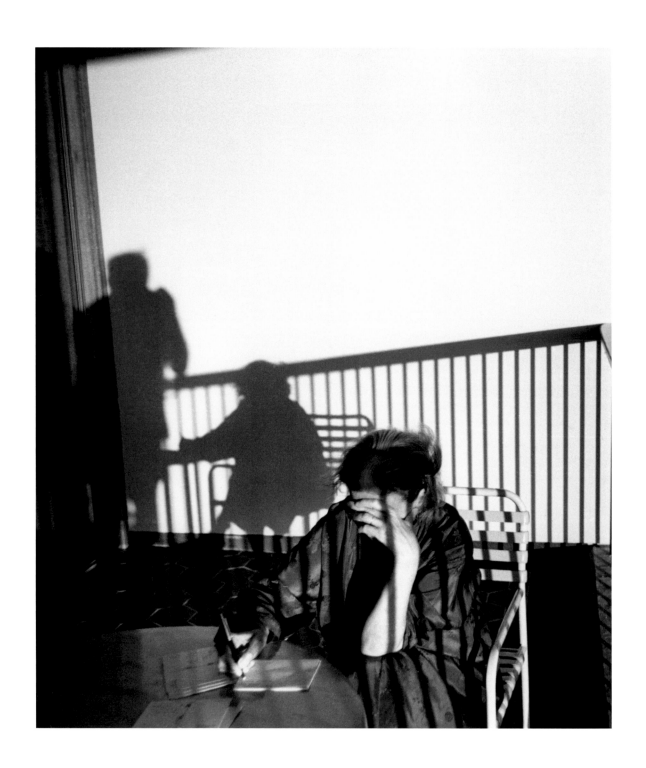

107 *Mauna Kea, 1974*

108 *Flowers for Elizabeth, 1976*

109 *Glass Sculpture with World Trade Center, 1979*

110 *The Tuileries Gardens, 1980*

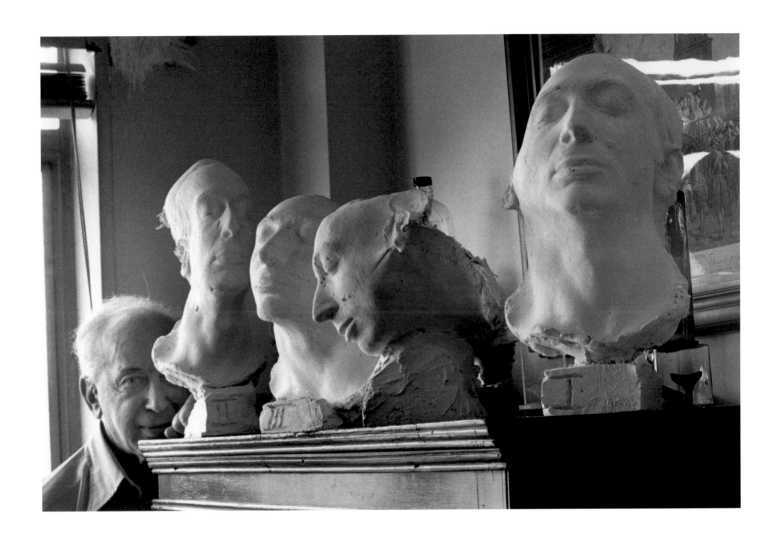

111 *Self-Portrait with Life Masks, 1976*

112 *Paris, 1984*

113 *From My Window,* 1980

Chronology, 1894–1985 Sarah Kennel

André Kertész, *Buda*, 1913, gelatin silver print, Kertész Foundation

André Kertész, *Népliget*, 1913, gelatin silver print, Kertész Foundation

1894

2 July Kertész Andor born in Budapest to a lower-middle-class Jewish-Hungarian family. Parents Ernesztin and Lipót, brothers Imre and Jenő. Ernesztin runs a small coffee and pastry shop near their house and Lipót is a bookseller. Ernesztin, who seems to have spoken German, may have Austrian-Jewish origins.[1] The family is close to Ernesztin's brother, Hoffman Lipót (Uncle Poldi), who is a successful businessman in the grain trade. Kertész is often called by the familiar "Bandi"; Jenő, by the familiar "Jancsi."

1909

Commences studies at Academy of Commerce, Budapest, a commercially oriented high school similar to a trade school for business, but neither excels at, nor enjoys it. During this period, he writes extensively in his diary, particularly about his romantic feelings for Balog Jolán, a neighbor three weeks his junior.[2]

22 February Kertész Lípot dies.

14 March Quits school and apprentices in various manual labor professions (gardener and possibly glazier) for two months. Returns to the Academy of Commerce in late May 1909.

1912

28 January His interest in the fine arts is revealed after a visit to a public art gallery, where he deplores his inability to be a good judge and critic of artistic merit: *The afternoon I was in the Art Hall....We could not see it all as they closed as early as 3. Today I could see how useless I am. I believed that I am capable of judging pictures, although I barely am. I judge them too much according to my own personality, which I should not do, as one's personality, unless it is something extraordinary, is usually ignored. I am unable to pass judgment according to the taste of the masses. I look for the poetic in everything. Criticism requires enormous knowledge and courage. I lack both. These thoughts filled my mind while I viewed the pictures—feeling my own inadequacy—and even after.*[3]

25 February Evinces an interest in photography, in diary: *I spent the afternoon thinking. Now I see Strázsa and Szepesszombat [small towns in northern Hungary, now in Slovakia] as so very lovely. Everything is so enchantingly ancient. I would like to go back there during the summer, but with a camera. What great pictures I could take. All filled with poetry.*[4]

15 April After attending the theater, affirms his desire to become a good critic of the arts: The Young Lass *by Pierre Weber and Henri de Gorsse, translated by Heltai. The first French comedy I have seen. I was pleased by it. I am not able to judge plays yet, but to my greatest joy, lately I am somewhat able to judge objects of art and other solid artistic creations, although only in broad outlines. I cannot penetrate deeply yet. I lack the words, even though I have it inside me.*[5]

20 June Mother buys him and his brother Jenő an Ica box camera that accommodates 4.5 by 6 cm plates; the pair immediately begins to use the camera. First photographs are of family and street scenes in and around Budapest, which he and Jenő print on printing-out-paper.

22 June *Jenő took a picture of me, it was his first successful shot.*[6]

23 June *We succeeded in surreptitiously taking a shot of Jolán. In the afternoon Jenő developed it, but it did not come out particularly great as he did not treat it long enough. Moreover, at the drying the plate broke. At about six Jenő took a picture of Jolán, Ilus, and Ella [Balog] from the window, with their mother's knowledge. They stood in the kitchen door and their mother watched them from the kitchen. This is the best picture so far, Jenő has just developed it this evening. I am so happy, there are no words for it.*[7]

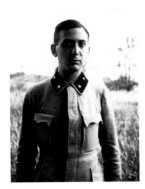

André Kertész, *Self-Portrait*, 1915, gelatin silver print, Kertész Foundation

André Kertész, *Görz*, 1915, gelatin silver print, Kertész Foundation

André Kertész, *Self-Portrait, Picking Lice*, 1915, gelatin silver print, Kertész Foundation

24 June *Coming home, a great disappointment awaited me. The picture I took [of the Balog sisters] yesterday was quite coincidentally damaged by me. I put it on the washbasin for drying, but I did not position it well and it became largely blurred. The place where they are standing remained clear. This afternoon we made copies from the plate successfully. They came out splendidly. Tiny picture, but sharp. I can stare at it endlessly, and I am very happy. We gave a copy to them, too.*[8]

27 June Passes high school exams and receives baccalaureate from the Academy of Commerce. With the help of his uncle Poldi, begins to seek employment.

22 July On the recommendation of his uncle Józsi (Ernesztin's brother), hired as a clerk in the Giro Bank and Transfers, Ltd.[9]

1913

Takes pictures of Budapest and surrounding countryside. Continues his secret romance with Balog.

By the summer, his dislike for working in the bank is apparent. After being criticized by Imre for laziness and failing to continue his study of German, he writes in his diary, *I do not deserve to be alive, I do not have a drop of ambition in me.*[10]

1914

5 October Drafted into the Austro-Hungarian army. During the fall, his unit moves to various places, including Trieste, Montefalcone, and Gorizia. Photographs scenes of daily life in the army, as well as the different towns and landscapes encountered during travels.

17 November In a letter, Jenő describes a camera he plans to purchase for Andor: *The machine I mentioned on the postcard is an Ica Bébé. With plates, six cassettes. List price 205 Koronas. He sells it for 120. I believe this would be better, as its lens is outstanding, very fast (f:5.5). Just the machine for you. You could take snapshots in overcast weather, even in a storm.*[11]

12 December *The little machine arrived.*[12]

1915

15 January Suffers from typhoid fever. Enters into a hospital in Klagenfurt, Austria, where he stays until 27 March.

28 March *On weakened legs I walked around town the whole day. I took photographs.*[13]

30 March Transferred to Esztergom, thirty miles north of Budapest.

Spring Granted one-week leave; returns to Budapest to visit his family and Balog. On his return to his unit, learns he will be sent to the front, but keeps this information from his mother. The ruse is successful, thanks to his brothers and Uncle Poldi, who maintain the charade by "sending" Andor's letters from Esztergom and pretending to visit him there.[14]

8–15 July Unit travels from Esztergom to the war zone around Lemberg (today L'viv in Ukraine). Going to the combat zone, the military train stops at a suburban station at Budapest; several relatives who were alerted to this opportunity, including younger brother Jenő, say goodbye to Andor. At the various stops Kertész writes with great sensitivity and empathy about the families seeing off sons, husbands, brothers:

The train left at 2:15. The crying, the last words of farewell almost drowned out the band that was supposed to fire us with enthusiasm. The visible utter desperations resulted in heartbreaking scenes. I saw a desperate, shrieking mother who could hardly be withheld from running after the train. One of the sergeants jumped off the already moving train to go to his wife who desperately ran after the train. 'But, my dear little mommy, don't cry'. And he gave another farewell kiss to his tormented woman who could barely stand on her feet. It was a horrible kiss, the woman

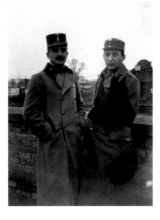

André Kertész, *Self-Portrait with Soldier*, 1916, gelatin silver print, National Gallery of Art

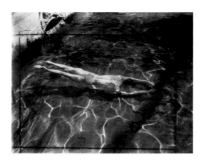

André Kertész, *Underwater Swimmer, Esztergom*, 1917, gelatin silver print, The Sir Elton John Photography Collection (plate 16, uncropped)

André Kertész, *Budapest*, 1919, gelatin silver print, Kertész Foundation

did not want to let him go. The sergeant tore himself from her arms and ran after his compartment. Everybody stopped only this poor woman was running after the train, reaching up with her arms and when she saw it was hopeless, she stopped and dropped her head in utter desolation.[15]

15 July First taste of direct action in the war. *In the morning as I stood in the dugout without any foreboding, a stupid bullet flew by directly next to me. It was the first bullet intended for me.*[16]

August Learns in a letter from Uncle Poldi that his mother discovered the truth about his location.[17]

11 August Continues to take photographs while at the front in Poland; instructs Jenő to send some of them for publication: *I believe that I may be able to send home my exposed shots by Ensign Hodos, who is about to go on vacation. I am still uncertain as I write these lines, but out of foresight I ask the following from you.... Send me a copy of each shot. Do not send them all at once, but forward them as you finish them day by day, more than one copy if you think so. I marked a few of them here and I give you addresses where you should send a copy each of the given picture.... Make as many copies of this picture as the number of people in front of the entrenchment.... Of this one, send me a copy, too. More*

over, make four copies of the picture at the latrine as well, etc. Of this kind of personal photo make several more, as you feel, on gaslight paper and at my expense. I believe I left enough money at home to cover it. I thank you in advance, Öcskös [little brother], for your troubles, and I wish that we mutually do a good job to please both of us. Naturally, the copies do not have to be top quality, just the kind of mass copying. We might have time to make first-class copies together if I may ever get home. If you send the enlargements in somewhere, do not use my real name, use some pseudonym... send the humorous pictures under the name "Impostor" and those with serious subjects briefly under my initials. Also, try to sell the simpler shots at the trashier papers but, for heavens, not under my name, use a different pseudonym with each paper "Photograph by a volunteer" or under a similar dumb title.[18]

23 August Jenő writes to Andor: "Send me copies of those pictures, I would like to see them. I will send you a picture of our father.... The photographic things will go tomorrow. Could those plates be sent to me somehow? I would like to enlarge them. Our poor camera dries up badly, I do not work with it at all."[19]

27 August – 1 September Wounded by bullet that pierces his chest and arm, severing a nerve and partially paralyzing left arm.

1916

Spends much of the year in recovery, first in Budapest hospitals and later at home. During the fall, returns to active duty, stationed in Esztergom, and travels all over eastern and central Europe, probably as a military escort. During these military trips from Esztergom, Kertész visited or passed through, among others, the following towns (place names as cited in 2003): Prague, Brno, Graz, Vienna, Wiener Neustadt, Semmering, Bucharest, Timişoara, Orşova, Caransebeş, Ploeşti, Craiova, Brăila, Budapest, Csáktornya, Komárom, Cegléd, Kecskemét, Grodek, Lesh, Durrës, Belgrade, Maribor, Skoútari, Rijeka, Kotor, Slavonski Brod, Mostar, and Sarajevo. Today these localities are part of eleven separate independent states.

Submits work to the fourth competition for Hungarian photography sponsored by the journal *Érdekes Újság* (Interesting Newspaper). 1,786 entries received.[20]

20 February Wins ninth place in competition of war-related drawings and photographs sponsored by *Borsszem Jankó* (Johnny Peppercorn), a satirical weekly magazine.[21]

1917

25 March Publishes first photographs in Budapest weekly *Érdekes Újság*. Under the title "Entries from our fourth 3000 Korona photography contest" are published two photographs, *The Fairy Tale* (plate 9) and *Village Council*.[22]

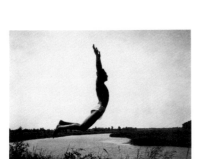

André Kertész, *Jenő Kertész*, 1919, gelatin silver print, Kertész Foundation

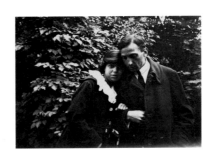

André Kertész, *André Kertész and Erzsébet Salamon*, 1920, gelatin silver print, Kertész Foundation

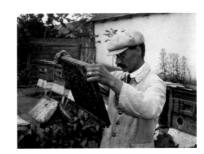

André Kertész, *Ede Papszt*, 1921, gelatin silver print, Kertész Foundation

1918

In the early part of 1918, transfers to Brăila, at the head of the Danube delta in today's Romania, to a unit called Black Sea Station (Schwartze Meer-Stelle). By fall, the Hungarian army has disbanded.

Late Fall Reemployed with the Giro Bank but continues to photograph in his spare time.

1919

Photographs excursions with friends and family, landscapes, and street scenes, including events surrounding the Hungarian Revolution. Participates in sports, especially running and rowing, often with his brother Jenő.

Meets Salamon Erzsébet, who goes by the familiar names Böszi and Erzsi.[23]

1920

May–June Sends series of flirtatious postcards to Salamon.[24]

1921

Meets and photographs many Hungarian artists, including Vilmos Aba-Novák, Imre Czumpf, Rezső Czierlich, and Gyula Zilzer.

10 March With the recommendation of Ervin Szűts, interviews for employment at Hungarian Steel Products.[25]

24 March Denied a job at Hungarian Steel Products "with the false pretext" that a manager at the company opposed him.[26]

10 April Records in diary that Szűts helps him gain employment with "Boczonádi," operating some sort of press.[27]

11 April Records in diary *Notice sent to Giro.*[28]

17 April Fired from job with Boczonádi. In his diary, Kertész records *I met Szűts. They told him that my being Jewish was the problem. He is angry…does not believe what they said.*[29]

5 May On the recommendation of Szűts, travels to Abony to train as a beekeeper and gourmet farmer, with Ede Papszt, a farmer, beekeeper, and painter. During the next five weeks, learns the rudiments of apiculture and takes pictures, including *Self-Portrait with Ede Papszt* and *Blind Musician, Abony* (plates 28, 12).

13 May Kertész records in his diary *Papszt shows me his pictures. They are splendid!*[30]

July Quits training as a beekeeper, returns to Budapest.

1922

September Enters three photographs in an exhibition sponsored by the National Association of Hungarian Amateur Photographers.

11 September Receives postcard from Dr. Fejérváry, general secretary of the National Association of Hungarian Amateur Photographers: "the three pictures you sent in to the Budapest competition of painters [*sic?*] were found praiseworthy by the jury, who decided that they are the works of a person who is advancing along uniquely interesting ideas… your praised works will be shown at the national exhibition; if you want to be part of it, please have the pictures framed.… and delivered to the Museum of Industrial Art."[31]

1924

Spring Enters three photographs in an exhibition sponsored by the National Association of Hungarian Amateur Photographers.[32]

23 May Records that Angelo (Pál Funk), a Budapest-based photographer who later opened studios in Paris and Nice, offered to teach him how to become a professional photographer.[33]

30 May *I told Angelo that I accept his offer. He postponed the beginning until September or October, when there will be work.*[34]

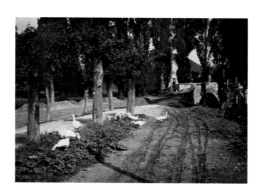

André Kertész, *Pomáz*,
1924, gelatin silver print,
Kertész Foundation

20 June Describes in diary a trip taken the previous day with Angelo: *I was in Pomáz with Angelo to take pictures.*[35]

23 June *Pictures from Angelo with smarmy dedications. I don't like it.*[36]

8 July *Midday at Angelo's. He received me coldly and purposefully directed the conversation to dissuade me from photography. Then he eased up. Seemingly his vanity is hurt that I did not respond the way he hoped. I am fearful of his reputation. Later he warmed up. I told him that I did not go to him for so long because of the things at home.*[37]

10 July Records quarrel with Salamon in diary: *She was irritated, nervous, pensive. Directly before we parted: 'I am tired of this situation. In the winter of 1924–25 I want to be a bride. Either this will happen, or you go away and until you establish an existence you do not come for me, and we do not even correspond.' I responded with a few bewildered, childish words. She walked out on me imperiously. I am having dreadful days. I am so desirous of a little gentleness and I do not get it from her. What will happen to us? There is no promise anywhere. I do not even want to leave any more. I want to feel her next to me but not like this. I suffer terribly.*[38]

1925

4 January "Rue de la Paix of Pest: The 24 Hours of Váci Street" is published in *Szinházi Élet* (Theater Life) with four photographs signed by Angelo. Kertész later claimed that these were his works.[39]

26 June A night photograph, *Evening in the Taban,* appears on cover of *Érdekes Újság.*

25 September Receives three-month visa to France.[40]

8 October Arrives in Paris.[41]

Late October Receives mail at two different addresses in Courbevoie, a suburb of Paris.[42]

17 November Registers with Paris Police department. Gives address as rue Vavin, states profession as "photo reporter."[43]

December Receives as a holiday present from his family a new Goerz 10 by 12.5 cm camera (Goerz Ango Anschutz with Goerz Dagor lens).[44]

1926

Receives auditor pass for courses in cinematography, École National d'Arts et Métiers, Paris.[45]

Publishes photographs in French journal *Art et Industrie* and German journal *Das Illustrierte Blatt; Frankfurter Illustrierte.*[46] First publication of photographs since arrival in France.

1 January Issued press pass from Continental Photo Agency, Budapest and Berlin, possibly to help secure work and extend his visa.[47]

25 January – 3 April Works as a retoucher and developer for a professional photography studio, L'Atelier Moderne, in the Parisian suburb Boulougne-sur-Seine. Receives certificate dated 3 April 1926, attesting to his service and that he was let go for lack of work. Certificate records residence at 8, rue du Plâtre (Hotel des Archives) in the Marais district.[48]

2 July Friend and fellow photographer Max Winterstein writes, "I hear that you are jobless again and you subsist only on private jobs… you are not advancing, you don't earn enough and Paris is seemingly not the ground where you could establish your future." Brother Imre cautions, "With the fact that you have insurmountable language difficulties, your situation is even more serious…Bandi, come home!"[49]

19 August Visits Piet Mondrian's studio, probably for the first time.[50]

17 October Budapest daily *Magyar Hirlap* mentions Kertész (but misidentifies him): "A light report on various things in Paris also talk about Hungarian Parisians, among them a few painters who are gaining attention.…We also have to speak about a youth from Pest, who is the sensation of Montparnasse. He is not a painter: a photographer. His name is Andor Székely. What he does is art. We will hear of him a lot yet."[51]

André Kertész, *Mr. X, Lahner, Csáky and His Wife, Mr. and Mrs. Blattner, Pferferné, Mr. Y, Csáky's Daughter,* 1927, gelatin silver print, Kertész Foundation

PHOTO-KERTÉSZ EXPOSITION

"BERGÈRE O TOUR EIFFEL" (APOLLINAIRE)

AU SACRE DU PRINTEMPS
5, RUE DU CHERCHE-MIDI, PARIS
A PARTIR DU 9 MARS

Exhibition invitation, 1927, Au Sacre du Printemps, Kertész Foundation

28 October *Magyar Hirlap* publishes correction: "A Hungarian photographer in Paris. An error slipped into our latest report from Paris. We wrote about a Hungarian photographer whose pictures are regarded as sensational by the artists of Montparnasse, known for their demanding taste. We misprinted his name. His name is Andor Kertész. He can elicit quite extraordinary results from the camera, he has an original vision, what he does is bordering on art. He gained attention in Paris quickly and we will certainly hear of him more often."[52]

4 November Jenő writes, "I was most happy to receive Bandi's good news. He is beyond the hardships of the beginning and his affairs will have a smoother progress from now on."[53]

25 November Receives mail at a hotel, 19, rue Bourg Tibourg, possibly indicating another move.[54]

13 December Commissioned by architect and designer André Lurcat to take photographs of interior of fashion and design studio.[55]

24 December Receives letter from the painter and fellow Hungarian Lajos Tihanyi discussing a photographic assignment: "You will photograph the family of a bishop at my place. I set a maximum of 100 francs for the first six pages, but you will raise that for other Americans if you will, as we hope, be successful. Do not make many copies of my new picture. In part because I do not want to keep handing them out and also…because I do not like exhibitionism—but do not take this as a sign of mistrust in your work. It is a beautiful, good picture."[56]

1927

Begins to do more freelance work for various journals, including French periodicals *Art et Industrie, Cahiers d'Art,* and German fashion magazine *Die Dame.*

February Moves to 5, rue de Vanves, in the Montparnasse district.[57] Frequents Café du Dôme; spends time with and photographs many artists, including fellow Hungarians living in Paris.

12–24 March First exhibition at Au Sacre du Printemps, a left-bank gallery owned by pianist Jan Sliwinsky. Forty-two photographs accompanied by abstract paintings by Ida Thal.[58] *Portrait of Mme R.* (plate 45) and Paul Dermée's poem entitled "Frère voyant" (Brother Seer), dedicated to Kertész, are published on the exhibition invitation.

"Kertész, now exhibiting at the Sacre du Printemps,…is one of the few talented photographers who recognize that their medium possesses the necessary qualifications for being an independent art…. What makes ordinary objects and scenes take on a fresh value in the photographs…is his habit of placing the accent in an unexpected place or of taking the picture from a new angle. His view of [the] Eiffel Tower dimly thrust [as] a solid arrangement of vertical and horizontal planes demonstrates the originality of his treatment, as does his night picture of the portals of Notre Dame, a composition contrasting the curved lives of rain on the oily pavement with the straight lines of the façade."[59] CHICAGO TRIBUNE

"Here's Kertész, who opens his eyes to the creation of the world. No premeditation. He is curious and smitten. He doesn't even have the photographer's usual tricks. Thus he makes simple, nude, and true beauty."[60] CHANTECLER

1–16 October Exhibits *Eiffel Tower* (plate 33) in *XXII Salon International d'Art Photographique,* organized by the Photo-Club, Paris, and the Société Française de Photographie.

October Exhibits *Après la Pluie* at the third international exhibition of photography, Zaragoza, Spain.

December Commissioned by musician Ferenc Roth to take pictures of the Roth Quartet for publicity (plates 53, 54).

Still Lifes by Kertész and Tihanyi, in "Bildhafte Photographie," *Das Neue Frankfurt: Monatsschrift für die Probleme Gestaltung 2* (March 1928), National Gallery of Art

André Kertész, *Carlo Rim*, cover, *Vu* (6 August 1930), Patrimoine Photographique

1928

Purchases first Leica camera.

First commissions for *Vu*, an elegant, high quality publication founded by Lucien Vogel in 1928 and featuring extensive photographic reportage. Also publishes in French journals *L'Art Vivant* and *Variétés*, and German publications *Berliner Tageblatt* and *Der Querschnitt*.

March Article praising Kertész's still-life photography appears in *Das Neue Frankfurt*: "Especially interesting are the completely self-contained and balanced pictorial effects of Andor Kertész's photographic still lifes, such that the collection is effectively of the most naked, puritanical severity. We reproduce this photograph [plate 51] next to the painting by [Lajos] Tihanyi. The close relationship of these two works in subject and composition gives us the opportunity to point out an essential difference between painterly and photographic effects."[61]

9–27 March Exhibits one work in *Mezinarodni Fotograficky Salon V. Praze* (*First International Salon of Pictorial Photography*), Association of Czechoslovak Clubs of Amateur Photographers, Prague.

24 May–7 June Participates in the *Salon de l'Escalier* (*Premier Salon Indépendant de la Photographie*), Comédie des Champs-Élysées, Paris. Fifteen works, including *Fork* (plate 52), *Chairs, Luxembourg Gardens* (plate 39), *Stairs, Montmartre* (plate 38), *Portrait of Mme R.* (plate 45), and *Mr. and Mrs. Rosskam*. Other artists include Berenice Abbott, D'Ora, Germaine Krull, Man Ray, Laure Albin-Guillot, Paul and Félix Nadar, Paul Outerbridge. Exhibition includes a retrospective of Eugène Atget's photographs.

"Kertész is a prestigious creator of poems and his metaphors are humble objects, the skies, the trees and the rooftops of Paris."[62] L'ART VIVANT

"André Kertész attempts to reveal the object, to translate it with maximum intensity."[63] L'ART VIVANT

"Among the still-lifes, one must above all admire a fork by André Kertész; a simple fork, which is almost moving in its purity…. It is perhaps the only image that gave me the impression of a real work of art."[64] LA REVUE HEBDOMADAIRE

25 May Receives fifty-franc prize for the purchase of photographic equipment in the *Concours National de Photographie,* sponsored by the Chambre Syndicale des Industries et du Commerce Photographique, Paris.[65]

2–18 June Exhibits *Fork* (plate 52) and a still-life at the *Internationale Foto Salon 1928*, Arnhem, the Netherlands. Exhibition travels to Amsterdam, 23 June–28 June, and Rotterdam, 15 July–15 August.

2 October Receives visa for Spain.

27 October Marries Rozsi Klein, a fellow Hungarian living in the same building at 5, rue de Vanves. He teaches her how to photograph; she subsequently uses professional name Rogi André.[66]

October and November Exhibits *Anne Marie Merkel; Stairs, Montmartre* (plate 38); *Cello Study* (plate 54); *Mondrian's Glasses and Pipe* (plate 51); *Chez Mondrian* (plate 50); and *Fork* (plate 52) at Galerie de l'Epoque, Brussels.

11 December Letter from Krull, Eli Lotar, and Kertész to Vogel, *Vu*, discusses the issue of reproduction rights in foreign journals and papers.[67]

17 December Letter from Krull, Lotar, and Kertész to Vogel expresses disappointment in his reluctance to grant the photographers right to the sale of prints abroad.[68]

André Kertész, "Das Haus des Schweigens," *Berliner Illustrirte Zeitung*, 1 January 1929, reproduced in *Neue Jugend* 4 (1934), Patrimoine Photographique

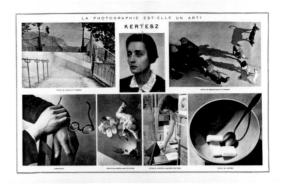

"Kertész," in *L'Art Vivant* (1 March 1929), Patrimoine Photographique

1929

Publishes regularly in French publications *Vu, Bifur, Variétés, Ce Temps-Ci, Jazz,* and German publications *Berliner Illustrirte Zeitung, Münchner Illustrierte Presse,* and *UHU.*

Experiments with photographing images in distorted mirrors.

20 January–24 February Exhibits twenty photographs in *Fotografie der Gegenwart,* Museum Folkwang, Essen. Show circulates to Hannover, Berlin, London, Frankfurt, Leipzig, Dresden, Rostock, Magdeburg, Kaiserlautern, Weimar, Gottingen, Vienna, Amsterdam, and Kiel.[69]

4 February Receives letter of reprimand from Edmond Wellhoff, *Vu,* for publishing photographs of Trappist monks in the *Berliner Illustrirte Zeitung.*[70]

Late February Moves to 75, boulevard Montparnasse.[71]

March Jean Gallotti publishes article on Kertész in *L'Art Vivant* as part of the series "La Photographie: Est-Elle un Art?"[72]

12 May Kertész's photographs of Eiffel Tower accompany Brassaï's article in *Münchner Illustrierte Presse.*[73]

18 May–7 July Exhibits thirteen works in *International Ausstellung von Film und Foto,* Interim Theater Platz, Hall d'Exposition, Stuttgart. Exhibition travels to Zurich, Berlin, Vienna, Danzig, Zagreb, Munich, Tokyo, and Osaka.[74] In conjunction with the exhibition, the journal *Die Forme* publishes an extensive article on the exhibition, in which *Fork* (plate 52) and *Ropes* are reproduced.[75]

26 June Kertész informed by organizers of *Film und Foto* that several prints had adhered to the glass and were damaged. They offer to pay for costs and for replacements for the remainder of the tour.[76]

25 September Asked by the director of the Graphische Lehr-und Versuchsanstalt (Institute for Teaching and Graphic Research), Vienna, to donate one print of a photograph in *Film und Foto.*[77]

October *UHU* publishes an article on "A New Corporation of Artists," which discusses the rise of photography as a pure art and asks several leading photographers to discuss their preferred images. *Fork* (plate 52) is reproduced with the following caption: "Why do I consider this photograph as my most successful work? Because I succeeded in rendering the object with the strong suggestiveness of the play of shadows, lights, and lines in the most direct and richest manner."[78]

1 November Albrecht, director of the exhibitions office of the city of Madgeburg, asks Kertész to participate in a series of "small, special exhibitions" by "the most distinguished contemporary photographers," to be held in conjunction with *Fotografie der Gegenwart,* organized by the Museum Folkwang.[79]

15 November Vogel, discussing his desire to "reproduce as many artists of talent like you" while staying within a reasonable budget, proposes to Kertész a fee schedule of 150 francs for "first photographs" and 100 francs for each photograph that is of the same subject, with extraneous expenses included.[80]

25 December Article on Kertész in *Pesti Futár.*[81]

29 December Three photographs purchased by the director of the Museum König-Albert, Zwickau.[82]

1930

Series of photographs appear in portfolio, *Photographies modernes,* published by Pierre Bost.[83]

Contributes photographs to Paul Morand, *Route de Paris à la Mediterranée,* published by Firmin-Didot, Paris.

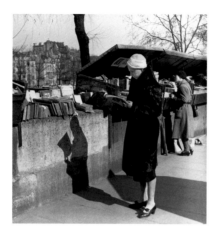

André Kertész, *Erzsébet Salamon*, 1931, gelatin silver print, Kertész Foundation

André Kertész, Night views of Paris, in *L'Image* 27 (1932), Courtesy, Private collection

Begins to publish photographs in *Art et Médecine*, a high quality publication edited by Vogel.

Photographs the construction of the re-creation of the temple of Angkor Vat at the 1931 *Colonial Exposition*, Paris.[84]

March Shows five works in exhibition of photography, Antwerp.

1 April *L'Intransigeant* publishes article on Kertész: "Kertész fishes for photographs. In place of running to find them, he waits patiently for them to bite. 'Have confidence' he says, 'in the inventions and transformations of chance.... Look at reporters, amateurs—both of whose sole aim is to gather a memory or a document: that is pure photography.'"[85]

April Participates in *Photographies d'Aujourd'hui*, Galerie d'Art Contemporain, Paris.

30 April – 20 May Exhibits twenty-nine works in *Das Lichtbild*, Munich. Exhibition travels to Basel and Essen.[86]

May Exhibits six photographs in *Primer Salon Annual de Fotografía*, Buenos Aires.

June Exhibits eight works in *XIème Salon de l'Araignée*, Galerie G. L. Manuel Frères. Preface to exhibition catalogue written by Carlo Rim.

22 September – 19 October Participates in *Gebrauchsgerät in Frankreich*, Gewerbemuseum, Basel.

2 November Article on Kertész's photography is published in *Ujsàg Vasàrnapja*.[87]

December Participates in exhibition organized by the "Amateur worker photographers," Paris. Other photographers include Krull, Man Ray, and Lotar.

30 December Exhibits sixteen photographs in *Exhibition of Foreign Advertising Photography*, The Art Center, New York, sponsored by Lyddon, Hanford, and Kimball, Inc. Advertising Agency.

1931

Separates from Rogi André, moves to 32 bis, rue du Cotentin.[88]

Travels on assignment to Île-de-France, Corsica, Normandy.

Erzsébet Salamon visits Kertész in Paris.[89]

Contributes photographs to Jeanne Fernandez, *Le Jardin de la Beauté: Conseils à Toutes Les Femmes*, published by the Société Anonyme "Le Jardin des Modes," of which Vogel was director, and by Publications Condé Nast. Also publishes in *Vogue* (Paris), another Condé Nast publication.

April Participates in *Photographies d'Aujourd'hui*, Galerie d'Art Contemporain, Paris.

May Participates in *Deuxième Groupe de Photographes*, Galerie d'Art Contemporain, Paris.

28 May – 15 June Exhibits two photographs in the tenth *Salon de Photographie*, Association Belge de Photographie, Brussels.

June Exhibits thirteen photographs in *Neue Sportbauten*, Gewerbemuseum, Basel.[90]

11 July – 23 August Exhibits four photographs in *Das Lichtbild*, Essen.

1932

Divorces Rogi André.[91]

Travels on assignment to Savoie, Brittany, Lyons. Begins to publish photographs in *Paris-Magazine* and *L'Image*.

February Participates in *Exhibition of Modern Photography*, Royal Photographic Society of Great Britain, London.[92]

20 February – 11 March Exhibits thirty-five photographs in *Modern European Photography*, Julien Levy Gallery, New York.

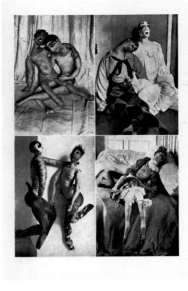

André Kertész, Distortion
photographs, in *Le Sourire*,
2 March 1933, Patrimoine
Photographique

André Kertész, Puppets,
in *Le Sourire*, 20 July 1933,
Patrimoine Photographique

André Kertész, cover,
Paris Vu par André Kertész,
National Gallery of Art

8–31 March Exhibits *Clochards, Reveille, André Bauchant,* and *Cheval de Bois* in *International Photographers,* Brooklyn Museum of Art. The four photographs are lent by the Julien Levy Gallery.

Late Spring Participates in *Modern Photography,* Albright Art Gallery, Buffalo. Two photographs, *Cheval de Bois* and *Chevaux (et Boef) de Bois,* are lent by the Julien Levy Gallery.[93]

2–31 July Exhibits six photographs in *Exposition Internationale de la Photographie,* Palais des Beaux-Arts, Brussels.[94]

November Possibly participates in exhibition on modern photography at Galerie d'Art Contemporain, Paris.[95]

1933

Enfants, text by Jaboune (Jean Nohain), sixty photographs, published by Éditions d'Histoire et d'Art, Librairie Plon, Paris.

Participates in *Deuxième Exposition Internationale de la Photographie et Cinema,* Brussels.

At the request of Louis Querelle, editor of the humorous weekly *Le Sourire,* employs mirrors to create a series of distorted nude figures. Uses 9 by 12 cm glass plate Linhof camera with Hugo Meyer Plasmat Satz Lens.[96]

2 March Twelve distortion photographs appear in *Le Sourire.*[97]

1–15 June Possibly participates in *Exhibition of Social Photography,* Brno.[98]

17 June Marries Erzsébet.

28 June Ernesztin Kertész dies; André and Erzsébet return to Budapest for funeral.

20 July Publishes photographs of puppets to accompany article on fetishes in *Le Sourire.*[99]

15 September Bertrand Guégan publishes article on photographs of distorted figures in *Arts et Métiers Graphiques:* "It is worth noting the analogy that these photographs present with certain canvases by Derain or Picasso that date from the epoch where the pictorial fashion was for huge legs and gourd-like hands. The parentage of these photographs is affirmed by several portraits by Modigliani embellished with an interminable neck, as well as by certain sculptures by Archipenko, Brancusi, and Nadelman. The latter connection is not the least unusual to signal; for the three artists that we cited originated, like Kertész, in central Europe."[100]

November Participates in *Groupe Annuel des Photographes,* Galerie de la Pléiade, Paris.

1934

Paris Vu par André Kertész, sixty photographs, text by Pierre Mac Orlan, published by Éditions d'Histoire et d'Art, Libraire Plon, Paris.

Photographs published in György Bölöni, *Az Igazi Ady* (The Real Ady).[101]

Exhibits in Galerie Leleu, Paris.[102]

15–18 February Participates in exhibition of modern photography, Salle de l'Association Florence Blumenthal, Paris.

6–30 April Exhibits two photographs in *The Modern Spirit in Photography and Advertising,* Royal Photographic Society of Great Britain, London.

July Exhibits two photographs in *Exposition de la société des artistes photographes,* Studio St. Jacques, Paris.

November Exhibits in *Groupe Annuel des Photographes,* Galerie de la Pléiade, Paris.

November Returns to Budapest on assignment; possibly stays through January 1935.[103]

23 December Article on Kertész by Làzlo Gàl in *Pesti Hirlap:* "Since 1927, Andor Kertész...has been at the head of the new wave of photography. Aside from his numerous studies, reportages,

André Kertész, Plate from *Les Cathédrales du vin*, National Gallery of Art

nudes, and landscapes, which have made his name known and admired by the readers of the most prestigious revues of Europe and America, he has published some six albums. His earlier albums, like this curious, real, oneiric 'Paris' [*Paris Vu par André Kertész*], which plays with fugitive impressions and fixes acute visions, show us integrally his fundamental qualities: the search for gentle harmonies, the use of genre scenes however small that are very characteristic, abstention from all aggressiveness, exaggeration, or violence, this filtered art where the perfection of technical know-how is already so natural that we no longer even perceive it."[104]

1935

June Participates in *Documents de la Vie Sociale,* organized by L'Association des Écrivains et Artistes Revolutionnaires (AEAR), Galerie de la Pléiade, Paris.

18 August – 1 September Participates in *Premier Exposition Internationale de la Photographie Contemporaine,* Pavillon des Escales Transatlantiques, Cannes, sponsored by Fédération Française des Cinés Clubs, and the journals *Arts et Métiers Graphiques* and *Photo-Ciné-Graphie.*

1936

Publishes *Nos amies les bêtes,* with text by Jaboune. Also publishes photographs in Marcel Natkin's *L'Art de voir et la photographie.*

16 January – 1 March Exhibits four photographs, including *The Vert-Galant under the Snow* (plate 65), in *Exposition Internationale de la Photographie Contemporaine,* Musée des Arts Décoratifs, Paris.

February Participates in *Solarisations et Peinture révélateur par Tabard,* Galerie de la Pléiade, Paris. Other photographers include Maurice Tabard, Lotar, and Herbert Matter.

27 March – April Exhibits four works in *La Photographie Vivante, Les Dix.* Galerie Leleu, Paris. Other photographers include Pierre Boucher, Roger Schall, François Kollar, Réné Zuber, Tabard, Brassaï, Nora Dumas, Ylla (Camilla Koffler), and Ergy Landau.

August Erney Prince, general manager of Keystone Press Agency, New York, initiates visa applications for André and Erzsébet.[105] Advises André to study English and "fashion photography, leaf through the American *Vogue* and *Harper's Bazaar* magazines—Hoyningen-Huene and Horst style is what is needed here, so that is what you should concentrate on. Try to think up backdrop ideas, etc."[106]

2 October Receives visa for the United States.

13 October Beaumont Newhall, Museum of Modern Art (MOMA), New York, writes to Kertész in Paris asking him to participate in *Photography 1839–1937.*[107]

15 October Arrives in New York on the SS *Washington* under contract with Keystone Press Agency, a division of Keystone View Company of New York, Inc.; first settles in Beaux-Arts Apartments at 307 East 44th Street, just down from "Studio Prince" and the Keystone Press Agency at 219 East 44th.

1937

Works as freelance photographer for *American Magazine, Collier's, Coronet, Harper's Bazaar, Look, Town and Country,* and *Vogue.* Executes series of photographs for catalogue of the New Theatre School, New York.

January *Les Cathédrales du vin,* with text by Pierre Hamp, published by Sainrapt et Brice, Paris.

17 March – 18 April Exhibits two distorted photographs and *The Vert-Galant under the Snow,* 1935 (plate 65), *Road Mender,* 1936, and *Fashion Plate,* 1937, in *Photography 1839–1937,* a large historical overview of photography curated by Beaumont Newhall for MOMA and traveling throughout the United States. Kertész also lends an album of photographs of the Paris Commune, 1871.[108]

10 July Ends contract with Keystone; legal dispute ensues.[109]

Installation view, *André Kertész, An Exhibition of 60 Photographs*, 1937, PM Galleries, Kertész Foundation

André and Elizabeth Kertész, 1941, gelatin silver print, Kertész Foundation

1–15 December *André Kertész, An Exhibition of 60 Photographs,* PM Galleries, New York.

1938

Publishes work in *House and Garden, Vogue.* Does advertising work for CBS.

Designs layout for Robert Capa's *Death in the Making.*[110]

4–18 January Exhibits work in *Pioneers of Modern French Photography,* Julien Levy Gallery.

21 April Imre and Gréti Kertész write long letter about the increasing destabilization in Europe and rise of anti-Semitism. "What tomorrow brings, no one knows…. Now it can really be seen how right it was for the two of you to leave Europe. Paris, in fact the whole of France has undergone tremendous convulsions and anxieties in this past year and a half."[111]

June Exhibits four works in the *International Photographic Salon* at the Baltimore Museum of Art.

25 October Photographs by Kertész credited to Erney Prince are published in *Look.*[112]

1939

War regulations hamper procurement of photographic materials.[113]

Suffers health problems.[114]

Represented by Wick Miller, who helps Kertész secure freelance work, including a series of photographs for General Motors of their diesel locomotives and a series of photographs on mushroom cultivation for *Collier's.* Also executes a series of publicity photographs for American Ballet Theater.[115]

August Article on distortion series appears in *Minicam.*[116] He also takes a series of photographs on the tugboat industry, concentrating mainly on New York and New Jersey harbors; some photographs taken from the Goodyear Blimp at an elevation of approximately 1,500 feet. Kertész later claimed that the series was destined for *Life:* "*it was done in the usual* Life *manner—around a central theme—Transatlantic liners. The pictures were turned in the last of August, war was declared five days later, and air shots of the docking of the* Queen Mary *and the* Normandy *were records of activities that no longer existed. The story was killed.*"[117] Several works from this series are later published in *Coronet, U.S. Camera Annual 1941, Collier's, Lamp,* and *Compass.*[118]

Late Summer Moves to 67 West 44th Street.

1940

Publishes pictures featuring the Cleveland Play House in the August 1940 issue of *American Magazine.*[119] Also publishes photographs in *Stage* magazine.

Possibly reproduces artworks for a number of New York galleries.[120]

April Exhibits at Hungarian Reference Library, New York. Exhibition is part of a series devoted to Hungarian photographers, including André Dienes, Nickolas Muray, Gabor Eder, and Martin Munkacsi.[121]

6 September Mentioned for first time by John Adam Knight, critic for *New York Post.*[122]

1941

Executes publicity photographs for the Martha Graham Dance Company and for the American Ballet Theater.

10 February–10 April Exhibits five works in group exhibition at Friendship House, New York.

29 October–February 1942 Exhibits *Armonk, New York* (plate 85) and *Peace, Vermont* in *The Image of Freedom,* MOMA. Images selected in a competition organized by Beaumont and Nancy Newhall.

André Kertész, *Paris*,
1948, gelatin silver print,
Jane Corkin Gallery,
Toronto

André Kertész, Plate
from *Day of Paris*,
National Gallery of Art

1942

January Sends five photographs to an exhibition organized by MOMA's Armed Services Division and traveling to army camps.[123]

1 July *Life* decides not to publish photographs of Trappist monks taken in late 1928.[124]

2 October Contacted by John Rewald about a possible exhibition at the E. Weyhe Gallery, New York; these plans do not come to fruition.[125]

December Receives mail at 152 West 20th Street, possibly indicating a move.[126]

31 December Favorable article by John Adam Knight appears in *New York Post:* "It was a great day for American photography when André Kertész landed on our shores—a greater day than many editors, critics, and museum curators realize as yet. Not having a flair for self-advertising, he is being 'discovered' but slowly. Yet it is most certain that in the years to come his work will be as much admired and appreciated as that of Hill, Atget, Stieglitz, Steichen, Weston, Strand and Hine."[127]

1944

Moves to 31 East 12th Street (31 Union Square).

20 January Erzsébet Salamon, who assumes the name Elizabeth Sali, becomes Unites States citizen.[128]

3 February Kertész becomes a United States citizen.

March *Marionettes de Pilsen* chosen by *Minicam Photography* to appear in special section devoted to MOMA's Photographic Center.[129]

8 – 21 April Exhibits in *The Instant in Photography,* The New School, New York, curated by Berenice Abbott.

June Profile of Kertész appears in *Minicam:* "Kertész is not a man of the past, in spite of his historical importance. He is one of our great photographers, still in our midst, very much alive. Yet, strangely enough, Kertész is something of a 'forgotten man' here in America. This is regrettable and it is an injustice."[130]

8 June László Moholy-Nagy invites Kertész to teach at the School of Design in Chicago for one semester.[131]

July Work appears in *Fortune.*[132]

5 October Application to secure preference in obtaining photographic film denied by War Production Board; appeals with letters of support from Condé Nast.[133]

1945

Day of Paris, published by J. J. Augustin, New York, layout designed by Alexey Brodovitch, 147 plates with text by George Davis. Receives numerous positive reviews.

5 March Invited by Philippe Halsman to join the Society for Magazine Photographers, which changes its name to the American Society for Magazine Photographers (ASMP) in 1946.[134]

1946

19 February Writes to Carl Schniewind, curator of prints and drawings, the Art Institute of Chicago, about whether any of the distortion photographs will be included in an upcoming solo exhibition.[135]

4 March Schniewind replies, "because of recent experiences in the exhibition of nudes…we will have to be a bit careful. The public is apt to react in the most curious sort of way."[136]

7 June – 14 July Exhibits thirty-seven photographs in solo exhibition, *Day of Paris,* at the Art Institute of Chicago.

1947

13 January Signs one-year contract with Condé Nast.

1948

Receives a commission from the French Embassy to photograph the monuments and countryside of France.[137] Also visits Budapest and Britain on this trip.

André Kertész, New-
town, *Connecticut,* 1956,
gelatin silver print,
Kertész Foundation

1949

17 February Elected to membership in the
National Geographic Society.

15 September Photographs of chimneys
returned by *Life,* which decides not to publish
them.[138]

1950

Spring André and Elizabeth each suffer health
problems.[139]

1951

Contributes photographs to *The Art and Tech-
nique of Color Photography,* edited and designed
by Alexander Liberman, and *The American
House Today,* by Katherine Morrow Ford and
Thomas H. Creighton. [140]

12 January Receives letter from Jacqueline
Paouillac informing Kertész that her parents
are leaving Paris and therefore he must make
arrangements for the retrieval of negatives
he had left behind in Paris "for commercial
exploitation with mutual benefit."[141]

5 March Joseph Hudnut, dean of Harvard Uni-
versity, sends note of thanks for photographic
portrait, calling Kertész a "master of his art."[142]

1952

Begins series of photographs of Washington
Square.

12 August Signs lease for terrace apartment
at 2 Fifth Avenue.

1954

1 February "A Photographer's Love Letter to
America," a photo essay accompanying Jacques
Barzun's essay "Love Letter to America," is
published in *Vogue.*

1955

February Suffers from health problems, likely
related to erysipelas, an acute bacterial infection
affecting the skin and underlying tissue.[143]

1956

Buys weekend house in Newtown, Connecticut.

16 December–13 January 1957 Participates in
Creative Photography, Montclair Art Museum,
New Jersey.

1957

Receives certificate of merit from Art Directors
Club, New York.

5 May–30 May Participates in exhibition
organized by the ASMP, Newark Public Library
Art Gallery, New Jersey. Exhibition travels to
Florida, Tennessee, and Louisiana.

14 or 15 November Imre Kertész dies.

1959

April Profile of Kertész appears in *Infinity.*[144]

1960

20 May–4 September Exhibits one work,
Street Scene, Nassau, in *Photography in the Fine
Arts II,* held at the Metropolitan Museum of
Art, New York. The show subsequently travels to
twenty-eight institutions across the United
States. Kertész's work was nominated by Alex-
ander Liberman.[145]

1961

Exhibits *Snow in the Park* in *Photography in the
Fine Arts III,* which opens at the Metropolitan
Museum of Art, New York, and travels to
twenty-nine museums in the United States.

11–15 September Hospitalized in Mount Sinai
Hospital, New York. Because of illness, does
not work for Condé Nast from October through
December; decides not to renew contract for
1962.[146]

1962

13 January Speaks with Jenő Kertész for the
first time since 1926.[147]

23 January Records in date book: *I called
Wheeler* [Monroe Wheeler, MOMA] *because of
the exhibition. Now it doesn't work. I gave the
material October 18, 1961.* [Edward] *Steichen
left and a new curator comes in July.*[148]

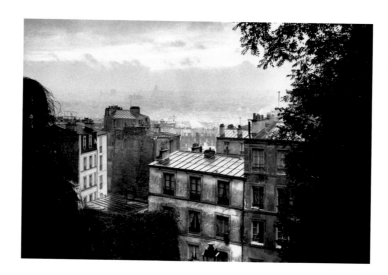

André Kertész, *Montmartre*, 1963, gelatin silver print, Kertész Foundation

24 June Departs for Buenos Aires to visit Jenő Kertész.

10 October – 9 November Exhibits over one hundred photographs in retrospective exhibition, curated by Nathan Resnick, at Long Island University, New York.

"Mr. Kertész has an eye for the warmly human situation, the moods of nature and the atmosphere of place and incident. He has a feeling for the quality of light that marked the early photographers but is rarely seen today. Occasionally reminiscent of Eugène Atget's penchant for recording the ordinary, his pictures are mainly appreciative observations rather than commentaries."[149] NEW YORK TIMES

6 November Meets with John Szarkowski to discuss possible solo exhibition at MOMA. That same day, writes to Gréti Kertész about exhibition at Long Island University: *As I give up the slave work, I start again where I stopped before I stepped onto this sacred land. In the little time that I have left, I want to live according to my own taste, if possible. Or rather, to work according to my own style.*[150]

1963

15 February – 25 June Exhibits *Marionettes de Pilsen* in *A Bid for Space, IV*, MOMA.

April *Camera* publishes portfolio of Kertész's work as well as Brassaï's article "My Friend André Kertész."[151]

Spring Exhibits *White Horses in Meadow* in *Photography in the Fine Arts IV*, Metropolitan Museum of Art, New York. Exhibition subsequently travels throughout United States.

6 June Opening reception for solo exhibition, Modernage Studio, New York, organized in conjunction with portfolio of Kertész's work in *Camera*.

"[Kertész]…retains an individuality that is distinctively his own. This combines a sympathetic feeling for warm human relationships, a sense of the importance of ordinary life situations, and a highly competent photographer's ability to communicate what he sees."[152] NEW YORK TIMES

14 September – 20 October Exhibits forty-two photographs from Hungary, Paris, and New York periods in *IV Mostra Biennale Internazionale della Fotografia*, Venice; awarded gold medal. Visits Venice for opening; travels to Budapest briefly either before or after this trip.

October – November Spends two months in Paris preparing an exhibition at the Bibliothèque Nationale. Visits friends; takes pictures in the Tuileries Gardens and Montmartre. While visiting France, arranges to recover negatives saved

for him outside Paris during the war. Also meets with many old friends and acquaintances, including Brassaï, André Jammes, and Jean Adhémar, who helped organize the exhibition at the Bibliothèque Nationale.[153]

23 October Elizabeth sends letter to Paris urging Kertész to "Go and see everyone—try to make a new career in Paris and then we will go over and live there.… I only see now how ugly it is [in New York] and how much I dislike it.… I will call and stay until I can come over and then we will never come back."[154]

15 November – 1 December *Photographes de Kertész: Budapest, Paris, New York*, retrospective exhibition at the Bibliothèque Nationale, Paris.

29 November Receives letter from Alexandre Garai, director of Keystone, Paris, and uncle of Erney Prince: "Since I last saw you, much time has passed and the world has gone through many things. I don't think you have any reason to be angry or to avoid me. Because even though the short time that you spent with Keystone in New York did not work out, I am not to be blamed for that. If you have time I would enjoy talking to you."[155]

André Kertész, *La Réunion*, 1963, gelatin silver print, Kertész Foundation

Installation view, *The Concerned Photographer*, 1967, Riverside Museum, Kertész Foundation

André Kertész, *Self-Portrait, Takayama, Japan*, 1968, gelatin silver print, Kertész Foundation

1964

27 May – 23 August Exhibits several works, including *Poughkeepsie, New York* (plate 76), *Underwater Swimmer, Esztergom* (plate 16), and *Lafayette, Munson-Williams-Proctor Museum* (plate 89) in *The Photographer's Eye*, MOMA. Nine of his photographs are included on MOMA's draft of the checklist; six are included in the catalogue.

24 July Invited to become "Contributing Photographer" by Magnum Photos, Inc.[156]

24 November – 24 January 1965 Solo exhibition *André Kertész, Photographer*, at MOMA, curated by John Szarkowski.

"The amateur spirit in photography is seldom so characteristically represented as in the retrospective exhibition by André Kertész…neither place nor time has altered this photographer's basic approach. Always there is the human touch, the warmth of spirit, and the endless capacity for surprise and a sense of wonder."[157]
NEW YORK TIMES

1965

Appointed honorary member, ASMP.[158]

16 March – 16 May Series of photographs of Trappist monks originally published in 1929 are exhibited in *The Photo Essay*, MOMA.

21 – 23 April Speaker, Miami Conference on Communication Arts, Coral Gables, Florida.

1966

André Kertész by Anna Fárová is published by Paragraphic Books, New York. Kertész dedicates book to the late Robert Capa.

Begins association with Igor Bakht, who produces archival prints of work.

1967

1 October – 7 January 1968 Participates in *The Concerned Photographer* at the Riverside Museum, New York. The exhibition, sponsored by the International Fund for Concerned Photography, Inc. (later called International Center of Photography), travels throughout the world.

1968

Summer Travels to Tokyo with Cornell Capa for opening of *The Concerned Photographer*. Meets Japanese photographer Hiroji Kubota; takes photographs in and around Tokyo.[159]

1970

Inge Bondi Ltd., The Photography House publishes *Melancholic Tulip* (plate 80) in edition of 150.

Exhibits ten photographs at United States Pavilion, World's Fair Expo, Tokyo.

5 – 28 February Solo exhibition, San Francisco Art Institute.

7 February – 3 May Exhibits portrait of Sergei Eisenstein in *Fotoportrait*, Gemeentemuseum den Haag (The Hague).

16 March – 11 April Exhibits work from Hungary and Paris periods in group show at Boston University. Other participants include Henri Cartier-Bresson, Walker Evans, Robert Frank, Joel Meyerowitz, Tod Papageorge, and Garry Winogrand.

3 June – 8 September Exhibits in *Photo Eye of the 20s*, MOMA.

1971

On Reading, with sixty-three photographs, is published by Grossman and dedicated "to my brothers." *The book has no text at all. Just my photos "speaking" for themselves. To my knowledge the first photo-book where photos are not "explained" by someone else.*[160]

Fifty Landscapes by André Kertész, Rice University, Houston, organized by Inge Bondi Ltd., The Photography House.

May Attends opening of solo exhibition *André Kertész, Fotóművész*, Hungarian National Gallery, Budapest.

June Travels to Spain with Elizabeth.[161]

4 September – 10 October *André Kertész. Fotografier 1913–1971*, Moderna Museet, Stockholm.

Installation view,
Themes and Variations,
1974, Hallmark Gallery,
Kertész Foundation

Kertész on press for
J'aime Paris, 1973,
Kertész Foundation

1972

André Kertész: Sixty Years of Photography, 1912–1972, edited by Nicolas Ducrot, with 250 photographs reproduced in heliogravure, is published by Grossman and printed in France by Braun.

"For me the photographs bring back so many cherished memories—Tihanyi outside the Dôme smoking a cigarette, Eisenstein, Katharine Károlyi, Foujita, and the portraits of those whom I didn't know personally—Colette, Chagall, Brancusi, Mondrian, Vlaminck. What a wonderful age and what wonderful people. Their faces will be remembered as you saw them." [162] STEFAN LORANT

Vacations with Elizabeth in Martinique (winter) and East Hampton (summer).

3–20 February Solo exhibition, Finnish Museum of Photography, Helsinki.

13 September–15 October *Sixty Years of Photography, 1912–1972*, The Photographer's Gallery, London. Exhibition travels to Trent Polytechnic, Delpire Gallery, Paris, and Salone Internationale Cine-Foto-Ottica (SICOF), Milan.

28 September Signs contract with LIGHT Gallery, New York, which becomes his sole representative. [163]

9 November Interviewed by Casey Allen for *In and Out of Focus*, Channel 31, New York.

1973

Begins using an Olympus 35 mm camera, Tri-X film, and two lenses, a 50 mm and a zoom. [164]

Awarded the Prix Nadar, a prize from the French government for the book *Sixty Years of Photography*.

LIGHT Gallery publishes two portfolios, each with ten prints in an edition of fifty. *André Kertész, Volume I, 1913–1929* contains *Ripples, May 11, 1913, Hungary; Underwater Swimmer, August 31, 1913; Esztergom, Swimming, September 14, 1919 Duna Haraszti; Satiric Dancer, 1926, Paris; Tihanyi, 1926, Paris; Chez Mondrian, 1926, Paris; Chairs of Paris, 1927; Meudon, 1928; Broken Plate, 1929, Paris; Sidewalk, 1929, Paris.* (See plates 16, 47, 50, 39, 58, 94; titles and dates may vary from those used in the portfolios).

André Kertész, Volume II, 1930–1972 contains *Carrefour, 1930, Blois; Elizabeth, 1931, Paris; Distortion, #6, 1933, Paris; Lost Cloud, 1937 New York; Fan, December 1937; Homing Ship, October 13, 1944; Brick Walls, October 23, 1961; Promenade, October 17, 1962, New York; Broken Bench, September 20, 1962, New York; January 1, 1972, Martinique.* (See plates 72, 78, 81, 83, 95, 97, 106).

17 January–28 February Solo exhibition, *André Kertész, Themes and Variations*, curated by Margaret Weiss, Hallmark Gallery, New York.

2 February–20 March Participates in *Nine Photographers Look Beyond* at American Greetings Gallery, Pan Am Building, New York. Other participants include Thomas Barrow, Wynn Bullock, Harry Callahan, Mark Cohen, Emmet Gowin, Keith Smith, Frederick Sommer, and Jerry Uelsmann.

April Participates in *Manhattan Now,* New York Historical Society.

June Participates in *The Twenties,* Museum Bellerive, Zurich.

19 June–22 July *Kertész: Photographs*, Friends of Photography, Carmel, California.

11 September–6 October *André Kertész*, LIGHT Gallery, New York.

4 November–4 December *André Kertész (Early Hungarian Years)*, SoHo Photo Gallery, New York.

1974

Receives John Simon Guggenhiem Fellowship to have his oxidized glass plate negatives restored by Gerd Sander, who used the same technique to clean August Sander's negatives. Applies upon recommendation of Brendan Gill of the *New Yorker*. [165]

Travels to Sydney to discuss a future exhibition. [166]

André Kertész and
Jacques Henri Lartigue,
1973, gelatin silver
print, Kertész Foundation

J'aime Paris: Photographs since the Twenties, published by Grossman, 122 photographs.

28 January–7 April *Kertész, Rodchenko, and Moholy-Nagy: Photographs from the Collection,* MOMA.

5 February–2 March *André Kertész, Photographs,* Phoenix Gallery, San Francisco.

Spring Briefly hospitalized.

10 April–12 May Exhibits nine photographs in *Eleven American Photographers,* Emily Lowe Gallery, Hofstra University, Long Island.

6 May–9 June Participates in *A Collector's Exhibit,* Midtown Gallery, New York.

1975

Washington Square, small format paperback with 102 images and foreword by Brendan Gill, published by Grossman and Viking Press.

July Solo exhibition; Kertész elected guest of honor at the sixth Rencontres Internationales de la Photographie, Arles.

20 September–15 October Solo exhibition, David Mirvish Gallery, Toronto.

30 September–8 November *André Kertész,* Galerie Agathe Gaillard, Paris.

1–25 October Solo exhibition, Yajima/Galerie, Montreal.

8–16 November Participates in *Paris, Capitale de la Photographie, 1930–1939, XXXI Salon de la Photo,* Paris.

18 December Honored by the American Society of Picture Professionals in reception at the Time Life Building, New York.

1976

Of New York, 181 photographs from 1937 to 1975, dedicated "To Elizabeth," edited by Nicolas Ducrot and published by Alfred A. Knopf.

Distortions, two hundred numbered reproductions of distortion photographs taken in 1933, introduction by Hilton Kramer, published by Knopf.

Elizabeth is diagnosed with lung cancer and undergoes surgery; remains extremely ill all year.

January Elizabeth is hospitalized.

23 January–20 February Solo exhibition, Davidson Art Center, Wesleyan University, Middletown, Connecticut.

30 January Appears again on *In and Out of Focus,* Channel 31 (New York).

10 March–11 April *André Kertész, Sixty Years of Photography,* Janet Fleisher Gallery, Philadelphia.

25 March–15 April *André Kertész and France, 1925–1975,* French Cultural Services, New York. Exhibition travels throughout United States.

"The sum of his work manifests that process of discovery which extends from pattern, yet constantly overturns pattern, and is the equivalent of healthy life itself.... Perhaps this camera's consummate pursuit of the world is not an inspired response to reality's intrigues, but a provocation of them."[167] ARTFORUM

15 April Filmed for British Broadcasting Company (BBC) special *Omnibus: Kertész.*

Spring Hospitalized for one week with phlebitis.[168]

20 May–20 October Participates in *The Golden Door: Artist Immigrants of America, 1876–1976,* Hirshhorn Museum and Sculpture Garden, Smithsonian Institution, Washington.

29 May Profile of Kertész by Stefan Fischer appears on German television.[169]

15 June–31 August Exhibits in *Neuf photographes américains,* FNAC Étoile, Paris. Other participants include Michael J. Spencer, Aaron Siskind, Doug Prince, Arnold Newman, Gowin, Bullock, Callahan, and Minor White.

14 July Appears with Lucien Clergue on French television program *Créations*, filmed at the Musée Réattu in conjunction with Rencontres Internationales de la Photographie, Arles.

Late July Checks into Doctor's Hospital, New York.[170]

Early Fall – 31 October *André Kertész, Photographs 1914–1975*, National Gallery of Victoria, Melbourne. Exhibition travels to Sydney.

20 October Attends dinner in honor of Alexander Calder at the Whitney Museum of American Art, New York.

9 November Appointed Commander of the Order of Arts and Letters by the French government at ceremony held at the French Consulate, New York, in conjunction with an exhibition at the French Cultural Services, New York.

17 November Interviewed by Barbaralee Diamonstein for *Inside the Arts*, WNYC-TV (New York).

11 December – 20 February 1977 Participates in *Photographs from the Julien Levy Collection*, The Art Institute of Chicago.

1977

Receives Mayor's Award of Honor for Arts and Culture, New York.

Everything Is Photograph: Profile of André Kertész, by John Musilli, Camera Three Productions, airs on CBS.

6 May – 12 June *André Kertész, Fotografien 1914–1972*, Städtisches Museum Leverkusen, Germany.

Spring – Summer Exhibits fifteen *Distortions* in *Malerei und Photographie im Dialog von 1840 bis Heute* (*Painting and Photography in Dialogue from 1840 to the Present*), Kunsthaus, Zurich.

24 June – 2 October Participates in *Documenta 6*, Kassel, Germany.

21 October Elizabeth dies.

9 December – 30 January 1978 *André Kertész*, a large-scale retrospective exhibition at the Centre Georges Pompidou, Paris. Artist donates two prints each of two hundred photographs to the centre; edited set travels throughout France, and is circulated in England by the Arts Council of Great Britain.

1978

Interview with Ben Lifson airs on Public Broadcast Station (PBS), New York.

20 May – 30 July *Sympathetic Explorations: Kertész/Harbutt*, Plains Art Museum, Moorhead, Minnesota.

8 July – 17 September Solo exhibition, *Biennale Internationale d'Art de Menton*, Palais de l'Europe, Menton.

6 – 30 September *André Kertész, Recent and Unseen Work*, LIGHT Gallery, New York.

12 September – 4 November *André Kertész, Recent Photographs 1975–1978*, Simon Lowinsky Gallery, San Francisco.

11 November – 14 January 1979 Exhibits seven photographs in *Neue Sachlichkeit and German Realism of the 20s*, Hayward Gallery, London.

1979

Four small-format paperbacks, *Landscapes, Americana, Birds,* and *Portraits,* with sixty-four illustrations each, edited by Nicolas Ducrot, published by Visual Books.

A Hungarian Memory, a portfolio of fifteen prints in an edition of one hundred, published by Hyperion Press.

Begins using SX-70 camera given to him by Polaroid Corporation.[171]

23 February Featured speaker for "An Evening with André Kertész," sponsored by the Photographer's Forum and the New School, New York.

1 – 31 April *André Kertész,* Galerie Municipale du Château d'Eau, Toulouse.

Summer Attends tenth Rencontres Internationales de la Photographie, Arles.

André Kertész, *Still Life*,
Kertész Foundation

16 November – 31 December *André Kertész, Homage to Elizabeth*, Equivalents Gallery, Seattle.

4 December – 5 January 1980 Participates in *France between the Wars, 1925–1940*, Zabriskie Gallery, New York; exhibition travels to Zabriskie Gallery, Paris.

29 December – 10 February 1980 *André Kertész*, Serpentine Gallery, London. Kertész travels to London for opening of exhibition, which was organized in 1977 by the Centre Georges Pompidou, Paris.

1980
Receives Medal of the City of Paris; exhibition of works at Galerie Agathe Gaillard in conjunction with prize.

Receives first annual award from the Association of International Photography Art Dealers, New York.

Exhibits in galleries across the United States, and in Canada and France, including LIGHT Gallery, New York; Susan Harder Gallery, New York; Edwynn Houk Gallery, Chicago; Janet Fleisher Gallery, Philadelphia; Jane Corkin Gallery, Toronto; and Galerie Agathe Gaillard, Paris. Continues to exhibit regularly at these and other galleries until his death in 1985.[172]

5 January BBC airs *Critic's Forum*, a round-table discussion on Kertész's exhibition at the Serpentine Gallery. Speakers include Richard Cork, Frank Kermode, Peter Porter, and Claire Tomalin.[173]

7 July – 20 August *André Kertész*, Salford University, England, retrospective exhibition of 230 photographs purchased by Raymond Slater and Norwest Holst Ltd. as a gift for the people of Salford and Manchester. In conjunction with the exhibition, Kertész receives a certificate of merit from His Royal Highness Prince Philip, Duke of Edinburgh.

7 October *Photographs of a Lifetime* opens at Israel Art Museum, Jerusalem.

21 October Visits Jerusalem on the occasion of the exhibition *Photographs of a Lifetime*.

1981
From My Window, fifty-three color reproductions of Polaroids taken from 1979 to 1981, published by New York Graphic Society/ Little Brown.

André Kertész: Still Life, a portfolio of ten photographs in an edition of thirty, with foreword by John Szarkowski, published by QED Editions.

Orminda Corporation publishes a portfolio of ten works printed by Igor Bakht in an edition of fifty: *Chez Mondrian; Eiffel Tower; Distortion #40; Satiric Dancer; Stairs, Montmartre; Mondrian's Glasses and Pipe; Fork; Melancholic Tulip; Carrefour;* and *Colette* (plates 50, 33, 69, 47, 38, 51, 52, 80).

17 February Receives second Mayor's Award of Honor for Arts and Culture, New York, presented by Arnold Newman.

30 May Receives Honorary Doctorate of Fine Arts, Bard College, Annandale-on-Hudson, New York.

15 September – 17 October *André Kertész, View: Washington Square*, Grey Gallery, New York University.

24 October – 29 November *André Kertész: A Retrospective Exhibition*, shared between three Florida venues: Cornell Fine Arts Center, Rollins College, Winter Park; Maitland Art Center, Maitland; and Galleries International, Winter Park.

1982
Receives National Grand Prize of Photography, Paris.

Appointed first member of the Honorary Trustees of the Canadian Centre of Photography, Toronto.[174]

Dorothy Gelatt, *André Kertész with the Medal of the Legion of Honor*, 1983, Kertész Foundation

André Kertész, *Self-Portrait, Hungary*, 1984, gelatin silver print, Kertész Foundation

André Kertész: A Lifetime of Perception, introduction by Ben Lifson, published by Harry N. Abrams, New York, as catalogue for exhibition circulated by the Canadian Centre for Photography, Toronto.

Hungarian Memories, 137 photographs, with introduction by Hilton Kramer, published by New York Graphic Society/Little Brown.

31 January – 21 March *André Kertész: Still Life Photographs*, Neuberger Museum, State University of New York, Purchase.

29 April – 27 June Retrospective, *André Kertész: A Lifetime of Perception*, at the Canadian Centre of Photography, Toronto, travels to Surrey Art Gallery, British Columbia.

9 July – 3 October *André Kertész, Master of Photography*, Chrysler Art Museum, Norfolk, Virginia; exhibition circulated by Southern Arts Federation.

9 July Opening of *André Kertész. Magyarországi Fényképei*, Vármúzeum, Esztergom.

18 September – 16 October *André Kertész, Vintage Fotografien auz der Zeit von 1925 bis 1930*, Galerie Wilde, Cologne.

6 December Receives the George Washington Award from the American Hungarian Foundation.[175]

1983

Receives Commander of the Order of the Legion of Honor; French government establishes an apartment for his use in Paris.

Subject of BBC series *Master Photographers*. Other photographers profiled include Alfred Eisenstadt, Bill Brandt, Andreas Feininger, Jacques Henri Lartigue, and Ansel Adams.

André Kertész: Form and Feeling, circulated by the Hallmark Photographic Collection, Kansas City. An exhibition of eighty-eight photographs spanning the years 1914 to 1972, the show travels extensively throughout the United States.

La Poesie della Simplicità, solo exhibition, Padiglione d'Arte Contemporanea, Milan.

6 May – 2 July *On Reading*, solo exhibition, New York Public Library.

27 June – 9 July *Hungarian Memories Collection*, sponsored by the American Hungarian Foundation at the Jane Vorhees Zimmerli Art Museum, Rutgers University, New Brunswick, New Jersey.

8 July Receives Honorary Doctorate from the Royal College of Art, London. Travels to Britain for the ceremony.[176]

2 September – 23 October *André Kertész, fotos, Parijs 1925–1936*, Stedelijk Museum, Amsterdam.

1984

Retrospective exhibition, National Museum of Photography, Film, and Television, Bradford, England. *André Kertész: The Manchester Collection*, a catalogue in the form of a "Festschrift," with plates and essays by colleagues honoring Kertész, published by the Manchester Collection to accompany the exhibition.

Over one hundred of Kertész's photographs purchased by the Metropolitan Museum of Art.[177]

Receives first annual Lifetime Achievement Award from the Maine Photographic Workshop.

March Travels to Paris and takes photographs of the city. While in Paris, completes footage on *André dans les Villes: Budapest, Paris, New York. Portrait d'André Kertész*, written and directed by Teri Wehn-Damisch and produced by French television. For the film, re-creates distortion experiment of 1933, using Mylar sheets in place of mirrors.[178]

André Kertész, *Self-Portrait*, 1984, gelatin silver print, Kertész Foundation

Spring Attends Budapest Spring Festival as guest of honor. Visits Budapest and Szigetbecse with fellow photographer Sylvia Plachy. Receives Order of the Banner of the Hungarian People's Republic. *André Kertész: Magyarországon* (André Kertész: In Hungary) published in conjunction with award.

15 March – 15 April *André Kertész*, Vigado Gallery, Budapest.

30 March Signs deed donating negatives and archives to the French Ministry of Culture.[179]

3 July *Paris Revisited*, exhibition in honor of Kertész's ninetieth birthday, opens at the Olympus Gallery, London.

1985

Kertész on Kertész: A Self-Portrait, published by Abbeville Press.

"André Kertész, Poet with a Camera" is completed by Bela Ugrin; airs on PBS in 1986.

Village of Szigetbecse, Hungary, establishes permanent home for Kertész's work (now the André Kertész Memorial Museum); collection includes 120 photographs donated by the artist.

16 February Receives Distinguished Career in Photography Award from the Friends of Photography, Carmel, California.

23 April Cornell Capa presents Kertész with Master of Photography award from International Center of Photography "for lifetime work which has had an extraordinary impact on the field."[180]

3 May – 9 June *André Kertész: A Portrait at Ninety*, International Center of Photography, New York. Exhibition travels to Printemps Ginza, Tokyo, and Printemps Osaka. In July, Kertész travels to Japan for opening of show.

10 May – 14 July *André Kertész: Of Paris and New York*, major retrospective exhibition at the Art Institute of Chicago, travels to the Metropolitan Museum of Art, New York (11 December – 23 February 1986) and to the Palais de Tokyo, Paris (24 April – 2 June 1986).

11 May Receives Honorary Doctorate of Fine Arts from Parsons School of Design, New School for Social Research, New York.

27 July – 29 September *André Kertész: Die Poetische Welt Eines Photographen*, Kunsthaus, Zurich.

23 August – 12 September *André Kertész: A Diary with Light*, Ernesto Mayans Gallery, Santa Fe.

3 – 29 September *André Kertész: 150 Fotografias,* Museo Nacional de Bellas Artes, Buenos Aires. Attends opening; visits ailing brother Jenő in hospital in Argentina.

28 September Dies at home in New York. Hilton Kramer gives eulogy at memorial service.

———

Note to the reader: I wish to acknowledge the meticulous research of Elvire Perego, who organized and compiled information concerning Kertész's exhibition activities in Paris. See Elvire Perego, "Expositions d'André Kertész: 1926 – 1936: la décade prodigieuse," unpublished manuscript, PP.

Notes

Notes

Note to the reader: Sources consulted include the André Kertész archive, Mission du Patrimoine Photographique, Paris (PP), and the André and Elizabeth Kertész Foundation, New York (AEKF).

Page iii

Kertész, as quoted by Jean Vidal, "En photographiant les photographes," *L'Intransigeant*, 1 April 1930.

Introduction

1 Kertész as quoted by Brendan Gill, "Outrageous Fortune — Memories of André Kertész," *Architectural Digest* 47 (September 1990), 33.

2 Gill 1990, 36, speculates that if Kertész's "fifty years in New York City were spent incessantly griping, so, I suspect, were his early years in Paris, to say nothing of his youth in Budapest."

3 Despite the fact that he moved many times — from Hungary to Paris, where he lived in several locations, and from Paris to New York, where he also had several apartments — Kertész saved a vast amount of material about his life, including diaries from his youth and teenage years; date books from throughout his life; copious amounts of correspondence sent to him by his family, friends, business acquaintances, museums, and galleries; contracts with magazines, book publishers, and commercial galleries; exhibition catalogues; articles and reviews of his work; and clippings of his published photographs. Most of this material is now at the PP; copies of some items are at the AEKF, and the National Gallery of Art, Washington.

4 See, for example, Kertész quoted by Gill 1990, 33.

5 Kertész in Jain Kelly, ed., *Nude: Theory* (New York, 1979), 117: "Photography has not influenced my life; my life has influenced my photography." See also Tamás Féner, "Presence and Consistency," in *André Kertész: Magyarországon* (Budapest, 1984), 97; Kertész, *Kertész on Kertész* (New York, 1985), 29.

6 André Kertész to Robert Gurbo, conversations from 1978 to 1985.

A Hungarian Diary, 1894–1925

1 Kertész, Diary, 25 February 1912, PP and AEKF. I am grateful to Bulcsu Veress for his sensitive translations of Kertész's diaries and letters, and for the insights he has shared with me on Kertész's life and family in Hungary. Unless otherwise noted, all translations from Hungarian to English are by him.

2 Kertész, Diary, 2 July 1924, PP and AEKF.

3 Kertész, Diary, 10 July 1924, PP and AEKF.

4 See, for example, Kertész's statement in Sylvia Plachy, "Hungary by Heart," *Artforum International* 24 (February 1986), 90: "all that is treasured in my life had its source" in Hungary.

5 For a rich description of this time in Hungarian history, as well as a discussion of the "generation of 1900" — those scientists, writers, artists, and intellectuals who came to maturity in Budapest about 1900 — see John Lukacs, *Budapest 1900: A Historical Portrait of a City and Its Culture* (New York, 1988).

6 Thomas Bender and Carl E. Schorske, eds., *Budapest and New York, Studies in Metropolitan Transformation: 1870–1930* (New York, 1994), 2.

7 See Lukacs 1988, 47–67.

8 See Lukacs 1988, 147–148.

9 For further discussion of this issue, see Lukacs 1988, xiv; and Éva Forgács, "Avant-Garde and Conservatism in the Budapest Art World: 1910–1932," in Bender and Schorske 1994, 309–331. Noting both the similarity between Budapest and Paris and the difference between Budapest and Hungary, Kertész told Barbaralee Diamonstein — *Visions and Images: American Photographers on Photography* (New York, 1981), 86 — "the French discovered that the style I had started was purely French — and Hungarian. More exactly, Budapestian. Budapest makes a difference."

10 Kertész also commented on the unusual position of Hungary: "the East and West met in Hungary…The European and Oriental cultures mixed and developed something special." Yvette Benedek, "Interview: André Kertész, 25 April 1977," manuscript, PP and AEKF. See also Károly Kincses, *Fotógrafos: Made in Hungary* (Sevilla, 2002), 314–317.

11 Anti-Semitism increased significantly in Hungary in the early 1920s following the collapse of the 1919 Communist government of Béla Kún, which had included many Jewish people in prominent positions. For further discussion, see Lukacs 1988, 187–196, and 211–212, and Bender and Schorske 1994, 29–40.

12 See, for example, Kertész as quoted by Owen Edwards, "Zen and the Art of Photography," *Voice Arts (The Village Voice)*, 5 April 1976, 99.

13 In 1982 Kertész told Krisztina Passuth that his family first lived on Bulyovszky Street in Budapest. See Passuth, "Párizsi beszélgetés André Kertésszel," *Új Mûvészet* (June 1994), 15. By 1905 they had moved to Teleki Square; see 1905 newspaper clipping, "The Little Robinson," AEKF. Unless otherwise noted, the information on Kertész's family and his early life is derived from Kertész's early diaries from 1909 to 1914 in the PP with facsimiles in the AEKF.

14 Lukacs 1988, 54.

15 As World War II approached, Andor's brother Imre, who became a Lutheran in 1919, collected birth, marriage, occupation, and death certificates for the family to prove that they were not part of the "infiltrated elements," that is, the Jews who had escaped into Hungary from Galicia and elsewhere. He also discovered that their grandfather, Kohn József Albert was a soldier in the Hungarian war of independence in 1848 and 1849. For information on the family's history, see Imre and Gréti Kertész to André and Elizabeth Kertész, 21 April 1938, 24 April 1939, and 8 May 1946, PP.

16 See Imre and Gréti Kertész to André and Elizabeth Kertész, 21 April 1938, 24 April 1939, and 8 May 1946, PP.

17 See Imre and Gréti Kertész to André and Elizabeth Kertész, 24 April 1939, PP. In his letter of 8 May 1946, Imre recounts that he spoke to a friend of their father who served with him in the Ninth Cavalry and told Imre that Lipót was rumored to be the illegitimate child of a Count with whom their grandmother had an affair. After Lipót was born, their grandfather did not accept him as his son. In an interview with James Borcoman, 27 February 1971, Kertész, when asked if he spent time in his father's bookstore, replied, "No. There was no store. He sold in the country." My thanks to James Borcoman and the National Gallery of Canada for sharing a tape of this interview with me. In 1982 Kertész told Passuth that his father "was a trader, owned some real estate as well, and also worked at the stock exchange." Passuth 1994, 15.

18 Kertész's diaries do not indicate whether Ernesztin Kertész ran the coffee shop before or only after Lipót's death in 1909.

19 When Jenő immigrated to South America in 1926 he assumed the Latin "Eugeno."

20 Kertész, in his Diary, 1910, 54, PP and AEKF, notes that he became an apprentice for two months "during which I had to walk up and down on the top of the museum in the rain and I dug 11 meters in the cemetery." Whether he was a roofer, gravedigger, or gardener is unclear. After that, he worked for eleven days as a glazier, a job that so displeased him he did not go back to pick up his pay.

21 Kertész, Diary, 28 December 1909, 49, PP and AEKF.

22 Lipót was born in Aszár and Ernesztin in Tököl. Imre and Gréti Kertész to André and Elizabeth Kertész, 8 May 1946, PP.

23 Kertész kept detailed diaries from 1909 through 1910 and again in 1912, PP and AEKF. Once he began to work in 1912, his entries become shorter, but he continued to write through 1915. He also kept diaries in 1921 and 1924, although both are fragmentary with only scattered entries. Once he moved to Paris, he kept yearly date books for the rest of his life, which usually include appointments, addresses, and brief annotations. For notations of books he read or plays he saw, see, for example, Diary, 1 October 1909, 12, and Diary, 5, 7, 12, 20, 23, and 27 February 1912, PP and AEKF.

24 His sedentary behavior gave him constipation, which he feared might "have serious consequences and I have to worry about myself." Diary, 20 December 1909, 44, PP and AEKF. "The reason I don't go to the doctor," he continued, "is that he would most likely order me to take daily walks, but then I would not be at home" to continue the surveillance.

25 Eighteen poems written between 1911 and 1912 are at the PP and AEKF.

26 Kertész, Diary, 26 September 1909, 10, PP and AEKF.

27 Kertész, Diary, 22 June 1912, PP and AEKF.

28 Kertész, Diary, 28 January 1912, 16, PP and AEKF.

29 Kertész, Diary, 28 January 1912, PP and AEKF.

30 Kertész, Diary, 15 April 1912, 55, PP and AEKF.

31 Despite the fact that Kertész's diaries start in 1909 and his entries for each day are often several pages in length, he never mentioned photography before 25 February 1912. Therefore, his claim, first asserted in the early 1960s, that when he was a child he discovered stacks of old magazines filled with illustrations in a relative's attic "and wanted to do the same thing with photography" is, perhaps, a later construction. See "André Kertész: Unsung Pioneer," *U.S. Camera* 26 (January 1963), 56. He also never mentioned in his diaries that he made photographs in his mind's eye long before he actually received a camera. The first time this is discussed in conjunction with his work was in 1963 ("André Kertész: Unsung Pioneer," 56) when the author wrote of the young Kertész, "Examining photographs of his day critically, Kertész felt that they followed painting too closely. The pictures he took in his mind were different, 'I photographed years before I touched the camera,' he said."

32 On 23 June 1912 Andor noted in his diary that Jenő took a photograph of the three Balog sisters, yet the next day, referring to the same photograph, he wrote of the "picture I took of them." Later in his life he told Béla Tarcai, "The experience is mine and therefore every picture belongs to me even if I made it through someone else." Kertész as quoted by Béla Tarcai, *Guide to Photographic Art* (Budapest, 1964), 61–69, published by the Hungarian Amateur Photography Group.

33 Kertész, Diary, 23 June 1912, PP and AEKF.

34 Kertész, Diary, 24 June 1912, PP and AEKF.

35 Kertész, Diary, 13 July 1913, PP and AEKF.

36 Kertész, as quoted by Avis Berman, "The 'Little Happenings' of André Kertész," *ArtNews* 83 (March 1984), 68.

37 Kertész told Ben Lifson he "absorbed" the paintings he saw in Hungarian museums; see Interview with Ben Lifson (unpublished transcript, tape 2, 1981–1982, page 1). I would like to thank Ben Lifson for sharing with us a transcript of his extensive interviews with Kertész. Endre Ady, "The Kiss," *20th Century Hungarian Short Stories* (Budapest, 1993), 7–13.

38 In "Avant-Garde and Conservatism in the Budapest Art World: 1910–1932," in Bender and Schorske 1994, 309–331, Forgács points out the ambivalent embrace of modernism by Hungarian artists at the turn of the century. Lukacs 1988, 187–213, discusses the rift that began to develop, even before war, between the more modern, cosmopolitan Budapest and the more traditional, rural rest of the country, as well as the rift between Jews and non-Jews.

39 Kertész, Diary, 25 October 1914, 141, PP and AEKF.

40 Kertész, Diary, 1915, 3, PP and AEKF.

41 Dr. Friedrich Groszmann in a letter to Kertész, 31 October 1915, PP and AEKF, included a copy of an article he wrote describing the "event we went through together" that was published in *Egyenlöség* (described as a weekly of Hungarian Jewry) on 24 October 1915.

42 Kertész, Diary, 15 July 1915, PP and AEKF.

43 Kertész to Jolán Balog, 27 August 1915, PP and AEKF. Kertész was probably wounded very shortly after he wrote this postcard, for by 8 September 1915 he was in a hospital in Eperjes. See Kertész, postcard, 8 September 1915, PP and AEKF.

44 See Dr. Friedrich Groszmann to Kertész, 13 October 1915, PP and AEKF.

45 Information derived from Dr. Friedrich Groszmann to Kertész, 15 June 1916; and Boriska Fischel to Kertész, spring 1916 and 15 April 1922, PP and AEKF.

46 Kertész was stationed with the Twenty-sixth Regiment in Esztergom. See János Bodnár, "Talking to André Kertész," in *André Kertész: Magyarországon* (Budapest, 1984), 91.

47 Information gleaned from Kertész's diaries and papers from 1916 to 1918, PP and AEKF, reveals that he traveled great distances to such places as Prague, Brno, Graz, Vienna, Bucharest, and Sarajevo, as well as deep into Poland and on the Adriatic Sea. In "André Kertész: Unsung Pioneer," *U.S. Camera*, 1963, 64, Kertész told the author that he escorted "convalescent troops to Austria, Czechoslovakia and Poland." In *12 at War* (New York, 1967), 47, he told Robert E. Hood that after he was wounded he was sent to take charge of a small Russian prisoner camp by the Black Sea. However, the exact nature of his duties from late 1916 until he was discharged in 1918 remains unclear, nor is it known why the military authorities felt it necessary for him to accompany ordinary soldiers (not officers or prisoners), occasionally only one or two at a time, such great distances.

48 Stefan Lorant, unpublished manuscript included with copies of *Érdekes Újság*, Stefan Lorant Papers, The Research Library, The Getty Research Institute, Los Angeles (920024). Lorant's claim is overstated, as there were many other magazines that shared a similar layout and approach to *Érdekes Újság*, including *La Vie au Grand Air*, *L'Illustration*, and *Leslie's Weekly*, to name but a few. However, as Lorant was born in Hungary and grew up in Budapest, his comments indicate the importance of *Érdekes Újság* to the Hungarian community at the time.

49 "Ez Pest," *Érdekes Újság*, 23 March 1913, 30–32, and "Fehér éjszakák," *Érdekes Újság*, 23 March 1913, 26–27.

50 *Érdekes Újság*, 26 December 1914. See also Gábor Szilágyi, "An Album of War," in Colin Ford, ed., *The Hungarian Connection: The Roots of Photojournalism* (Bradford, England, 1987), 10.

51 *Az Érdekes Újság: Háborus Albuma* (Interesting Newspaper: Wartime Album) (Budapest, 1915–1916).

52 *Érdekes Újság*, 27 June 1915, 17.

53 "A Borsszem Jankó háborus rajz- es fénykép-pályázata," *Borsszem Jankó*, 14 November 1915, 8.

54 Jenő Kertész to Andor Kertész, 17 November 1914, PP and AEKF. Andor received the camera in early December 1914.

55 Kertész, Diary, 28 March 1915, PP and AEKF. For reproductions of several of these photographs, see *André Kertész: Inediti a Gorizia — Dicembre 1914 – Marzo 1915* [exh. cat., Musei Provinciali di Gorizia] (Gorizia, 2003).

56 Andor Kertész to Jenő Kertész, 11 August 1915, PP and AEKF. Indicating that they were still collaborating closely, at least on making prints, Andor continued, "We might have time to make first-class copies together if I may ever get home."

57 For further discussion of Kertész's knowledge of Hungarian photographically illustrated periodicals, see Lifson, 1981, tape 2, pages 6–8. Andor Kertész to Jenő Kertész, 11 August 1915, PP and AEKF. Postcards from Jenő to Andor, dated 19, 22, and 23 August 1915, suggest that Andor was making prints at the front. On 22 August, Jenő asks Andor to "send me copies of those pictures"; on 23 August, Jenő lists "plates, papers, developing [chemicals] and gold toner as included in a package to be sent the next day."

58 "A Borsszem Jankó," *Borsszem Jankó*, 20 February 1916, 12. Kertész was described as a "volunteer (Budapest, Franz Joszef Hospital)." For his ninth prize, he won a "Shrapnel Calendar" illustrated by Marcel Vertes. He may also have won the fifth prize, a Zőrád drawing, for a photograph submitted by "Kertész Jenő (lieutenant), Russian front." In later years, Kertész repeatedly said that he submitted the photograph of him picking lice off his clothing to a *Borsszem Jankó* competition. See Bodnár 1984, 92.

59 "Negyedik 3000 Koronás fényképpályázatunkra beérkezett pályamüvek," *Érdekes Újság*, 25 March 1917, 10 and 12. Another of Kertész's photographs was published in *Érdekes Újság*, 5 August 1917, 5. Acknowledging the importance of *Érdekes Újság*, Kertész later told Paul Hill and Tom Cooper, "We had a very good illustrated paper in Hungary then, called *Érdekes Újság*, which means Interesting Newspaper. There were many very good and intelligent Hungarian photographers" (Paul Hill and Tom Cooper, eds., *Dialogue with Photography* [New York, 1978], 45). Without specifically referring to *Érdekes Újság*, Kertész also recalled the pioneering "photo-illustrated magazine we had in Budapest," noting that they had a "photo-culture" long before other Western countries (Interview with Borcoman, 1971).

60 In 1981, when asked by Barbaralee Diamonstein why he never made photographs of "the bloody scenes of battle," Kertész testily replied, "Look, I was in the front line. It wasn't possible to take photographs in battle. I am sure my officer would not have understood" (Diamonstein 1981, 85).

61 See, for example, Kertész as quoted in Diamonstein 1981, 82, and in Berman 1984, 68.

62 In conversations with Robert Gurbo, from 1978 to 1985, Kertész recalled that he had a machinist build a self-timer for him.

63 Kertész, as quoted in "Kertész: Dénes Dévényi Interviews the 'Father of 35mm Vision,'" *Photo Life*, 3 (January 1978), 11.

64 See note 23 for a discussion of Kertész's diaries and date books.

65 Later in his life Kertész repeatedly insisted that many of his negatives were destroyed during the war. Although the details varied from story to story, he appears to have been based in Esztergom in 1916 after he had recovered from his wound. When he returned there at the end of the war, the barracks were deserted and whatever equipment, negatives, and pictures he had left were gone. (See Bodnár 1984, 91, and Diamonstein 1981, 85.) However, many negatives, no doubt those he had sent to Jenő, did survive.

66 Kertész interview with Krisztina Passuth (Passuth 1994, 18). Kertész continued: "But then I saw what happened during the Commune....I read and heard that my friends were executed for nothing, nothing but for the act of killing....What happened was a horror."

67 He later told Jacob Deschin, "Kertész," *Popular Photography* 55 (December 1964), 42, that he tried to "avoid the bombastic, sensational and contrived."

68 Kertész, as quoted by Berman 1984, 69.

69 Bodnár 1984, 91.

70 When Szőnyi exhibited his works in the Palace of Art's Winter Show, 1919–1920, they were widely praised; shortly thereafter he received the prestigious Szinyei Award. In 1921 he had a retrospective exhibition at the Ernst Museum, Budapest, and regularly exhibited at the annual exhibitions in the Palace of Art throughout the 1920s. For further discussion, see András Zwickl, "The Pictures of the Ideal and the Real," in *In the Land of Arcadia: István Szőnyi and His Circle* [exh. cat., Hungarian National Gallery] (Budapest, 2001), 57.

71 Count Kunó Klebelsberg, 1922, as quoted in György Szűcs, "Among the Décor of History — Pessimism and Quests for Intellectual Paths in the 1920s," in *In the Land of Arcadia*, Budapest, 2001, 50.

72 For further discussion of the return to conservative ideals in Hungarian art in the early 1920s, see *In the Land of Arcadia* 2001, 47–59, and Forgács, "Avant-Garde and Conservatism in the Budapest Art World: 1910–1932," in Bender and Schorske 1994, 309–330. For a discussion of the similar occurrence in French art of this time, see Kenneth Silver, *Esprit de Corps* (Princeton, 1989), and Romy Golan's *Modernity and Nostalgia: Art and Politics in France between the Wars* (New Haven, 1995).

73 Simon Hollósy and Iványi Grünwald, 1895, as quoted in Lajos Németh, *Modern Art in Hungary* (Budapest, 1969), 16.

74 Kertész told Lifson he "had nothing to do" with Kassák (Interview, 1982, tape 11, page 8). Oliver A. I. Botar with M. Phileen Tattersall, *Tibor Pólya and the Group of Seven* [exh. cat., University of Toronto, Justina M. Batnicke Gallery] (Toronto, 1989), 39, identified Aba-Novák and the artist Emil Kelemen in Kertész's 1923 photograph reproduced in *Hungarian Memories* (Boston, 1982), 74. Kertész also spoke about these artists with Lifson (1981), saying that Aba-Novák offered him "steady" encouragement (tape 1, page 4); he described Szőnyi as "very sensitive" (tape 6, page 6); he told Borcoman (1971) that after the war, all his friends were artists, and he described Aba-Novák as an "excellent" painter; and he told Bodnár (1984, 91) that they were "close friends." In addition, Kertész owned a number of prints by Aba-Novák, dated 1922 and 1923, that the artist gave him just before he left for Paris (Lifson, tape 6, page 8); one print by Imre Czumpf, dated 1925; one print by Károly Patkó, dated 1925; one work by Alexander (Sándor) Laicht, dated 1919; and one work by Sándor Norodi (or Kórodi), dated 1922. All are now in a private collection in New York. Information on Erzsébet Salamon is from Kertész's Diary, 6 February 1924, PP and AEKF.

75 Kertész mentioned Imre Nagy in his Diary, 17 June 1924 and told Lifson (Interview, 1981, tape 6, page 2) that Nagy was in the same hospital with him during the war. In a letter to Béla Tarcai, 24 March 1964, Kertész mentioned Imre Czumpf, Aba-Novák, Kelemen, and an artist named Ratkó. In his 1982 interview with Krisztina Passuth, he mentioned Pál Pátzay and Emil Novotny (Passuth 1994, 18). And he photographed Zilzer in 1921 (National Gallery of Art).

76 Their exhibition was held at the Alkotás Müvészház; see *In the Land of Arcadia* 2001, 116.

77 For further discussion, see Ferenc Zsákovics, "'The Young Hungarian Etchers'—The Renewal of Graphical Art after the First World War," in *In the Land of Arcadia* 2001, 65–71.

78 Kertész owned prints by Aba-Novák, Károly, and Czumpf, now in a private collection in New York; see note 74.

79 As quoted by Németh 1969, 80.

80 As quoted by Németh 1969, 80.

81 For further discussion, see Mihály Simon, *Összehasonlító Magyar Fotótörténet* (Budapest, 2000), 129–164.

82 Balogh as quoted by Károly Kincses, *Fotógrafos Made in Hungary: Los que se Fueron, Los que se Quedaron* (Madrid, 2003), 336.

83 The National Association of Hungarian Amateur Photographers (Magyar Amatörök Országos Szövetsége, MAOSZ) was founded in 1905 and the Photo Club, dedicated to improving the quality of Hungarian art photography, was established in 1899. See Károly Kincses, *A Magyaros Stilus* (Kecskemét, Hungary, 2001), 48.

84 Dr. Sándor Fejérváry to Kertész, 11 September 1922, PP and AEKF. It appears that only members of either the National Association of Hungarian Amateur Photographers or the Photo Club could submit work to this annual exhibition. In the listing of the 1924 exhibition, Kertész's photographs were included with those of other members of the National Association of Hungarian Amateur Photographers; "Tárgymutató," *Fotomüvészeti Hirek* (1924), 27.

85 "Tárgymutató," *Fotomüvészeti Hirek* (1924), 27. Although he often misremembered the date, Kertész later in his life repeatedly insisted that he was asked to make bromoil prints of the work he submitted to either the 1922, 1923, or 1924 annual exhibition of the National Association of Hungarian Amateur Photographers. When he refused, he said he was not given a silver medal, but only an honorable mention. (See, for example, interview with Dévényi in *Photo Life*, 1978, 11.) Kertész's copious archive contains no reference to this event, only a letter from Dr. Sándor Fejérváry to Kertész, 11 October 1922, PP and AEKF, cited in note 84. In a slightly different version of this story, Kertész told Bodnár, "there was a competition at the time, where I also entered. They accepted the two photographs I submitted, but they were hardly noticed at the side of the drawing-room photography that was decisive then" (Bodnár 1984, 91).

86 Károly Kincses, *Angelo* (Budapest, 2002), 392.

87 On 23 May 1924 Kertész wrote in his diary, PP and AEKF, "Angelo offers to teach me photography, that I should be a photographer." On 30 May 1924, he wrote, "I told Angelo that I accept his offer. He postponed the beginning until September or October, when there will be work."

88 In Interview with Borcoman, 1971, Kertész said that Angelo offered to teach him how to become a professional photographer and suggested that he may have briefly worked in Angelo's studio, "sometimes holding the light." In this same interview, Kertész also spoke about taking a group of photographers to Budafok. A photograph of this outing is in the collection of the National Gallery of Art. In an interview quoted by Kincses in *Angelo* 2002, 57, Kertész said that Angelo was a homosexual; this may have been one of the reasons why he did not accept the apprenticeship, for he wrote in his 1924 diary that Angelo had given him "pictures…with smarmy dedications. I don't like it."

89 Jenő Kertész to Andor Kertész, 29 July 1926, PP.

90 *Evening in the Taban* was printed on the cover of *Érdekes Újság*, 26 June 1925. In Interview with Borcoman, 1971, Kertész claimed that he actually made the photographs credited to Angelo and reproduced in "A Pesti rue de la Paix: A Váci-Utca Huszonnégy Órája," *Szinházi Élet*, 4 January 1925, 44–45. He told Borcoman that his friends at that time told him, "if you can do this, [you] will have fantastic success." Although Angelo was a frequent contributor to *Szinházi Élet* (Theater Life), the photographs published in "A Pesti rue de la Paix," look more like Kertész's work than Angelo's soft-focus, pictorial studies. Further supporting his claim, Kertész took a copy of this publication to Paris (perhaps to show to prospective employers) and then to New York. As he preserved almost no work by other photographers in his archive, he clearly considered these his photographs. If they are his, their publication in 1925 may also have encouraged him to believe he could carve out a career for himself as a photographer.

91 On 10 March 1921 Kertész spoke to the director of Hungarian Steel Products about a job, and noted in his diary: "They inquired about my religion. They want to get more information." On 24 March 1921 he was denied a job "with the false pretext" that a manager at the company opposed him. After taking another job where he worked on some kind of press, fellow employees complained that his "being Jewish was [a] problem." Diary, 17 April 1921, PP and AEKF. Kertész told Bodnár that he worked in an "estates office" after the war. However, no evidence has been found of this employment in his diaries or letters of the period (Bodnár 1984, 91).

92 Although in later years Kertész repeatedly said that he worked in a "stock exchange" both before and after World War I, the only reference in his diary to one is on 8 February 1924, PP and AEKF, where he wrote that he "teeter[ed]" at the stock exchange in a daze."

93 Kertész, Diary, 10 July 1924 and 12 July 1924, PP and AEKF.

94 My thanks to Sándor Szilágyi for suggesting Kertész may have selected Paris because of his love for Ady's poetry.

95 Kertész, Diary, 22 July 1924, PP and AEKF.

Page 20

Kertész Andor, Diary, 26 September 1909, AEKF and PP.

To Become a Virgin Again, 1925–1936

1 A stamp on Kertész's passport indicates he arrived in Paris on 8 October 1925, PP. On 17 November 1925 he signed his "Extrait du Registre d'Immatriculation," as "André Kertész" and stated his profession as "photo reporter," PP. All translations from French are by Sara Cooling and Sarah Kennel, and from German by Sabine Kriebel.

2 On 27 October 1925 Imre Kertész wrote to André Kertész reminding him to renew his visa if he wanted to stay in France. Kertész told Borcoman, 1971, that if he had not found a job shortly after his arrival in Paris he intended to return to Budapest: "I should find something or leave," he said.

3 For further discussion of this issue, see Kenneth Silver, *Esprit de Corps: The Art of the Parisian Avant-Garde and the First World War, 1914–1925* (Princeton, 1989); and Romy Golan, *Modernity and Nostalgia: Art and Politics in France between the Wars* (New Haven, 1995).

4 Janet Flanner, *Paris Was Yesterday* (New York, 1972), xxiii.

5 See Jenő Kertész to André Kertész, 2 December 1925, PP; Imre Kertész to André Kertész, 27 October 1925, PP; and Anonymous to André Kertész, 29 October 1925, PP. See also "André Kertész: Unsung Pioneer," *U.S. Camera* 26 (January 1963), 64.

6 On 1 January 1926 Kertész was issued a press pass from Continental Photo, an agency located in Berlin and Budapest, PP.

7 Certificate of employment from L'Atelier Moderne, Boulogne sur Seine, 3 April 1926, PP. "Kertész András," *Pesti Futár*, 25 December 1929, 21–22. See also Max Winterstein and Imre Kertész to André Kertész, 2 July 1926, PP.

8 Carte d'auditeur, École National d'Arts et Métiers, 1926–1927, PP.

9 See the chronology in this publication for a listing of the various places where Kertész lived or received mail during his years in Paris.

10 Imre Kertész to André Kertész, 11 January 1926, PP; and Max Winterstein and Imre Kertész to André Kertész, 2 July 1926, PP.

11 Max Winterstein and Imre Kertész to André Kertész, 2 July 1926, PP.

12 Sandra S. Phillips, "André Kertész: The Years in Paris," in Sandra S. Phillips, David Travis, and Weston Naef, *Of Paris and New York* (New York, 1985), 17.

13 For further discussion of this idea, see Phillips, in *Of Paris and New York* 1985, 17.

14 Michel Seuphor later claimed that he suggested Kertész take this photograph. See Sandra S. Phillips, "The Photographic Work of André Kertész in France, 1925–1936: A Critical Essay and Catalogue" (PhD diss., City University of New York, 1985), and Michel Seuphor with Rik Sauwen, Germaine Viatte, *Seuphor* (Antwerp, 1976), 313. Kertész, who seems to have had a falling out with Seuphor, later denied his claim. Mistakenly claiming that the photograph was made on the Champs-Élysées, he wrote, "I went walking with a painter friend of mine who was a deaf mute [Tihanyi], and I saw those chairs on the Champs Elysées and started to photograph them. He went berserk and signaled me that I am crazy. But when he saw the result he understood what I was after." See *Kertész on Kertész: A Self-Portrait* (New York, 1985), 74.

15 Krisztina Passuth, "Párizsi beszélgetés André Kertésszel," *Új Művészet* (June 1994), 15–21, 74–76.

16 See Jenő Kertész to André Kertész, 2 December 1925, 15 December 1925, and 28 December 1925, PP, in which he tells his brother that the family plans to give him a "new model, barely used" Goerz Ango Anschutz camera, 10 by 12.5 cm, with a Goerz Dagor 150 mm lens and a shutter with speeds from 1/15 to 1/1000 of a second. While Kertész was still in Budapest, Jenő urged his brother to accept a commission to make photographs of a home redecorated by their friend, the artist Imre Czumpf. While making the photograph, Jenő had what Kertész described as the "brilliant idea" to put black paper behind the curtain to suggest evening light. See Passuth 1994. Once Jenő moved to Argentina he offered to sell his brother's photographs to the Argentinean newspapers; see Jenő Kertész to André Kertész, 5 February 1927, PP.

17 Jenő Kertész to André Kertész, 29 July 1926, PP.

18 Jenő Kertész to André Kertész, 13 November 1926, PP.

19 Jenő Kertész to André Kertész, 13 November 1926, PP.

20 Late in his life Kertész once admitted that he and his friends in Paris "were like a big family and each of us borrowed artistic ideas from the other"; see "The World of Kertész," *Show* 4 (March 1964), 56.

21 For further information on Tihanyi, see Valérie Vanília Majoros, *Lajos Tihanyi: Írásai és Dokumentumok* (Budapest, 2002); Valérie Vanília Majoros, "Lajos Tihanyi and His Friends in the Paris of the 1930s," *French Cultural Studies* 11 (2001), 387–395; and Valérie Vanília Majoros, "Berlin et Paris de Lajos Tihanyi," *Hungarian Studies* 11 (1996), 97–113.

22 Jan Sliwinsky's name is frequently also spelled Slivinsky. However, as it was printed with the "w" in several exhibition announcements issued by his gallery, that spelling has been used in this publication.

23 Lajos Tihanyi, "What Is Painting?" June 1928, reprinted in Majoros 2002, 275.

24 Kertész told David Travis that he was an "autodidact," and that Tihanyi did not influence him artistically. Interview with Travis, Edwynn Houk, and Nicholas Pritzker, ©1991. My thanks to David Travis for sharing these tapes with me.

25 The painter Jenő Barcsay, who knew Kertész in Paris in the 1920s, later recalled, "it is impossible to think of Kertész's work apart from painting." János Bodnár, "Space and Form," in *André Kertész: Magyarországon* (Budapest, 1984), 95.

26 Although his speech was labored and barely intelligible, Tihanyi's voice was often described as "booming." See Majoros 2001, 389.

27 See, for example, Tihanyi to Kertész, 24 December 1926, PP, in which he arranges for Kertész to photograph "the family of a bishop at my place. I set a maximum of 100 francs for the first six pages, but you will raise that for other Americans if you will, as we hope, be successful." He continued, asking Kertész not to make too many prints of his new painting "because I do not want to keep handing them out…but do not take this as a sign of mistrust in your work. It is a beautiful, good picture." Kertész appears to have photographed other artists' works. See *Magyar Iparművészet*, issues 1 and 2 (1928), which notes that most of the reproductions of the paintings, sculptures, and textiles were made from Kertész's photographs. Also, André Lurcat to Kertész, 13 December 1926, PP, notes that Kertész was taking photographs of Lurcat's "fashion house."

28 Majoros 2002, 376.

29 Majoros 2002, 376. Kertész also photographed a spoon in a bowl with sugar cubes (now in the collection of the J. Paul Getty Museum), suggesting that the *Fork* may have been part of a larger series of photographs on kitchen utensils. See Jean Gallotti, "La Photographie: Est-Elle un Art?" *L'Art Vivant* 5 (1 March 1929), 209.

30 Tihanyi, "What Is Painting?" June 1928, quoted in Majoros 2002, 274.

31 Piet Mondrian, "Neo-plasticisme. De Woning—De Straat—De Stad," *i10*, 1 (1927), 12–18. The published article does not include any of Kertész's photographs; instead, Mondrian used photographs by Paul Delbo.

32 Kertész's date books indicate that he visited Mondrian several times in 1926 and 1927, including 19 and 20 August 1926, 2 September 1926, 30 November 1926, and 1 and 10 January 1927, PP. Seuphor remembered that when Kertész first met Mondrian, he spoke no French and only a few words of German. He also recalled that Kertész photographed Mondrian on several different occasions. See Michel Seuphor, "Seuphor's Hat: Memories of 26 Rue du Départ Paris," in Cees Boekraad, ed., *26, Rue du Départ: Mondrian's Studio in Paris, 1921–1936* (Berlin, 1995), 9–16. For further discussion, see David Travis, "André Kertész: The Gaiety of Genius," in *At the Edge of Light: Thoughts on Photography and Photographers, Talent and Genius* (Boston, 2003), 35–50.

33 In "Seuphor's Hat" (Boekraad 1995), 13, the author notes that because his straw hat could be seen hanging in *Chez Mondrian* the photograph was made in the summer of 1926.

34 Seuphor remembered that Mondrian kept an artificial tulip on the table at the entrance to his studio and that "an artificial leaf which went with it was painted white by Mondrian to banish entirely any recollection of the green he found so intolerable." Michel Seuphor, *Piet Mondrian: Life and Work* (New York, 1955), 86 and 160.

35 Mondrian 1927.

36 Alfred Roth, as quoted in "'Earthly Paradise': The Secrets of Mondrian's Studio," in Boekraad 1995, 33.

37 In "Seuphor's Hat" in Boekraad 1995, the author remembered that he told Kertész what to photograph in Mondrian's studio: "He would make all the photographs I asked him for, as well as a few extra." However, Kertész told Paul Hill and Thomas Cooper, "A year after I did my 'Entrants de Mondrian,' a critical essay was published about one of these photographs. The writer had discovered exactly why this picture was slanted, he had never seen a picture cut in the middle before, with the design and the light balanced. But I had done the picture without knowing, very naturally." See Paul Hill and Thomas Cooper, *Dialogue with Photography* (New York, 1979), 47.

38 See cat. 50, *Of Paris and New York* 1985, 152. As documented in photographs by Paul Delbo, at least two examples of Mondrian's diamond paintings hung in his studio during the months Kertész visited. See E. A. Carmean Jr., *Mondrian: The Diamond Compositions* [exh. cat., National Gallery of Art] (Washington, 1979), 37.

39 See Carmean, *Mondrian*, 1979, 37–38.

40 Léger, as quoted by John Golding, *Visions of the Modern* (Berkeley, 1994), 134.

41 Paul Delbo's 1926 photograph on Mondrian's studio includes *Pier and Ocean 5*; see Yve-Alain Bois, Joop Joosten, Angelica Zander Rudenstine, and Hans Janssen, *Piet Mondrian, 1872–1944* [exh. cat., National Gallery of Art and the Museum of Modern Art] (Washington and New York, 1994), 51.

42 See, for example, *Pierre Demaria* in *André Kertész: In Focus* (Los Angeles, 1994), 68.

43 "Lehet, hogy a bakancsunk otromba, de a világháború idején mi nem öltűnk embert…" *Magyar Hirlap*, 17 October 1926, 7, PP, and "Egy Magyar fényképész, Párizsban," *Magyar Hirlap*, 28 October 1926, 7.

44 The exhibition appears to have been originally scheduled to open earlier in 1927, but Kertész, for unknown reasons, postponed it. See Imre Kertész to Andre Kertész, 3 February 1927 and 9 February 1927, PP.

45 Seuphor et al. 1976, 68–69, and 312.

46 Paul Dermée, "Kertész," *Exhibition Announcement* (Au Sacre du Printemps, 12–24 March) (Paris, 1927).

47 The specific photographs Kertész exhibited have been identified in *Stranger to Paris: Au Sacre du Printemps Gallerie, 1927*, Introduction by Robert Enright (Toronto, 1992).

48 Kertész's photograph illustrated a library by Szinesy and Ernő Goldfinger; see *Documents internationaux de l'esprit nouveau*, 1 (1927), unpaginated.

49 Montpar, "Photo-Kertész," *Chantecler*, 19 March 1927.

50 "Art and Artists," *Chicago Tribune*, 13 March 1927.

51 "Beaux-Arts," *Comoedia*, 12 March 1927.

52 "Neue Fotografie," *Tageschronik der Kunst*, 8 (July 1927), 29–30.

53 Kertész, as quoted by Hill and Cooper 1979, 48.

54 Interview with Borcoman, 1971. As Ian Walker notes in *City Gorged with Dreams: Surrealism and Documentary Photography in Interwar Paris* (Manchester, England, 2002), 168, Henri Cartier-Bresson remarked in 1974 that the Hungarian photographer Robert Capa told him that he "must not have a label of a surrealist photographer. If you do, you won't have an assignment and you'll be like a hothouse plant. Do whatever you like, but the label should be 'photojournalist.'"

55 *Of Paris and New York* 1985, 259, notes that on the verso of a print of his photograph *Legs*, which was first reproduced in 1928, Kertész wrote, "Interesting coincidence. They claim it as being surrealistic, if it suits people better." The authors also note that this print is at the J. Paul Getty Museum; however, its print of this photograph does not bear this inscription.

56 Dermée was never officially accepted by Breton as a member of the group, most likely because he had used the term "surrealist" in a 1920 article in *L'Esprit Nouveau*, four years prior to Breton's *Surrealist Manifesto*.

57 Dermée as quoted by Matthew Gale, *Dada & Surrealism* (London, 1997), 217.

58 "Brassaï: Talking about Photography: An Interview with Tony Ray-Jones," *Creative Camera* 70 (April 1970), 121.

59 For a different interpretation of Kertész's relationship to surrealism, see Dominique Baqué, "Paris, Kertész: Elective Affinities," in Pierre Borhan, ed., *André Kertész: His Life and Work* (Boston, 1994), 86–88.

60 Breton wrote: "The invention of photography dealt a mortal blow to old means of expression, as much in painting as in poetry, where automatic writing . . . is a veritable photography of thought." For further discussion of this quote and surrealist documentary photography, see Walker 2002, 10; Nancy Hall-Duncan, "Out of Context," *Afterimage* (April 1986), 18–19; Steven Edwards, "Gizmo Surrealism," *Art History* 10 (December 1987), 509–517; and John Roberts, *The Art of Interruption: Realism, Photography and the Everyday* (Manchester, England, 1998), 98–113.

61 Salvador Dalí, "La Photographie: Pure Creation de l'esprit," *L'Amic de les Arts* (Sitgès) 18 (30 September 1927). See also Christopher Phillips, "Resurrecting Vision: The New Photography in Europe between the Wars," in Maria Morris Hambourg and Christopher Phillips, *The New Vision: Photography between the World Wars* (New York, 1989), 98–99.

62 For an extensive discussion of *Nadja* see Walker 2002.

63 Kertész told James Borcoman that he first saw Atget's photographs in the 1928 *Premier Salon Indépendant de la Photographie*, known as the *Salon de l'Escalier*, and he described Atget's work as "very honest, sensitive documentation." But, stressing what he perceived to be the differences between their work, he said Atget's photographs were "too static. Look, I was the first to interpret the real Paris. He documented." Interview with Borcoman, 1971.

64 Robert Desnos, "Spectacles of the Street—Eugène Atget," reprinted in Christopher Phillips, ed., *Photography in the Modern Era: European Documents and Critical Writings, 1913–1940* (New York, 1989), 16–17.

65 Man Ray, as quoted in "Man Ray," *Dialogue with Photography* (New York, 1979), 18. See also Maria Morris Hambourg, "Atget: Precursor of Modern Documentary Photography," in David Featherstone, ed., *Observations: Essays on Documentary Photography* (Carmel, Calif., 1984), 25–39.

66 "Bruxelles: Exposition de photographie (Galerie de l'Époque)," *Cahiers d'Art* 8 (1928), 356. The forthcoming monograph referred to in the quote was most likely the 1930 publication *Atget, photographe de Paris*, with an essay by Pierre Mac Orlan.

67 Pierre Mac Orlan wrote several important articles on photography in the late 1920s and early 1930s, including "La Photographie et le fantastique social," *Les Annales* (1 November 1928), 414; "L'Art littéraire d'imagination et la photographie," *Les Nouvelles littéraires* (22 September 1928), reprinted in Phillips, *Photography and the Modern Era*, 1989, 27–30; and "Éléments de fantastique social," *Le Crapouillot* (January 1929), reprinted in Phillips, *Photography and the Modern Era*, 1989, 31–33, as well as several introductions to books of photographs, including *Atget, photographe de Paris* (New York, 1930); *Photographes nouveaux: Germaine Krull* (Paris, 1931); and *Paris Vu par André Kertész* (Paris, 1934). Kertész photographed Mac Orlan several times in 1928.

68 Mac Orlan called this collision of old and new "the social fantastic." For further discussion, see Mac Orlan, "La photographie et le fantastique social," *Les Annales*, 1928, 414; Mac Orlan, *Les Nouvelles littéraires*, 1928, reprinted in Phillips, *Photography in the Modern Era*, 1989, 27–30; and Mac Orlan, *Krull*, 1931, 6; as well as Phillips, "Resurrecting Vision: The New Photography in Europe between the Wars," in *Photography in the Modern Era*, 1989, 98–99.

69 In "Ephemeral Truths," in Sarah Greenough, David Travis, Joel Snyder, and Colin Westerbeck, *On the Art of Fixing a Shadow: 150 Years of Photography* [exh. cat., National Gallery of Art] (Washington, 1989), 258, David Travis notes that *révélateurs* is also the French word for the developing agent that makes the photographic image visible in the darkroom.

70 Mac Orlan, *Les Nouvelles littéraires*, 1928, reprinted in Phillips, *Photography in the Modern Era*, 1989, 28; and Mac Orlan, *Le Crapouillot*, 1929, reprinted in Phillips, *Photography in the Modern Era*, 1989, 33.

71 Mac Orlan, *Les Nouvelles littéraires*, 1928, in Phillips, *Photography in the Modern Era*, 1989, 28.

72 Mac Orlan, *Les Annales*, 1928, 414.

73 From the turn of the century through the late 1920s, so many Hungarian amateur photographers made manipulated, pictorialist images that the amateur tradition was intimately linked with pictorialism. By embracing the term amateur in 1928, Kertész was emphatically not returning to this earlier definition, but referring to a new understanding of an amateur as naive and untrained.

74 "Kertész András," *Pesti Futár*, 1929, 21–22.

75 Kertész as quoted by Jean Vidal, "En photographiant les photographes," *L'Intransigeant*, 1 April 1930.

76 Kertész as quoted by Jean Vidal, *L'Intransigeant*, 1930.

77 Kertész as quoted by Jean Vidal, *L'Intransigeant*, 1930.

78 Kertész as quoted by Gallotti, *L'Art Vivant*, 1929, 211.

79 See note 1. On 27 October 1928 when Kertész married Rozsi Klein (later Rogi André), he stated that he was a "photo-reporter." See Brigitte Ollier and Elisabeth Nora, *Rogi André, Photo Sensible* (Paris, 1999), 107, and Interview with Borcoman, 1971. See also Barbaralee Diamonstein, "André Kertész," in *Visions and Images: American Photographers on Photography* (New York, 1981), 86. Years later Kertész still acknowledged the importance of Mac Orlan's article; see "André Kertész: Unsung Pioneer," *U.S. Camera* 1963, 64.

80 Interview with Borcoman, 1971.

81 The editor of *Variétés* wrote to Kertész on 28 November 1928, PP, asking him to submit photographs for the 15 January 1929 issue "representing 'mysterious things' and . . . surrealist, metaphysical or abstract works." Two of Kertész's photographs, *L'Académie des fétiches* (a study of a wooden figurine) and *La Naissance de mannequin* (a mannequin's legs resting on a table) were published in *Variétés* (15 January 1929), unpaginated. See also André Breton, "What Is Surrealism?" 1934, in Herschel B. Chipp, *Theories of Modern Art: A Source Book by Artists and Critics* (Berkeley, 1968), 411.

82 "Ida Rubinstein!" *Vu* (28 November 1928), 820.

83 *Bifur* 1 (May 1929), opposite 72.

84 Aragon, "Un 'Salon' Photographique," *Commune* 22 (June 1935).

85 When this photograph was first published in "La Tour à Quarante Ans," *Vu* 63 (29 May 1929), 433, it was titled, *Ces fourmis: Des promeneurs vus du premier étage*.

86 A. P. Barancy, "Fétiches," *Le Sourire*, 20 July 1933, unpaginated.

87 Kertész as quoted by Jean Vidal, *L'Intransigeant*, 1930.

88 Michel Frizot, "Jardinier. Mine de rien," in *André Kertész: Ma France* (Paris, 1985), 159, suggests that the similarities of this photograph to Giorgio de Chirico's subjects—trains, streets, and viaducts—have given this photograph a greater aura.

89 "André Kertész," in Pat Booth, ed., *Master Photographers: The World's Great Photographers on Their Art and Technique* (New York, 1983), 139.

90 *Kertész on Kertész* 1985, 55.

91 For a reproduction of Kertész's photograph of the empty street in Meudon with a train on the viaduct, see Évelyne Rogniat, *André Kertész: Le Photographe à L'Oeuvre* (Paris, 1997), plate 8.

92 Kertész as quoted in "Photography," *Newsweek* (6 December 1982), 142; Kertész as quoted in "Kertész: Denes Devenyi Interviews the 'Father of 35 mm Vision,'" *Photo Life* 3 (January 1978), 30.

93 Fels, as quoted by Hambourg 1984, 29.

94 Fels, as quoted by Hambourg 1984, 29. Kim Sichel, *Germaine Krull: Photographer of Modernity* (Cambridge, Mass., 1999), 91, notes that Krull wrote in her memoirs that the exhibition grew out of discussions she had with Kertész, Man Ray, and Abbott.

95 The number of works shown by Atget, Nadar (Gaspard Félix Tournachon), and his son Paul Nadar is not known. For further discussion of the exhibition, see Hambourg 1984, 27–29.

96 Pierre Bost, "Promenades et spectacles," *La Revue Hebdomadaire* 24 (16 June 1928), 358, and G. G-J, "Un Salon de la photographie," *Paris-Midi*, 6 June 1928.

97 Throughout 1929 and into 1930 as the exhibition of contemporary photography traveled to more than a dozen venues, the Museum Folkwang, Essen, sent Kertész periodic letters informing him of the extensive and favorable press coverage; see Museum Folkwang, Essen, to Kertész, 9 April 1929, 5 June 1929, 28 August 1929, 23 September 1929, 31 December 1929, 15 January 1930, and 31 March 1930, PP.

98 Director, Graphische Lehr-und Versuchsanstalt to Kertész, 25 September 1929, PP. Kertész sold prints of *Glasses and Pipe*, *Cat*, and *Parisian Square* to Hildebrand Gulitt, director, Museum König-Albert, Zwickau; see Gulitt to Kertész, 3 September 1929, and 27 December 1929, PP.

99 Kertész to Jenő and Olga Kertész, 30 August 1935, PP.

100 *Of Paris and New York* 1985, 42, notes that Kertész said Vogel came to his March 1927 exhibition at Au Sacre du Printemps and asked him to contribute to his forthcoming publication. Because Kertész's work did not appear until the fifth number of *Vu* on 18 April 1928, it seems more likely they met later in 1927 or 1928, possibly in connection with Vogel's participation in the 1928 (May–June) *Salon de l'Escalier* exhibition. For further discussion of Vogel, see Sandra Phillips, "The French Picture Magazine *Vu*," in *Picture Magazines before "Life"* [exh. cat., Catskill Center for Photography] (Woodstock, N.Y., 1982), unpaginated; and Sichel 1999, 98–101.

101 *Vu* 1 (21 March 1928), 11–12.

102 Kertész as quoted in a press release from the French Cultural Services, about 1976, PP; see also Ben Lifson, "Kertész at Eighty-Five," *Portfolio* 1 (June–July 1979), 61.

103 Colette, "En Bourgogne dans les Vignes du Seigneur," with photographs by Kertész, *Vu* 55 (3 April 1929), 268–270; Philippe Soupault, "Les Vacances à Paris," *Vu* 128 (27 August 1930), 846–847.

104 "Au feu," *Vu* 52 (13 March 1929), 186–187; and "Le Triomphe de la Femme," *Vu* 104 (12 March 1930), 203.

105 "Les Panneaux sacrilèges," *Vu* 25 (5 September 1928), 529–571.

106 Soupault, "Les Vacances à Paris," *Vu*, 1930, 846–847.

107 Kertész's correspondence from the late 1920s and early 1930s indicates extensive contacts with publishers: see, for example, Ortéga, *Les Grands Journaux Ibéro-Américains*, to Kertész, 11 April 1929; Nino Frank, *Bifur*, to Kertész late April 1929; Pr. L. Querelle of *Jazz* to Kertész, 9 May 1930, and Carlo Rim, editor in chief of *Jazz*, to Kertész, undated, early 1930; Firmin-Didot, Editors, to Kertész, 24 March 1931; *Les Nouvelles littéraires*, to Kertész, 6 August 1931; *L'Echo de Paris*, 9 August 1931; Georges Rillement, *Figaro Artistique Littéraire*, to Kertész, 23 January 1932; Kertész to Stefan Lorant, 22 May 1934; Florent Fels, *Voilà*, to Kertész, 9 November 1934. See also *Of Paris and New York* 1985, 43–44.

108 For the *Colonial Exposition*, see "Les Merveilles Techniques de L'Exposition Coloniale," *Vu* 154 (25 February 1931), 284–285; and "Exotisme 100%," *Vu* 165 (13 May 1931), 666–667.

109 Kertész, *J'Aime Paris: Photographs since the Twenties* (Paris, 1974), 5.

110 Germaine Krull, "Autobiographische Erinnerungen einer Fotografin aus der Zeit zwischen den Kriegen," as quoted in *Of Paris and New York* 1985, 77.

111 See Kertész, Krull, and Lotar to Lucien Vogel, 11 December 1928, PP: the three photographers note they accept Vogel's proposal to sell commissioned photographs to other journals and newspapers abroad with the proviso that he only do so for those photographs he actually published in *Vu*. In addition, noting the lucrative German market, they want to continue to deal directly with German publishers.

112 See Kertész, Krull, and Lotar, 17 December 1928, PP: they express regret that they were not able to come to an agreement about the sale of prints abroad, and note that they have spoken to editors of other journals "who agree with us that no journal has ever thought to impose such conditions as those which you have asked of us, of three independent photographers of the Avant-Garde." Abandoning their original request, they further state that they hope "this minor issue" did not cause "even a slight rupture between your publication and our group."

113 Kertész's photographs of the Trappist monks were published in "Das Haus des Schweigens," *Berliner Illustrirte Zeitung*, 1 January 1929, 35–37. *Vu* later published many of the same photographs in "Sous le Règle de St. Benoît," *Vu* 109 (16 April 1930), 337–340.

114 Edmond Wellhoff of *Vu* wrote to Kertész on 4 February 1929, PP, of the "consequence" of his sale of the photographs to "the Germans," noting that one of his photographs of a Trappist monk appeared in an article in *UHU* about a defrocked monk, "which will create very serious new complications between us and those who permitted us to do this reporting." On 19 February 1929, PP, Wellhoff again wrote to Kertész, telling him that "the monasteries of Yugoslavia have lodged a complaint with the court in Rome against the abbot of the Trappe because he received Jewish photographers. In addition it says in an article in the *Berliner* that you developed the plates in a darkroom in the monastery. The results were immediate: the Father abbot who had received us so graciously is facing a disciplinary action from Rome and will probably be relieved from office. I tell you this fact not to protest once again against the past, but to demonstrate to you the horrible consequences of your act."

115 Florent Fels, *Voilà*, to Kertész, 9 November 1934, PP; and *Les Nouvelles littéraires* to Kertész, 9 August 1931, PP.

116 *Vu* 371 (24 April 1935), cover; reproduced in *Of Paris and New York* 1985, 62.

117 See, for example, *La Renaissance*, 4–5 (April–May 1935), unpaginated; "Haute Couture," *Vu* 264 (5 April 1933), 513–514; "Château de Villarceaux," *Plaisir de France* 2 (November 1934), 6–8.

118 Kertész as quoted by Avis Berman, "André Kertész: The 'Little Happenings,'" *ArtNews* 83 (March 1984), 69.

119 Phillips, PhD diss., 1985, 435.

120 Kertész told Borcoman, Interview 1971, that he made most of the photographs for *Nos amies les bêtes* in two days on two farms just shortly before he left for America.

121 In 1931 and 1932 Kertész had made several portraits that he titled *Grotesques*; see G. Bauer to Kertész, 27 July 1931, PP, and Töber (?) to Kertész, 13 April 1932, PP. When he exhibited his nude distortions in his 1937 show at the PM Galleries, New York, he titled them *Grotesques*. In recent years there has been a significant body of literature devoted to women in surrealist art, several of which mention Kertész's *Distortions*, including Rosalind Krauss and Jane Livingston, *L'Amour fou: Photography and Surrealism* (New York, 1985); Whitney Chadwick, *Women Artists and the Surrealist Movement* (Boston, 1985); Susan Gubar, "Representing Pornography: Feminism, Criticism, and Depiction of Female Violation," *Critical Inquiry* 13 (1987), 712–741; *Surrealism and Women*, Mary Ann Caws, Rudolf Kuenzli, and Gwen Raaberg, eds. (Cambridge, Mass., 1990); Hal Foster, "L'Amour Faux," *Art in America* (January 1986), 117–128; and Hal Foster, "Armor Fou," *October* 56 (Spring 1991), 64–97. More extensive discussions of these photographs include Carol Armstrong, "The Reflexive and the Possessive View: Thoughts on Kertész, Brandt, and the Photographic Nude," *Representations* 25 (Winter 1989), 57–70; Mary Ann Caws, "Ladies Shot and Painted: Female Embodiment in Surrealist Art," in *The Female Body in Western Culture*, Susan R. Suleiman, ed. (Cambridge, Mass., 1986); and Amy J. Lyford, "Body Parts: Surrealism and the Reconstruction of Masculinity" (PhD diss., University of California, Berkeley, 1997).

122 Kertész, in Jain Kelly, ed., *Nude: Theory* (New York, 1979), 120.

123 Kertész, in Kelly 1979, 120. Hilton Kramer, in his introduction to *André Kertész: Distortions* (New York, 1977), writes about "the air of spontaneity and surprise" in these photographs, which were not published as an entire series until this volume. When they were published in *Le Sourire Querelle* titled them, "window on the infinite"; see A. P. Barancy, "Fenêtre ouverte sur l'au-delà," *Le Sourire*, 2 March 1933. Five of these photographs were later published by Bertrand Guégan, "Kertész et son miroir," *Arts et Métiers Graphiques* 37 (15 September 1933), 23–24.

124 Arthur Browning, "Paradox of a Distortionist," *Minicam* 2 (August 1939), 38.

125 Kertész, in Kelly 1979, 120.

126 Kertész as quoted by Vidal, *L'Intransigeant*, 1930. These photographs were first referred to as *Distortions* by Browning, *Minicam*, 1939, 36–41.

127 Browning, *Minicam*, 1939, 38, notes that the *Distortions*, not the "realism" of his other photographs, had established Kertész as a "recognized master."

128 Building on ideas first proposed in Foster 1986, Amy J. Lyford has extensively explored this relationship in Lyford, PhD diss., 1997, 130–152.

129 Interview with Borcoman, 1971. For a complete bibliography of Krull's publications, see Sichel 1999, 340–341.

130 For a complete bibliography of Brassaï's publications, see Anne Wilkes Tucker, *Brassaï: The Eye of Paris* (New York, 1999), 332.

131 See Kim Debora Sichel, "Photographs of Paris: Brassaï, André Kertész, Germaine Krull and Man Ray" (PhD diss., Yale University, 1986), 130–170, and Kim Sichel, "*Paris Vu par André Kertész*: An Urban Diary," *History of Photography* 16 (Summer 1992), 105–114, for extensive discussions of this publication. See also *Of Paris and New York* 1985, 77–81, for a discussion of books by Kertész's colleagues.

132 Contract, Éditions d'Histoire et d'Art and André Kertész, 3 September 1934, PP. By the terms of the contract, Kertész was to submit fifty to sixty photographs for an album on "Paris." Although the contract stipulates that Éditions d'Histoire et d'Art had the right to edit the book, it is unclear who made the final selection or sequence. I would like to thank Kim Sichel for sharing her notes on this contract with me. Kertész told Borcoman, Interview 1971, that the editor at Éditions d'Histoire et d'Art made the layout.

133 For a discussion of the clochard as an important urban figure in the photographic and literary imagination of early 1930s France, see Sichel 1999, 106–110.

134 Eugène Dabit, "Paris, par André Kertész," *Nouvelle revue française* 43 (1 March 1935), 474–475. Other reviewers noted these same qualities: C. S. in "Paris Vu par André Kertész," *Photo Illustrations* 9 (January 1935), 7, wrote "the Paris seen by Kertész is melancholic, romantic and harsh."

135 Marcel Natkin to Kertész, 13 November 1934, PP.

136 Sandra Phillips was the first to publish this fact about Kertész's life; see *Of Paris and New York* 1985, 55, note 50. For further discussion, see Ollier and Nora 1999, 107.

137 Kertész's friend, Max Winterstein wrote to him on 13 March 1934, PP, noting that he hoped Kertész's mother, who had recently died, had "lived long enough to learn of your divorce...as this was a sore point for the poor soul." He continued, wishing him well on his marriage to Erzsébet Salamon and extending his hopes that "with this marriage you have ended your dark period."

138 Erzsébet Salamon was in Paris in 1931, and she may have been the reason, as some have claimed, that Kertész separated from Rozsi Klein; see Ollier and Nora 1999, 107. However, it is not known whether Salamon was simply visiting Paris in 1931 or had moved there permanently. A letter from an editor of *Nouvelles littéraires* to Kertész, 6 August 1931, PP, which sent "greetings to your charming fiancée," indicates that she was living there by August of that year. A postcard from Imre and Gréti Kertész to André Kertész, 29 July 1932, PP, indicates that they had recently visited André and Erzsébet Salamon in Paris. Similarly, a letter from Brassaï to his parents, 18 September 1932, mentions that Kertész "divorced his first wife and now lives in seclusion with his new wife," although they did not actually marry until 1933; see *Brassai: Letters to My Parents*, Peter Laki and Barna Kantor, trans. (Chicago, 1997), 202.

139 Kertész to Olga and Jenő Kertész, 30 August 1935, PP.

140 Although Kertész later said that Keystone had pestered him for over a year to come to New York, the first mention of it in his archive is in a 17 April 1936 letter from Imre Kertész to André Kertész, PP.

141 Kertész also had frequent correspondence with the French office of *Vogue* in September and October 1931, and received checks from them in January, September, October, November 1932, and again in October 1933, PP. Kertész also published at least one photograph in the American edition of *Vogue*. See "As They Wear It: The French," *Vogue* (1 January 1932), 40–41.

142 Imre Kertész to André Kertész, 17 April 1936, PP.

143 Imre Kertész to André Kertész, 17 April 1936, PP.

144 Imre Kertész to André Kertész, 17 April 1936, PP.

145 Imre Kertész to André Kertész, 17 April 1936, PP.

146 Gréti and Imre Kertész wrote André Kertész, 13 July 1936, PP, asking why he thought "the trip to America will come to nothing." On 20 August 1936, PP, Erney Prince of Keystone wrote to Kertész that he had received the $200 and was glad to hear they had their immigration visas that would allow them to bring anything they owned. On 1 September 1936, PP, Imre Kertész wrote to his brother, asking why "with a global company such as Hearst, you have to advance expenses even when the contract offer itself was, according to you, disadvantageous."

147 Erney Prince, Keystone Press Agency, to Kertész, 20 August 1936, PP.

148 Erney Prince, Keystone Press Agency, to Kertész, 20 August 1936, PP.

Page 88

Kertész, as quoted by Jean Vidal, "En photographiant les photographes," *L'Intransigeant*, 1 April 1930.

The Circle of Confusion, 1936–1961

1 André Kertész to Brassaï, c. 1956, as quoted by Brassaï, "My Friend André Kertész," *Camera* 42 (April 1963), 32.

2 André Kertész to Olga and Jenő Kertész, 30 August 1936, PP.

3 Gréti and Imre Kertész to André Kertész, 13 July 1936, PP.

4 Gréti and Imre Kertész to André Kertész, 17 April 1936, PP.

5 Gréti and Imre Kertész to André Kertész, 17 April 1936, PP.

6 While in Paris working at Helena Rubinstein, Elizabeth Kertész had befriended business associate Frank Tamas, who was a chemist and a partner in Cosmia Laboratories. They appear to have made plans to open a branch of Cosmia in New York. Frank Tamas appears in Kertész's date book at 130 East 17th Street on 6 November 1937, and Cosmia Laboratories is listed in the address portion of his 1937 appointment book, PP.

7 Erney Prince to André Kertész, 20 August 1936, PP, and Erney Prince to André Kertész, 4 September 1936, PP. Weston Naef in "The Making of an American Photographer," in *Of Paris and New York*, Sandra S. Phillips, David Travis, and Weston Naef (New York, 1985), 122, notes that André and Elizabeth Kertész arrived in New York on 15 October 1936. Kertész's 1936 date book, PP, includes many New York addresses starting on 20 September 1936, PP; an undated cable from Erney Prince to Kertész (probably from early September 1936), PP, states that they should pick up their visas in Paris on 9 September 1936; and a 4 September 1936 letter from Prince to Kertész, PP, notes that they should be able to arrive by 1 October. However, Kertész only received a visa on 2 October 1936; see Kertész's passport, PP.

8 Beginning in the 1960s, Kertész repeatedly asserted that he had originally planned to come to America for a twelve to twenty-four month "sabbatical"; see, for example, Kertész as quoted in Pat Booth, ed., *Master Photographers: The World's Great Photographers on Their Art and Technique* (New York, 1983), 140. However, as Prince stated in his letter of 20 August 1936 to Kertész, PP, their visas gave them "permission for a permanent stay" in the United States.

9 Naef in *Of Paris and New York* 1985, 122, notes that André and Elizabeth Saloman [sic] Kertész applied for a Petition for Naturalization on 21 October 1937.

10 Manuel Komroff, "They Changed Photography: An Informal History of the Circle of Confusion" (unpublished manuscript, copyright, Odette Komroff, 1992). I would like to thank Tom Wolf for sharing his notes and papers on the Circle of Confusion and for providing a copy of Komroff's unpublished manuscript. I would also like to express my gratitude to Doug James, Ariel Shanberg at the Center for Photography at Woodstock, and Neil Trager at the Samuel Dorsky Museum of Art at State University of New York, New Paltz, for their help in gathering materials, photographs, and documents related to the Circle of Confusion. "The circle of confusion represents the area of the film illuminated by light from a point outside the camera. If the circle of confusion is as small as or smaller than the film grain or pixel size, that portion of the image will appear in focus. An out of focus point light source, such as a distant street lamp in a nighttime cityscape, will appear as a visible disk (or, depending on the shape of the camera's iris, a polygon, while larger objects simply appear blurry as the circles of each point on the object combine" (http://www.thefreedictionary.com), ©2004 Farlex, Inc.

11 André Kertész to Robert Gurbo, conversations from 1978 to 1985.

12 Archibald MacLeish, "American's Duty to French Culture," *Saturday Review of Literature* 25 (14 November 1942), 6.

13 An "October Statement" from Keystone View Company of New York, PP, lists payment for $75 for work completed for "Best and Co" on 19 October [1936], and $80 for work for Jay Thorpe on 29 October [1936].

14 Erney Prince to André Kertész, 20 August 1936, PP.

15 Many of the photographs Kertész made for Keystone are in the André and Elizabeth Kertész Foundation, New York. Naef in *Of Paris and New York* 1985, 93, relates that Kertész recalled making "traditional photographic studio photographs of products, commercial portraits, and even figure studies from models. Kertész remembers seeing his work displayed in the elevators of the Saks Fifth Avenue store to promote the products."

16 In an interview with Ben Lifson (unpublished transcript, tape 4, 1981–1982), Kertész said that he first met Brodovitch in New York.

17 "5:30: The Curtain Falls," *Harper's Bazaar*, no. 2694 (April 1937), 116–117. Possibly to hide from Keystone the fact that Kertész made these pictures, they were credited to the picture agency European.

18 Greenbaum, Wolff, and Ernst, New York, to Kertész, 20 August 1937, PP, suggests that Keystone View Company initiated the suit, claiming that Kertész violated his contract by working for *Harper's Bazaar* during the time he worked for them. Kertész claimed that Keystone withheld commissions from him.

19 Alexander Lindey Greenbaum, attorney at Greenbaum, Wolff, and Ernst, New York, to Kertész, 11 August 1939, PP, wrote that "The Action which was started against you by Keystone View Company, Inc. on October 8, 1937 has been dismissed.... The matter has worked out pretty much as I figured. You may recall that I told you at the outset that if we put up some show of determined opposition, the Keystone people would not go ahead."

20 In the 1960s and 1970s Kertész frequently complained that Prince had published one of his photographs under his own name in "A Fireman Goes to School," *Look*, 2, no. 22 (25 October 1938), 16–17; see, for example, Kertész as quoted in Booth 1983, 143, in which he mistakenly states that the photographs were published in *Life*, and Kertész, as quoted by Barbaralee Diamonstein, *Visions and Images: American Photographers on Photography* (New York, 1981), 86. However, at the time it was common for picture agencies to claim credit for photographs they had commissioned.

21 Kertész as quoted in "In this Issue," *House and Garden* (November 1946), 141.

22 See Kertész's photographs in "Peas in a Pod: The Children of Mr. and Mrs. Nicholas Ludington of Ardmore," *Harper's Bazaar*, no. 2698 (August 1937), 60–63; and in *Vogue* (15 May 1938). Kertész published several photographs of Paris in *Coronet*; see, for example, May 1938, 117, 120–121, and 167. Erney Prince also published some of Kertész's photographs after they severed their contract: see "Fair Gets Warmer," *Town and Country* 92 (October 1937), 62–63.

23 Although Kertész dated this photograph 1936, the contact sheet is dated 1938.

24 Bela Ugrin, "Dialogues with Kertész, 1978–1985," transcripts compiled and edited by Manuela Caravageli Ugrin, courtesy of the Research Library, The Getty Research Institute, Los Angeles (880198).

25 For Kertész and Evans, see Naef in *Of Paris and New York* 1985, 95–96, and 109. Kertész could have seen Stieglitz's later photographs of New York, made between 1929 and 1935, when he visited the photographer at his gallery, An American Place, or in exhibitions at MOMA in 1941 and 1942; see Sarah Greenough, *Alfred Stieglitz: The Key Set* (Washington, 2002), 971. Also, select examples of these photographs were reproduced in *America and Alfred Stieglitz*, Waldo Frank, ed. (New York, 1934), *Twice A Year 1* (Fall–Winter 1938), 76, and "Speaking of Pictures," *Life*, 14 (5 April 1943), 7.

26 John Adam Knight, "Photography," *New York Post*, 31 December 1942. This review was clearly of great importance to Kertész, as he clipped it, underlined this passage, and kept the article for the rest of his life, PP.

27 Imre and Gréti Kertész to Andre Kertész, 21 April 1938, PP.

28 Imre and Gréti Kertész to André Kertész, 19 September 1938, PP.

29 Despite Komroff's assertion that Kertész was an active member in the Circle of Confusion (Komroff, "They Changed Photography"), the extent of his participation in its meetings is unclear. He noted a Circle of Confusion meeting in 1941 in his date book, PP, and there are appointments with individual members from the Circle scattered throughout other appointment books. However, his most active participation may have been in the 1960s when his date books indicate that he regularly attended meetings. See also Manuel Komroff, "The Circle of Confusion," *Leica Photography*, 14 (1961), 19–21.

30 Tom Wolf, "The Circle of Confusion and the Third Eye," in *Keys to Unlock the Heart: A Manuel Komroff Retrospective* [exh. cat., The Center for Photography at Woodstock] (Woodstock, New York, undated [c. 1995]), 7, notes that the group was founded in 1933 and that other members included Henry Lester, Jim Leonard, Jack Davenport, Glen Pickett, "Doc" Davis, Henry Harvey, and Wolfgang Zieler.

31 Komroff, "They Changed Photography."

32 David A. Smart wrote to Kertész on 22 January 1938, PP, suggesting that Komroff had helped to arrange for *Coronet* to accept forty-four photographs for publication, for which they paid Kertész $220.

33 Erin K. Malone, *The Doctor Leslie Project*, Rochester Institute of Technology, copyright 1994–2000. For an extensive exploration of PM and AD magazine, see *The Doctor Leslie Project* at http://www.drleslie.com/Contributors/.

34 See *André Kertész: An Exhibition of 60 Photographs* [exh. cat., PM Galleries] (New York, 1937).

35 See *An Exhibition of 60 Photographs*, New York, 1937.

36 André Kertész, "Caricatures and Distortions," *The Complete Photographer*, 2 (December 1941), 652. See *An Exhibition of 60 Photographs*, New York, 1937, in which he titles six photographs *Grotesque*.

37 Arthur Browning, "Paradox of a Distortionist," *Minicam*, 2, 12 (August 1939), 38.

38 Gary Strider, "Kertész — Camera Surrealist," *Popular Photography*, 2 (March 1938), 42.

39 Kertész, as quoted by Maria Giovanna Eisner, "Citizen Kertész," *Minicam Photography* 7 (June 1944), 33. In addition to the PM Galleries exhibition, Kertész showed *Distortions or Grotesques in Photography 1839–1937* at MOMA in 1937; in 1938 he submitted one *Grotesque* to the 5th International Salon of Photography in New York (although none of his work was included in the salon); see Ira. W. Martin to Kertész, 27 January 1938, and *5th International Salon of Photography* [exh. cat., American Museum of Natural History] (New York, 1938); he also reproduced them in "André Kertész," *Advertising Agency Magazine* 2 (December 1937), 46–47; "Vogue's-Eye View of Holiday Time," *Vogue* (15 May 1938); Strider, "Camera Surrealist," *Popular Photography*, 1938, 42, who reported that Kertész had numerous orders for *Distortions*, but he was unable to get the kind of distorting mirrors he needed to make them; Browning, "Paradox," *Minicam*, 1939, 36–41; Kertész, "Caricatures and Distortions," *The Complete Photographer*, 1941, 651–656; and Eisner, "Citizen Kertész," *Minicam Photography*, 1944, 27–33.

40 Strider 1938, 42.

41 Unsigned preface to Kertész, "Caricatures and Distortions," *The Complete Photographer*, 1941, 651.

42 Kertész, as quoted by Strider, "Camera Surrealist," *Popular Photography*, 1938, 42; and unsigned preface to Kertész, "Caricatures and Distortions," *The Complete Photographer*, 1941, 651. Throughout the 1940s and 1950s Kertész continued to try to encourage interest in these photographs. In 1944 he showed them to James Johnson Sweeney at MOMA (see Sweeney to Kertész, 8 May 1944, PP); in 1946 he tried to get the Art Institute of Chicago to include some *Distortions* in its exhibition of his photographs from *Day of Paris*; and in 1952 he submitted *Distortion #40* to the World Exhibition of Photography, but it was returned and not exhibited; see *World Exhibition of Photography* to André Kertész, received 22 January 1952, PP.

43 See chronology for a detailed listing. In addition, in 1938 Kertész submitted four photographs to the 5th International Salon of Photography in New York, but none were exhibited; see Martin to Kertész, 27 January 1938, and *5th International Salon of Photography* (New York, 1938).

44 Beaumont Newhall to André Kertész, 13 October 1936, PP.

45 See, for example, Kertész, as quoted by Ben Lifson, "Kertész at Eighty-Five," *Portfolio*, 1 (June–July 1979), 63, in which he reported that Newhall "told me I must crop out *le sexe*. With *le sexe*, it's pornography: without, art. And this is *le bienvenu pour moi*.... Newhall tells me I'm making pornography. In the end I gave in and I cropped. I was green." He told the same story, using almost identical words, to Paul Hill and Tom Cooper, authors of "André Kertész," in *Dialogue with Photography* (New York, 1979), 46.

46 See undated draft of letter from Kertész to Newhall, PP; Newhall to Kertész, 19 April 1937, PP; receipt from MOMA, 26 March 1937, to Kertész, PP; and Newhall to Kertész, 14 March 1938, PP.

47 Receipt for donation of "one photograph" from President and Trustee of MOMA to André Kertész, 13 February 1941, PP.

48 *The Image of Freedom — A Competition for Photographers* [exh. cat., MOMA] (New York, 1941), unpaginated, PP.

49 Untitled manuscript notes with material on the 1941 *Image of Freedom* exhibition at MOMA, PP.

50 All photographs that were selected by the judges for inclusion in the exhibition were purchased by the museum for $25. See *Image of Freedom* brochure soliciting submissions, 1941, PP.

51 Kertész later said, "My English is bad. My French is bad. Photography is my only language." See Carol Schwalberg, "André Kertész: Unsung Pioneer," *U.S. Camera*, 26, no. 1 (January 1963), 57.

52 The Cleveland Play House photographs were reproduced in the *Cleveland Plain Dealer*, 1 October 1939, and in *American Magazine* (August 1940); see also "Famous Artist-Photographer Takes Pictures for Hudson's," *Hudsonian* 27 (June 1940), 14.

53 Although later in life Kertész repeatedly claimed that *Life* had commissioned him to make the photographs he referred to as the "tug boat" series, no evidence has been found of this assignment. His correspondence and articles written on him in the late 1930s and early 1940s often refer to photographs made for, or submitted to *Life*; see Strider, "Camera Surrealist," *Popular Photography*, 1938, 42, who wrote that when Kertész came to America "*Life* immediately gave him orders" for new *Distortion* photographs; and Kertész, "Central of New Jersey Pier," *U.S. Camera Annual 1941*, Tom Maloney, ed. (New York, 1941), 96, in which he wrote that his aerial photograph *New Jersey Piers and Railroads* was made for *Life*. However, Goodyear may also have commissioned this photograph; see Wick Miller to Karl Helm, 29 August 1939, PP.

54 As quoted by John Kobler in *Luce: His Time, Life and Fortune* (New York, 1968), 105.

55 Kertész's photograph of the Empire State Building titled *Sentry* was reproduced in *Coronet*, 12 (October 1942).

56 Photographs from this series were published in other publications at the time: see Frank D. Morris, "Trial Run," *Collier's* (19 November 1939); "Up Ship!" *Lamp*, 22, 4 (December 1939), 20–24; "The Fleet's In," *Coronet* (July 1940), 73; *U.S. Camera Annual 1941*, *Vol. II* (New York, 1941), 67 and 96; and "Tugboat Life," *Compass*, 18, 2 (1942).

57 Kertész, *U.S. Camera Annual 1941*, *Vol. II* (New York, 1941), 96.

58 See, for example, Jim Hughes, *W. Eugene Smith: Shadow and Substance, The Life and Work of an American Photographer* (New York, 1989), 75, 123, 194, 204, 208, 222, 430; *Dream Street: W. Eugene Smith's Pittsburg Project*, Sam Stephenson, ed. (New York, 2001), 18–19; and Glenn G. Willumson, *W. Eugene Smith and the Photographic Essay* (New York, 1992).

59 Wilson Hicks, *Words and Pictures* (New York, 1952), 85, as quoted by Carol Squires, "Looking at *Life*," in *Picture Magazines before Life* (Catskill, New York, 1982), 4.

60 André Kertész, Interview with James Borcoman, 1971. See also Jacob Deschin, "Kertész: Rebirth of an 'Eternal Amateur,'" *Popular Photography*, 55 (December 1964), 34.

61 David Douglas Duncan, "A Tribute of Wilson Hicks," in *Photographic Communication: Principles, Problems, and Challenges of Photojournalism*, R. Smith Schuneman, ed. (New York, 1972), 10.

62 Kertész, Interview with Borcoman, 1971.

63 See Maitland Edey, *Great Photographic Essays from Life* (Boston, 1978), 11.

64 "Das Haus des Schweigens," *Berliner Illustrirte Zeitung*, 1 January 1929, 35–37; *Vu* later published many of the same photographs in "Sous la Règle de St. Benoît," *Vu* 109 (16 April 1930), 337–340.

65 Alice Crocker, editorial office, *Life*, to Kertész, 1 July 1942, PP.

66 Oliver Allen, *Life*, to Kertész, 15 September 1949, PP and AEKF.

67 "Anniversary Dividend of 32 Memorable Photographs," *Coronet*, 9 (November 1940), unpaginated. For further discussion, see Naef in *Of Paris and New York* 1985, 109–110.

68 *Coronet* did publish some of Kertész's photographs after this time; see *Coronet*, 9, 10, and 13 (February 1941), 113; (June 1941), 95; (August 1941), 100; (September 1941), 91; and (April 1943), 105. Most likely, however, these were works he had previously submitted.

69 *Look* (25 October 1938), 21. For further discussion, see Naef in *Of Paris and New York* 1985, 105, 114–115.

70 M. F. Agha, "Photography 1839–1944," *Harper's Bazaar*, no. 2795 (November 1944), 71.

71 A. M. Mathieu to André Kertész, 18 January 1945, PP.

72 After World War II many American photographers became exasperated with the lack of control they had over their photographs once they were submitted for publication in commercial magazines. In 1945 Philippe Halsman, a successful photographer for *Life*, spearheaded the formation of the Society for Magazine Photographers (SMP), a trade union that represented the rights of photojournalists, which has since evolved into the American Society for Magazine Photographers. Prior to its establishment, photographers had little say in matters of copyright, ownership of imagery and negatives, and reuse fees.

73 See Imre Kertész to André Kertész, 4 June 1939, PP.

74 Janis Bultman, "Masters of Photography: The Up and Down Life of Andre Kertész," *Darkroom Photography*, 5 (September–October 1983), 48–50.

75 Bultman 1983.

76 Kertész, as quoted in Hill and Cooper 1979, 41. If André and Elizabeth Kertész applied for naturalization in the fall of 1937, as Naef, *Of Paris and New York*, 1985, 122, notes, it is unclear why he would be fingerprinted as an enemy alien during the war. They became United States citizens in 1944.

77 Mathias F. Correa, U.S. Attorney, to André Kertész, 20 January 1942, PP; Henry P. Wherry, War Production Board, to André Kertész, 5 October 1944, PP; Percy Ruston, Condé Nast, to André Kertész, 19 October 1944, PP; and "Application for Priority Assistance," 2 October 1944, PP.

78 See Janet Abramowicz, "A European Sensibility: André Kertész," *The Print Collector's Newsletter* (1982), 149.

79 John Adam Knight, "Photography," *New York Post*, 6 September 1940 (photograph and caption); 2 November 1940, 26 November 1941, and 31 December 1942; Eisner, "Citizen Kertész, *Minicam Photography*, 1944, 27–33.

80 For older photographs that Kertész recycled, see *Old Order* in *Coronet*, 13 (April 1943), unpaginated; for fashion photographs, see *Junior Bazaar* (December 1943), 98–99.

81 See "1940 List of photoreproductions," PP; and Monroe Wheeler to André Kertész, 16 November 1943, PP.

82 See Ken McCormick, Doubleday, Doran and Company, to André Kertész, 27 February 1942, PP.

83 *Day of Paris* (New York, 1945), 146. William Kerry Purcell in *Alexey Brodovitch* (New York, 2002), 152, notes that Peter Pollock assisted with the design. Kertész told James Borcoman, Interview 1971, that he, Brodovitch, and Davis made the sequence, and that the idea of arranging the photographs around the progress of a day was Davis'.

84 For further discussion of the relationship of *Day of Paris* to Brandt's books, as well as to Brodovitch's *Ballet*, see Sarah Greenough, "Fragments that Make a Whole: Meaning in Photographic Sequences," in *Robert Frank: Moving Out* [exh. cat., National Gallery of Art] (Washington, 1994), 100–102.

85 Purcell, *Brodovitch*, 2002, 160.

86 Kertész helped Capa sequence the photographs in *Death in the Making* (New York, 1938).

87 *Day of Paris* (New York, 1945), 146.

88 "A Photographer's Tour of Paris," *St. Louis Post Dispatch*, 21 May 1945; "Photography," *New York Post*, 3 May 1945; "The Paris Millions Love," *Nashville Banner*, 30 May 1945.

89 "A Mood from the Dim Past," *Saturday Review of Literature* (18 May 1945), 10; "André Kertész: Day of Paris," *Popular Photography*, 16 (June 1945), 48.

90 On 25 July 1946, PP, Kertész wrote to the curator at the Art Institute of Chicago who had organized the exhibition, Carl O. Schniewind, and asked to be sent any reviews. Hugh Edwards subsequently sent Kertész the only notice that was published, a short paragraph by Eleanor Jewett in "Art Institute Has Show of Masterpieces," *Chicago Tribune*, 30 June 1946. Schniewind replied on 20 September 1946, PP, noting "exhibition after exhibition in this department have remained without any review on the part of the local papers."

91 Kertész, as quoted by Bela Ugrin, "Kertész's Photography in Full Bloom," *Houston Post*, 2 January 1983, 12G.

92 "Decorating," *House and Garden* (October 1945), 73–75. Naef in *Of Paris and New York* 1985, 114, notes that Kertész's photographs were published in "The Small Shop," *Fortune* (November 1945), 158–162. Although no individual is given credit for the five photographs, Naef's claim is substantiated by the fact that Kertész kept a copy of the article in his archive. See also *Harper's Bazaar* (September 1946). For a very different interpretation of Kertész's life and career at this time, see Naef in *Of Paris and New York* 1985, 116–117.

93 Contract between André Kertész and Condé Nast Inc., 31 January 1947, PP.

94 Kertész, interview with Borcoman, 1971.

95 See, for example, Joseph Hudnut, dean, Graduate School of Design, Harvard University, to André Kertész, 5 March 1951, PP.

96 See André Kertész's 1949 date book, PP.

97 André Kertész to Jenő Kertész, 25 September 1957, PP.

98 André Kertész to Robert Gurbo, conversation in December 1978.

99 Avis Berman, "The Little Happenings of Andre Kertész," *ArtNews*, 83 (March 1984), 68.

100 Robert Frank knew of Kertész's work and cited *Day of Paris* as an influence on his early photographic books; see Greenough, *Moving Out*, 1994, 109–112.

101 See chronology in this volume for a list of group exhibitions in which Kertész participated in the 1950s.

102 Ivan Dmitri, director, *Photography in the Fine Arts II*, to Kertész, 25 March 1960, PP and AEKF. See also press release, *Photography in the Fine Arts II*, 1960, PP and AEKF.

103 József Csáky to André Kertész, 30 December 1951, PP.

104 Bela Ugrin, "Dialogues with Kertész, 1978–1985," 34; courtesy of the Research Library, The Getty Research Institute, Los Angeles (880198).

105 Dodie Kazanjian and Calvin Tomkins, *Alex: The Life of Alexander Liberman* (New York, 1993), 138.

106 Kertész, interview with Borcoman, 1971.

Page 164

Jenő Kertész to André Kertész, 12 January 1943, PP.

La Réunion, 1962–1985

1 André Kertész to Gréti Kertész, 6 November 1962, PP. I would like to thank Paul Berlanga and Sarah Kennel for their invaluable assistance with this essay.

2 In André Kertész to Gréti Kertész, 8 July 1961, PP, he writes, "whatever is going on here in the meantime is not much, it is the usual toil, and they are cutting back on my services slowly." Although Kertész always claimed he chose to leave *House and Garden*, in Dodie Kazanjian and Calvin Tomkins, *Alex: The Life of Alexander Liberman* (New York, 1993), 138, Liberman states that Kertész became too difficult to work with, so he "let him go."

3 For a discussion of the photography boom and its attendant consequences, see Keith Davis, *An American Century of Photography* (Kansas City, Mo., 1999), 387–396. See also Stuart Alexander, "Photographic Institutions and Practices," in Michel Frizot, ed., *A New History of Photography* (Cologne, 1998), 694–707.

4 Brassaï, "My Friend André Kertész," *Camera* 42, 4 (April 1963), 32.

5 In Date book, 13 January 1962, PP, Kertész notes, "I talked to my younger brother [Jenő] for the first time since 1926" (telephone conversation).

6 Krisztina Passuth, "Párizsi beszélgetés André Kertésszel," *Új Művészet* (June 1994), 15–21, 74–76. Translated by Bulcsu Veress.

7 Jenő Kertész to André Kertész, 2 July 1963, PP.

8 It is possible that this list represents a planned publication of New York period photographs, as it includes twenty photographs that Kertész indicated he "[took] out of New York Portfolio 4." André Kertész, manuscript list of fifty-four photographs taken from 1945 through 1962, inscribed "Copy for Myself," 1962, PP.

9 My knowledge of the organization of these prints is a result of assisting Kertész when he reorganized and reboxed all of his prints in 1983 and 1984. It was then that I saw the 1960s prints of images from 1912 through the early 1960s organized in this way and placed in folders and boxes labeled "children," "landscapes," "telephoto," "parks," and "night."

10 Ed Nusbaum, Long Island University press release, 2 October 1962, PP, and André Kertész to Gréti Kertész, 6 November 1962, PP, in which he explained to Gréti that he had long been offered an exhibition at Long Island University, but that exhibiting in America was of little interest to him before this time.

11 Jacob Deschin, "Careers in Review: Retrospective Exhibits by Kertész, Ruohomaa," *New York Times*, 28 October 1962.

12 Nathan Resnick, *Kertész at Long Island University* [exh. cat., Long Island University] (New York, 1962).

13 André Kertész to Robert Gurbo, conversations from 1978 to 1985. Kertész often complained that commercial interests drove American society and repeated the phrase, "The religion of America is the almighty dollar." Noting the disparity between his New York and Parisian pictures, Kertész explained that "the photographs I make today in New York can never be as warm as the ones I made in Paris in the 30s. Everything in the United States is different. The people are different, even the streets are constructed differently. In Paris, everyone is an individual; here are only the masses." Cited in *Nude: Theory*, Jain Kelley, ed. (New York, 1979), 117.

14 Deschin, *New York Times*, 1962. See also Kenneth Poli, "One-Man Show: André Kertész, Photojournalist," *Leica Photography* 15, no. 3 (1962), 4–8.

15 Carol Schwalberg, "André Kertész: Unsung Pioneer," *U.S. Camera* 26, no. 1 (January 1963), 54–57, 64.

16 Brassaï, "My friend André Kertész," *Camera* 4 (April 1963), 7–32.

17 Georges Régnier, "Un Long Régard Amical: André Kertész," *Le Photographe* (20 December 1963). See also Maximilien Gauthier, "Quand l'Oeil a du Génie," *Les Nouvelles littéraires* (28 November 1963); Girod de l'Ain, "La Photographie: André Kertész," *Le Monde*, 29 November 1963.

18 B.G.A., "Photographie: Brassaï et 'Paris la nuit,'" *Le Monde*, 10 May 1963. Brassaï also had an exhibition of his graffiti photographs at the Bibliothèque Nationale in January 1962. In 1955, the Musée des Arts Décoratifs, Pavillon de Marsan, held a 358-print exhibition of Cartier-Bresson's photographs from 1930 to 1955, which then traveled for the next five years throughout Europe, Japan, and the United States, where it was shown under the title *The Decisive Moment*. See *Henri Cartier-Bresson: The Man, the Image, and the World* (London, 2003), 424.

19 Kertész's "audacious" exploration of these new subjects is discussed in the article "New York, Paris, Budapest," *Le Photographe* (5 December 1963); see also Régnier, *Le Photographe*, 1963.

20 In André Kertész to Bela Tarcai, 24 March 1964, PP, Kertész writes that his extended stay in Paris in late 1963 "will result in another Paris book during the summer. It is published by my old publisher." In André Kertész to R. Wittman, 29 January 1964, Kertész writes "I have always been nostalgic for Paris, of which the proof is my future album of Paris."

21 André Kertész, Date book, 31 October 1963, PP.

22 André Kertész, Date book, 12 October 1963, PP.

23 André Kertész, Date book, 31 October 1963, PP.

24 André Kertész, interview with Bela Tarcai, 22 November 1963, PP.

25 Jacqueline Paouillac to Kertész, 12 January 1951, PP: "I hope to have news from you after your quick visit that you made to us two years ago. But waiting in vain, I have heard nothing from you." She further asked him to "tell me as soon as possible what we should do" with the negatives and documents.

26 Kertész to Paul Paouillac, 16 October 1963, PP, and Jacqueline Paouillac to André Kertész, 23 October 1963, PP.

27 Jacqueline Paouillac to André Kertész, 12 December 1963, PP.

28 Jacqueline Paouillac to André Kertész, 12 December 1963, PP. This letter is a detailed account of the fate of his negatives between 1936 and the end of World War II. To illustrate how close she came to being arrested, Paouillac wrote, "while leaving one of these little towns of Lot where trusted friends were keeping documents, I brought some in a large suitcase and was stopped by two policemen at the train station who were looking for black market transport. At that moment, I would have preferred that my bag was full of provisions and not photos! I tried to stall a little bit, but one of the men started to pull on the latch of the bag, slipped his hand in and reached around a bit, pitifully pulling out just what I said, some nightclothes and feminine hygiene objects. This was ridiculous and terrifying."

29 Jacqueline Paouillac to André Kertész, 12 December 1963, PP.

30 The title "La Réunion" is written on the back of some of the prints in this series and on the original envelope in which the prints were stored. An account of the event and some of the pictures were eventually published in "André Kertész: A Meeting of Friends," *Creative Camera* 62 (September 1969), 280–281.

31 André Kertész to Robert Gurbo.

32 In *Kertész on Kertész: A Self-Portrait* (New York, 1985), 72, he writes, "In this picture of Montmartre, I was just testing a new lens for a special effect."

33 Elizabeth Kertész to André Kertész, 18 November 1963, PP.

34 André Kertész to Gréti Kertész, 8 July 1961, PP, writes that Tamas had gone blind in 1955 and notes, "You know our situation, there is no change in it for us. It would be good to change it, but for the time being, we are incapable of doing that. Tamas is slowly improving. He is where he should have been after a year if his vanity had not intervened. He wants to behave as someone who has his eyesight and he's doing this for the sixth year now." Kertész to Jenő Kertész, February or March 1960, PP: "With us, no change. If it were not so, perhaps we could have gone to see you. Everything is on Erzsi's [Elizabeth's] shoulders in the laboratory, and she is incapable of getting away."

35 In Elizabeth Kertész to André Kertész, 18 November 1963, PP, Elizabeth writes, "You were so uncertain writing about the day of the opening and I had so little trust in the fact that the Venice pictures would show up that this is almost the main reason why I didn't go over. I feared disappointment with respect to Venice. I had a very bad day on Friday when I received your telegram that the pictures arrived and were being hung. And the invite arrived on Saturday. I was upset. I cried myself sick."

36 Elizabeth Kertész to André Kertész, 21 November 1963, PP. See also André Kertész to Gréti Kertész, 6 November 1962, PP, in which he describes his lack of business skills, refers to the aggressive nature of his competition, and suggests that he is relatively helpless in an environment "where they work with elbows and knives [which] were never among my skills."

37 Elizabeth Kertész to André Kertész, 22 November 1963, PP.

38 Elizabeth Kertész to André Kertész, 23 October 1963, PP.

39 Elizabeth Kertész to André Kertész, 23 October 1963, PP.

40 A cropped print from 1933 of the other half of Elizabeth's face is in the André Kertész Archive, the André and Elizabeth Kertész Foundation (AEKF), New York. There are no extant vintage prints of the more famous cropped version.

41 Bela Ugrin, "Dialogues with Kertész, 1978–1985," transcripts compiled and edited by Manuela Caravageli Ugrin, page 19. Courtesy of The Getty Research Institute, The Research Library, Los Angeles (880198).

42 The uncropped version of *Hazy Day*, 1920, is reproduced in *André Kertész: Sixty Years of Photography, 1912–1962*, Nicolas Ducrot, ed. (New York, 1972), 11.

43 John Szarkowski, acknowledgments, *The Photographer's Eye* [exh. cat., MOMA] (New York, 1966).

44 John Szarkowski, "The Photographs of Jacques-Henri Lartigue," *Bulletin of the Museum of Modern Art* 30, 1 (1963), unpaginated.

45 John Szarkowski, *Mirrors and Windows: American Photography since 1960* (New York, 1978), 23–24. A rising interest in the snapshot aesthetic is articulated in both curatorial decisions as well as in a number of publications in the late 1960s and early 1970s, including John Kouwenhoven, "Living in a Snapshot World," in John Kouwenhoven, *Half a Truth is Better than None* (Chicago, 1982); Jonathan Green, "The Snapshot," *Aperture* 19, 1 (1974); and Brian Coe and Paul Gates, *The Snapshot Photograph: The Rise of Popular Photography, 1888–1939* (London, 1977).

46 Szarkowski had already discussed the issue of amateur photography in 1959, writing that "A high degree of competence is within the reach of any genuinely serious amateur. This amateur is in no sense a dilettante. He is free of the necessity of earning his living by photography, but not of the obligations of responsible statement and effective craft. Possibly it will be through the work of such amateur photographers...that a new approach to architectural photography will evolve." John Szarkowski, "Photographing Architecture," *Art in America*, 47 (Summer 1959), 89. Szarkowski discusses "modern photographic seeing" in Szarkowski, *Museum of Modern Art Bulletin*, 1963, unpaginated.

47 Jacob Deschin, in "Kertész: Rebirth of an 'Eternal Amateur,'" *Popular Photography* 55 (December 1964), 32, notes that the exhibition included seventy-five prints; Margaret Weiss, "André Kertész, Photographer," *Saturday Review* (26 December 1964), 28, states that the exhibition included seventy prints. However, a loan receipt, MOMA, 16 October 1964, PP, lists only thirty-nine prints, though it is likely that Kertész added more to the exhibition.

48 Szarkowski, *Photographer's Eye*, 1966, 4. For further discussion of Szarkowski's curatorial and theoretical position, see Christopher Phillips, "The Judgment Seat of Photography," *October* 22 (Fall 1982), 27–63.

49 "The photographic world has begun to realize again that in much of what it values it is the heir of André Kertész. Fortunately, this rediscovery has come while Kertész is still working, still seeking to express all that he sees and feels, and while his colleagues can not only be grateful for his past but look forward to his future." Szarkowski, *Photographer's Eye*, 1966, 8.

50 Interview with Tarcai, 1963, PP.

51 Szarkowksi, *Museum of Modern Art Bulletin*, 1963, unpaginated. It is important to note that Szarkowski was actually cautioning his readers not to succumb to the nostalgia evoked by Lartigue's imagery and thus overlook his formal innovation.

52 Jacob Deschin, "Brassaï looks back to the 1930s," *New York Times*, 3 November 1968.

53 Renee Bruns, "Book Review in Brief-*On Reading*, by André Kertész," *Popular Photography* (September 1972), writes that "perhaps the most satisfying aspect of the book — for me, at least — is the visual statement it makes about media and behavior patterns. In this, the McLuhan age, where — we are made to believe — people are turning more and more to electronic media for information and entertainment, one is tempted to think that 'read' is nothing more than a four-letter word."

54 As a reviewer for *Modern Photography* claimed, "Kertész is not only one of the first and finest but also probably the most influential miniature camera user." See Patricia Caulfield, "Don't Miss These Books," *Modern Photography* (February 1966), 62. Similarly, in 1965, Dan Budnik wrote that "the essence of photojournalism as we know it today originated some fifty years ago with Kertész and his desire to remain anonymous." See Dan Budnik, "A Point Vue," *Infinity* 14 (March 1968), 4. In a review of *The Descriptive Tradition*, an exhibition held at Boston University in March 1970 featuring the work of Kertész, Cartier-Bresson, Evans, Frank, Winogrand, Meyerowitz, and Papageorge, Jonathan Goell identifies Kertész and Cartier-Bresson as the progenitors of a documentary tradition of small-camera street photography that was being taken in new directions by Evans, Frank, Winogrand, and others. See Jonathan Goell, "Texture, Substance: Documenting an Age," *Boston Globe*, 5 April 1970. For a discussion of Szarkowski's role in placing Lartigue as precursor to contemporary documentary photography, see Kevin Moore, "Jacques Henri Lartigue (1894–1986): Invention of an Artist" (PhD diss., Princeton University, 2002); and Martine D'Astier, Quentin Bajac, and Alain Sayag, *Lartigue: Album of a Century* (New York, 2003).

55 A.D. Coleman, "Latent Image," *Village Voice*, 14 November 1968.

56 "At the time I arrived [in the United States], the most highly regarded photography was done by the Group f/64. Their idea of art was to make everything technically perfect, everything sharp from foreground to background. Art was killed by supertechnique," quoted in Kelly 1979, 122. Kertész's status as a master of small-camera photography was secured in 1973 by John Szarkowski, who wrote "Perhaps more than any other photographer, André Kertész discovered and demonstrated the special aesthetic of the small camera." See John Szarkowksi, *Looking at Photographs* (New York, 1973).

57 "I am not talking about simple documentary photography. I never document, I always *interpret* with my pictures." Quoted in "Kertész: Denes Devenyi Interviews the 'Father of 35 mm Vision,'" *Photo Life* 3, no. 1 (January 1978), 13.

58 Moore, PhD. diss., 2003, 258, notes that the anecdote about Lartigue's "eyetrap" was first published in the July 1954 issue of the French picture magazine *Point de Vue*; however, it does not seem to have been published in English until the near-simultaneous publication in November 1963 of both *Life*'s profile on Lartigue and Szarkowski's catalogue for the exhibition at MOMA; Moore, 263, relates that the release of the MOMA catalogue was delayed because *Life*'s editor David Scherman demanded exclusive first-publication rights. See "The World Leaps into an Age of Innovation," *Life* 55, no. 2 (29 November 1963), 65–72. Although the first published reference to Kertész's childhood memories of "imagining photographs" appeared in "Kertész, Unsung Pioneer," *U.S. Camera*, 1963, 54–57, 65, 76, and thus before the opening of Lartigue's exhibition, Kertész frequently met with Szarkowski while the latter was preparing the Lartigue show and may have learned of the anecdote from Szarkowski. While it is possible that Kertész never had the opportunity or venue to tell how as a child he had mentally composed photographs without a camera, his biographical information in wall texts prepared for the 1937 PM Galleries exhibition, the 1946 exhibition at the Art Institute of Chicago, and the 1962 Long Island University exhibition do not contain any references to these incidents. Perhaps the shared use of such terminology points to an interest in an inherent "photographic gaze," one which is not dependent upon the apparatus of the camera, but which is expressed through it. In this regard, it is telling that in a 1963 reedition of a 1947 monograph on Cartier-Bresson, Lincoln Kirstein writes that Cartier-Bresson is "always taking pictures, whether or not he has a camera in hand"—a description that was not part of Kirstein's original 1947 essay. See Lincoln Kirstein, introduction, *Henri Cartier-Bresson* (New York, 1963), unpaginated.

59 "Like many great artists, so busy with their work that they can easily go unnoticed, Kertész has been a forgotten master" (Modernage, press release, June 1963, PP).

60 Ugrin, "Dialogues," 1985, 20.

61 Anne Tucker, interview with Maria Morris Hambourg, 14 February 1985, cited in Anne Wilkes Tucker, *Brassaï: The Eye of Paris* (Houston, 1999), 125, note 77.

62 See Brassaï's interview with Avis Berman, in Tucker 1999, 149–150; see also Michel Boujut, "Brassaï: Propos recueillis par Michel Boujut," *Nouveau Photo Cinema* (April 1978), 26. In this interview, Brassaï also claimed that he borrowed his first camera from a woman. According to Tucker 1999, 30, there is no agreement as to how and when Brassaï acquired his first camera.

63 Discussing the lack of reviews of his 1946 solo show, Kertész claimed "I felt like I was buried alive" in Bela Ugrin, "Kertész's Photography in Full Bloom," *Houston Post*, 2 January 1983.

64 Tucker 1999, 150.

65 Tucker 1999, 150.

66 Susan Morgan, "Martin Munkacsi, Biographical Profile," *Aperture* 128 (Summer 1992).

67 Richard Whelan, *Robert Capa, A Biography* (New York, 1985), 80–81.

68 Anna Fárová, *André Kertész* (New York, 1966), 11.

69 Brassaï, *Camera*, 1963, 32

70 A.D. Coleman, "André Kertész Continues," *Camera* 35, 24 (October 1979), 12.

71 Although Bakht claimed to have started working for Kertész earlier, most references to Bakht in Kertész's archive begin about 1966.

72 Quoted in Janis Bultman, "The Up and Down Life of André Kertész," *Darkroom Photography* 5, no. 6 (September–October, 1983), 48–50.

73 Cornell Capa to André Kertész, 24 July 1964, PP, writes, "To be sure, this is an honorary position, for both sides, but it has practical sides to it as well...it is our feeling that your past work should get the fullest opportunity to be seen all over the world...We are hoping that you will engage our photographers in discussion, criticize some of our work and take part in some of our occasional projects...of course, our Editors and photographers will keep you in mind for all sorts of book, exhibit, and photographic opportunities." For information on the *Concerned Photographer* exhibition, see Cornell Capa, "André: A Personal Reminiscence," in Susan Harder with Hiroji Kubota, *André Kertész, Diary of Light, 1912–1985* (New York, 1987), 9.

74 Cornell Capa, *The Concerned Photographer* (New York, 1968), unpaginated.

75 Capa in Harder 1987, 9.

76 Capa in Harder 1987, 9. In André Kertész to Robert Gurbo, conversations from 1978 and 1985, Kertész went to great lengths to express his surprise and gratitude about his experiences in Tokyo.

77 Capa in Harder 1987, 9. Kertész's accounting of these events later in life was quite different. Kertész told Robert Gurbo and Nina Barnett that he never donated prints to Capa's cause, and he complained that Capa never returned the prints he had lent to the exhibition.

78 Studio Books was an independent company that published fine art books in conjunction with Viking Press. It subsequently became a subsidiary of Viking Press. Information about Nicolas Ducrot, Grossman, and Viking Press was gathered in a series of interviews between myself and Nina Barnett, who worked as Ducrot's assistant at Viking Press from 1973 to 1978. I would like to thank Nina Barnett for sharing her extensive knowledge of these events with me.

79 André Kertész to Robert Gurbo, conversations in 1979.

80 Renee Bruns, "André Kertész: Sixty Years of Photography 1912–1972," *Popular Photography* (undated clipping, PP and AEKF), 115.

81 Nina Barnett, telephone interview, 22 April 2004.

82 Bruns, unidentified clipping, PP and AEKF, 120. Barnett remembers that Kertész deeply trusted Ducrot's instincts and allowed him to select many of the unpublished images. Nina Barnett, telephone interview, 22 April 2004.

83 Brendan Gill, "André Kertész: Sixty Years of Photography," *New Yorker* (30 November 1972). Gill became a good friend and supporter of Kertész. In Brendan Gill, *A New York Life: Of Friends and Others* (New York, 1990), 129, Gill relates that in the process of writing an introduction to Kertész's *Washington Square* (1975), Gill learned that many of Kertész's glass plate negatives had deteriorated and suggested that he apply for a Guggenheim Fellowship to pay for their restoration. Gill even contacted other former Guggenheim fellows to request that they write letters on Kertész's behalf. He recalled, "André shook his head. The very mention of a Guggenheim appeared to depress him. It was of no use to ask anyone for money. When he was young, nobody had ever given him any help. Now that he was old, the Guggenheim people would only laugh at him. 'Do something nice for a man in his eighties? Forget it! That's how life is.'" But over Kertész's objections, he and Ducrot filled out an application to the John Simon Guggenheim Memorial Foundation and left it for Kertész to sign. In Brendan Gill to André Kertész, 3 October 1973, PP, Gill left a note handwritten on the envelope: "Dear André: Look this over and trust me! Brendan 10/17/73." In the early summer of 1974 Kertész received a notice that he was the recipient of a $10,000 fellowship. He subsequently used this money to hire Gerd Sander, the grandson of the renowned German photographer August Sander, to restore his negatives.

84 "Prints Valiant," unidentified clipping, 1973, PP.

85 Davis 1999, 297.

86 On this subject, see Davis 1999, 393–397.

87 See "List of Prints," Witkin Gallery, 1970, PP and AEKF. Helen Gee's Limelight gallery, the first gallery in America exclusively devoted to photography, opened in May 1954 and closed in January 1961. See Helen Gee, *Limelight* (Albuquerque, 1997). I would personally like to thank Harold Jones, Fern Schad, Charles Traub, and Victor Schreiger for providing the information about LIGHT Gallery. I would also like to thank Stephen Daiter, who provided background information on photography galleries in the 1960s and 1970s.

88 Charles Traub to Robert Gurbo, telephone interview, 20 April 2004. In 1970, Kertész also made a limited edition of 150 prints of *Melancholic Tulip* (plate 80), priced at $250 each, for Inge Bondi Ltd., The Photography House, a venture that was designed to appeal to what Jacob Deschin described as the "growing, although still small, market of discriminating collectors." In the same article, Deschin states that it was Bondi, former director of special projects at Magnum, who suggested to the organizers of *The Concerned Photographer* a selling price of $150 for a print of *Chez Mondrian* (plate 50). See Jacob Deschin, "Drooping Tulip Heralds New Business," *Viewpoint* (August 1970), unpaginated.

89 Hilton Kramer, "Three Who Photographed the 20s and 30s," *New York Times*, 3 March 1974.

90 André Kertész to Robert Gurbo, conversations from 1978 to 1985. Kertész often complained of losing Elizabeth prematurely because her problem was misdiagnosed. He overlooked her years of chain-smoking and felt instead that it was the American medical system that had killed her.

91 André Kertész to Robert Gurbo, conversations in 1979.

92 Ben Lifson, "A Great Photographer's Love Story," *Saturday Review* (December 1981), 23.

93 In 1973 Ducrot had moved from Grossman to E.P. Dutton; subsequently Dutton was sold and his department was eliminated, although not before he and Kertész began collaborating on two books: *Of New York*, a compilation of his New York photographs, and *Distortions*, a book of nudes made from his restored negatives. While working on these books, Ducrot founded Visual Books with partner Woody Eitel. They functioned as book packagers, designing and organizing the production of books for other publishing houses. Although production delays on *Of New York* and *Distortions* postponed their publication, the two books were released by Alfred A. Knopf in the fall of 1976. Nina Barnett to Robert Gurbo, 22 April 2004. She wrote this letter to clarify information and provide details after reviewing her personal notes and documents.

94 Nina Barnett to Robert Gurbo, 22 April 2004.

95 UPI, "*Candid Photography Pioneer Kertész Putting His Works Together at 84*," unidentified clipping, 1978, PP and AEKF.

96 It is not clear whether Kertész purchased the glass bust before or after Elizabeth's death. There are photographs of the bust that he dated well before her death in 1977. However, it is possible he misdated them.

97 Lifson, *Saturday Review*, 1981, 23.

98 Lifson, *Saturday Review*, 1981, 23.

99 Lifson, *Saturday Review*, 1981, 23.

100 André Kertész to Robert Gurbo, conversation on 4 November 1981.

101 "You make it in a moment, and then you try something different. Like an artist making a sketch for working." Quoted in Lifson, *Saturday Review*, 1981, 23.

102 André Kertész to Robert Gurbo, conversations from 1978 to 1985. Although Elizabeth's family seems to have originally been Jewish, she was Catholic. She kept a set of rosary beads next to her bed. Kertész defined himself as an atheist.

103 Lifson, *Saturday Review*, 1981, 23.

104 Quoted in Kelly 1979, 117.

105 Jean Nohain, preface, *Enfants* (Paris, 1933).

106 André Kertész to Robert Gurbo, conversation on 27 September 1985.

107 "Kertész: Denes Devenyi Interviews," *Photo Life*, 1978, 11.

Page 216

André Kertész, as quoted by Jacob Deschin, "Kertész: Rebirth of an 'Eternal Amateur," *Popular Photography*, 55 (December 1964), 42.

Chronology, 1894–1985

1 This conclusion was reached by Bulcsu Veress, who translated the diaries and letters of Kertész.

2 Unless noted, all biographical information for the Hungarian period is gleaned from the diaries. Kertész's diaries for the years 1909 to 1924 are conserved at the Patrimoine Photographique, with copies at the André and Elizabeth Kertész Foundation, New York, hereafter cited as PP and AEKF. Unless noted, all translations from Hungarian are by Bulcsu Veress, from French by Sara Cooling and Sarah Kennel, and from German by Sabine Kriebel.

3 Diary, 28 January 1912, PP and AEKF.

4 Diary, 25 February 1912, PP and AEKF.

5 Diary, 15 April 1912. The play premiered in Paris on 24 March 1911.

6 Diary, 20 June 1912, PP and AEKF.

7 Diary, 23 June 1912, PP and AEKF.

8 Diary, 24 June 1912, PP and AEKF.

9 A giro bank is a type of transfer bank.

10 Diary, 13 June 1913, PP and AEKF.

11 Jenő Kertész to Andor Kertész, 17 November 1914, PP and AEKF.

12 Diary, 12 December 1914, PP and AEKF.

13 Diary, 28 March 1915, PP and AEKF.

14 Diary, 8–15 July 1915, PP and AEKF.

15 Diary, 8–15 July 1915, PP and AEKF.

16 Diary, 15 July 1915, PP and AEKF.

17 Hoffman Lípot to Andor Kertész, 7 August 1915, PP and AEKF.

18 Andor Kertész to Jenő Kertész, 11 August 1915, PP and AEKF.

19 Jenő Kertész to Andor Kertész, 23 August 1915, PP and AEKF.

20 See Gábor Szilágyi, "An Album of War," Erika László, trans., in Colin Ford, ed., *The Hungarian Connection: The Roots of Photojournalism* (Bradford, England, 1987), 10.

21 "A Borsszem Jankó háborus rajz- es fénykép-pályázata," *Borsszem Jankó*, 20 February 1916, 12. The competition was announced in the 14 November 1915 issue, with an original deadline for 15 December. The deadline was extended to 31 January 1916 to allow for delays in the delivery of military mail. The winners were announced in the 20 February 1916 issue.

22 "Negyedik 3000 Koronás fényképpályázatunkra beérkezett pályamüvek," *Érdekes Újság*, 25 March 1917, 10 and 12. Another of Kertész's photographs was published in *Érdekes Újság*, 5 August 1917, 5.

23 The couple met at the office of Giro Bank and Transfers, Ltd., where they both worked. Although the exact date of their meeting is not known, Kertész indicates that he knew Erzsébet by the start of the Hungarian Revolution in March 1919. See Ben Lifson, interview with André Kertész, unpublished transcript, tape 8, 1981–1982, courtesy of Ben Lifson.

24 Kertész to Salamon, ten postcards dated between 31 May 1920 and 25 June 1920, PP and AEKF.

25 Diary, 10 March 1921, PP and AEKF.

26 Diary, 24 March 1921, PP and AEKF.

27 Diary, 10 April 1921, PP and AEKF.

28 Diary, 11 April 1921, PP and AEKF.

29 Diary, 17 April 1921, PP and AEKF.

30 Diary, 13 May 1921, PP and AEKF.

31 Dr. Fejérváry to Kertész, 11 September 1922, PP and AEKF.

32 "Tárgymutató," *Fotoművészeti Hirek* (1924), 27.

33 Diary, 23 May 1924, PP and AEKF.

34 Diary, 30 May 1924, PP and AEKF.

35 Diary, 20 June 1924, PP and AEKF. Pomáz is a village close to Budapest.

36 Diary, 23 June 1924, PP and AEKF.

37 Diary, 8 July 1924, PP and AEKF.

38 Diary, 10 July 1924, PP and AEKF.

39 Interview with James Borcoman, 1971.

40 Visa, photocopy, PP.

41 Kertész recorded his arrival date in Paris as 9 October on his "Extrait du Registre d'Immatriculation," dated 17 November 1925, PP. However, a passport stamp shows that he entered France on 8 October 1925.

42 Kertész's whereabouts during his first month in Paris is uncertain. Two letters from his brothers dated 20 and 29 October 1925 were sent to H. Starozum, 10, rue St. Bon, IV arrondissement, Paris. Two letters dated 9 November and 2 December were sent to Kertész at 4, rue Haussman, IV, Courbevoie (a suburb of Paris), while letters dated 4 November, 15 December, and 20 December 1925 were sent to Kertész, in care of A. Ujvári, 2, rue de l'Ourcq, Courbevoie. It is possible that Kertész was receiving mail at different addresses; where he actually lived is unclear, though he later claimed to have moved immediately to Montparnasse. All letters are in the possession of PP.

43 "Extrait du Registre d'Immatriculation," 17 November 1925, PP. The street number on rue Vavin is illegible.

44 Jenő Kertész to André Kertész, 2 December 1925, PP and AEKF.

45 Carte d'auditeur, École National d'Arts et Métiers, 1926–1927, PP.

46 Three photographs of interior design in Réné Jacomy and Joseph Ney, "Architecture: Jeux de Construction," *Art et Industrie* (January 1926), 19–21; one photograph, *Café de Dôme*, in *Das Illustrierte Blatte; Frankfurter Illustrierte* 44 (1926), 984.

47 Press pass, Continental Photo Agency, 1 January 1926, PP.

48 The certificate is in the archives of the PP. Once again, in 1926, Kertész's place of living is difficult to determine. He continues to receive mail in care of A. Ujvári, 2, rue de l'Ourcq, in Courbevoie through early February of that year. However, he also receives mail at an unnamed hotel, 19, rue Bourg Tibourg on 27 January and again from June through December. He also receives a letter dated 30 March at the Hotel des Archives, 8, rue du Plâtre, which is the residence recorded on the certificate from L'Atelier Moderne. Again, Kertész seems to have received this mail at several different addresses in the care of friends or acquaintances.

49 Imre Kertész and Max Winterstein to André Kertész, 2 July 1926, PP.

50 19 August is the first recorded visit to Mondrian's studio; other appointments that year include 20 August, 2 September, and 30 November. Appointment book, 1926, PP and AEKF.

51 *Magyar Hirlap*, 17 October 1926, PP.

52 *Maygar Hirlap*, 28 October 1926, PP.

53 Jenő Kertész to Kertész family, 4 November 1926, PP.

54 Imre Kertész to André Kertész, 25 November 1926, PP.

55 André Lurcat to André Kertész, 13 December 1926, PP.

56 Lajos Tihanyi to André Kertész, 24 December 1926, PP.

57 The exact date of the move is unknown, but had occurred sometime between 9 February, when Imre Kertész sent a letter addressed to 19, rue Bourg Tibourg, and 15 February, when Imre Kertész sent a letter to 5, rue de Vanves. Both letters are in the possession of PP.

58 For information about the exhibition, see Jane Corkin, *Stranger to Paris* (Toronto, 1992).

59 *Chicago Tribune*, 13 March 1927.

60 Montpar, "Photo Kertész," *Chantecler*, 19 March 1927.

61 Ernst Kallai, "Bildhafte Photographie," *Das Neue Frankfurt: Monatsschrift für die Probleme Gestaltung* 2 (March 1928), 42–47.

62 Florent Fels, "Le Premier Salon Indépendant de la Photographie," *L'Art Vivant* (1 June 1928), 445.

63 G. Charensol, "Les Expositions," *L'Art Vivant* (15 June 1928).

64 Pierre Bost, "Promenades et Spectacles," *La Revue Hebdomadaire* (16 June 1928), 358, PP.

65 Certificate, "Bon pour cinquant francs de fournitures photographiques," provided by the Chambre Syndicale des Industries et du Commerce Photographique, stamped 25 May 1928, PP.

66 Marriage certificate is reproduced in Sandra Phillips, "The Photographic Work of André Kertész in France, 1925–1936" (PhD diss., City University of New York, 1985), vol. 1, 518. Brigitte Ollier and Elisabeth Nora write that the couple moves to 75, boulevard Montparnasse immediately after their marriage, but since Kertész continues to receive mail at 5, rue de Vanves in early 1929 this move is dated to February 1929 here. See Brigitte Ollier and Elisabeth Nora, *Rogi André, Photo Sensible* (Paris, 1999), 107.

67 André Kertész, Germaine Krull, and Eli Lotar to Lucien Vogel, 11 December 1928, PP.

68 André Kertész, Germaine Krull, and Eli Lotar to Lucien Vogel, 17 December 1928, PP.

69 Kertész may have sold or given four of these photographs; Kastner, the director of the Folkwang, to Kertész, 9 January 1929, PP, acknowledges the receipt of twenty photographs for the exhibition; a 5 January 1929 note in Kertész's hand lists, under the heading Museum Folkwang, the titles of twenty photographs. However, Kastner to André Kertész, 24 June 1931, PP, confirms that the museum sent sixteen photographs lent to the exhibition back to the artist.

70 Edmond Wellhoff to André Kertész, 4 February 1929, PP. Many of the photographs were later published in Wellhoff's article "Sous la Règle de St. Benoît," *Vu* 109 (16 April 1930), 337–340.

71 The date of the move is likely between 19 February 1929, when Kertész received a letter at 5, rue de Vanves, and 29 February 1929, when he received mail at 75, boulevard Montparnasse.

72 Jean Gallotti, "La Photographie: Est-Elle un Art?-Kertész," *L'Art Vivant* 5, 101 (1 March 1929), 208–211.

73 Brassaï, "40 Jahre Eiffelturm," *Münchner Illustrierte Presse* 19 (12 May 1929), 637. Reprinted in a longer French version as "La Tour à quarante ans," text by Jean d'Erliech [Brassaï] *Vu* 63 (29 May 1929), 431–433. Kertész as photographer and Brassaï as journalist collaborated on several projects in 1929, including "Das deutsche Paris," *Die Wochenschau* (1930) n.p.; "Die Technik in der Kirche," *Das Illustrierte Blatt* 12 (27 March 1930), 324; "Das Heilsarmee-Schiff auf der Seine," *Münchner Illustrierte Presse* 25 (22 June 1930), 863; "Kennen-Sie schon Moochi und Broadway?" *Das Illustrierte Blatt* 27 (9 July 1930), 770; "Wochenend auf Baumen," *Kolnische Illustrierte Zeitung* 31 (2 August 1930), 949; "Mr. Molier und Sein Privatzirkus," *Kolnische Illustrierte Zeitung* 20 (16 May 1931); and possibly reportage on a dog cemetery in Paris that does not appear to have been published. In a letter to his parents, 4 December 1929, Brassaï writes: "my 'Berlin secretary' has two of my articles: 'Paris Dog Cemetery' (with drawings) and 'How Sardines Lose Their Heads' (also illustrated with photographs and drawings).... *Vu* also bought 'Dog Cemetery' in my own French version (my first article in French!)." Quoted in *Brassaï: Letters to My Parents*, Peter Laki and Barna Kantor, trans. (Chicago, 1997), 177–178. Kertész was granted permission to photograph in the dog cemetery in late July 1929. See Société Anonyme Française du Cimitière pour Chiens to André Kertész, 23, 27, and 29 July 1929, PP and AEKF. For Brassaï's relationship with Kertész, see Anne Wilkes Tucker, *Brassaï: The Eye of Paris* (New York, 1999), 30.

74 For more information on this exhibition, see *Film und Foto der Zwanziger Jahre*, Ute Eskildsen and Jan-Christopher Horak, eds. (Stuttgart, 1979).

75 Lotz, "Film und Foto," *Die Forme* (June 1929), 277–279. Although Kertész is not mentioned by name in the article, it is significant that of the three photographs reproduced, two are by Kertész.

76 Lotz, *Film und Foto*, to André Kertész, 26 June 1929, PP.

77 Director, Graphische Lehr-und Versuchsanstalt, to André Kertész, 25 September 1929, PP.

78 "Eine neue Künstler-Gilde: Der Fotograf erobert Neuland," *UHU* (October 1929), 34–41.

79 Albrecht, director of the exhibitions office of the city of Madgeburg, to André Kertész, 1 November 1929, PP. Another letter from Albrecht to André Kertész, 21 November, 1929, PP, confirms the receipt of Kertész's photographs.

80 Lucien Vogel to André Kertész, 15 November 1929, PP.

81 G. Gy, "Kertész András," *Pesti Futár*, 25 December 1929, 21–22.

82 Dr. Hildebrand Gulitt, Museum König-Albert, to Kertész, 27 December 1929, PP, requesting *Mondrian's Glasses and Pipe*, *Parisian Square*, and *Cat*.

83 Pierre Bost, *Photographies modernes* (Paris, 1930).

84 Some of Kertész's photographs of the *Colonial Exposition* were published in Jean Gallotti, "Comment s'annonce L'Exposition Coloniale," *L'Art Vivant* (1 November 1930), 858–859.

85 Jean Vidal, "En photographiant les photographes," *L'Intransigeant*, 1 April 1930.

86 Manuscript list of twenty-nine photographs "sent 12 April 1930" in Kertész's hand, PP. See also Josef Jurinek, director of the exhibition *Das Lichtbild*, to André Kertész, 14 April 1930, PP.

87 M.S. "A Fotó Müvészete," *Ujsàg Vasàrnapja* 44 (2 November 1930), 17–18.

88 Ollier and Nora 1999, 107.

89 Ollier and Nora 1999, 107. It is unclear whether Erzsébet Salamon was simply visiting or whether she had moved permanently to Paris in 1931. A letter from an editor of *Nouvelles littéraires* to Kertész, 6 August 1931, PP, which sent "greetings to your charming fiancée" indicates that she was in Paris in August of that year. A postcard from Imre and Gréti Kertész to André Kertész, 29 July 1932, PP, indicates that they had recently visited André and Erzsébet Salamon in Paris. Similarly, a letter from Brassaï to his parents, 18 September 1932, mentions that Kertész "divorced his first wife and now lives in seclusion with his new wife." Quoted from *Brassaï: Letters to My Parents*, 1997, 202.

90 While the date of the exhibition is unknown, Kertész received confirmation on 20 July that his photographs were being returned. Director, Gewerbemuseum, Basel, to André Kertész, 20 July 1931, PP. According to Sandra S. Phillips, David Travis, and Weston Naef, *Of Paris and New York* (New York, 1985), 258, this exhibition was held at Graphische Lehr-und Versuchanstalt, Vienna, which suggests that the exhibition may have been held at both venues.

91 Ollier and Nora 1999, 107.

92 H. H. Blacklock, Royal Photographic Society of Great Britain, to André Kertész, 10 December 1931, PP.

93 Letter from Julien Levy to Gordon B. Washburn, 20 January 1932, R.G. 3:1:37; letter from Julien Levy to Nora Christensen, 2 February 1932, R.G. 3:1:37. Both letters are courtesy of G. Robert Strauss, Jr. Memorial Library and Archives, Albright-Knox Art Gallery. In the letter of 2 February, Julien Levy describes Kertész as "Young Paris photographer, prolific leader of modern school of documentary phot [sic]."

94 *Exposition Internationale de la Photographie* (Brussels, 1932). The catalogue lists six works by Kertész; however, a photograph of André Bauchant by Kertész is reproduced in the catalogue, though it is not listed as one of the works that he exhibited.

95 Galerie d'Art Contemporain to André Kertész, 10 November 1932, PP.

96 For information on the making of the Distortion images, see Jain Kelly, ed., *Nude: Theory* (New York, 1979), 116–129.

97 A.-P. Barancy, "Fenêtre ouvert sur l'au-delà," *Le Sourire*, 2 March 1933.

98 The French section of the exhibition was identified in the catalogue only as the "amateurs photographes ouvriers, Paris" (amateur worker-photographers), which is the same title under which Kertész, along with several other photographers, exhibited in December 1930. Kertész also kept a copy of the catalogue, which suggests that he did participate in this exhibition. *Výstava sociální fotografie* (Exhibition of Social Photography) [exh. cat., YWCA] (Brno, 1933).

99 A.-P. Barancy, "Fétiches," *Le Sourire*, 20 July 1933.

100 Bertrand Guégan, "Kertész et son miroir," *Arts et Métiers Graphiques* (15 September 1933), 24.

101 György Bölöni, *Az Igazi Ady* (Paris, 1934).

102 Kertész seems to have exhibited at least one distortion photograph at this exhibition. In "Citizen Kertész," *Minicam Photography* (June 1944), 30, Maria Giovanna Eisner discusses Kertész's "distortion pictures, one of which had so startled me at the Leleu exhibit in 1934."

103 A customs declaration from the "Légation Royale de Hongrie en France," 8 November 1934, PP, states that Kertész will travel to Budapest to photograph for French journals and is bringing with him a Leica and a Lorilla 6.5 x 9 cm camera. That Kertész remained in Budapest through January 1935 is suggested by the administrator for the Central Committee of Bathing Establishments and Tourism in Budapest to the administration of all the bathing, mineral baths, and health spas in Budapest, 3 January 1935, PP; he states that Kertész is authorized to photograph these establishments under the auspices of the central committee.

104 Làzlo Gàl, "Egy Magyar Fényképész párizsi munkái," *Pesti Hirlap*, 23 December 1934, 26–27.

105 Erney Prince to André Kertész, 1 and 20 August 1936, PP. Keystone Press Agency was part of Keystone View Company of New York, Inc. Erney Prince, general manager of Keystone Press Agency, New York, also seems to have set up a photographic studio at 219 East 44th Street; Jenő Kertész sent a letter to André Kertész, 21 November 1936, PP, at "Studio Prince, 219 East 44th Street, New York."

106 Erney Prince to André Kertész, 20 August 1936, PP.

107 Beaumont Newhall to André Kertész, 13 October 1936, PP.

108 Receipt, MOMA, 26 March 1937, PP.

109 Greenbaum, Wolff, and Ernst, New York, to Kertész, 20 August 1937, suggests that Keystone filed a claim against Kertész for executing work for *Harper's Bazaar* "during the time you worked for the Keystone Company, i.e. that it was done before July 10, 1937." Greenbaum, Wolff, and Ernst, New York, to Kertész, 9 October 1937, PP, discusses Kertész's claim against Keystone, which charged them with withholding commissions. According to Greenbaum, Wolff, and Ernst, New York, to Kertész, 11 August 1939, PP, the case Keystone View vs. Kertész was dismissed.

110 Robert Capa, *Death in the Making*, with captions by Robert Capa, translation by Jay Allen, and photo arrangement by André Kertész (New York, 1938).

111 Imre and Gréti Kertész to Elizabeth and André Kertész, 21 April 1938, PP. This letter foreshadowed the numerous indignities that Imre and Gréti would suffer during the war, including a forced relocation to a Jewish ghetto on the Pest side of town. See Imre Kertész to André and Elizabeth Kertész, 31 January 1946, PP.

112 "A Fireman Goes to School," *Look* 2, no. 22 (25 October 1938), 21, as cited in *Of Paris and New York* 1985, 105.

113 Although Kertész later claimed that he was prevented by war restrictions from photographing outdoors, no concrete evidence to support this has been found. If indeed a restriction prevented Kertész from using photographic equipment, it seems to have been lifted by 1942. Mathias Correa, U.S. Attorney, Southern District New York, 20 January 1942, PP, states "Inasmuch as you state that you are a Hungarian national it appears that the present regulations respecting the use of photographic equipment do not apply to you. Accordingly, it will not be necessary to renew the license dated January 10, 1942, which I have previously sent you."

114 See Imre Kertész to André Kertész, 4 June 1939, PP.

115 Copies of Miller's correspondence concerning these commissions date from January 1939 to August 1940, PP.

116 Arthur Browning, "Paradox of a Distortionist," *Minicam* 2, 12 (August 1939), 36–40.

117 André Kertész, "Central of New Jersey Pier," *U.S. Camera Annual 1941*, *Vol. II* (New York, 1941), 67, 96.

118 "The Fleet's In," *Coronet* (July 1940), 73; "Tugboat Life," *Compass* 18, 2 (1942); Frank D. Morris, "Trial Run," *Collier's* (19 November 1939), 21; "Up Ship!" *Lamp* 22, 4 (December 1939), 20–24; *U.S. Camera Annual 1941*, *Vol. II*, 67, 96.

119 William A. H. Birnie, "Cleveland Takes the Stage," *American Magazine* (August 1940).

120 Manuscript note in Kertész's hand lists artists, titles, and locations of artworks, PP.

121 Laszlo Telkes to André Kertész, 4 May 1940, PP.

122 John Adam Knight, "Photography," *New York Post*, 6 September 1940.

123 Letter from James Thrall Soby, director of Armed Services Division, MOMA, to André Kertész, 30 January 1942, PP.

124 Editorial office, *Life*, to André Kertész, 1 July 1942, PP.

125 John Rewald to André Kertész, 2 October 1942, PP.

126 Jenő Kertész to André Kertész, 26 December 1942, PP. However, Kertész receives mail throughout 1943 at 67 West 44th Street.

127 John Adam Knight, "Photography," *New York Post*, 31 December 1942.

128 Although it is very difficult to determine exactly when or why Erzsébet Salamon changed her name, it is possible that she, like André, assumed a new name upon arrival in Paris. In 1944, when she received her United States citizenship papers, she identified herself as "Elizabeth Kertész." She is identified as "Elizabeth Sali" in a draft of the biographical information André Kertész provided to *Who's Who in America*, 1977, PP and AEKF.

129 A. M. Mathieu to André Kertész, 7 February 1944, PP.

130 Maria Giovanna Eisner, "Citizen Kertész," *Minicam Photography*, 7 (June 1944), 27–33.

131 Lázló Moholy-Nagy to André Kertész, 8 June 1944, PP.

132 "Rubber on the Rebound," *Fortune* (July 1944), 135–139.

133 Henry P. Wherry, War Production Board, to André Kertész, 5 October 1944, PP, denying application. Letter from Percy Ruston, Condé Nast, to André Kertész, 19 October 1944, PP.

134 Philippe Halsman to André Kertész, 5 March 1945, PP and AEKF. Because Kertész was elected to honorary membership in 1965, it appears that he did not join in 1945. The society was first proposed in 1942 after casual discussions between *Click* photographers Bradley Smith and Ike Vern with *New York Post* critic John Adam Knight about the need for an organization for magazine photographers. The club was officially chartered by the state of New York in 1944. Knight, who recognized Kertész's talent in an article that appeared in the *New York Post* on 31 December 1942, was a well-known critic and advocate of photography. For more on the history of the ASMP, see *http://www.asmp.org/about/history.php*.

135 André Kertész to Carl Schniewind, 19 February 1946, PP and AEKF.

136 Carl Schniewind to André Kertész, 4 March 1946, PP and AEKF.

137 "Ordre de Mission," signed by Pierre Guedenet, adjunct cultural advisor, French Embassy, 19 August 1948, PP.

138 Oliver Allen, *Life*, to André Kertész, 15 September 1949, PP and AEKF.

139 Imre Kertész to André and Elizabeth Kertész, 10 April 1950, PP.

140 *The Art and Technique of Color Photography*, Alexander Liberman, ed. (New York, 1951); Katherine Morrow Ford and Thomas H. Creighton, *The American House Today* (New York, 1951).

141 Jacqueline Paouillac to André Kertész, 12 January 1951, PP.

142 Joseph Hudnut to André Kertész, 5 March 1951, PP and AEKF.

143 Imre Kertész to André Kertész, 24 February 1955, PP, indicates that Kertész had been suffering from erysipelas for "a whole year."

144 William Houseman, "André Kertész," *Infinity*, vol. 8, no. 4 (April 1959), 4–13, 22.

145 Ivan Dmitri, director, *Photography in the Fine Arts*, to Kertész, 25 March 1960, PP and AEKF. See also press release, *Photography in the Fine Arts II*, 1960, PP and AEKF.

146 The date usually given for the dissolution of the contract with Condé Nast is 1962; however, Percy Ruston, Condé Nast, in a memo dated 5 April 1962, PP and AEKF, notes that in 1961 Kertész did not work from October through December; that in 1962 Condé Nast paid Kertész $850 for additional photos used from prior sittings; and that Kertész is not renewing his con-

tract. This memo suggests that Kertész effectively stopped working for Condé Nast in October 1961, which is when he seems to have entered negotiations with Monroe Wheeler for a possible exhibition at MOMA.

147 Date book, 13 January 1962, PP.

148 Date book, 23 January 1962, PP. In his date book for 6 February 1962, PP, Kertész records that he "got the material back from Wheeler."

149 Jacob Deschin, "Careers in Review," *New York Times*, 28 October 1962.

150 Date book, 6 November 1962, PP; André Kertész to Gréti Kertész, 6 November 1962, PP.

151 Brassaï, "My Friend André Kertész," *Camera* 42, 4 (April 1963), 7–32.

152 "Camera Notes: Kertész Exhibit Recalls His Earlier Activity," *New York Times*, 16 June 1963.

153 Date book, 10–31 October 1963, PP. André Kertész to Paul Paouillac, 16 October 1963, PP. The negatives had been transferred to a property in the region of the Lot et Garonne in southern France.

154 Elizabeth Kertész to André Kertész, 23 October 1963, PP.

155 Alexandre Garai to André Kertész, 29 November 1963, PP.

156 Letter from Wayne Miller, president of Magnum Photos, Inc., to Kertész, 24 July 1964, PP and AEKF.

157 Jacob Deschin, "Camera News," *New York Times*, 29 November 1964.

158 Maria Giovanna Eisner, "Citizen Kertész," *Minicam Photography* (June 1944), 27–33.

159 Hiroji Kubota, "André Kertész/ Personality and his Photography," undated typescript, PP and AEKF.

160 André Kertész to Douglas Kneedler, 8 April 1971, PP.

161 Bela Ugrin, "Dialogues with Kertész, 1978–1985," courtesy of the Research Library, The Getty Research Institute, Los Angeles (880198), 127.

162 Stefan Lorant to André Kertész, 17 January 1973, PP and AEKF.

163 Contract between André Kertész and LIGHT Gallery, New York, 28 September 1972, PP and AEKF.

164 See "Chronology," in Susan Harder with Hiroji Kubota, *André Kertész: Diary of Light*, 1912–1985, foreword by Cornell Capa, essay by Hal Hinson (New York, 1987), 201.

165 Brendan Gill to André Kertész, 5 September 1973, PP and AEKF.

166 Graham Howe and David More, The Australian Centre for Photography, to Kertész, 26 July 1974, PP and AEKF.

167 Leo Rubinfein, "André Kertész, French Cultural Services," *Artforum*, vol. 14, no. 10 (June 1976), 68.

168 Nicolas Ducrot to Colta Ives, 19 April 1976, PP and AEKF.

169 Stefan Fischer to Nicolas Ducrot, 28 April 1976, PP and AEKF.

170 Pat Harvey to André Kertész, 26 July 1976, PP and AEKF.

171 Harder 1987, 203.

172 Exhibitions include *André Kertész, Vintage Photographs*, Jane Corkin Gallery, 1980; *André Kertész, Photographs of South Fork*, LIGHT Gallery, 1980; *André Kertész*, Jane Corkin Gallery, Toronto, 1981; *André Kertész, Paris Photographs 1980*, Janet Fleisher Gallery, Philadelphia, 1981; Solo exhibition, Galerie Agathe Gaillard, Paris, 1980; *Hungarian Memories*, Susan Harder Gallery, New York, 1982; *André Kertész, A Retrospective*, The Benteler Gallery, Houston; *André Kertész: Color*, Susan Harder Gallery, New York, 1984; *André Kertész: Exhibition of New Work*, 1980–1984, Edwynn Houk Gallery, Chicago, 1984.

173 Undated typescript, Philip French, producer, *Critic's Forum*, to André Kertész, PP and AEKF.

174 Al Gilbert, chairman, Canadian Centre of Photography, to André Kertész, 10 July 1982, PP and AEKF.

175 Invitation, twenty-first annual George Washington awards dinner, American Hungarian Foundation, PP and AEKF.

176 Invitation, convocation, and conferral of honorary doctorates, Royal College of Art, 8 July 1983, PP and AEKF.

177 Harder 1987, 204.

178 A film of the 1984 *Distortions* produced by Teri Wehn-Damisch aired on TF1, France, on 28 June 1984.

179 In 1983, Kertész arranged for the donation of his negatives and archive to the French state after his death. The negatives and archives arrived in Paris in 1987. See *André Kertész, Ma France*, with Pierre Bonhomme, Isabelle Jammes, Sandra Phillips, Michel Frizot, and Jean-Claude Lemagny (Paris, 1990), 267.

180 Program, International Center of Photography first annual ICP awards dinner, 23 April 1985, PP.

Acknowledgments · Like many exhibitions and publications, *André Kertész* has a long history. I first became intrigued with Kertész's photographs while working on the National Gallery's 1994 exhibition *Robert Frank: Moving Out.* Frank spoke about the great impact Kertész's books *Paris Vu,* 1934, and *Day of Paris,* 1945, had on his early work and especially his understanding of the power of a sequence of still photographs. Shortly thereafter I met Robert Gurbo, curator of The André and Elizabeth Kertész Foundation, and discovered that Kertész, like Frank, inspired a passionate following of photographers, writers, curators, and historians. We spent many hours together looking at and talking about Kertész's photographs, and my understanding of Kertész's life and art benefited enormously from these discussions. For giving so freely of his time and expertise, I would like to thank Robert Gurbo, as well as Alexander Hollander and Jose Fernandez, president and treasurer of the Kertész Foundation, for their many generous donations of Kertész's photographs to the National Gallery.

Projects such as this one cannot be completed without the enthusiastic support of numerous individuals. I would especially like to thank Earl A. Powell III, director, and Alan Shestack, deputy director, for their unwavering commitment. D. Dodge Thompson, chief of exhibitions programs, Judy Metro, editor in chief, and Mark Leithauser, chief of design, are also to be thanked for their astute guidance at all phases of the conception, organization, and execution of both the exhibition and publication. Equally critical has been the exceptional work of Sarah Kennel, assistant curator in the department of photographs, who has not only handled the myriad details associated with this complex undertaking, but also authored the chronology, assisted with all the essays, and completed many translations of documents written in French. Special thanks, too, are due Sara Cooling Trucksess, former staff assistant in the department of photographs, for her skillful translations and to her and Brooke Lampley, also in the department of photographs, for their unfailing assistance and attentive support at all phases of the project. Other past and present members of the department of photographs who generously shared their expertise and assistance include Matthew Witkovsky, Julia Thompson, Janet Blyberg, Charles Brock, and interns Sabine Kriebel and Jongwoo Kim.

Many individuals at the National Gallery have been critical to the success of this undertaking. In the publishing office, Julie Warnement edited the catalogue with a grace, discernment, and meticulous attention to detail that has been greatly appreciated and Chris Vogel skillfully managed its production. Special recognition is due Margaret Bauer, who matched the poetry and elegance of Kertész's photographs in her design of this catalogue. Also to be thanked for their critical work on the exhibition are Carol Kelley in the director's office; Joseph Krakora, executive officer, external and international affairs; Naomi Remes and Tamara Wilson in the department of exhibitions; Susan Arensberg and Lynn Matheny in the department of exhibition programs; Constance McCabe, Hugh Phibbs, Jenny Ritchie, and Jamie Stout in the department of conservation; Elizabeth Croog and Lara Levinson in the office of the secretary and general counsel; Gordon Anson, Jame Anderson, William Bowser, Mari Forsell, Deborah Kirkpatrick, and Barbara Keyes in the department of design and installation; Sally Freitag, Melissa Stegeman, Theresa Beall, and David Smith in the office of the registrar; Sara Sanders-Buell and Ira Bartfield in the publishing office; Cathryn Scoville and Bonnie Hourigan

in the development office; Christine Myers in the office of corporate relations; and Deborah Ziska and Mary Jane McKinven in the press and public information office.

Kertész was a beloved figure within the photography community in the 1970s and 1980s and many individuals who knew him personally have eagerly shared both their expertise and insights into his art and life. I would especially like to thank my colleagues Sandra Phillips, San Francisco Museum of Modern Art; David Travis, The Art Institute of Chicago; and Weston Naef, The J. Paul Getty Museum; as well as James Borcoman, Ben Lifson, and Sylvia Plachy. Photography dealers Stephen Daiter, Jeffrey Fraenkel, Howard Greenberg, Edwynn Houk, Peter MacGill, Jill Quasha, and Margaret Weston aided me immeasurably as I sought to track down vintage prints of Kertész's work. As Kertész's representatives at the end of his life, Susan Harder and Jane Corkin also shared their knowledge of the artist. Pierre Borhan Bonhomme, Philippe Arbaïzar, and Christophe Mauberret patiently endured my many visits and greatly facilitated my research in the large Kertész archive at the Mission du Patrimoine Photographique. In Hungary my research was greatly aided by Sándor Szilágyi, who provided many translations of Hungarian journals. In Washington, Bulcsu Veress skillfully translated from Hungarian many of Kertész's own diaries and letters, as well as correspondence from family and friends.

At the Los Angeles County Museum of Art, I would like to thank the director, Andrea Rich, and curator Robert Sobieszek for sharing the Gallery's enthusiasm for Kertész and presenting this exhibition to a West Coast audience. I would also like to thank Irene Martin, Kristin Fredericks, Bernard Kestler, and Eve Schillo.

As the National Gallery of Art has worked on this project over a number of years, many colleagues and friends, both old and new, have assisted us, often repeatedly, with a level of generosity that is truly exceptional. We wish especially to thank Lisa d'Acquisto at The Art Institute of Chicago; Oliver Botar; Marianne Courville and Blair Rainey at The Buhl Collection; Tom Hinson at The Cleveland Museum of Art; Paul Berlanga at the Stephen Daiter Gallery; Nancy Barr at The Detroit Institute of Arts; Pierre Apraxine and Maria Umali at the Gilman Paper Company Collection; Keith Davis at the Hallmark Photographic Collection; Jane Jackson at the Sir Elton John Collection; Julian Cox at The J. Paul Getty Museum; Wim de Wit at The J. Paul Getty Research Library; Károly Kincses and Magdolna Kolta at the Hungarian Museum of Photography; Vanilia Majoros; Lee Marks; Malcolm Daniel at The Metropolitan Museum of Art; Raina Goldbas and Dr. Paul Schweizer at the Munson Procter Arts Institute; Cliff Ackley and Anne Havinga at the Museum of Fine Arts, Boston; Anne Tucker at The Museum of Fine Arts, Houston; Peter Galassi and Susan Kismaric at The Museum of Modern Art; Zsófia Nemes; Stephen Maklansky at the New Orleans Museum of Art; Kim Sichel; and Andrew Szegedy-Maszak.

I would also particularly like to acknowledge the critical funding we have received from the Trellis Fund and The Ryna and Melvin Cohen Family Foundation. Their multiyear support has enabled the National Gallery not only to mount *André Kertész*, but also to present eight other exhibitions of photographs in our newly dedicated galleries for photographs.

Sarah Greenough, *curator and head of the department of photographs, National Gallery of Art*

287

I would like to thank the many hundreds of fellow lovers of André Kertész's art with whom I have crossed paths over the nineteen years I have served as curator of this great body of work. Their passionate insights and enthusiasm have provided a nurturing framework for my own understanding of Kertész's vision. I am especially indebted to Paul Berlanga, whose nuanced comprehension of Kertész's art informs my essays. I would like to thank Sarah Greenough and Sarah Kennel. Their understanding and steadfast guidance have been invaluable. I would also like to express my gratitude to Robert D'Allesandro, Sarah Morthland, and Louise Voccoli for their editorial assistance and the many hours of conversations that furthered the development of several of my concepts and ideas. Many thanks go to Stephen Daiter and Michael Welch for their support and friendship. Thanks also go to Nina Barnett, Doug James, Sylvia Plachy, Ariel Shanberg, Sándor Szilágyi, Neil Trager, and Tom Wolf for sharing their research and ideas. I am indebted to Harold Jones, Fern Schad, Charles Traub, and Victor Schreiger for generously sharing their time and knowledge. Mike Bradley provided crucial assistance with the scanning and organization of the databases. Peter Mustardo of The Better Image offered astute advice and care in matters of conservation.

Special thanks go to Jose Fernandez and Alex Hollander of The André and Elizabeth Kertész Foundation for supporting my extensive research for this project. I also would like to thank my brother Walter Gurbo for giving me my first Kertész book. I will always be in debt to Nancy Stevens for introducing me to André Kertész.

Above all, my deepest gratitude goes to André Kertész, whose visual poetry has forever penetrated my soul.

Robert Gurbo, *curator of The André and Elizabeth Kertész Foundation*

Checklist of the Exhibition

1

Camera in Landscape
1918–1925
gelatin silver print
4.2 x 5.8 (1 5/8 x 2 5/16)
The J. Paul Getty Museum,
Los Angeles

2

Sleeping Boy
1912
gelatin silver print
4.4 x 5.9 (1 3/4 x 2 5/16)
National Gallery of Art,
Washington, Gift of
The André and Elizabeth
Kertész Foundation

3

Bocskay-tér, Budapest
1914
gelatin silver print
3.7 x 5.1 (1 7/16 x 2)
The Museum of Modern Art,
New York, Thomas Walther Collection, Gift of Thomas Walther

4

Soldier with Cello
1914–1918
gelatin silver print
5.5 x 4.2 (2 3/16 x 1 5/8)
Nicholas Pritzker

5

Self-Portrait
1915
gelatin silver print
5.1 x 3.8 (2 x 1 1/2)
National Gallery of Art,
Washington, Gift of
The André and Elizabeth
Kertész Foundation

6

Latrine, Gologóry, Poland
1915–1916
gelatin silver print
4 x 5.2 (1 9/16 x 2 1/16)
Estate of André Kertész,
New York

7

A Red Hussar Leaving
1919
gelatin silver print
4 x 5.5 (1 9/16 x 2 3/16)
National Gallery of Art,
Washington, Gift of
The André and Elizabeth
Kertész Foundation

8

Albania
1918
gelatin silver print
11.4 x 16.7 (4 1/2 x 6 9/16)
National Gallery of Art,
Washington, Gift of
The André and Elizabeth
Kertész Foundation

9

The Fairy Tale
1914–1917
gelatin silver print
4.1 x 5.2 (1 5/8 x 2 1/16)
National Gallery of Art,
Washington, Gift of
The André and Elizabeth
Kertész Foundation

10

Feeding Ducks, Tisza Szalka
1924
gelatin silver print
4.3 x 4.6 (1 11/16 x 1 13/16)
Estate of André Kertész,
New York

11

Népliget, Budapest
1918
gelatin silver print
5.1 x 3.9 (2 x 1 9/16)
National Gallery of Art,
Washington, Gift of
The André and Elizabeth
Kertész Foundation

12

Blind Musician, Abony
1921
gelatin silver print
5.1 x 3.8 (2 x 1 1/2)
National Gallery of Art,
Washington, Gift of
The André and Elizabeth
Kertész Foundation

13

Esztergom
1917
gelatin silver print
4.6 x 5.9 (1 13/16 x 2 5/16)
Estate of André Kertész,
New York

14

Parliament Building, Budapest
1919–1925
gelatin silver print
4.1 x 2.8 (1 5/8 x 1 1/8)
National Gallery of Art,
Washington, Gift of
The André and Elizabeth
Kertész Foundation

15

Esztergom Cathedral
1917
gelatin silver print
3.7 x 5.1 (1 7/16 x 2)
National Gallery of Art,
Washington, Gift of
The André and Elizabeth
Kertész Foundation

16

Underwater Swimmer, Esztergom
1917
gelatin silver print
3.8 x 5.7 (1 1/2 x 2 1/4)
The Sir Elton John Photography
Collection

17

Jenő Kertész
1923
gelatin silver print
3.7 x 5.1 (1 7/16 x 2)
National Gallery of Art,
Washington, Gift of
The André and Elizabeth
Kertész Foundation

18

Jenő Kertész as Icarus
1919–1920
gelatin silver print
3.8 x 5.1 (1 1/2 x 2)
National Gallery of Art,
Washington, Gift of
The André and Elizabeth
Kertész Foundation

19

Jenő Kertész
1919–1924
gelatin silver print
7.8 x 7.3 (3 1/16 x 2 7/8)
National Gallery of Art,
Washington, Gift of
The André and Elizabeth
Kertész Foundation

20

The Dancing Faun
1919
gelatin silver print
5.7 x 9.8 (2 1/4 x 3 7/8)
Betsy Karel

21

Jenő Kertész
1920
gelatin silver print
3.8 x 5.1 (1 1/2 x 2)
National Gallery of Art,
Washington, Gift of
The André and Elizabeth
Kertész Foundation

22

*Erzsébet Salamon, Imre Czumpf,
Andor Kertész, and Rezső Czierlich*
1924
gelatin silver print
11.4 x 14.3 (4 1/2 x 5 5/8)
Estate of André Kertész,
New York

23

*Vilmos Aba-Novák and
Káto Vulkovics*
1923–1924
gelatin silver print
3.8 x 5.6 (1 1/2 x 2 3/16)
Estate of André Kertész,
New York

24

Meeting, Budapest
1919
gelatin silver print
3.4 x 4.7 (1 5/16 x 1 7/8)
National Gallery of Art,
Washington, Gift of
The André and Elizabeth
Kertész Foundation

25
Budapest
1919
gelatin silver print
3.9 x 5.5 (1 9/16 x 2 3/16)
National Gallery of Art,
Washington, Gift of
The André and Elizabeth
Kertész Foundation

26
Street Scene, Budapest
1919
gelatin silver print
5.1 x 3.7 (2 x 1 7/16)
National Gallery of Art,
Washington, Gift of
The André and Elizabeth
Kertész Foundation

27
Jenő Kertész
1920
gelatin silver print
5.2 x 4 (2 1/16 x 1 9/16)
National Gallery of Art,
Washington, Gift of
The André and Elizabeth
Kertész Foundation

28
Self-Portrait with Ede Papszt
1921
gelatin silver print
11.2 x 15.2 (4 7/16 x 6)
National Gallery of Art,
Washington, Gift of
The André and Elizabeth
Kertész Foundation

29
Self-Portrait with Erzsébet Salamon
1920
gelatin silver print
3.7 x 5.1 (1 7/16 x 2)
National Gallery of Art,
Washington, Gift of
The André and Elizabeth
Kertész Foundation

30
Self-Portrait with Jenő Kertész
1923
gelatin silver print
3.7 x 5.1 (1 7/16 x 2)
National Gallery of Art,
Washington, Gift of
The André and Elizabeth
Kertész Foundation

31
Wine Cellars, Budafok
1924
gelatin silver print
3.9 x 5.4 (1 9/16 x 2 1/8)
Collection of the Prentice and
Paul Sack Photographic Trust of
the San Francisco Museum of
Modern Art

32
Dunaharaszti
1919
gelatin silver print
5.2 x 3.9 (2 1/16 x 1 9/16)
National Gallery of Art,
Washington, Gift of
The André and Elizabeth
Kertész Foundation

33
Eiffel Tower
1925
gelatin silver print
7.1 x 3.9 (2 13/16 x 1 9/16)
Nicholas Pritzker

34
Behind Notre Dame
1925 – 1926
gelatin silver print
8.3 x 10.4 (3 1/4 x 4 1/8)
Collection of Joy of Giving
Something, Inc., New York

35
Théâtre Odéon at Night
1925 – 1926
gelatin silver print
8 x 7.3 (3 1/8 x 2 7/8)
New Orleans Museum of Art,
Museum Purchase, Women's
Volunteer Committee Fund

36
Behind the Hôtel de Ville
1925
gelatin silver print
7.9 x 10.8 (3 1/8 x 4 1/4)
Nicholas Pritzker

37
Fête Foraine
1926
gelatin silver print
7.3 x 7.1 (2 7/8 x 2 13/16)
Courtesy Stephen Daiter Gallery

38
Stairs, Montmartre
1926
gelatin silver print
8.3 x 10.6 (3 1/4 x 4 3/16)
Fraenkel Gallery, San Francisco

39
Chairs, Luxembourg Gardens
1926
gelatin silver print
7.8 x 9.7 (3 1/16 x 3 13/16)
Private Collection, San Francisco

40
Wall of Posters
1926 – 1927
gelatin silver print
10.3 x 7.8 (4 1/16 x 3 1/16)
The Museum of Fine Arts,
Houston, The Manfred Heiting
Collection

41
Sécurité, Grand Boulevard
1926 – 1927
gelatin silver print
7.8 x 10.9 (3 1/16 x 4 5/16)
The Museum of Modern Art,
New York, Thomas Walther
Collection, Gift of Thomas
Walther

42
*Portrait of a Young Yugoslav
Bibliophile*
1926 – 1927
gelatin silver print
10.9 x 8 (4 5/16 x 3 1/8)
The Art Institute of Chicago,
Wirt D. Walker Fund

43
Self-Portrait, Paris
1926 – 1927
gelatin silver print
10.9 x 7.9 (4 5/16 x 3 1/8)
Lent by The Metropolitan
Museum of Art, Promised and
partial gift of Isaac Lagnado

44
Mlle Jaffe
1926
gelatin silver print
15.8 x 14.5 (6 1/4 x 5 11/16)
The Museum of Modern Art,
New York, Thomas Walther
Collection, Purchase

45
Portrait of Mme R.
1926
gelatin silver print
21.4 x 12.9 (8 7/16 x 5 1/16)
The Museum of Modern Art,
New York, Thomas Walther
Collection, Gift of Thomas
Walther

46
Magda Förstner
1926
gelatin silver print
10.9 x 5.9 (4 9/32 x 2 11/32)
The J. Paul Getty Museum,
Los Angeles

47
Satiric Dancer
1926
gelatin silver print
9.6 x 7.8 (3 3/4 x 3 1/16)
Nicholas Pritzker

48
Géza Blattner
1925
gelatin silver print
7.7 x 8.1 (3 $\frac{1}{16}$ x 3 $\frac{3}{16}$)
The Museum of Modern Art,
New York, Thomas Walther
Collection, Gift of Thomas
Walther

49
Mondrian's Studio
1926
gelatin silver print
10.9 x 7.9 (4 $\frac{5}{16}$ x 3 $\frac{1}{8}$)
Courtesy Edwynn Houk Gallery,
New York, and Pace/MacGill
Gallery, New York

50
Chez Mondrian
1926
gelatin silver print
10.8 x 7.9 (4 $\frac{1}{4}$ x 3 $\frac{1}{8}$)
Lent by The Metropolitan Museum
of Art, Gift of Harry Holtzman

51
Mondrian's Glasses and Pipe
1926
gelatin silver print
7.9 x 9.2 (3 $\frac{1}{8}$ x 3 $\frac{5}{8}$)
The Museum of Modern Art,
New York, Thomas Walther
Collection, Purchase

52
Fork
1928
gelatin silver print
7.6 x 9.2 (3 x 3 $\frac{5}{8}$)
Hallmark Photographic Collection,
Hallmark Cards, Inc., Kansas City,
Missouri

53
Quartet
1926
gelatin silver print
7.9 x 14.4 (3 $\frac{1}{8}$ x 5 $\frac{11}{16}$)
Collection of Joy of Giving
Something, Inc., New York

54
Cello Study
1926
gelatin silver print
39.1 x 14.6 (15 $\frac{3}{8}$ x 5 $\frac{3}{4}$)
Private Collection, San Francisco

55
Chairs in the American Library
1928
gelatin silver print
21.5 x 13.3 (8 $\frac{7}{16}$ x 5 $\frac{1}{4}$)
The Art Institute of Chicago,
Julien Levy Collection, Gift of
Jean and Julien Levy

56
Rue Vavin
1925
gelatin silver print
25.2 x 20 (9 $\frac{15}{16}$ x 7 $\frac{7}{8}$)
Collection of the Prentice and
Paul Sack Photographic Trust of
the San Francisco Museum of
Modern Art

57
Siesta
1927
gelatin silver print
23.9 x 15.5 (9 $\frac{7}{16}$ x 6 $\frac{1}{8}$)
The Art Institute of Chicago,
Julien Levy Collection, Special
Photography Acquisition Fund

58
Meudon
1928
gelatin silver print
23.8 x 17.7 (9 $\frac{3}{8}$ x 6 $\frac{15}{16}$)
Collection Soizic Audouard,
Paris

59
Quai d'Orsay
1926
gelatin silver print
31.2 x 22.9 (12 $\frac{1}{4}$ x 9)
Gilman Paper Company Collection

60
Muguet Seller
1928 or 1930
gelatin silver print
18.7 x 24.1 (7 $\frac{3}{8}$ x 9 $\frac{1}{2}$)
Estate of André Kertész,
New York

61
Montparnasse
1928
gelatin silver print
24.7 x 19.6 (9 $\frac{3}{4}$ x 7 $\frac{3}{4}$)
Estate of André Kertész,
New York

62
On the Boulevards
1934
gelatin silver print
23.8 x 18 (9 $\frac{3}{8}$ x 7 $\frac{1}{6}$)
Lent by The Metropolitan Museum
of Art, Ford Motor Company
Collection, Gift of Ford Motor
Company and John C. Waddell

63
Clock of the Académie Française
1929
gelatin silver print
17.2 x 23.5 (6 $\frac{3}{4}$ x 9 $\frac{1}{4}$)
National Gallery of Art, Wash-
ington, Gift of The Howard
Gilman Foundation and The André
and Elizabeth Kertész Foundation

64
Under the Eiffel Tower
1929
gelatin silver print
19.6 x 22.4 (7 $\frac{11}{16}$ x 8 $\frac{13}{16}$)
National Gallery of Art,
Washington, Gift of
The André and Elizabeth
Kertész Foundation

65
The Vert-Galant under the Snow
1935
gelatin silver print
24.4 x 19.6 (9 $\frac{5}{8}$ x 7 $\frac{3}{4}$)
Margaret W. Weston

66
Café Extra
1927 – 1932
gelatin silver print
20.1 x 13 (7 $\frac{15}{16}$ x 5 $\frac{1}{8}$)
The Art Institute of Chicago,
Julien Levy Collection, Special
Photography Acquisition Fund

67
Hanging Pictures
1928
gelatin silver print
22.7 x 17 (8 $\frac{15}{16}$ x 6 $\frac{11}{16}$)
Courtesy Stephen Daiter Gallery

68
*Distortion — Self-Portrait
with Carlo Rim*
1930
gelatin silver print
22.4 x 14.4 (8 $\frac{13}{16}$ x 5 $\frac{11}{16}$)
The Buhl Collection
(NOT IN EXHIBITION)

69
Distortion #40
1933
gelatin silver print
26.7 x 33.8 (10 $\frac{1}{2}$ x 13 $\frac{5}{16}$)
Dorothy Press

70
Distortion #150
1933
gelatin silver print
29.5 x 22.8 (11 $\frac{5}{8}$ x 9)
The Cleveland Museum of Art,
Dudley P. Allen Fund

71
Distortion #167
1933
gelatin silver print
23.8 x 16.7 (9 $\frac{3}{8}$ x 6 $\frac{9}{16}$)
The Art Institute of Chicago,
Gift of Charles Levin

72
Elizabeth
1931 – 1936
gelatin silver print
23.8 x 17.8 (9 $\frac{3}{8}$ x 7)
National Gallery of Art,
Washington, Gift of
The André and Elizabeth
Kertész Foundation

73
Elizabeth and I
1933
gelatin silver print
23.8 x 17.9 (9 $\frac{3}{8}$ x 7 $\frac{1}{16}$)
National Gallery of Art,
Washington, Gift of
The André and Elizabeth
Kertész Foundation

74
Self-Portrait
1927
gelatin silver print
15.4 x 14.6 (6 x 5 ³/₄)
Susan Harder Collection,
New York

75
Self-Portrait in the Hotel Beaux-Arts
1936 or 1938
gelatin silver print
24.5 x 16.6 (9 ⁵/₈ x 6 ⁹/₁₆)
National Gallery of Art,
Washington, Gift of
The André and Elizabeth
Kertész Foundation

76
Poughkeepsie, New York
1937
gelatin silver print
23.6 x 18.3 (9 ⁵/₁₆ x 7 ³/₁₆)
Lent by The Metropolitan Museum
of Art, Ford Motor Company
Collection, Gift of Ford Motor
Company and John C. Waddell

77
Communications Building,
New York World's Fair
1939
gelatin silver print
23.8 x 19 (9 ³/₈ x 7 ¹/₂)
National Gallery of Art,
Washington, Gift of
Diana Walker

78
Lost Cloud
1937
gelatin silver print
24.7 x 16.8 (9 ³/₄ x 6 ⁵/₈)
Estate of André Kertész,
New York

79
Skywriting
1937–1940
gelatin silver print
24.4 x 18.9 (9 ⁵/₈ x 7 ⁷/₁₆)
National Gallery of Art,
Washington, Gift of
The André and Elizabeth
Kertész Foundation

80
Melancholic Tulip
1939
gelatin silver print
34 x 21.6 (13 ³/₈ x 8 ¹/₂)
The Detroit Institute of Arts,
Founders Society Purchase,
Acquisition Fund

81
Arm and Ventilator
1937
gelatin silver print
21.7 x 20.8 (8 ⁹/₁₆ x 8 ³/₁₆)
The Buhl Collection

82
Lion and Shadow
1949
gelatin silver print
24.3 x 19.6 (9 ⁹/₁₆ x 7 ¹¹/₁₆)
National Gallery of Art,
Washington, Gift of
The André and Elizabeth
Kertész Foundation

83
Homing Ship
1944
gelatin silver print
24.5 x 19.1 (9 ⁵/₈ x 7 ¹/₂)
Estate of André Kertész,
New York

84
Ballet
1938
gelatin silver print
27.6 x 34.5 (10 ⁷/₈ x 13 ⁵/₈)
Emily Anne Dixon-Ryan

85
Armonk, New York
1941
gelatin silver print
24.9 x 19.7 (9 ⁹/₁₆ x 7 ³/₄)
The Museum of Modern Art,
New York, Purchase

86
Disappearing Act
1955
gelatin silver print
23.5 x 19.7 (9 ¹/₄ x 7 ³/₄)
Estate of André Kertész,
New York

87
River Walk of Carl Schurz Park
1948
gelatin silver print
25.1 x 18.7 (9 ⁷/₈ x 7 ³/₈)
Mary Reese Green
and Donald Ross Green

88
Studio Corner of Miss Maxine Picard
1956
gelatin silver print
17.1 x 25.1 (6 ³/₄ x 9 ⁷/₈)
Anonymous Collection, Courtesy
Stephen Daiter Gallery

89
Lafayette, Munson-Williams-
Proctor Museum
1961
gelatin silver print
11.5 x 16.1 (4 ¹/₂ x 6 ⁵/₁₆)
National Gallery of Art,
Washington, Gift of
The André and Elizabeth
Kertész Foundation

90
MacDougal Alley
1961
gelatin silver print
24.5 x 16.8 (9 ⁵/₈ x 6 ⁵/₈)
Karen Daiter

91
Washington Square
1954
gelatin silver print
12.6 x 9.4 (4 ¹⁵/₁₆ x 3 ¹¹/₁₆)
National Gallery of Art,
Washington, Gift of
The André and Elizabeth
Kertész Foundation

92
Billboard
1959
gelatin silver print
19.6 x 24 (7 ¹¹/₁₆ x 9 ⁷/₁₆)
Estate of André Kertész,
New York

93
Going for a Walk
1958
gelatin silver print
9 x 8.7 (3 ⁹/₁₆ x 3 ⁷/₁₆)
National Gallery of Art,
Washington, Gift of
The André and Elizabeth
Kertész Foundation

94
Broken Plate, Paris
1929
gelatin silver print
late 1960s
19.3 x 24.7 (7 ⁵/₈ x 9 ³/₄)
The J. Paul Getty Museum,
Los Angeles

95
Promenade
1962
gelatin silver print
24.8 x 19.8 (9 ³/₄ x 7 ¹³/₁₆)
Estate of André Kertész,
New York

96
The White Horse
1962
gelatin silver print
24 x 19.7 (9 ⁷/₁₆ x 7 ³/₄)
Estate of André Kertész,
New York

97
The Broken Bench
1962
gelatin silver print
17.1 x 24.7 (6 ³/₄ x 9 ³/₄)
Hallmark Photographic
Collection, Hallmark Cards, Inc.,
Kansas City, Missouri

98
The Heron
1969
gelatin silver print
24.6 x 17 (9 $^{11}/_{16}$ x 6 $^{11}/_{16}$)
Estate of André Kertész,
New York

99
Rainy Day, Tokyo
1968
gelatin silver print
24.7 x 13.7 (9 $^{3}/_{4}$ x 5 $^{3}/_{8}$)
The J. Paul Getty Museum,
Los Angeles

100
"Buy," Long Island University
1962
gelatin silver print
24.5 x 17.6 (9 $^{5}/_{8}$ x 6 $^{15}/_{16}$)
National Gallery of Art,
Washington, Gift of
The André and Elizabeth
Kertész Foundation

101
MacDougal Alley
1962
gelatin silver print
24 x 18.1 (9 $^{3}/_{4}$ x 7 $^{1}/_{8}$)
National Gallery of Art,
Washington, Gift of
The André and Elizabeth
Kertész Foundation

102
Shadows and Buildings
1966
gelatin silver print
34.6 x 27 (13 $^{5}/_{8}$ x 10 $^{5}/_{8}$)
Collection of Eric Ceputis and
David W. Williams

103
Washington Square
1966
gelatin silver print
24.1 x 16.2 (9 $^{1}/_{2}$ x 6 $^{3}/_{8}$)
Estate of André Kertész,
New York

104
MacDougal Alley
1977
gelatin silver print
24.8 x 17.2 (9 $^{3}/_{4}$ x 6 $^{3}/_{4}$)
Estate of André Kertész,
New York

105
Washington Square
1968
gelatin silver print
24.8 x 16.8 (9 $^{3}/_{4}$ x 6 $^{5}/_{8}$)
Estate of André Kertész,
New York

106
Martinique
1972
gelatin silver print
20.3 x 25.4 (8 x 10)
Wendy Handler

107
Mauna Kea
1974
gelatin silver print
22.5 x 19.7 (8 $^{7}/_{8}$ x 7 $^{3}/_{4}$)
Estate of André Kertész,
New York

108
Flowers for Elizabeth
1976
gelatin silver print
17 x 24.6 (6 $^{11}/_{16}$ x 9 $^{11}/_{16}$)
Estate of André Kertész,
New York

109
*Glass Sculpture with
World Trade Center*
1979
gelatin silver print
24.8 x 16.7 (9 $^{3}/_{4}$ x 6 $^{9}/_{16}$)
Estate of André Kertész,
New York

110
The Tuileries Gardens
1980
gelatin silver print
24.8 x 19.7 (9 $^{3}/_{4}$ x 7 $^{3}/_{4}$)
Hallmark Photographic Collection,
Hallmark Cards, Inc., Kansas City,
Missouri

111
Self-Portrait with Life Masks
1976
gelatin silver print
16.4 x 24.8 (6 $^{7}/_{16}$ x 9 $^{3}/_{4}$)
Estate of André Kertész,
New York

112
Paris
1984
gelatin silver print
24.6 x 17.2 (9 $^{11}/_{16}$ x 6 $^{3}/_{4}$)
Courtesy Stephen Daiter Gallery

113
From My Window
1980
Cibachrome
10.5 x 10.3 (4 $^{1}/_{8}$ x 4 $^{1}/_{16}$)
Estate of André Kertész,
New York

114
New York
1980
Polaroid SX-70
7.9 x 7.9 (3 $^{1}/_{8}$ x 3 $^{1}/_{8}$)
Estate of André Kertész,
New York

115
Self-Portrait
1984
Cibachrome
10.5 x 10.3 (4 $^{1}/_{8}$ x 4 $^{1}/_{16}$)
Estate of André Kertész,
New York

116
New York
1980
Cibachrome
10.3 x 10.2 (4 $^{1}/_{16}$ x 4)
Estate of André Kertész,
New York

The bibliography is divided into sections; entries within each section are arranged chronologically.

Archival sources and unpublished interviews

PP: Patrimoine Photographique, André Kertész archives, Paris. The largest holdings of letters, documents, and clippings pertaining to Kertész's life and career, donated by The André and Elizabeth Kertész Foundation (AEKF). The foundation retained copies of many items and donated additional copies to The Art Institute of Chicago; The Metropolitan Museum of Art, New York; The J. Paul Getty Museum, Los Angeles; and the National Gallery of Art, Washington.

Borcoman: Interview with James Borcoman, 27 February 1971, courtesy of James Borcoman and the National Gallery of Canada.

Ugrin: Dialogues with Bela Ugrin, 1978–1985. Transcripts of taped interviews and notes compiled and edited by Manuela Caravageli Ugrin. Typescript copy, courtesy of The Getty Research Institute, The Research Library, Los Angeles (880198).

Lifson: Series of interviews with Ben Lifson, 1981–1982, courtesy of Ben Lifson.

Books and publications by Kertész

Enfants. Text by Jaboune [Jean Nohain]. Paris, 1933.

Paris Vu par André Kertész. Text by Pierre Mac Orlan. Paris, 1934.

Nos amies les bêtes. Text by Jaboune [Jean Nohain]. Paris, 1936.

Les Cathédrales du vin. Text by Pierre Hamp. Paris, 1937.

"Caricatures and Distortions." *The Complete Photographer* 2, 10 (20 December 1941), 651–656.

Day of Paris. Edited by George Davis. New York, 1945.

André Kertész. Introduction by Anna Fárová. Adapted for American edition by Robert Sagalyn. New York, 1966.

On Reading. New York, 1971.

André Kertész: Sixty Years of Photography, 1912–1972. Edited by Nicolas Ducrot. New York, 1972.

J'aime Paris: Photographs since the Twenties. Edited by Nicolas Ducrot. New York, 1974.

Washington Square. Edited by Nicolas Ducrot, text by Brendan Gill. New York, 1975.

Distortions. Edited by Nicolas Ducrot. Introduction by Hilton Kramer. New York, 1976.

Of New York. Edited by Nicolas Ducrot. New York, 1976.

Americana. Edited by Nicolas Ducrot. New York, 1979.

Birds. Edited by Nicolas Ducrot. New York, 1979.

Landscapes. Edited by Nicolas Ducrot. New York, 1979.

Portraits. Edited by Nicolas Ducrot. New York, 1979.

From My Window. Introduction by Peter MacGill. Boston, 1981.

André Kertész: A Lifetime of Perception. Introduction by Ben Lifson. New York, 1982.

Hungarian Memories. Introduction by Hilton Kramer. Boston, 1982.

Kertész on Kertész: A Self-Portrait. With Peter Adam. Edited by Anne Hoy. New York, 1985.

Solo Exhibition Catalogues

Kertész at Long Island University. Text by Nathan Resnick. Long Island University, New York, 1962.

André Kertész photographies. Text by Alix Gambier. Bibliothèque Nationale, Paris, 1963.

André Kertész, Photographer. Text by John Szarkowski. Museum of Modern Art, New York, 1964.

André Kertész Fotómüvész. Hungarian National Gallery, Budapest, 1971.

André Kertész: Fotografier, 1913–1971. Text by Rune Hassner. Moderna Museet, Stockholm, 1971.

André Kertész, Photographs. Davidson Art Center, Wesleyan University, Middletown, Conn., 1976.

André Kertész. Introduction by Pierre de Fenoyl. Centre Georges Pompidou, Paris, 1979. Published in English as *André Kertész: An Exhibition of Photographs from the Centre Georges Pompidou*. Text by Colin Ford. Arts Council of Great Britain, London, 1979.

André Kertész, Master of Photography. Text by Brooks Johnson. Chrysler Art Museum, Norfolk, Va., 1982.

André Kertész. Edited by Thomas Walter. Galerie Wilde, Cologne, 1982.

André Kertész: Form and Feeling. Keith F. Davis. Hallmark Photographic Collection, Kansas City, 1983.

André Kertész: A Ninetieth Birthday Celebration. National Museum of Photography, Film, and Television, West Yorkshire, 1984.

André Kertész: Fotómüvész Kiállítása. Vigado Gallery, Budapest, 1984.

André Kertész: Of Paris and New York. Texts by Sandra S. Phillips, David Travis, and Weston J. Naef. The Art Institute of Chicago and The Metropolitan Museum of Art, New York, 1985.

André Kertész: Vintage Photographs. Edwynn Houk Gallery, Chicago, 1985.

André Kertész: A Portrait at Ninety. International Center of Photography, New York, 1985.

André Kertész (1894–1985): 70 Photographien 1912–1966. Text by Peter Baum. Neue Galerie der Stadt Linz, 1986.

Omaggio ad André Kertész, 1894–1985. Académie de France à Rome, 1986.

André Kertész photographe. Text by René Huyghe and Jean-Paul Sarpitta. Institut de France, Musée Jacquemart-André, Paris, 1987.

Stranger to Paris: Au Sacre du Printemps Gallerie, 1927. Text by Robert Enright. Jane Corkin Gallery, Toronto, 1992.

André Kertész: Lost in America. Linfield College, McMinnville, Ore., 1998.

André Kertész and Avant-Garde Photography of the Twenties and Thirties. Annely Juda Fine Art, London, 1999.

André Kertész: The Mirror as Muse. Stephen Daiter Gallery, Chicago, 1999.

André Kertész: New York State of Mind. Text by Robert Gurbo. Stephen Daiter Gallery, Chicago, 2001.

In the New York Apartment of André Kertész. Hungarian Museum of Photography and the Institute Française, Budapest, 2001.

André Kertész: Inediti a Gorizia. Musei Provinciali di Gorizia, 2003.

Books and Theses

André Kertész: Munkássága. With Bajomi Lázár Endre. Budapest, 1972.

Kismaric, Carole. *André Kertész*. New York, 1977.

Ford, Colin. *André Kertész*. London, 1979.

Borhan, Pierre. *Voyons Voir*. Paris, 1980.

André Kertész: A Lifetime of Perception. Edited by Jane Corkin, introduction by Ben Lifson. New York, 1982.

André Kertész. Text by Attilio Colombo. Milan, 1983.

André Kertész: Magyarországon. Budapest, 1984.

André Kertész: The Manchester Collection. Manchester, England, 1984.

André Kertész. Text by Keith Davis. Chicago, 1985.

Phillips, Sandra S. "The Photographic Work of André Kertész in France, 1925–1936: A Critical Essay and Catalogue." PhD dissertation, City University of New York, 1985.

Sallenave, Danièle. *André Kertész*. New York and Paris, 1986.

Sichel, Kim Debora. "Photographs of Paris: Brassaï, André Kertész, Germaine Krull, and Man Ray." PhD dissertation, Yale University, 1986.

Harder, Susan, with Hiroji Kubota. *André Kertész: Diary of Light, 1912–1985*. New York, 1987.

André Kertész, Ma France. Text by Pierre Bonhomme, Sandra Phillips, Jean-Claude Lemagny, Michel Frizot. Paris, 1990.

Fonvielle, Lloyd. *André Kertész*. New York, 1993.

Kismaric, Carole. *André Kertész, 1894–1985*. New York, 1993.

André Kertész, 1894–1985–1994. Texts by Kincses Károly, Miklós Mátyássy, Pierre Borhan. Budapest, 1994.

André Kertész: His Life and Work. Edited by Pierre Borhan. Boston, New York, Toronto, and London, 1994.

André Kertész: In Focus. Photographs from The J. Paul Getty Museum. Los Angeles, 1994.

Lyford, Amy J. "Body Parts: Surrealism and the Reconstruction of Masculinity." PhD dissertation, University of California, Berkeley, 1997.

Rogniat, Évelyne. *André Kertész: Le Photographe à L'Oeuvre*. Paris, 1997.

J'aime la France: Capolavorie della fotografia dai Nadar à Kertesz, 1855–1985. Milan, 1998.

Bourcier, Noel. *André Kertész*. London, 2001.

Kertész: Made in USA. Text by Alain d'Hooge. Paris, 2003.

Travis, David. "André Kertész: The Gaiety of Genius." In *At the Edge of Light: Thoughts on Photographers, Talent, and Genuis*. Boston, 2003, 35–50.

Articles

"Egy Magyar fényképész, Párizsban." *Magyar Hirlap*, 28 October 1926.

Mareschal, Yvonne. "Au Sacre du Printemps." *La Semaine à Paris* 251 (March 1927), 18–23.

S., M. "Beaux-Arts: Frère Voyant." *Comoedia*, 12 March 1927.

"Art and Artists." *Chicago Tribune* (Paris edition), 13 March 1927.

Montpar. "Photo-Kertész." *Chantecler*, 19 March 1927.

Benoist, Luc. "Memento: Petites Expositions." *Le Crapouillot* (April 1927).

Review of exhibition at Au Sacre du Printemps. *Art et Photo* (November 1927), 19.

"Salon to be Held by Photographers." *New York Herald Tribune* (Paris edition), 12 May 1928.

"Oldest and Newest in Photography Contrasted in Unique Exhibition." *Chicago Tribune* (Paris edition), 26 May 1928.

Fels, Florent. "Le Premier Salon Indépendant de la Photographie." *L'Art Vivant* 4 (1 June 1928), 444–445.

G., G-J. "Un Salon de la photographie." *Paris-Midi*, 6 June 1928.

Charensol, Georges. "Les Expositions." *L'Art Vivant* 4 (15 June 1928), 486–487.

Bost, Pierre. "Promenades et Spectacles: Le Salon des Indépendants de la Photographie." *La Revue Hebdomadaire* 24 (16 June 1928), 356–359.

Mac Orlan, Pierre. "La Vie Moderne: L'Art littéraire d'imagination et la photographie." *Les Nouvelles littéraires* 17, 210 (22 September 1928), 1.

Waldemar, Georges. "L'art photographique, Le XXIIIième Salon internationale." *La Presse* (16 October 1928).

Mac Orlan, Pierre. "La photographie et le fantastique social." *Les Annales [Annales Politiques et Littéraires]* 2321 (1 November 1928), 413–414.

"Bruxelles: Exposition de photographie (Galerie de l'Époque)." *Cahiers d'Art* 8 (November 1928), 356.

L., F. "L'exposition de la photographie à la Galerie de l'Europe." *Variétés* 1, 7 (15 November 1928), 400–401.

Gallotti, Jean. "La Photographie: Est-Elle un Art?" *L'Art Vivant* 5, 101 (1 March 1929), 208–211.

Mac Orlan, Pierre. "Photographie." *Das Kunstblatt* (May 1929), 136–140.

Lotz, W. "Film und Foto." *Die Forme* 4, 11 (1 June 1929), 277–279.

Nachod, Hans. "Die Photographie der Gegenwart." *Neue Leipziger Zeitung*, 20 August 1929.

"Eine neue Künstler-Gilde: Der Fotograf erobert Neuland." *UHU* 6, 1 (October 1929), 34–41.

F., E. "Photografie de Gegenwart: Die neuste Aussstellung in Magdeburg." *Magdeburgische Zeitung* (November 1929), 5.

Gy, G. "Kertész András." *Pesti Futár*, 5 December 1929, 21–22.

"Images." *L'Illustration* 88, no. 4539 (1 March 1930), 291.

Waldemar, George. "Photographie, vision du monde." *Arts et Métiers Graphiques* 3, 16 (15 March 1930).

"L'art de la photographie." *La Revue Hebdomadaire* 12 (22 March 1930), 32, 39–40.

"Photographes d'Aujourd'hui." *Art et Décoration* (April 1930), 3.

Vidal, Jean. "En photographiant les photographes." *L'Intransigeant*, 1 April 1930.

Kerdyk, René. "Le Salon de l'Araignée." *Le Crapouillot* (June 1930).

"Le Salon de l'Araignée." *Art et Décoration* 57 (June 1930), IV–V.

Rim, Carlo. "Curiosités photographiques." *L'Art Vivant* 6, 135 (1 August 1930), 604–605.

S., M. "A Fotó Müvészete [Art of Photography]." *Usjàg Vasàrnapja* 44 (2 November 1930), 17–18.

Fels, Florent. "Photographie—Nouvel Organe." *L'Art Vivant* 7, 147 (April 1931), 145–147.

Fels, Florent. "Une exposition de la photographie." *Vu* 161, (15 April 1931), 539.

Fels, Florent. "Actualités Photographiques." *L'Art Vivant* 7, 148 (May 1931), 197–199.

Wilhelm-Kastner, R. "Die Fotografie von Heute, zur Aussstellung, 'Das Lichtbild' in Essen." *Die Wochensau* 29, no. 5 (19 July 1931), 4–5.

Rim, Carlo. "Defense et illustration de la photographie." *Vu* 214 (20 April 1932), 587.

J.E.P. "Exposition photographique à la Galerie de la Pléiade." *Arts et Métiers Graphiques* 36 (15 July 1933) 52–53.

Guégan, Bertrand. "Kertész et son miroir." *Arts et Métiers Graphiques* 37 (15 September 1933), 24–25.

"Enfants." *La Liberté* (23 November 1933), 4.

P., C. "L'album 'Enfants' de M. André Kertész." *Photo-Illustrations* 7 (1934), 15.

De Santeul, Charles. "L'album Enfants de M. André Kertész." *Photo-Illustrations* 1 (1 January 1934), 15.

Rim, Carlo. "Grandeur et Servitude du Reporteur Photographique." *Marianne*, 21 February 1934, 8.

Malo, Pierre. "Une exposition d'oeuvres photographiques." *L'Homme libre*, 15 July 1934.

Gàl, Làzlo. "Egy Magyar Fényképész párizsi munkái [The Work of a Hungarian Photographer in Paris]." *Pesti Hirlap*, 23 December 1934, 26–27.

S[anteul], C[harles de] . "À la Galerie de la Pléiade." *Photo-Illustrations* 11 (1935), 19.

S[anteul], C[harles de]. "L'Exposition de l'A.E.A.R. (Association des Ecrivains et Artistes Révolutionnaires)." *Photo-Illustrations* 13 (1935), 47–48.

S[anteul], C[harles de] ."Les Artistes Photographes d'Aujourd'hui." *Photo-Illustrations* 2 (January 1935), 1–4.

S[anteul], C[harles de]. "Paris Vu par André Kertész." *Photo-Illustrations* 9 (January 1935), 7.

Dabit, Eugène. "Paris, par André Kertész." *Nouvelle revue française* 43, no. 258 (1 March 1935), 474–475.

Aragon, Louis. "Ou va la peinture?—Un 'Salon' Photographique." *Commune* 2, no. 22 (June 1935), 1189–1192.

Vauxcelles, Louis. "Au Salon de la Photographie." *Le Monde Illustré* 4060 (12 October 1935), 893.

Cheronnet, Louis. "La Photographie: Image de la Vie." *Vu* (5 January 1936), 155.

Gilson, Paul. "Les Arts: La Photographie au Pavillon de Marsanne." *L'Intransigeant*, 20 January 1936.

Lhote, Andre. "Un Peintre chez les Photographes." *Revue de la Photographie* 35 (February 1936), 1–2.

Guenne, Jacques. "Les Dix." *L'Art Vivant* (March 1936), 37–57.

Moutard-Uldry, Renée. "Le Groupe des Dix." *Beaux Arts*, 3 April 1936.

Chavance, Rene. "Les Expositions: Hier et Aujourd'Hui." *La Liberté*, 13 April 1936.

"Mirror Photography Gives the Grotesque Touch." *Photography* (London) 4, no. 46 (June 1936), 1.

"Photographer Sails to New York." *New York Herald Tribune* (Paris edition), 8 October 1936.

Sougez, Emmanuel. "La Photographie." *Le Point* 1, 6 (December 1936), 6–26.

"André Kertész et Jaboune: Nos amis les bêtes." *Je Suis Partout*, 5 December 1936.

Audiat, Pierre. "Nos amis les bêtes." *Paris-Midi*, 25 December 1936.

H., A. "Nos amis les bêtes." *La Libre Belgique*, 28 January 1937, 9.

"André Kertész." *Advertising Agency Magazine* 2 (December 1937), 46–47.

"P. M. Shorts." *PM* 4, 4 (December 1937–January 1938), 82.

Strider, Gary. "Kertész — Camera Surrealist." *Popular Photography* 2, 3 (March 1938), 42.

King, Alexander. "Are Editors Vandals?" *Minicam* 2, 8 (April 1939), 26–33, 80–81.

Browning, Arthur. "Paradox of a Distortionist." *Minicam* 2, 12 (August 1939), 36–41.

Knight, John Adam. "Photography." *New York Post*, 2 November 1940.

Newhall, Beaumont. "Image of Freedom." *Museum of Modern Art Bulletin* 9, 2 (November 1941), 14–16.

Newhall, Nancy. "What is Pictorialism?" *Camera Craft* 47, no. 11 (November 1941), 653–663.

Knight, John Adam. "Photography." *New York Post*, 31 December 1942.

Eisner, Maria Giovanna. "Citizen Kertész." *Minicam Photography* 7, 10 (June 1944), 27–33.

Elliot, Paul. "Day of Paris." *Saturday Review of Literature* 28, 20 (19 May 1945).

Downes, Bruce. "André Kertész: Day of Paris." *Popular Photography* 16, 6 (June 1945), 48–49, 101.

Reed, Judith Kaye. "A Day in Paris." *Arts Digest* 19 (June 1945), 26.

"Day of Paris." *Minicam Photography* 8, 10 (July 1945), 22–29.

Zucker, Paul. "André Kertész, *Day of Paris.*" *Journal of Aesthetics and Art Criticism* 5, no. 3 (March 1947), 235–236.

Dembling, Merwin. "Art in the Kitchen." *Minicam Photography* 12 (November 1948), 26–29.

"Photographer's Love Letter." *Vogue* (February 1954).

Houseman, William. "André Kertész." *Infinity* 8, 4 (April 1959), 4–13, 22.

Poli, Kenneth. "One-Man Show: André Kertész, Photojournalist." *Leica Photography* 15, 3 (1962), 4–8.

Deschin, Jacob. "Careers in Review: Retrospective Exhibits by Kertész, Ruohomaa." *New York Times*, 28 October 1962.

Schwalberg, Carol. "André Kertész: Unsung Pioneer." *U.S. Camera* 26, 1 (January 1963), 54–57, 64.

Brassaï. "My Friend André Kertész." *Camera* 42, 4 (April 1963), 7–32.

"Kertész Exhibit Recalls His Earlier Activity." *New York Times*, 16 June 1963.

Pluchart, François. "Un Grande Photographe: André Kertész." *Combat Paris*, 16 November 1963.

Gautier, Maximilien. "Quand l'Oeil a du Génie." *Les Nouvelles littéraires* (28 November 1963), 9.

de l'Ain, Girod. "La Photographie: André Kertész." *Le Monde*, 29 November 1963.

Régnier, Georges. "Un Long Régard Amical: André Kertész." *Le Photographe* (20 December 1963).

Plecy, Albert. "Andre Kertész." *Images du Monde* 815 (24 January 1964) 18–19.

"The World of Kertész: A Great Photographer Has Spent a Lifetime in Pursuit of His Art." *Show* 4, 3 (March 1964), 56–61.

Gruber, L. Fritz. "André Kertész, ein keinesfalls verschollener Altmeister." *Foto Magazin* (July 1964).

Jakowsky, Anatole. "Le Royaume enchanté des naifs." *Beaux Arts* (7 October 1964).

Deschin, Jacob. "Camera News." *New York Times*, 29 November 1964.

Deschin, Jacob. "Kertész: Rebirth of an Eternal Amateur." *Popular Photography* 55, 6 (December 1964), 32–34, 42.

Weiss, Margaret. "André Kertész, Photographer." *Saturday Review of Literature* (26 December 1964), 28–30.

Budnik, Dan. "A Point de Vue." *Infinity* 14, 3 (March 1965), 4–11.

Vestal, David. "Kertész at MOMA: An Improper Review." *Contemporary Photographer* 5, 2 (Spring 1965), 65–66.

"Six Exceptional Women: A Portfolio by Kertész." *Harper's Bazaar* (June 1965), 66–71.

Hood, Robert. "The Deadly Métier." *Infinity* 15, no. 6 (June 1966), 5, 28–30.

Jay, Bill. "André Kertész: Nude Distortion, an Incredible Experiment." *Creative Camera* 55 (January 1969).

Jay, Bill. "André Kertész: A Meeting of Friends." *Creative Camera* 62 (August 1969), 280–281.

Jay, Bill. "André Kertész: Portfolio." *Creative Camera* 63 (September 1969), 312–321.

"André Kertész." *Aperture* 14, 2 (Fall 1969).

James, Geoffrey. "André Kertész." *Vie des Arts* 57 (Winter 1969–1970), 52–55.

Kramer, Hilton. "Photo Show at Modern Surveys 20s." *New York Times* (4 June 1970), 48.

Malcolm, Janet. "On and Off the Avenue: About the House." *New Yorker* 47, 11 (1 May 1971), 118–121.

Gassner, Manuel. "Kertész: Paris um 1930." *Du* 31 (July 1971), 520–537.

Weiss, Margaret. "Everyman's Reader." *Saturday Review of Literature* (3 July 1971), 30–31.

Weiss, Margaret. "Photography." *Saturday Review of Literature* 54, 32 (7 August 1971), 36–37.

"On Reading, by André Kertész." *Camera* 25 (December 1971).

Kismaric, Carole. "André Kertész." *Camera* 51, 5 (May 1972), 34–44.

Russell, John. "Faces and Places." *Sunday Times London*, 1 October 1972.

Ellis, Ainslie. "A Triumph for the Innocent Eye: The Work of André Kertész." *British Journal of Photography* 119, 5857 (20 October 1972), 922–925.

Nuridsany, Michel. "André Kertész: Soixante ans de photographie." *Le Figaro*, 23 October 1972.

Gill, Brendan. "André Kertész: Sixty Years of Photography." *New Yorker* (30 November 1972).

Weiss, Margaret. "Anniversary Salute to André Kertész." *Saturday Review of Literature* (January 1973), 26–28,

Kramer, Hilton. "Kertész Conveys Poetic Significance of Details." *New York Times*, 17 January 1973.

Coleman, A. D. "André Kertész." *New York Times*, 28 January 1973.

Levine, Martin. "Photography: Visual Variations." *Newsday* (29 January 1973).

Langer, Don. "Books. The Sensitive Eye." *New York Post*, 8 February 1973.

Tasnadi, Attila. "Foto André Kertész." *Nepszava* (8 April 1973).

Galassi, Peter. "Kertész and Erwitt: The 35 mm Point of View." *The Richmond Mercury*, 1 August 1973.

Larson, Kay. "Art: Revolution and Muckraking in Photography." *The Real Paper*, 17 October 1973.

"Omaggio a André Kertész." *Fotografia Italiana* 187 (November 1973), 10.

Bloomfield, Arthur. "Sampling 60 Years of a Great Photographer." *San Francisco Examiner*, 12 February 1974.

Murray, Joan. "André Kertész." *Artweek* (23 February 1974), 11.

Kramer, Hilton. "Three Who Photographed the 20s and 30s." *New York Times*, 3 March 1974.

Knapp, Gottfried. "Was die Dinge erzahlen. Photos von André Kertész in der neuen Sammlung." *Suddeutsche Zeitung*, 8 May 1974.

Gelatt, Dorothy. "André Kertész at 80." *Popular Photography* 75, 5 (November 1974), PP.

Artner, Alan. "An 80-Year Old Master." *Chicago Tribune*, 10 November 1974.

Stevens, Nancy. "André Kertész." *The Soho Weekly News*, 19 December 1974.

Brassaï. "La Deuxième Vie de Kertész." *Photo* 90 (March 1975), 65, 71.

"Dossier: André Kertész." *Photo* 90 (March 1975), 56–66, 71.

"Face to Face: Professionalism. Kertész." *ASMP Journal of Photography in Communications Bulletin* 75 (March 1975), 12–13.

Voyeux, Martine. "Kertész qui aime Paris." *Quotidien de Paris*, 10 March 1975.

Bruns, Renee. "Books." *Popular Photography* 74, 6 (April 1975), 101–102.

Greenfield, Lois. "André Kertész: 'Rediscovered' at 70." *Changes* (April 1975), 20–21.

Spencer, Ruth. "André Kertész." *British Journal of Photography* 122, 5985 (4 April 1975), 290–293.

Salgado, Robert. "It Was Like Picasso Asking to Draw You." *Sunday Bulletin*, 20 April 1975.

Dubrou, Robert. "Les rencontres de la Photo à Arles. Le grand Kertész." *La Marseillaise*, 18 July 1975.

Edelson, Michael. "The Diary of André Kertész." *Camera* 35 (October 1975), 47.

Nuridsany, Michel. "Kertész, un grand des années 20 et d'aujourd'hui." *Le Figaro*, 20 October 1975.

Gill, Brendan. "Visiting Photographer." *New York Times Book Review*, 28 December 1975.

Perloff, Stephen. "Master of the Human Spirit: André Kertész." *Philadelphia Photo Review* 1, no. 3 (March 1976), 2–3.

Kramer, Hilton. "Two Masters of Photography." *New York Times*, 27 March 1976.

Thornton, Gene. "André Kertész's Romance with Paris." *New York Times*, 4 April 1976.

Edwards, Owen. "André Kertész at 80: Zen and the Art of Photography." *The Village Voice*, 5 April 1976, 99–100.

Rubenfein, Leo. "André Kertész, French Cultural Services." *Artforum* 14, 10 (June 1976), 67–68.

Grundberg, Andy. "André Kertész at the French Cultural Services." *Art in America* 64, 4 (July/August 1976), 103–104.

Roskill, Mark, and Roger Baldwin. "André Kertész's 'Chez Mondrian,'" *Arts Magazine* 51, 5 (January 1977), 106–107.

Dévényi, Dénes. "Kertész: Dénes Dévényi Interviews the 'Father of 35mm Vision.'" *Photo Life* (January 1978), 10–13, 30.

Claass, Arnaud. "André Kertész." *Zoom* 50 (January–February 1978), 116–129, 138.

Morris, John. "A Gentle Vision." *Quest* 78, vol. 1, no. 2 (January–February 1978), 48–55.

Allen, Casey. "André Kertész." *Camera 35*, 23 (7 August 1978), 22–29; 77–78.

Lifson, Ben. "Kertész Tells an Old Story, Forever New." *Village Voice*, 25 September 1978, 114.

Canavor, Lisa. "Shows We've Seen." *Popular Photography* 84, 4 (April 1979), 64, 151.

Lifson, Ben. "Kertész at Eight-Five." *Portfolio I/2* (June–July 1979), 58–64.

"Kertész, André." *Current Biography* (August 1979), 15–18.

Coleman, A. D. "André Kertész Continues." *Camera 35* 24 (October 1979), 12–13.

Steinorth, Karl. "The International Werkbund Exhibition 'Film und Foto' Stuttgart, 1929." *Camera* 58 (October 1979), 4–31.

Cooper, Thomas, and Paul Hill. "André Kertész." *Camera* 58, 11 (November 1979), 33, 40.

Kismaric, Carole. "The Master of the Moment." *Sunday Times Magazine*, London, 13 January 1980.

György, Mikes. "Kertész." *Amerikai Magyar Népszava* (7 March 1980).

Hughes, George. "Kertész on Colour." *Amateur Photographer* (5 April 1980), 109–110.

Ford, Colin. "André Kertész." *Creative Camera* 193–194 (July–August 1980), 242–245.

Colby, Joy. "It's the Eye, not the F-Stop." *Detroit News*, 10 December 1980.

DiGrappa, Carol. "The Diarist." *Camera Arts* 1, 1 (January–February 1981), 40–55.

Diamonstein, Barbaralee. "Visions and Images: American Photographers on Photography." *ArtNews* 80 (October 1981), 162–166.

Lifson, Ben. "A Great Photographer's Love Story." *Saturday Review* 8, 12 (December 1981), 20–24.

Kramer, Hilton. "Andre Kertész: Birth of a Vision." *Camera Arts* 2 (November 1982), 50–61.

Davis, Douglas. "I Looked, I Saw, I Did." *Newsweek* (6 December 1982), 142–144.

Ugrin, Bela. "Kertész's Photography in Full Bloom." *The Houston Post*, 2 January 1983, 12G.

Goldberg, Vicki. "Staking a Claim in the Heart's Territory." *American Photographer* 10, 2 (February 1983), 22–24.

Gruber, Fritz L. "Der ewige Amateur." *Fotomagazin* (March 1983), 73–83.

Harris, Lin. "Master of the Exact Moment." *Villager Downtown*, 19 May 1983.

Bultman, Janis. "The Up and Down Life of André Kertész." *Darkroom Photography* 5, no. 6 (September–October 1983), 32–35, 42, 48–50.

Ellis, Ainslie. "The View from Above." *British Journal of Photography*, 131, 6444 (3 February 1984), 120–123, 137.

Berman, Avis. "The 'Little Happenings' of André Kertész." *ArtNews* 83, 3 (March 1984), 66–73.

Thornton, Gene. "Kertész: The Great Democrat of Modern Photography." *New York Times*, 22 July 1984.

Gross, Jozef. "Exposure." *British Journal of Photography* 131, 6470 (3 August 1984), 800–803, 812–813.

Robinson, Katherine. "André Kertész: A Diary with Light." *M* (December 1984), 105–108

Clark, Roger. "The Fall and Rise of André Kertész." *British Journal of Photography* 130, 6401 (8 April 1985), 358–361.

Berman, Avis. "Artist's Dialogue: The Tireless Eye of André Kertész." *Architectural Digest* 42, 5 (May 1985), 72, 76, 80–84.

Fondiller, Harvey. "Persistence of Vision." *Popular Photography* 92, 8 (August 1985), 52–59, 136, 147–148.

"André Kertész: 1894–1985." *Afterimage* 13 (November 1985), 2.

Robinson, Walter. "Obituaries: André Kertész." *Art in America* 73 (November 1985), 190.

Plachy, Sylvia. "Hungary by Heart." *Artforum International* 24 (Feburary 1986), 90–96.

Armstrong, Carol. "The Reflexive and the Possessive View: Thoughts on Kertész, Brandt, and the Photographic Nude." *Representations* 25 (Winter 1989), 57–70.

Gill, Brendan. "Outrageous Fortune — Memories of André Kertész." *Architectural Digest* 47 (September 1990), 33, 36, 42, 44, 50.

Szirtes, George. "Kingdom of Shadows." *Modern Painters* 4, no. 1 (Spring 1991), 46–49.

Bauret, Gabriel. "André Kertész: 'Ma France,' Artists' Studios in the Twenties." *Art International* 14 (Spring–Summer 1991), 35–40.

Sichel, Kim. "*Paris Vu par André Kertész*: An Urban Diary." *History of Photography* 16, 2 (Summer 1992), 105–114.

Ford, Sue Grayson. "A Hungarian Abroad." *British Journal of Photography* 6938 (2 September 1993), 14–15.

Teleky, Richard. "'What the Moment Told Me'; The Photographs of André Kertész." *Hungarian Studies Review* 21, nos. 1–2 (1994), 31–41.

Passuth, Krisztina. "Párizsi beszélgetés André Kertésszel." *Új Mũvészet* (June 1994), 15–31, 74–76.

Hamilton, Peter. "The Mighty Magyar." *British Journal of Photography* 14, 7501 (15 November 1995), 14–15.

Allen, Fergus. "Ronis and Kertész." *London Magazine* 35, nos. 11–12 (February–March 1996), 137–143.

De Luca, Michele. "André Kertész, Lo Specchio di una Vita." *Terzio Occhio* 24, 2 (June 1998), 35–37.

Gurbo, Robert. "André Kertész: Lost in America." *Lenswork Quarterly* 23 (November 1998–January 1999), 31–44, 45–63.

Page numbers in bold refer to illustrations.